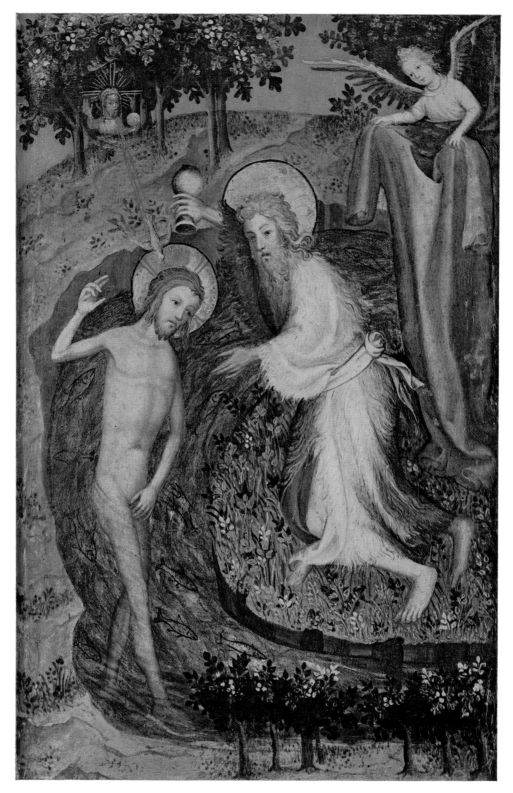

No. 24: The Baptism of Christ from the Netherlandish Altarpiece, ca. 1400

THE INTERNATIONAL STYLE

THE ARTS IN EUROPE AROUND 1400

OCTOBER 23 - - DECEMBER 2, 1962

THE WALTERS ART GALLERY BALTIMORE

TABLE OF CONTENTS

Lenders to the Exhibition . vi

Foreword . vii

Introduction . x

Abbreviations of Works most frequently Cited xvi

CATALOGUE

Paintings and Drawings (Nos. 1-37) 1

Illuminated Manuscripts (Nos. 38-76) 41

Sculpture (Nos. 77-99) 79

Decorative Arts

 Verre Eglomisé (Nos. 100-101) 99

 Coffrets and Secular Objects (Nos. 102-106) 100

 Ivory Carvings (Nos. 107-123) 103

 Goldsmithswork (Nos. 124-129) 122

 Enamels (Nos. 130-141) 128

 Metalwork (Nos. 142-148) 136

 Coins and Medals (Nos. 149-156) 142

 Textiles (Nos. 157-160) 148

 Addendum: The Pyx of Philip the Good (No. 161) 153

PLATES . I-CXXV

(Note: *In the description of objects belonging to the Walters Art Gallery the date of acquisition is given whenever known.*)

LENDERS TO THE EXHIBITION

BERLINER MUSEEN, STIFTUNG PREUSSISCHER KULTURBESITZ
MUSEUM OF FINE ARTS, BOSTON
CLEVELAND MUSEUM OF ART
MUSÉE DE CLUNY, PARIS
DETROIT INSTITUTE OF ARTS
MUSÉE DE DIJON
FOGG ART MUSEUM, HARVARD UNIVERSITY
WILLIAM S. GLAZIER, NEW YORK CITY
HARVARD COLLEGE LIBRARY
MR. AND MRS. PHILIP HOFER, CAMBRIDGE, MASS.
MR. AND MRS. T. S. HYLAND, GREENWICH, CONN.
JOHN WORK GARRETT LIBRARY, JOHNS HOPKINS UNIVERSITY
METROPOLITAN MUSEUM OF ART, NEW YORK CITY
MUSEUM OF ART, UNIVERSITY OF MICHIGAN
NATIONAL GALLERY OF ART, WASHINGTON, D. C.
NORTH CAROLINA MUSEUM OF ART, RALEIGH
PHILADELPHIA MUSEUM OF ART
PIERPONT MORGAN LIBRARY
ART MUSEUM, PRINCETON UNIVERSITY
LESSING J. ROSENWALD, JENKINTOWN, PA.
MR. AND MRS. GERMAIN SELIGMAN, NEW YORK CITY
JACQUES SELIGMANN AND CO., NEW YORK CITY
JANOS SCHOLZ, NEW YORK CITY
KUNSTHISTORISCHES MUSEUM, VIENNA

FOREWORD

From May 7 to July 31 of this year 600 art objects illustrating the arts of Western Europe from around 1360 to the mid-fifteenth century were displayed in a whole wing—seventeen large rooms—of the Kunsthistorisches Museum, Vienna. It was the eighth exhibition held under the auspices of the Council of Europe. Like the previous ones, dedicated to Romanesque art, Classicism, Mannerism, Baroque, Rococo, Romanticism, Sources of Twentieth-Century Art, it represented a census of the wealth of European art at crucial points in its glorious development. The themes chosen for these eight great exhibitions intentionally emphasized the supra-national relationships that always have maintained or reestablished an ideal unity in European art, in spite of varieties in expression due to ethnical and individual temperaments and to the exceptions due to some persons endowed with the highest creative genius. By helping both the public and the art specialists to think of successive manifestations in European art, from the Middle Ages to our own time, in terms that transcend the narrow and sometimes artificial national boundaries, and to grasp their essential message, the exhibitions sponsored by the Council of Europe symbolize the increasing consciousness which Europeans are acquiring of their unity of culture and focus it on the exigencies of today.

In Vienna this year, for the first time since the beginning of the Council of Europe exhibitions, the western half of the Atlantic community was represented by substantial loans from the United States and Canada. These, added to the splendid contributions of thirteen western European nations, recalled the fundamental unity of culture and artistic inheritance of the two parts of the Western World. Because American collections, public and private, are so unexpectedly rich in the arts of Western Europe of the period around 1400 and because, for technical and other reasons, only a relatively small proportion of their riches could be sent to Vienna, the Walters Art Gallery has planned a special exhibition as a sequel, albeit a modest one, to the magnificent art celebration held in Vienna. More than one hundred and sixty items have been assembled here: paintings, sculpture, illuminated manuscripts, drawings, goldsmith's art and metal work, ivories, verre églomisé, enamels, caskets in leather, textiles, medals and coins are on display. The Walters Art Gallery which has abundant possessions in all of the fields mentioned—but no drawings and textiles of the period—has contributed two-thirds of the exhibition from its own collection. One third is generously loaned by nineteen American and European lenders.

It is our privilege to acknowledge first of all the especially substantial loans granted by the Museum of Fine Arts, Boston, the Metropolitan Museum of Art and the Pierpont Morgan Library, New York, and the information provided by the staff of each of these institutions. Given the pressure of time, everyone was remarkably helpful in answering requests and making suggestions. It is a great pleasure to me to express my particular gratitude to Hanns Swarzenski and Richard Randall, Curator and Assistant Curator, respectively, of the Department of Decorative Arts in the Museum of Fine Arts, Boston, to Miss Dorothy Shepherd, Curator of Textiles, and William Wixom, Associate Curator of Decorative Arts, Cleveland Museum of Art, to Francis Robinson, Curator of Ancient and Medieval Art, The Detroit Institute of Arts, Justus Bier, Director of the North Carolina Museum of Art, and to Dr. Sarah Freeman, Curator of Fine Arts of The Johns Hopkins University, all of whom by their special efforts made this exhibition their personal concern.

To all the private collectors we are deeply grateful for their collaboration and their generosity in depriving themselves of their treasures. We may be forgiven for making special mention of certain of these: a friend of the late Henry Walters, Mr. Germain Seligman, who has loaned a part of the magnificent collection of rare translucent enamels which belongs to Mrs. Seligman and himself; and also some new friends of the Walters Art Gallery: Mr. and Mrs. Thomas S. Hyland, who in recent years began assembling their Italian primitive paintings in their former residence at Westminster, Maryland; and Mr. Janos Scholz, the musician of international reputation, who has gathered in his New York apartment the most remarkable private collection of drawings in America.

A number of very important or unique works of art pertaining to the International Style that are owned by American institutions will be missed here. The extremely limited space at the disposal of the Walters Art Gallery has imposed acute restrictions. Moreover, many precious and desirable objects were unobtainable because of ex-

treme fragility, or due to regulations requiring their permanent display in the institutions to which they belong. The visitor will notice that this difficulty has inevitably affected the balance of the paintings in the display, so far as regional representation is concerned. Many of these missing works of art, so intimately related to our theme, are referred to in various entries in this Catalogue. Among others which are not so mentioned are: the Death of the Virgin by the Master "del Bambino Vispo" in the Art Institute, Chicago, and a painting of the same subject by the Master of Heiligenkreuz in the Cleveland Museum of Art, a triptych of the school of Cologne in the Detroit Institute of Arts, the lovely Arras tapestry representing the Annunciation, as well as the project for the Gaia Fountain in Siena drawn by Jacopo della Quercia, both in the Metropolitan Museum of Art, the tapestries of the duc de Berry in The Cloisters, New York, the boxwood sketchbook with figures by an artist close to Jacquemart de Hesdin and the Bohemian Bible in the Pierpont Morgan Library, the morse of enamel encrusted on gold with a representation of the Trinity, in the National Gallery, Washington, as well as the beautiful Franco-Flemish drawing of the Death of the Virgin in the Rosenwald Collection of that institution, the Madonna in a Garden by Stefano da Verona in the Worcester Art Museum.

In order that Western Europe would not be represented *in absentia,* a very few loans were requested from the museums of Berlin and Vienna and from France. The ceremonial sword of Emperor Siegmund I has left the Imperial—today National—collections of Vienna only once before this—in 1896, on the occasion of the celebration in Budapest of the millennium of the Kingdom of Hungary. I want, in the name of the Walters Art Gallery, to express my special gratitude for the loan of such a glorious historical relic to Dr. Heinrich Drimmel, Minister of Public Education in Austria, to Dr. Vinzenz Oberhammer, Director of the Kunsthistorisches Museum, Vienna, and to Dr. Bruno Thomas, Director of the Collection of Arms and Armor there. I want also to offer my sincere gratitude to Professor Peter Metz, Director of the Department of Sculpture of the Museums of Berlin-Dahlem, for the loan of the unique cast of one of the jewels that had belonged to the Duke of Berry. Thanks to him, examples of all that survive of the medallions collected or commissioned by the Duke of Berry will be gathered together for the first time, along with an enamelled medallion acquired by Henry Walters, which is derived in part from the medals of the Duke of Berry.

Through the friendly cooperation of the Association Française d'Action Artistique, a branch of the French Foreign Office, and the French Attaché Culturel in New York, and the Musées du Louvre and de Cluny, and also the Musée de Dijon, it was possible to obtain the tapestry of the Offering of the Heart, one of the treasures of the Louvre, presently displayed at the Musée de Cluny, as well as the pyx of Philip the Good, Duke of Burgundy. I want to extend my warmest gratitude to Mr. Philippe Erlanger, Director of the Association Française d'Action Artistique, and to his assistant, M. F. Gobin, and to my friends, M. Edouard Morot-Sir, Conseiller Culturel, New York, M. Pierre Verlet, Conservateur en chef du département des objets d'art in the Musée du Louvre, M. Francis Salet, Conservateur en chef, Cluny Museum, Paris, and M. Pierre Quarré, Conservateur en chef, Musée des Beaux-Arts, Dijon.

A certain number of the art objects, both among the loans and among those from the collections of the Walters Art Gallery, will be displayed for the first time, or brought into conjunction. For instance, for the first time since they were collected by Giorgio Vasari in his *Libro de' Disegni,* the two most important copies of Giotto's famous mosaic, the "Navicella," will be presented side by side.

Compared to the series of spacious galleries in which the works of art were displayed at Vienna, the objects comprising our related exhibition will have the disadvantage of very limited space. Closely assembled as they will have to be, to those who are sensitive and attentive, these beautiful objects will not fail to speak. It is partly to compensate for the simplicity and the limitations of the presentation that we have undertaken to provide an extensive and abundantly illustrated catalogue. The opportunity has been seized to discuss many little-known objects in their relation to the theme of the exhibition, and to examine anew certain aspects of those that are well known. A number of new attributions will be noted. In leaving the shelter of just repeating traditional attributions, we do, of course, lay ourselves open to disagreement and criticism, but the lasting purpose of such an exhibition is to stimulate discussion and further research. The assembling from distant places of exceptionally precious and fragile works of art is not warranted unless it endows them with a new life. Under the extreme pressures which must always attend the writing and printing of such a catalogue as this, it is inevitable that omissions, blemishes and even more serious errors will creep in. The authors and editor are only too conscious that this is so. We can but ask for the reader's indulgence. Even with such faults, we hope

that this publication will serve its purpose of providing a useful record and a reservoir of ideas which will long outlive the brief duration of the exhibition.

The undertaking of our exhibition: The International Style—Arts in Western Europe around 1400—would hardly have been possible in the present difficult period confronting the Walters Art Gallery if, from the start, it had not met with the confidence of the Board of Trustees and been encouraged by their sympathetic and constant support. Our Director, Edward S. King, was so kind as to supervise the technical problems of the installation. Miss Mabel Kaji, who had just retired from the Baltimore Museum of Art, graciously accepted our invitation to take charge of the presentation of the objects, giving us the assistance of her long experience and her sensitiveness. Miss Helene Hedian has executed the banners which add to the show the gay note of a medieval pageant. The reunion of the Italian and Catalan paintings possessed by the Gallery has been made possible by the years of sustained work of our conservation department, initiated a quarter of a century ago by the late David Rosen and continued conscientiously and brilliantly by Elisabeth Packard, at first together with the late John Carroll Kirby, with the assistance of Elizabeth Carroll in 1954-57, and, since 1959, of Peter Michaels. Miss Packard has also been invaluable in helping with the actual work of installation. Miss Winifred Kennedy, Registrar of the Walters Art Gallery, has had the important responsibility of the registration and insurance formalities. We want also to thank the members of the guard force and shop of the Gallery who have helped to prepare the installation: Gustav T. Ellinger, the carpenter, Captain William H. Smith, Joseph Gilden, Edward Kahl, and all the others who helped in so many ways.

In regard to the Catalogue, the entries for numbers 1 to 37 and 77 to 161 (paintings and drawings, sculpture, and the decorative arts) are the responsibility of the undersigned. The entries numbers 38 to 76, describing the illuminated manuscripts, were written by Dorothy Miner, Librarian and Keeper of Manuscripts, who also undertook the general editing of the entire catalogue. The members of the staff on whom these authors depended for the exacting work of typing so extensive a text were Lily Wahbe, Alice V. Grigg, and most especially, Irene Butterbaugh. A loyal assistant in many matters was Aurelia G. Bolton. The photographs of all Walters Art Gallery objects and of certain others were made by the Photographer of the Gallery, Sherley B. Hobbs.

Finally, we cannot omit to express our deep appreciation to our friends, the John D. Lucas Printing Co., and especially to Benjamin Meeks, Jr., for accepting the challenge of producing so elaborate a catalogue under what can only be termed unrealistic limitations of time. To the loyalty, skill and enthusiasm of the specialists there who worked with us, we extend our heartfelt thanks. The engravings were produced by the Advertiser's Engraving Company of Baltimore, under the special supervision of Paul Love. The color-plate was originally prepared for the September 1962 issue of *Art News*. The cover-jacket was executed by the Lancaster, Pennsylvania, branch of the Donnelley Printing Company.

<div align="right">

PHILIPPE VERDIER

Curator of Medieval & Subsequent Decorative Arts

</div>

INTRODUCTION

The organizers of the Vienna exhibition called it: *European Art around 1400* (an "around" spanning some eighty years), avoiding in the title the appellation, "The International Style," which, however, is used unrestrictedly in the Vienna catalogue itself. The term "International Style"—*art international* in French—is the godchild of the French art-critic, Louis Courajod, who, towards the turn of the last century, in his famous lectures at the Ecole du Louvre, was the first to detect a *"courant international"* accounting for stylistic affinities between French and Florentine sculpture at the dawn of the Renaissance. Those were the days of Wölfflinian art criticism, in which, as a reaction against Taine's approach to art as a mirror of man's historical environment, works of art were to be divorced from their historical context and even from their content, and considered only as pure pattern analyzed according to the methods of abstract aesthetics. The Germans coined the term "soft style"—*weicher Stil*—as the common denominator characterizing European art at the end of the fourteenth and the beginning of the fifteenth century. Neither appellation—"International Style" or *weicher Stil*—covers appropriately the arts of the period under consideration, but the paradox is that today we could not go anywhere without them. So it was decided to keep "The International Style" as the title of this show, because the specialists have made it legitimate. The artists of the period around 1400 would nevertheless have been surprised to hear that they were international Europeans, because there were then neither nations nor a Europe, at least in the sense given to these political structures nowadays. We cannot help envisioning the past from the viewpoint of our total inheritance of it, and, in our case, from the angle of the new Europe in the making. In connection with this, it is of a great interest to note that the term "Europeans" was used first almost exclusively in times of threatening common danger; for instance, by the chronicler who continued Isidorus of Beja, when he related the defeat of the Arab invasion near Poitiers in 732, and by Pope Urban II (in 1095), when at Clermont he summoned the "provinces of Europe," "the Christian commonwealth," to liberate the tomb of Christ in Jerusalem. After the failure of the Crusades, the term "Europe," which had been created by the Greek and Roman geographers, began to be revived by Greek and Italian "inventors" and scholars towards the end of the fourteenth century and through the fifteenth century.

The term "International Style" is in itself justified by the scope of this exhibition, in which the arts of France, England, Flanders, the Netherlands, Burgundy, Germany, Bohemia, Austria, Northern Italy, Siena and Florence, Catalonia and Spain are represented by works which spread over three-quarters of a century—1360 and 1433 being the years of the earliest and of the latest dated documents—yet these have stylistic features in common. If we had to consider only its formal patterns of softly sweeping curves and melodiously meandering lines, 1360 could appear too late a date to start with. Such patterns are already present in our own chalice of Sigmaringen decorated with translucent enamels in Constance, southwestern Germany around 1320, and in the illuminations of the French artist, Jean Pucelle and his assistants in the Book of Hours of Jeanne d'Evreux, now in The Cloisters, New York, as well as in the Bible of Robert de Billyng and the Belleville Breviary in the Bibliothèque Nationale, Paris—all three manuscripts having been finished around 1326. The date 1360 makes sense as a "point of no return," after which the arts in Western Europe, considered as an ensemble and not only in a few outstanding precocious masterpieces, everywhere began to share increasingly the same characteristics and to confront us with similar traits. The irreversible transition from the previous style observed in the arts of the fourteenth century to the new one may be clearly traced in a single work begun in the first style and finished in the second one: the silver altarpiece in the Cathedral of Gerona. In that work the contrast between the slender mannerism of Master Bartomeu, who began it in 1320, and the florid mannerism of Pere Berneç who finished it in 1358, is striking. 1360 is also the approximate date of the following landmarks: the first surviving portraits on panels—that of the French King, Jean II "le Bon," in the Louvre, and that of the Austrian Duke Rudolf in Vienna—the adoption of the "plastic" style in Austrian stained glass (Strassengel near Graz, choir of the Cathedral of St. Maria am Gestade in Vienna) and the introduction by Theodorik of the Italian sense of spatial unity and the tactile values of the human form in the decoration of the otherwise still Byzantine chapel of the Holy Cross at Karlstejn, in the Kingdom of Bohemia.

As for the official end of the International Style, it is recognized as two-fold: it took place in the third decade of the fifteenth century with the Van Eycks in Flanders and with Brunelleschi and Masaccio in Florence—which does not preclude all sorts of continuations, overlappings and chronological discrepancies. The concrete

reality of a style is to consist of various styles more or less homogeneous, which never progress or recede *pari passu*.

The visitors to our exhibition who consult the bibliography accompanying the entries in the catalogue will perhaps feel puzzled by the wide, almost wild variety of attributions that have over the years been given to certain paintings or ivories. The most disconcerting cases are presented, perhaps, when a painting or a drawing, first held as of the school of Avignon or Franco-Flemish, is ultimately given with very plausible arguments to Bohemia or the Netherlands. It is but too normal to find French art and culture prevailing in Bohemia, as well as the adoption of the revolutionary principles of Tuscan painting, after the Electors chose Charles of Bohemia in July, 1346, to become Emperor under the name of Charles IV. His father, John (d. 1346), was French by culture. The French poet Guillaume de Machaut was in his service. Charles was brought up in Paris, at the court of the Louvre, and his first wife was Blanche de Valois. He was poly-lingual, proficient in Latin, French, Italian, German and Czech. He had sojourned in Avignon, and probably conceived there, before his election as Emperor, the policy of disentangling the German empire from Italy, thus preparing the way for the return of the Pope to Rome some thirty years later, after more than seventy years of "Babylonian captivity" in Avignon. With the reestablishment of the Papacy in Rome, the return of Italy to her supra-national mission was made possible, which, in its turn, paved the way to the Renaissance. An archbishop of Prague, John of Drazice (d. 1343), invited French architects to Bohemia. One of them, Matthew of Arras, who came from Avignon to Prague in 1344, took inspiration from a cathedral of southern France, that of Narbonne, to rebuild the Cathedral of Prague. Later, Charles IV invited Peter Parler to come to Prague from western Germany in order to finish this cathedral. The portraits of the royal family of Bohemia, of the archbishops of Prague and of the French and German architects of the Cathedral carved for the decoration of the triforium by Parler and his workshop, 1374-1385, rate among the highest accomplishments of portrait sculpture in the period of the International Style, together with the statues of the north tower of the Cathedral of Amiens and those of the hall of the palace of the Duke of Berry at Poitiers. The chancellor of Emperor Charles IV, John of Neumarkt, had illuminators who had been active in Avignon. He was a correspondent of Petrarch, whom he invited to sojourn in Prague. He was the first bibliophile in the grand manner, a poet, a translator and an amateur of lyric poetry.

The mixture of artists that occurred in Prague repeated itself everywhere. In Paris during the reign of Charles V (1364-1380), the sculptors engaged in the service of the King or of his brother, the Duke of Berry, were mostly from northeastern France or from the semi-independent regions between France and Flanders. André Beauneveu came from Hainaut; Jean de Rupy, from the neighborhood of Saint-Quentin, worked first for Louis de Male, Count of Flanders; Jean de Liège was a Mosan. In painting the Flemish artists rapidly superseded the French court painters, Gérard and Jean d'Orléans. When Duke Louis of Anjou ordered a series of tapestries illustrating the Apocalypse to be woven in Paris, the cartoons were provided in 1375-1379 by Jean Bondol (Hennequin of Bruges) who since 1371 had been painter to Charles V and his *valet de chambre*. Jean Bondol used as models manuscripts that had been illuminated in England or in northern France around 1250 and also perhaps fourteenth-century ones in which the Apocalyptic imagery, fallen in disregard at the time of the High Gothic Style, was for the first time revived. The Apocalype was to be represented very often in the International Style in a visionary manner, and with a weird turn of imagination, which sometimes curiously recalls the Apocalyptic theophanies of Romanesque art. Under the reign of Charles VI the situation in Paris, so far as painting is concerned, became incredibly confused. On the pure French tradition which survived, although very much reduced in importance, were superimposed in successive additions new influences from northern France—embodied in the mysterious personality of Jacquemart de Hesdin—and from Flanders, the Netherlands, Lombardy, and possibly also, around 1420, from Germany and England.

The most confused milieu in European art towards the end of the fourteenth century was brought into existence when, after the victorious campaigns of Duke Gian Galeazzo Visconti (1347-1402), the Milanese wanted to have a Gothic cathedral vast and splendid enough to compete with those of France and Germany. But they would not accept the high proportions of the French and German Gothic architecture based on the system *ad quadratum*. Between 1391 and 1401, the advisory body of the Cathedral of Milan disagreed with and dismissed in succession the Frenchman Nicolas Bonaventure, the Germans Annas of Firimburg, Heinrich Parler and Ulrich van Eisingen, and, finally, the Frenchman Jean Mignot. The existing cathedral is a typical Italian compromise between the empirical ground plan established in 1386-1391 by the Lombard architect Simone da Orsenigo and a design for a lower elevation based on proportions *ad triangulum*—an equilateral triangle for the outer aisles and a framework of Pythagorean triangles for the inner aisles and the nave. The sculptors swarmed from Lombardy, the Venetia, France and Germany to the workshop of the cathedral, with the result of producing what Costantino Baroni called "a kind of plastic esperanto, in which, if we had not

the help of documents, it would be almost impossible to distinguish between the works of a Nicolò da Venezia, or of a Giorgio Solari, from those of ghost-like personalities, Annex Marchestens, Walter Monich and others."

The international milieu, in which artists were wont to live and to travel around 1400, was the customary medieval environment. For instance, the main revelation at the exhibition of Romanesque Art is Barcelona in 1961 was afforded by the frescoes transferred from the Chapter House of the monastery of Sigena, in north-eastern Spain, which were painted at the beginning of the thirteenth century in a byzantinizing style by English itinerant artists. Europe had not yet begun to crystallize into differentiated national units, although the first prototypes of centralized states administered by a bureaucracy had been created by Frederic II in Sicily and Philippe le Bel in France, and the English King, Edward III, had at his disposal a national army at the start of the Hundred Years War. The frontiers were porous, the boundaries fluid, the buffer regions numerous. The complex mosaic of the European nations and provinces was in a state of constant flux and of inter-changing patterns. The loyalty of the people still was directed to their ruler more than to the nation. Acquisitive propensity on the part of the princes and the accidents of marriage and inheritance explain why, in the fourteenth century, Aragon became united with Sicily, Provence with Naples, Burgundy with Flanders. Although William of Ockham (d. 1349) distinguished within the Christian western world an *Anglia*, a *Francia*, a *Germania*, an *Italia*, those names represent hardly more than moral entities or loose ethnical communities. In the field of the arts, the centers of gravity were, as in politics, the courts: the royal or ducal courts of Paris, Prague, Vienna, Dijon, Bourges, Milan. After Pope Clement V took possession of Avignon in March, 1309, until St. Catherine of Siena succeeded in obtaining the return of Gregory XI to Rome in 1377, the court at Avignon played an essential part as a cradle of art and culture, in which northern imagination and the Italian vocation to stress the element of "reality" in the artistic form were fused in the new synthesis.

Fourteenth-century Europe looked like an agglomeration of small territorial units lacking any stability or unity. The dream of a German empire never recovered from the disaster inflicted at Parma on Emperor Frederic II in 1248. The decadence of the Papacy began immediately after the celebration in Rome of the jubilee year 1300 had seemed to demonstrate to the Christian world the supremacy of the Pope. France appeared for some time as a sure candidate for leadership. She was everywhere, culturally and politically, the leader in Europe in the first half of the fourteenth century. But she met her limit as early as 1308 in the calculated opposition of the first Pope in Avignon to her plans in Germany, and she suffered set-backs at the hands of England and of the Flemish allies of England. When the Great Schism broke in 1379, Europe was cleft into two camps: Scotland, Castille, Aragon, and a few German princes amenable to French diplomacy took sides with Clement VII and the King of France; the Italian States, together with the Emperor Charles IV, Hungary, Scandinavia, England and soon afterwards England's ally, Portugal, supported Urban VI. To the forces working in the direction of an increasing disruption of unity must be added the rapid proliferation of numerous small city-states in Germany and Italy. This coincided with the apogee of the guilds and of urban organization in the first half of the century. This development, which favored the intra-European trade, was checked only temporarily by the Black Death. In the subsequent period artifacts and art objects, such as the textiles of Lucca and Venice, the alabasters of England, Germany and the Franco-Flemish countries, the tapestries of Paris, Arras, Nuremberg and the Upper Rhine and even the so-called "Beautiful Madonnas" of Bohemia, became, through European trade, agents of the diffusion of iconographic formulae and decorative patterns.

Western Europe, if examined between 1369—the start of the Franco-English war, and 1417, the end of the Great Schism—offers principally social unrest, religious strife and great political confusion. The revolutionary trend that had begun to reshape the European society of the fourteenth century and materialized in the emergence of collective organizations, the coming to the fore of a *laic* opinion and, as a result of both movements, the promotion of new classes, were not to be suffocated in the crisis. What we would call a political "new deal" and was then termed *via moderna*, had been heralded in the period 1318-1338 by three literary works: the *Monarchia* of Dante, the *Defensor Pacis* by Marsilius of Padua, rector of the University of Paris, and the Aristotelian and Averroist philosopher John of Jandun, and finally the *Dialogus* of the English Franciscan, William of Ockham. All three expressed the dream of a restoration of the Empire as the supreme arbitrating power against the encroachments of a Papal theocracy, vindicating the "two swords" of the spiritual and temporal power. In verses stirred by emotion, Dante had invoked in his *Purgatorio* the return of the Emperor to Rome:

> Vieni a veder la tua Roma che piange
> Vedova e sola, et di e notte chiama:
> Cesare mio, perche non m'accompagne.

The restoration of the Empire as a political theory belonged to the past. But in it was involved the idea of the *desacralization* of the state—a contention that entailed, together with the independence of the rulers from the control of the church, the right of man to express his will free from ecclesiastical dictates. Marsilius and John formulated the theory—let us not call it democratic, but in the Aristotelian sense, timocratic—of a political regime, or legislative power, conceived after the self-governing city-states of Lombardy, a power which, embodied in the general assembly of the citizens, decreed the laws by the majority's rule and checked the executive power. The views of Ockham cut at the root of the pretensions of the Pope—then John XXII— to a supremacy, temporal as well as spiritual. Ockham applied to the Church the principles of naturalism in morals and politics which the knowledge of various treatises of Aristotle had begun to disseminate in the period 1230-1260. The power of the Pope, namely, should submit to the common weal or interest of all, just as the ruler, as head of the state, must remain respectful of the good of its body, which is the people. In the theological part of his treatises, Ockham, by upholding that the general ideas (universals) exist only in so far as they are nouns and are not essences, destroyed the rational intermediate gradations which scholasticism had managed between man and God. Paving the way for the fifteenth-century philosopher Nicholas of Cusa, he left man in a *tête à tête* with the multiplicity of things, in a universe engulfed in the incomprehensible infinity of God. The feeling of man's solitude in the cosmos may have exerted on his faith the same corroding influence as the naturalism of Averroist commentators of Aristotle, like Raymond Lulle. Towards the end of the thirteenth century, in the *Roman de la Rose* Jean de Meung gave the naïve formula for the new vision of a universe eternally circling around a God conceived as an immobile and non-interfering intelligence:

> Toujours feront li cors celestre
> Selonc leur revolucions
> Toutes leurs transmutacions
> E useront de leur poissances
> Par necessaires influences
> Seur les particulières choses.

This philosophy of necessity had its aesthetic counterpart which led to a pantheistic contemplation of nature: Jean de Meung was its interpreter also:

> Car Deus, li beaus outre mesure
> Quand il beauté mist en nature
> Il en fist une fontaine
> Toujours courant et toujours pleine
> De cui toute beauté desrive.

An analagous pantheistic vision of beauty had been that of Scot Erigena in the ninth century, but the new one opened onto unscanned perspectives. It ushered in the realism in art which marks the creations of the fourteenth century. The element of reality in the work of art was shifted from its symbolical aspect to its immediate content.

The *via moderna* in philosophy generated—or was it the sign of—a certain scepticism in matters affecting religious faith. The anticlerical tendencies of the *Defensor Pacis* had had their forerunners in more scathing pamphlets, like the *Disputatio inter clericum et militem* and the *Antequam essent clerici*. But their effect was counterbalanced by the more passionate attitude toward religion that is designated under the name of *devotio moderna*. Personal contacts were established with the divine through the raptures of the soul and the exploration of its most secret propensities, by means of the minutiae of a liturgy which was of a private nature, even if usually performed within the fold of the Church and through its objects of devotion. The tendencies to a personal religion alien to theological discipline were reinforced by mystical writers verging on pantheism, like the Dominicans Eckhardt (d. 1327), Tauler (d. 1361) and Suso (d. 1366). It is again the human, more than the theological and even more than the Christological element, that constitutes the originality of the "New Devotion" drive launched in the Netherlands by the founder of the Brotherhood of Common Life, Gerard Groote (d. 1384).

The *devotio moderna* explains the essential aspect of individual mysticism which one detects in the new iconographic themes created by the artists: the Madonna of Humility, the Man of Sorrows standing before the emblems of the *Arma Christi*, the *Dieu Piteux*. I do not believe that these are indebted to specific literary sources nor, too closely, to the Mystery plays. On the contrary, both literature and art bear testimony to the

greater degree of autonomy attained by writers and artists. Their common inspiration has to be searched for in the revolutionary changes that transformed the psyche of man with the decline of the Gothic world. The pathetic note is strangely mixed in them with a childlike outlook upon the mysteries of religion and of human life itself. The sweet music ends in sorrow. On the other hand, the new iconography of the Trinity and of the Coronation of the Virgin shows unmistakable marks of the collective spirit at work in the struggles for the reorganization of the Church and of the structure of society.

In the twilight of the imperial power—the *Regnum*—and when the Church itself—the *Sacerdotium*—was under attack, there appeared a substitute and arbitrating power, the *Studium,* represented by the universities. Men like Henry of Langenstein (in his *Concilium Pacis,* 1381), Pierre d'Ailly, the chancellor of the University of Paris, Zabarella, the doctor of laws of Bologna, stood for a conciliar reform and tried to shift the government of the Church from the autocracy of the Pope and of the Roman Curia to a regular succession of general councils. Their efforts—and the reformation of the Church itself—were finally to fail at the Council of Basel (1431-1449). The heretics and the social agitators had been taken care of much before. Wycliffe (d. 1384) had defended the revolutionary doctrine of a sort of *justicia moderna,* according to which the "dominion"—or possession justified by right—is sanctioned not by the orthodoxy of the owner and his loyalty to the Church, but by the righteousness of the individual founded on his direct relation with and obedience to God. The followers of Wycliffe, John Huss and Jerome of Prague, who held also that the Scripture and not the hierarchy of the Church is the unique infallible guide of human actions, were burned at the stake (1415 and 1416). Wycliffe's disciples in England, the Lollards, who for a time had managed to percolate into Parliament, were persecuted (1414). In Italy the social counter-revolution was signaled by the defeat of the workers of the Art of Wool and other guilds in Florence, and the triumphal return to power of the oligarchy of the wealthy (1382). That same year the Flemish proletariate of the wool-workers and wage-earners—called the "Bad" in the parlance of the time by the "Good," i.e., the nobles, merchants and craftsmen—which in 1379 had set up a reign of terror in Flanders, was finally crushed, together with the Flemish rebels led by Philip van Artevelde, at Roosebeke.

The rapid sway of the pendulum in the intricate fields of political and religious events should not mask the dominating fact that before 1400 all Europe—Hussite Bohemia excepted—had entered the road of reaction. It is no surprise that the art of the period is supremely aristocratic, with, of course, the "modern" countercurrents underlying it. The freedom of individual creation and the passion of rich patrons for possessing works of art became the primary factors. Forgotten were the sociological programs which had dominated the Gothic centuries, when, under the authority of the Church and an all powerful *maître de l'oeuvre,* all the arts and crafts converged on the cathedral. It is very significant in this respect that the new departure in architecture—the English style known as Perpendicular—was not born in the south transept of Gloucester Cathedral but, as recently proved, in the court school of London.

The International Style is in great part artificial, and also wistful. It expresses a farewell to the Middle Ages and the dream of self-perpetuation of a society which had already changed. The mundane and mystical ingredients so strangely mixed in it (and frequently interchanged) denote an exquisite sophistication in the gallant and luxurious approach to the themes of courtly love and personal devotion. The art collector had become the patron of the period. The greatest art collectors could retain more of a splendid *display* of power than the *reality* of power, as we see in the case of three sons of King John II of France, who were the brothers of his successor, Charles V: Louis, Duke of Anjou (d. 1384). John, Duke of Berry (d. 1416) and Philip the Bold, Duke of Burgundy (d. 1404). The latter, it is true, resurrected a formidable Lotharingia, thanks to the lucky occurrence of his marriage to the heiress of Flanders. John II and Charles VI cut the French Kingdom into slices which they allotted as *apanages* to the three dukes and heaped on them extraordinary wealth and privileges, with the intent that, "by extolling their persons, enhancing their names and setting them up as models of magnificence proposed to imitation," their respectful allegiance to the crown would be insured. The Duke of Berry lived off the fat of the land of his provinces, Berry, Auvergne and Poitou, and levied extortionate taxes in Languedoc where he was the lieutenant of the King. The resources he thus ruthlessly drained crystallized into enormous art collections, which were dispersed after his death and of which comparatively so little survives today. In the early fifteenth century the times were not ripe for the maintenance of art treasures. But among the manuscripts, the tapestries and the jewels which the magnificent duke accumulated during his life, a new taste, almost a new style was born, of far-ranging consequence for the development of humanistic culture in the early Renaissance.

After having taken command of the Italian city-states, the patricians there followed suit in adopting the fashion of the aristocratic centers of northern Europe. Siena had contributed very much to the start of the International

Style in Avignon and in Spain. Later that style returned to Italy from Germany through the Alps, and thanks in part also to the French, who were installed in Genoa and trying to hold Naples. Rational, humanist Florence was itself submerged by the International Style for a short span of time.

The works of art in the International Style have an especially enchanting quality. The form in the fourteenth century remained essentially that of line—the sensuous and spiritual line—and color in fusion with light. The delicate paleness of the gamut of colors is exemplified at its best in the stained glass. Some of the manuscripts in the exhibition, decorated with illuminations in *grisaille* or remaining near the subdued effects of the *grisaille,* conjure up the same impression of coloristic attenuation. The translucent enamels in *bassetaille* demonstrate admirably how shallow relief is reduced to a net of lines shimmering through the transparency of the colors. The aesthetic ideal of the fourteenth century brought about the culmination of the "aesthetics of light" that governed the conception of beauty in the High Gothic period. For a medieval poet, the blood shed by violence was not so much terrible as beautiful, in some qualities. The "Chanson de Roland" praises *li clers sans, li sancz vermeilz,* in the same manner as does Eustache le Paintre the luminous beauty of the face of a young lady:

Vostre douz vis, fres et vermeille et cler

Today we enjoy for its own sake the translucence of colors, but we should have in mind that in medieval times color was considered the manifestation of the divine light in the created world. This interpretation was metaphorically applied to the mystery of the Word made flesh in the Virgin Mary: "As the sunbeam through the glass—passeth but not staineth—thus the Virgin as she was—Virgin still remained," says a stanza of a fifteenth-century hymn.

Probably, the ivory carvings on display originally were more often pointed up with polychromy than their almost immaculate whiteness would indicate today, mellowed by age as it now is. But we may surmise that the pure beauty of the material had in itself a special appeal in the fourteenth century. Every delicate French ivory resurrects the musical and virginal images by which Chrestien de Troyes had evoked the sight of a maiden seated near a fountain:

En un vergier, lez une fontenelle
Dont clere est l'onde et blanche la gravelle
Siet fille à roi, sa main à sa maxelle;
En sospirant son doux ami rapele.

PHILIPPE VERDIER

ABBREVIATIONS OF WORKS MOST FREQUENTLY CITED

Berenson, *List*, 1932	Bernhard Berenson, *Italian Pictures of the Renaissance; A List of the Principal Artists and their Works, with an Index of Places.* Oxford, 1932
Berenson, *List*, 1936	Bernhard Berenson, *Pitture Italiane del rinascimento . . .* Milan [1936]
Bull. Bost.	*Bulletin of the Museum of Fine Arts, Boston*
Bull. Clev.	*Bulletin of the Cleveland Museum of Art*
Bull. MMA	*Bulletin of the Metropolitan Museum of Art*
Bull. WAG	*Bulletin of the Walters Art Gallery*
Dalton Catalogue	O. M. Dalton, *Catalogue of the Ivory Carvings of the Christian Era . . . in the Department of British and Mediaeval Antiquities and Ethnography of the British Museum.* London, 1909
De Ricci	S. De Ricci and W. J. Wilson, *Census of Medieval and Renaissance Manuscripts in the United States and Canada.* New York, 1935-40, 3 vols.
JWAG	*Journal of the Walters Art Gallery*
Koechlin, *Ivoires*	Raymond Koechlin, *Les ivoires gothiques français.* Paris, 1924, 3 vols.
Massarenti Cat.	[Dom Marcello Massarenti], *Catalogue du Musée de peinture, sculpture et archéologie au Palais Accoramboni . . .* Rome, 1897, plus Supplément, Rome, 1900
Morey Cat.	C. R. Morey, *Gli oggetti di avorio e di osso del Museo Sacro Vaticano.* Città del Vaticano, 1936
Panofsky, *Neth. Painting*	Erwin Panofsky, *Early Netherlandish Painting, its Origins and Character.* Cambridge, Mass., 1953, 2 vols.
Stohlman Cat.	F. Stohlman, *Gli smalti del Museo Sacro Vaticano.* Città del Vaticano, 1939
Van Marle	Raimond van Marle, *The Development of the Italian Schools of Painting.* The Hague, 1923-38. 19 vols.
Volbach Cat.	Wolfgang F. Volbach, *Die Elfenbeinbildwerke (Bildwerke des deutschen Museums.* Bd. I). Berlin and Leipzig, 1923
Walters Cat.	*The Walters Collection, Baltimore* (Baltimore, n.d., approxmate dates of three editions: 1909, 1922, 1929)
Walters Exhibition Cat.	*Illuminated Books of the Middle Ages and Renaissance, an exhibition held at the Baltimore Museum of Art January 27-March 13, organized by the Walters Art Gallery . . .* Baltimore, 1949

CATALOGUE

PAINTINGS AND DRAWINGS

1 ALTICHIERO (Circle of), Paduan, ca. 1400

The Crucifixion with the Two Thieves

Pen and ink shaded with black chalk, the outlines executed in iron-gall ink, on paper; 9⅝ x 7¾ in. (.244 x .195 m.)

This drawing, in its concentration and brutal expressionism, is evidence of the intrusion of northern elements which percolated through the Tyrol into the art of northeastern Italy. It has been attributed by Bernhard Degenhart to the circle of Altichiero, an artist born about 1330 in Zevio near Verona (d. 1395), but who was active in Padua, where he revived the style of Giotto.

The composition is a summary of elements drawn from the two frescoes of the Crucifixion executed by Altichiero, Avanzo and his workshop at Padua — one (around 1379) on the wall opposite the entrance to the Oratory of S. Felice in the church of S. Antonio, and the other on the south wall of the Chapel of St. George (ca. 1384). These two frescoes exerted a considerable influence in northern Italy. The squat but very human and pathetic figures of this drawing and the peculiarities of its draughtsmanship, such as the characteristic sharply cut profiles of the faces with their acute noses and protruding upper lips, may be noted in the panel of the Crucifixion signed by Jacopo di Paolo (Galleria, Bologna).

BIBLIOGRAPHY: H. S. Francis, "Rare Italian Drawings: A Crucifixion Close to Altichiero," *Bull. Cleveland* (1958), pp. 195-197.

PLATE XXXVII CLEVELAND MUSEUM OF ART, no. 56.43.
Purchase from the D. E. and L. E. Holden Funds and John L. Severance Fund

2 BARTOLO di MAESTRO FREDI, Sienese, ca. 1330–ca. 1407

Massacre of the Innocents

Tempera and gold-leaf on panel; 2 ft. 9½ in. x 4 ft. 1½ in. (.852 x 1.258 m.)

This composition is a copy of the fresco painted by Barna—possibly with the help of Giovanni d'Asciano—in the second lunette of the right aisle wall in the Collegiata of San Gimignano. After the death of Barna (1351), Bartolo di Maestro Fredi painted on the left aisle wall scenes of the Old Testament, as a complement to the New Testament scenes already painted by Barna and his assistant. According to Vasari, these additions by Bartolo were painted in 1356, but at the latest they must date from 1362-1366. In the Passage of the Red Sea and Moses on Sinai, Bartolo di Fredi repeated the same group of the mother holding her child (especially in the delineation of the child) that we find here at either end of the Walters panel. The group is derived from the Madonna Nursing the Child by Ambrogio Lorenzetti, which is in the chapel of the Seminario archivescovile, Siena. A further detail removes all doubt in attributing this present panel to Bartolo di Fredi as an early work of around 1360: the armor of Herod's soldiers here is the same as that of the Egyptian and Hebrew armies in the Old Testament frescoes at San Gimignano—especially the helmets (barbutes) with movable visor, typical of the third quarter of the fourteenth century.

The architecture may seem toy-like and the figures appear like dolls, but the colors produce a magnificently decorative effect, in which joyous scarlet reds, oranges and yellows strike a contrast with the tragic subject. But in a masterful manner they are keyed down by areas of salmon-rose and purplish pink to the cobalt and steel blues, the lavender, the lac and the whites. The excellent state of preservation of this painting affords a rare opportunity to verify what Cennino Cennini had in mind when he advised the painter to work with colors rightly tempered with "as much yolk as color" and shaded with values dark, medium and light, obtained by a graduated integration of white lead.

Bartolo di Fredi has successfully adapted Barna's original composition to a panel subdivided into five diminishing arches. For in the fresco of the Massacre of the Innocents Barna had introduced a spatial innovation—taking advantage of the pointed lunette of the wall to elevate Herod on a tribune, whence he commands the scene as the apex of a triangular composition. The tribune in Bartolo's present panel is draped with a silk brocade of Lucca.

CONDITION: The tempera paint is in excellent condition, despite losses resulting from splitting, warping and insect tunnelling of the panel. Although the moulding edging the picture is old, the pinnacles are new additions.

PROVENIENCE: B. d'Hendecourt Collection, Paris.

BIBLIOGRAPHY: F. Mason Perkins, "Dipinti Senesi sconosciuti o inediti," *Rassegna d'Arte*, XIV (1914), pp. 99-100, ill. —G. de Nicola, "Andrea di Bartolo," *Rassegna d'Arte Senese*, XIV, 1 (1921), p. 13 (as Andrea di Bartolo, certainly a lapsus)—S. L. Faison, Jr. "Barna and Bartoli di Fredi," *Art Bulletin*, XIV (1932), pp. 311-312, fig. 26 (as an early work of Bartolo di Fredi)—Berenson, *List*, 1932, p. 8 and *idem, List*, 1936, p. 7 (as Andrea di Bartolo—repeating the lapsus of G. de Nicola)—Van Marle, II, p. 489 (correctly attributed to the early period of Bartolo di Fredi, but p. 581, n. 1 as by Andrea di Bartolo, copying mechanically the list of G. de Nicola)—F. Antal, *Florentine Painting and its Social Background*, London, 1948, p. 195, pl. 50 (the stiffness of the forms in the painting being seen as a reflection of the democratic tendencies of Bartolo di Fredi).

PLATE XI WALTERS ART GALLERY, inv. no. 37.1018

3 BICCI di LORENZO, Florentine (1373-1452)

The Annunciation. Predella: The Birth of the Virgin, her Presentation and her Dormition.

Tempera and gold-leaf on panel; overall dimensions including frame: 63¾ x 57 in. (1.595 x 1.425 m.)

The painting is preserved in its original frame. This is decorated on the side strips with delicate rinceaux reserved in the gilded ground and, on the spandrels of the twin cusped arches, with scrolls tooled in relief in the gilded gesso. It retains its *supercoelum*—one of the few surviving canopies which were to protect the altarpiece from falling dust. Painted like the vaults of contemporary churches with a star-studded blue, it shelters the picture with the connotation of the dome of heaven. In the middle spandrel of the frame is painted David playing the psaltery: "In the presence of the Angels, I will sing hymns to Thee, my God" (Psalm 137:1). Across the base, between picture and predella, is an inscription referring to the mystery which is represented in the main panel: O BENE FECVNDA VIRGINITAS QVE NOVO INAVDITOQ (ue) GENERE ET MATER DICI POSSIT ET VIRGO.

The angel kneels with his forearms crossed in devotion before the Virgin seated on a bench in a semi-open study. On the gold nimbus of Gabriel is incised his message, beginning AVE MARIA . . . (Luke I, 28), and on that of the Virgin, her response ECCE ANCILLA . . . etc. (Luke I, 38). The space is divided between an outdoor area where Gabriel kneels, with a glimpse of a flower garden beyond, and an intimate area—the portico-like study of the Virgin, with, in the background, the bed of the sacred bridal chamber. Both areas are united by the rays issuing from the hand of the Father who sends the Dove, symbol of the conception of Christ through the Holy Ghost. The books in the little study allude to the passage in the Gospel of the Pseudo-Matthew where it is said that the Virgin was well instructed in the law of God. On her lap the book is open at the

prophecy of Isaiah: ECCE VIRGO CONCIPIET (7:14) ; and one reads in the volume lying upon a cushion the prophecy of Jeremiah: FEMINA CIRCVMDABIT VIRVM (31:22). What Bicci di Lorenzo has painted is not so much the Annunciation as an event, as rather its liturgical celebration on March 25th. The three scenes in the predella, however: the Birth and bathing of the Virgin, her Presentation in the Temple, and her Death, are all derived from the apocryphal gospels and their traditional iconography as developed in the Mediterranean art of the Near East.

In considering the general presentation of the theme, one recalls that architectural back-drops to circumscribe the outdoor area of the Annunciation were taken over from Hellenistic Christian art by Tuscan painters in the fourteenth century. However, the enclosed area, the character of intimacy and daily life, such as the representation of the bed, were introduced into the scene only in the second half of the fourteenth century by the Gothic painters of northern Italy. A synthesis of both open and enclosed space occurs in Florentine painting in the fresco of the Annunciation painted in Santa Maria Novella around 1400 by the workshop of Agnolo Gaddi and Lorenzo di Bicci (the father of our painter). The folded arms of the angel and the canopy supported by brackets are the same in the fresco and in the present altarpiece.

Bicci di Lorenzo had introduced certain of the elements of this Walters Annunciation in his earliest dated work—a much less developed Annunciation with Four Saints that he painted in 1414 for the parish church of Porciano in the Casentino: i.e., the Virgin's pose, as if interrupted in her reading, and the right hand held to her breast in humility (rather than raised in surprise as here). However, the modelling of the dress of the Virgin and the billowing, somewhat agitated folds of the angel's mantle in the present altarpiece show the influence of the Annunciation painted by Lorenzo Monaco around 1422-1425 for the church of Santa Trinità in Florence. This work by Lorenzo Monaco already reveals contact with the great painter from the Marches, Gentile da Fabriano, for in the garden background Lorenzo copied the naturalistic stalks of flowers which were a feature of the frame decoration of the famous Adoration of the Magi painted by Gentile in 1423 as his first work in Florence, at the order of Palla Strozzi, likewise to be placed in Santa Trinità. The garden in the Walters Annunciation also derives from Gentile da Fabriano. But in regard to his high and luminous color, Bicci depends upon the celestial palette of Fra Angelico.

Bicci di Lorenzo, who was also a sculptor, became acquainted with the new feeling for me-lodious plasticity of the International Style through the "soft manner" introduced into Florence by Ghiberti during the period 1401-1413, and developed in the second decade of the fifteenth century by Nanni di Banco and Donatello. The draperies rendered in paint by Bicci in the Walters altarpiece are handled like those he also sculptured for the glazed terracotta relief exe-cuted in 1424 for the lunette over the door of S. Eligio, the hospital-church of Santa Maria No-vella in Florence. Thus a date of about 1425 to 1430 seems highly probable for the Walters Annunciation.

At the same time, Bicci di Lorenzo turned his back on previous experiments by Masaccio in mastering perspective for the sake of integrating a composition in a "real" and unified space. Vasari tells us that Masaccio had painted in the church of St. Nicholas beyond the Arno an An-nunciation ". . . with a house and many columns . . . The design and colouring are alike perfect and the whole is so managed that the colonnade gradually recedes from view in a manner which proves Masaccio's knowledge of perspective." This lost painting influenced the Annunciations painted by Fra Angelico and his school. Bicci di Lorenzo was interested in the lyrical mood and the celestial colors of Fra Angelico, based on the complementary values of the blue and the pink, but not in his attempts at the scientific rendering of space. In the Walters panel, the perspective lines of the bed, the bench and the ledge above the portico are even inverted, so that they con-verge toward the Virgin. This has the result of visually compensating for her humility by pulling her shy figure to the fore. The same retardataire trend is manifest in the three scenes of the pre-della, which follow schemes established in Giottesque and Sienese painting of the fourteenth century.

Two fleurs de lys impressed on the reverse of the panel attest its Florentine origin. Of the lost altarpieces of Bicci recorded, it might well be the *tavola* painted for S. Marco in 1427-1428, commissioned by Cante di Perino Compagni, on account of the date indicated by its style, rather than the altarpiece painted in 1437 for the Scali choir in Santa Trinità.

CONDITION: In good condition except for a vertical crack which had opened between the two vertical members of the panel support. This has been filled with gesso and inpainted in tempera. The Madonna's mantle, incorrectly painted white in an earlier restoration, has been returned to its original deep blue. Some missing details of the little pendants on the frame have been reconstructed.

PROVENIENCE: Possibly Lawrence W. Hodson, Compton Hall, Wolverhampton, England (but not supported by any record). Acquired by Henry Walters before 1915.

BIBLIOGRAPHY: M. Logan Berenson, "Opere inedite di Bicci di Lorenzo" in *Rassegna d'Arte*, XV (1915), p. 210, figs. pp. 210, 211 (cf. p. 214 for description of an Annunciation and its predella with the same three subjects, in the Hodson Coll., Wolverhampton)—Van Marle, IX, p. 32 (as of artist's late period), cf. n. 3, p. 32 and p. 620—Berenson, *List*, 1932, p. 83—*idem, List*, 1936, p. 71—C. de Tolnay, "The Music of the Universe, Notes on a Painting by Bicci di Lorenzo" in *JWAG*, VI (1943), pp. 83 ff., fig. 1 (as ca. 1433)—W. G. Constable, "A Florentine Annunciation," in *Bull. Boston*, XLIII (Dec. 1945), pp. 74-75, fig. 3 (as of artist's late period).

PLATE XXIX WALTERS ART GALLERY, inv. no. 37.448

4 BOHEMIAN (Prague?), 1370 or later

Madonna and Child

Tempera and gold-leaf on panel; 4¼ x 3¼ in. (.108 x .83 m.), including the original frame.

This little panel first came to light at the Exposition of French Art at Burlington House, London, in 1932, and was published as French. Although for several years after its acquisition by the Boston Museum, it was considered as a product of the School of Avignon, now it is definitely attributed to the Bohemian school. The group of the Madonna and Child is a blend of a Madonna of Italo-Byzantine derivation, such as the Strahov Madonna (National Gallery, Prague) — note especially the complicated pose of the legs of the Christ Child—and of a group more lyrically conceived, like the Madonna of Kladsko, formerly in the Deutsches Museum, Berlin. In the Kladsko Madonna, the pose of the Mother and Child and the direction of their glance are explained by the presence of a donor at their feet. On the contrary, this little panel must be regarded as the right wing of a small devotional diptych, the left wing of which depicted a Man of Sorrows. There is a similar and contemporary Bohemian diptych of the Madonna and Child and the Man of Sorrows (with, it is true, the position of the shutters reversed) in the Kunstmuseum, Basel.

The critics have noted a close stylistic relationship between the Boston panel and a Bohemian diptych representing the Adoration of the Magi and the Death of Mary, which is in the Pierpont Morgan Library, New York. Similarities in the drawing of the nose, in the modelling of the eyes and in the action of the hands, cause one to wonder whether the artist may not be the same. The woman reading in her prayer book at the foot of the death bed of Mary, in the Morgan painting, is the same figure as the Virgin of our small panel, but turned toward the right instead of the left. As early as 1904, the year of the great exhibition of French primitives in Paris, it had been surmised that the author of the Morgan panels might have been one of the miniaturists who worked for the chancellor of Bohemia, John of Neumarkt, and had been active in Avignon. Around 1364 these illuminators executed for him a Breviary, the Liber Viaticus (Prague, National Museum cod. XIII A.12) where two miniatures, that of the Adoration of the Magi and of the Death of the Virgin, compare closely with his treatment of the same subjects in the Morgan diptych. If we retain that date as the approximate date of the Morgan diptych, then the Boston

panel of the Madonna and the Child is certainly later, because it shows already in full blossom a "soft style," hardly noticeable in the Morgan panels.

PROVENIENCE: Frederick Locker Collection, England.

EXHIBITIONS: "Exhibition of French Art 1200-1400," Royal Academy, London, 1932; "Europäische Kunst um 1400," Vienna, 1962.

BIBLIOGRAPHY: Royal Academy of Arts, *Exhibition of French Art: Commemorative Catalogue*, London, 1932, no. 2, pl. I, 2—H. Beenken in *Zeitschrift für Kunstgeschichte*, II (1933), pp. 323 f.—G. H. Edgell, "A Madonna of the School of Avignon (?)" in *Bull. Boston*, XXXIII (June, 1935), pp. 33-36—E. Wiegand, *Die böhmischen Gnadenbilder*, Wurzburg, 1936 (as Bohemian)—G. Bazin, *La peinture française des origines au XVIe siecle*, Paris, 1937, pl. 27—V. Kramár, *Madona se SV. Katerinou a Markétou Meského musea v.C. Budejovicich*, Prague, 1937—A. Matějcěk, *Cerká Malba Gotická*, Prague, 1938—idem, *Gotische Malerei in Böhmen*, Prague, 1939, pp. 21, 73, 77-78, 79, 88, 89, 127, pl. 47—C. Sterling, *La peinture française; les peintres du moyen age*, Paris, 1941, Repertoire et tables, no. 12, p. 16 (as Bohemian)—A. Matějcěk and J. Pešina, *Czech Gothic Painting 1350–1450*, Prague, 1950, p. 51, n. 24, pl. 51—*Europäische Kunst um 1400*, Vienna, 1962, no. 6 (notice by G. Heinz).

PLATE II MUSEUM OF FINE ARTS, BOSTON, no. 34.1459

5 BOHEMIAN (or VIENNA?), early 15th century

Heads of the Virgin Annunciate and of Gabriel

Brush drawings with gray and very light brown wash and touches of red, on vellum; each: 2 x 1 7/16 in. (.053 x .037 m.)

These two drawings relate directly to corresponding heads of the Angel of the Annunciation and of the Virgin in the famous model-book preserved in the Kunsthistorisches Museum, Vienna. The Vienna model-book was first published by Julius von Schlosser, who called it the *"vademecum* of a traveling artist." It consists of fourteen small, thin, maple panels, each divided into four sections, which fold together like a travelling icon and fit into a leather case with loops, so that it could be suspended from a belt. The fifty-six drawings on green paper in this travelling model-book consist of heads of Christ, the Virgin, the Apostles, of men and women, real and fantastic animals which the travelling artisan could refer to in the compositions he might be called upon to paint. The drawings copy originals of different origins which the designer chanced to have seen in his wanderings, presumably in Bohemia, South Germany and Northern Italy. Possibly their author was an artist working for the court of Vienna who had been trained in Prague. The drawings in the Vienna model-book that correspond to the two heads exhibited here are at the lower right of the first panel (Gabriel) and at the lower left of the second panel (the Virgin annunciate.)

As Agnes Mongan has pointed out, the two little heads exhibited here are drawn with a greater sensitiveness and subtlety than the Viennese ones. She believes them to be of Franco-Flemish origin and dating in the last decade of the fourteenth century. If they are in fact Bohemian—as it has been time and again suggested and recently restated—they should date nearer to 1400 than to 1390, since such characteristics as the delicate structure of the head of the Virgin, the physiognomic character and the lips of Gabriel opened to whisper rather than utter his message, evoke works like the Madonna of Misericorde on a wing of the Raudnitz altar (Prague, State Collection of Ancient Art, inv. OP 1988-1990) and figures in the Vera Icon (Chapel of the Cross in the Cathedral of Prague).

PROVENIENCE: Charles Albert de Burlet, Basel; Erwin Rosenthal, New York.

EXHIBITED: "Exhibition in Honor of the Seventieth Birthday of Paul J. Sachs," Fogg Art Museum, Cambridge, Mass., Nov. 1948-Jan. 1949; "Masterpieces of Drawing," Philadelphia Museum, Nov. 1950-Feb. 1951, *Catalogue*, n. 4, ill.; "French Painting," Carnegie Institute, Pittsburgh, Penna., Oct.-Dec. 1951, *Catalogue*, n. 128, ill.

BIBLIOGRAPHY: A. Mongan, *One Hundred Master Drawings*, Cambridge, Mass., 1949, p. 4, ill.—Drobná, *Die Gotische Zeichnung in Böhmen,* Prague, 1956, p. 44—*idem, Gothic Drawing,* translated by J. Layton, Prague, n.d., pp. 46-47, figs. 81-82 (as Czech and erroneously described as partly in silver-point on green paper).

PLATE II FOGG ART MUSEUM, nos. 1947,79 and 80

6 BOLOGNESE, late 14th century

Arma Christi

Tempera and gold-leaf on panel; 32¾ x 34⅛ in. (.832 x .867 m.)

A triptych depicting on the central panel the Passion of Christ, presented as a complex allegorical devotional image. On the wings, left: four male saints—St. John the Baptist and St. Augustine, St. Peter and St. Paul; right: four female saints—St. Lucy and St. Catherine, St. Ursula and St. Agnes. At the summit of the two wings: the Annunciation.

On the central panel are combined three images: a) a Trinitarian representation or modified version of the "Throne of Grace:" God the Father, the Dove of the Holy Ghost, and the dead Son. This theme is blended into b) an Entombment-Pietà, where Christ is tenderly and pathetically supported in His tomb by the Virgin Mary and St. John. Strewn over the background are c) the "Arma Christi" or "Arma Passionis," that is, a sort of heraldic synopsis of objects and abbreviations of scenes designed to evoke the Passion of Christ. Some of these "hieroglyphs" are easily recognizable, like the Cross itself and the ladder, the sponge soaked in vinegar, Peter denying Christ to the maid-servant and the cock crowing after the third denial. Some are more intriguing, like Peter's sword with the amputated ear of Malchus adhering to it. Some are fantastic, especially the hands: the hand that smote Christ in derision, the hand that plucked His hair, the hands that played their part in the Calvary scene: the imploring hands of Mary, the hand of the Centurion hailing Christ as the Son of God, and so on.

The problem for the artist was to make aesthetically acceptable such an image of devotion, and received a wide diffusion in the fourteenth, gathered and gave visual expression to all the fantastic relics which were venerated in connection with the Passion of Christ. Whoever prayed before such images was guaranteed indulgences after his death, immunity against sudden death and, for the pregnant woman, a safe delivery in her labor.

The problem for the artist was to make aesthetically acceptable such an image of devotion, in which were accumulated the magical objects or "hieroglyphs" of the Passion of Christ. The device applied here was to give prominence, in a sort of "close up," to Christ Himself, dead but raised in His tomb as a promise of the Resurrection, between Mary and John, the main witnesses of the drama of the Calvary and components themselves of the "Arma Christi." Unity with the figures of saints on the wings was also secured in this manner.

The Christ of the Walters panel may be located in a line of descent from the Man of Sorrows standing between the Virgin and St. John, as one sees Him on carvings, essentially funereal, in Tuscan and Lombard sculpture of the fourteenth century, and on many predellae of Florentine paintings. The composition was also boldly anticipated in a rare type of Entombment painted by Taddeo Gaddi (Yale University). But the intimate association of Christ with Mary and John in the *Arma Christi* context appears to be a formula invented by the painters of the Bologna-Rimini Schools; cf. the painting in the Museum of Budapest (inv. 58.1.), comparable with the more beautiful painting in the Fogg Museum of Art, Cambridge, Mass.—attributed by both Berenson and Morisani to the Cavallinesque master of Naples, Roberto Oderisi, but which must be Bolognese; a painting in the Museum of Strasbourg (inv. 157), which is very close to the Walters piece.

As a working hypothesis, it seems reasonable to give the Walters painting to the circle of masters who followed in the footsteps of Vitale in Bologna in the last decades of the fourteenth cen-

tury: Simone dei Crocifissi, Lippo Dalmasio, the so-called "Cugino die Romagnoli." On the sarcophagus in the Walters piece are still visible, although deteriorated, a sleeping soldier, one of the dice with which the Roman soldiers cast lots for Christ's robe, and a hand holding the seamless garment. A similar arrangement occurs on the Fogg panel.

CONDITION: The paint film has been damaged by abrasion and accumulations of resinous coatings and grime. There are losses, especially in the center panel along the cracks and the bottom edge. Recent cleaning has revealed many details previously obscured by darkened varnish. The frame is original.

PROVENIENCE: Don Marcello Massarenti, Rome. Acquired by Henry Walters in 1902.

BIBLIOGRAPHY: *Massarenti Cat.* n. 40 (as School of Lorenzo Monaco)—E. Carroll, "Meditations on the Passion of Christ in a Fifteenth Century Altarpiece," *Bull. WAG,* VIII, 7 (1956).

PLATE XVIII WALTERS ART GALLERY, inv. no. 37.740

7 CATALAN, ca. 1375

Triptych

Tempera and gold-leaf on panel; open: 4 ft. 2 in. x 6 ft. ¾ in. (1.268 x 1.849 m.); center panel 3 ft. wide (.915 m.); each wing: 18 in. (.455 m.)

Central panel: the Virgin enthroned with the Child, to whom two angels are proffering cups full of roses. Left wing: Annunciation and Crucifixion. Right wing: the Presentation of the Christ Child in the Temple and the Coronation of the Virgin.

The placing of the Crucifixion in the upper zone of a wing is unusual, but if we observe that the Virgin's sad glance is cast at the scene of the Presentation in the Temple, it becomes obvious that two scenes pertaining to the Sorrows of the Virgin: the Presentation and the Crucifixion, are interrelated diagonally on the wings with two scenes alluding to the Joys of the Virgin: the Annunciation and the Coronation. The Presentation is a premonition of the Crucifixion, and the mood pervading the group of the Madonna and Child would associate it with that of the icons of the Virgin of the Passion created in late Byzantine art. This interpretation is substantiated by the detail of the goldfinch which the Child holds by a string leading from his right hand, and which pecks His thumb. The spot of red on the neck of the bird connects it with the legend according to which its plummage was stained with a drop of Christ's blood when it plucked a thorn from the crown piercing His brow on His way to Calvary.

The general aspect of this painting impresses one with its strong connection with Italian and specifically Sienese style. Millard Meiss, however, was the first to point out that the architectural details and certain other features of the triptych locate it in the Catalan school of the fourteenth century, elaborating upon models of Simone Martini and his followers. Characteristic are the overhanging canopies, protruding without support from the background and recessing the figures into the plane of the painting, and the profusion of corbel-tables with *archetti pensili* deriving from the earliest Romanesque architecture. These motives are current in Catalan painting of the second third of the fourteenth century. The author of the triptych was a master in rendering depth with the help of oblique vistas (Annunciation and Presentation scenes), but he avoided enclosing the scenes in the box-like constructions of the Italian masters. Some details, like the two octagonal nimbuses in the Presentation and the leafy ends of the beams supporting the canopy above the Virgin of the Annunciation, are typically Catalan (cf. for the latter, the illuminated initials of the *Llibro Verd,* a manuscript in the Archivo Histórico, Barcelona, decorated in the third quarter of the fourteenth century, and a panel of the Presentation of the Virgin in the Temple by Lluis Borrassà in the church of San Francisco, Vilafranca del Panades, 1390-1400). But the throne of the Virgin, a medieval version of an antique marble exedra, is Tuscan (cf. the throne of the Madonna in the altarpiece by Giotto and his workshop in the Pinacoteca, Bologna, and that in

the painting by Bernardo Daddi in the church of S. Giusto a Signano, near Florence). On the other hand, the footstool of the Walters Virgin may be compared with that of the Madonna of the Franciscans by Duccio in the Gallery at Siena, although, again, its flattened arches are Catalan and its perspective *di sotto in sù*, revealing a wooden lining, belongs to the tricks of decorative perspective used at the dawn of the International Style. The inlaying of the throne with motives of mosaic also looks Sienese. Finally, the magnificent tooling and the delicate patterns of the gold background are certainly of Sienese derivation.

Owing to its eclectic character, the Walters triptych should properly be called a painting of the early International Style in Catalonia. It is evidence of the incorporation into Catalonian art of elements of drawing and of an aristocratic composure, the source of which is ultimately French. (In this connection one may note the activity in Catalonia, mentioned in documents, of: John and Nicholas of Brussels "del regno de Francia" in 1379; Jaco Tuno or Tormo, painter from Paris; and in 1388, weavers from Brabant). The coloring is peculiar in its delicate off-whites, areas of grey and lavender, pale greens, silvery blues and the glowing note of orange which meanders even between the blond locks of hair. Does it betray the hand of an artist originally trained as a miniaturist? His identity has not been revealed. As an alternative to an authorship in the circle of the Master of St. Mark, a plausible attribution has been informally proposed by Ainaud de Lasarte, namely that of Ramon Destorrents, the painter of Pedro III, King of Aragon, who was the successor of Ferrer Bassà at the court and master of Pere Serra. The latter entered his workshop as an apprentice in 1357, and it is not without interest to note that, as Millard Meiss has pointed out, the iconography of the Coronation by Pere Serra in the retable of the Cathedral of Manresa (1394) is almost identical with that in the Coronation in this Walters triptych: the same twin canopies, the same posture of Christ crowning His mother with one hand and in a three-quarter view, instead of turning in profile to place the crown with both hands.

The modelling of the figures and the tonality are of such excellence that one cannot help imagining a lost work of Lluis Borrassà in the period of his formation, around 1380. Whoever he was, the artist had an intimate knowledge of Tuscan painting, from which he borrowed the symbolical goldfinch and the filleted angels bringing the cups of roses, a theme created by Giotto (Madonna and Saints, Accademia, Florence). These flower-bearing angels were repeated by Taddeo Gaddi (Madonna and Angels painted for Giovanni di Ser Segnia in 1335, now in the Uffizzi, Florence) and timidly imitated in the central panel of a triptych attributed to the school of Jaume Serra in the Isabella Stewart Gardner Museum, Boston.

CONDITION: Losses occur in several faces, especially in the Crucifixion scene. No inpainting has been attempted in these areas, but they have been left in a neutral ground tone. Other losses have been inpainted in tempera.

BIBLIOGRAPHY: Millard Meiss, "Italian Style in Catalonia," *JWAG*, IV (1941), pp. 48, 78-81, figs. 1, 41—C. R. Post, *A History of Spanish Painting*, Cambridge, Mass., 1947, IX, 2, p. 743 (as skeptical of Catalan origin)—E. Packard, "An Italo-Spanish Altarpiece," *Bull. WAG*, I, 2 (1948), ill.—P. Verdier, "The Madonna and Child with a Bird," *ibid.*, VI, 3 (1953), ill.—D. S. Shorr, *The Christ Child in Devotional Images in Italy during the Fourteenth Century*, New York, 1954, p. 103, fig. p. 104.

PLATE I WALTERS ART GALLERY, inv. no. 37.468

8 CATERINO VENEZIANO, Venetian (recorded 1362-1382)

Ancona or Polyptych

Tempera and gold-leaf on panel; 63 x 72¼ in. (1.600 x 1.835 m.)

The central panel of the Madonna of Humility is flanked by the standing figures of St. Anthony Abbot, St. John the Baptist, St. Christopher and St. James the Greater with pilgrim's staff and wallet. *Above:* the Crucifixion with the Virgin and St. John, flanked by St. Lucy with her lamp and St. Catherine with the wheel. *Left and right* above the standing saints: the half-length figures

of St. Ursula (?), St. Bartholomew, St. Clare of Assisi and St. Barbara holding, not a tower, but a monstrance enclosing the Host.

It is exceptional that the two half-length saints on the ends look outwards and away from the Crucifixion at the top. This is not an accident of mounting, since the removal of the frame during the course of treatment in the technical laboratory has shown that each pair of half-length figures is painted on a single panel. It seems a conscious device of the artist to unify the assemblage by a diagonal interplay of similar poses at the two levels of the composition. However, confusion has occurred in the inscriptions of these outermost half-length saints: that on the left is labelled St. Barbara, although she holds an arrow which is not appropriate, while the saint on the far right holds the monstrance and Host suitable as an attribute of Barbara, but is labelled MAR. The frame dates from the mid-nineteenth century, but the base is contemporary with the painting. It is decorated with alternating cusped roundels and lozenges painted directly on the wood, to which ornaments in relief were formerly applied. The authentic signature reads CHA-TARINU' DE VENECII PINXIT. There never was a date. The obliterated coat of arms dividing the two parts of the signature referred to the donor shown kneeling at the feet of the Virgin.

For the adoption by Caterino of the Tuscan type of the Madonna of Humility (an iconographical creation of Simone Martini), see Cat. no. 16. Another innovation in Venetian painting is to be seen in the nakedness of the Child. The Madonna here is still majestically seated on a cushion, but this is placed on a flowered hillock, the curving top of which describes an arc, so that the Madonna of Humility appears exalted in heaven or in paradise. The blue mantle of the Virgin is brocaded in gold with a pomegranate design such as appeared on Venetian silks of the last quarter of the fourteenth century and was copied in drawings by Jacopo Bellini in the fifteenth. In the Walters ancona Caterino has retained a Byzantine stage-design device: the crenellated wall behind the Crucifixion. The work shows a complete abandonment of the method of modelling that Caterina used up to 1372, in the period of his collaboration with Donato (i.e., draperies broken into a serrated network of gilt lines suggestive of late Byzantine or Byzantinizing "cloisonné" enamels and mosaics in Venice) and a sudden shift to "westernization," both in iconography and form. The representation of St. Christopher presupposes a knowledge of the Christopher signed by Giovanni da Bologna in 1377 (today in the Museo Civico, Padua).

CONDITION: The former attachment of a modern frame and braces caused splitting of the panels and losses where the modern nails had dislodged the original paint. This condition has been corrected by reframing; the panels have been repaired and cleaned.

PROVENIENCE: Formerly belonged to a family in Osimo; then to Count Giovanni Orsi, Ancona; subsequently, the dealer Piccoli in Venice; acquired from him by Henry Walters in 1908 or 1909.

BIBLIOGRAPHY: Crowe and Cavalcaselle, *Storia della pittura in Italia*, 1900, IV, p. 321; *idem*, English edition, London, 1908, III, p. 277; L. Testi, *La Storia della pittura veneziana*, I, Bergamo, 1909, pp. 242-243, illus. p. 244; B. Berenson, *Venetian Painting in America—the Fifteenth Century; idem, List*, 1932, p. 139; *idem, List*, 1936, p. 120; Van Marle, IV, pp. 64, 84; Millard Meiss, *Painting in Florence and Siena after the Black Death*, Princeton, 1951, p. 138, n. 18 (cf. p. 140); Elisabeth Packard, "The Palette of a Fourteenth-century Venetian Painter," in *Bull. WAG*, III, (Dec. 1950), illus.; *idem* in *JWAG*, XV-XVI (1952-53), pp. 73-79, figs. 1-6; Dorothy Shorr, *The Christ Child in Devotional Images in Italy during the Fourteenth Century*, New York, 1954, p. 103, fig. p. 104.

PLATE X WALTERS ART GALLERY, inv. no. 37.635

9 FLORENTINE, early 15th century

Madonna Enthroned among the Evangelists and Four Angels

Tempera and gold-leaf on panel; 36½ x 24¾ in. (.927 x .625 m.)

The iconography of this painting is exceptional, because not only are the Madonna and Child enthroned among the Four Evangelists, but the Evangelists are accompanied by their symbols,

crouching at their feet. The only other Italian composition in which the Evangelists are associated with their symbols in an analogous manner is the allegorical painting of the Glory of St. Thomas Aquinas by the Pisan artist, Francesco Trani, in the church of Santa Catarina, Pisa. In that picture, the Evangelists gravitate around the figure of St. Thomas, but they are disposed also as intermediary beings between the saint and Christ in Majesty. The representations in which the Four Evangelists normally appear are the Majestas Domini, at the corners of a Crucifixion (cf. the Trinity panel by Barnaba da Modena in the National Gallery, London), or around the Lamb (as the symbol of Christ Crucified). However, the theme of the Virgin as the "Throne of Wisdom," bearing the Child and accompanied by the Four Evangelists, appeared in the ecclesiastical literature of the twelfth century and found visual expression in German art. It illustrates a conception of the Virgin as the Bride of the Song of Songs, dwelling in the garden of delights amidst the four rivers of Paradise, which were held to be "types" of the Four Evangelists.

Unusual also is the compositional type of the Virgin and Child, both turned to their right and not towards each other. Such a composition occurs in representations of the Child sitting on His Mother's lap and blessing a donor or suppliant. It will be noted that here in the Walters panel the Child is blessing. There is, however, no kneeling figure at the foot of the throne, so the gesture of the Child must here have the same meaning as when Christ is represented as Savior of the World, standing and holding in His left hand the Gospel book, while He blesses with His right. In the Middle Ages, the Gospel was conceived as having been born in the garden of delights, and the Four Evangelists as the mystical rivers that diffused the Gospel through four mysteries: the Incarnation, the Passion, the Resurrection and the Ascension. The painting presents us with the first mystery, that of the Incarnation. The Annunciation is depicted in the spandrels.

The Four Evangelists are integrated in a unified composition with the group of the Mother and Child, thus formulating an early stage of the group later to be known as the *Sacra Conversazione*. In Florentine art the suppression of the limits between the central theme and the accompanying figures—heretofore separately enframed—was characteristic of the school of Orcagna. The blessing Child exactly resembles in pose and type one in a painting of the Virgin and Child, surrounded by saints and angels in profile, by the Orcagnesque master named by Richard Offner the "Master of the Cionesque Humility."

The Walters panel has a great charm which suggests the influence of Sienese masters, particularly in its wistful mood. Most of the recent authorities have attributed it to Andrea di Bartolo. But the figures are squat and more sturdy than is usual in the works of painters like Andrea di Bartolo and Taddeo di Bartolo. There is also a rather dry precision of draughtsmanship which seems to root the painting in the production of the Florentine school still submissive to the style initiated by Orcagna. The two Evangelists portrayed as old men (St. John and St. Matthew) resemble ones represented as awe-inspring hermits with long beards in a picture attributed to Giovanni dal Ponte in the Lanz Collection, Amsterdam.

The gable of the Virgin's throne is edged with crockets alternating with trefoiled leaves, but this is hardly an indication of origin, since the same throne decoration is found also in a painting by Andrea Vanni in S. Donato, Siena, as well as in a panel attributed to a pupil of Barnaba da Modena in the Galleria Sabauda, Turin. The low-set girdle of the angels is not unlike that worn by those in the panel of the Assumption of the Virgin given to the Master "del Bambino Vispo" in the Fogg Art Museum.

CONDITION: Gold-leaf and paint film in very good condition. The panel is edged with a modern gilded moulding.

PROVENIENCE: Don Marcello Massarenti, Rome. Acquired by Henry Walters in 1902.

BIBLIOGRAPHY: *Massarenti Cat. Suppl.*, p. 3, n. 3 (as by Duccio)—G. da Nicola, "Andrea di Bartolo," in *Rassegna d'arte senese*, XIV (1921), p. 13 (as by Andrea di Bartolo); *Walters Cat.* (ca. 1929), p. 131 (as by Andrea Vanni)—Berenson, *List,* 1932, p. 8 and *idem, List,* 1936, p. 7 (as by Andrea di Bartolo—an opinion shared by Millard Meiss).

PLATE XX WALTERS ART GALLERY, inv. no. 37.717

10 GIOVANNI da MODENA (Circle of), Bolognese, ca. 1420

The Man of Sorrows between the Virgin and St. John

Tempera and gold-leaf on panel; 12 x 24½ in. (.304 x .615 m.)

This image derives from the Italo-Byzantine Entombments in which the Virgin and St. John support, with excruciating tenderness, the limbs of the dead Christ. A sort of abstract, or "close up," of the scene, changed the event into an image of devotion. The Man of Sorrows appeared in European art as early as the thirteenth century, but the theme gathered notable momentum only in the second half of the fourteenth century, to become one of the keynotes of the International Style. In Italy its model was the icon venerated in the church of Santa Croce in Jerusalem, Rome, a painting of Greek origin and itself a copy of the icon venerated in the church of the Resurrection in Jerusalem. The cult of the Man of Sorrows in the church built above the tomb of Christ can be traced liturgically back to the seventh century, and the feeling expressed in it may still be felt in the tender hymn: "Do not weep, Mother."

The first devotional images of the Man of Sorrows date between the end of the thirteenth century and the third quarter of the fourteenth (panels in the Casa Horne, Florence, and in the Accademia, Venice). They show the style of medieval Greek painting and the influence of Byzantine iconography. From these models Italian art developed a particular treatment of the Man of Sorrows in small painted images of devotion as well as in the predellas of altarpieces. The Walters picture was part of a predella and the central panel of it. The significance of the Man of Sorrows between the Virgin and St. John in the predellas may be explained in two ways. First, the Man of Sorrows had already become a common theme on the carved tombs, and when transferred onto the predella of an altarpiece was naturally considered as a memorial to the dead—i.e., the donor of the painting and his family. Then, the Man of Sorrows in the predella was located under the central panel of the polyptych, or triptych, which would ordinarily represent the Virgin and Child, thus associating, in a mystical link, Christ reigning "above on the throne" with Christ as "King of Glory" "under in the tomb," for the womb of the Virgin was interpreted as a symbol of the tomb of Christ.

The Walters predella shows the group of the Man of Sorrows, the Virgin and St. John, as an integrated and symmetrical composition. In the preliminary stages, in painting as well as in sculpture, the three images had been kept separate, when they were following the liturgical formulation of Byzantium. When derived from the scene of the Entombment, they would be brought together asymmetrically: the Virgin pressing her cheek against the face of Christ in a close embrace, or supporting His limp right arm, and St. John would kiss or contemplate the left hand of Christ. Here they both proffer the wounded hands of Christ, as if the group were a reliquary of the Stigmata of the Passion. The Byzantine heritage of the image is recalled in the color of the tomb, which is red as, according to tradition, was the stone on which the corpse of Christ was laid. The latter relic, at one time venerated in Ephesos, had been deposited in the church of the Pantocrator in Constantinople.

The colors have an even glow, suggestive of polychrome statuary, the flesh has a membranous tension. Exceptional in that period is the emphasis on the bleeding wounds of Christ: His blood is dripping abundantly and there is in His image an infinitely sad and gruesome aspect which, in Italy, is connected only with the carved *Crocifissi dolorosi*, imported from Germany or copied after German models. It is, however, also found in a Crucifixion attributed to Giovanni da Modena in S. Francesco, Bologna, and was anticipated in the illuminations of Niccolò di Giacomo da Bologna.

CONDITION: The paint film is in good condition except for small scattered losses. Some damaged areas of the gold-leaf background had previously been filled and regilded.

PROVENIENCE: Don Marcello Massarenti, Rome. Acquired by Henry Walters in 1902.

BIBLIOGRAPHY: *Massarenti Cat.*, p. 15, n. 73 (as Florentine)—Walters Cat. (ca. 1909), also as Florentine—Attributed to Michele di Matteo, Bolognese, by E. Sandberg-Vavalà (Dec. 1938).

PLATE XIX WALTERS ART GALLERY, inv. no. 37.738

11 GIOVANNI di PAOLO, Sienese (1403?-1482)

Four Panels from the Predella of the Pecci Altarpiece

Tempera and gold-leaf on panel; each panel 15⅞ x 17⅛ in. (.403 x .435 m.)

The Resurrection of Lazarus; the Way to Calvary; the Descent from the Cross; the Entombment. These four panels come from a dismembered polyptych which until after 1625 stood above the altar of St. John the Baptist in one of the chapels of the church of S. Domenico, Siena. Other surviving parts of the altarpiece are: the central panel of the predella, a Crucifixion in the Lindenau Museum at Altenburg (n. 77), longer (22 inches) than these Walters predella pieces; the main picture, a Madonna and Child with ten angels, which carries the signature and date, in the Prepositura of Castelnuovo Berardenga near Siena; two of the four original side panels, showing St. John the Baptist and St. Dominic, now in the Accademia, Siena (n. 193, 197). The companion panels with St. Lawrence and St. Paul are lost. Executed for the Pecci family in 1426, this altarpiece is the earliest signed and dated work of Giovanni di Paolo.

It was executed just at the time when Gentile da Fabriano was engaged in Siena in painting the Madonna dei Notai, but it reflects very little of the spell of Gentile, under which Giovanni di Paolo was to fall only later. It continues essentially the Sienese tradition of the fourteenth and early fifteenth century as epitomized by Taddeo di Bartolo.

a) *The Resurrection of Lazarus:* the composition follows that established by Duccio in one of the panels of his Maestà in Siena Cathedral, but it is more crowded. One may compare such details as the pose of Christ, of Martha and Mary, and of the man covering his nose, also the old men with their coifs. The aperture of the tomb and the slab removed from it have in both pictures a pointed top. A different landscape occurs in the Giovanni panel. The rocky nature of the tomb is still Byzantine, but the background looks as if it were influenced by Far Eastern landscape painting.

b) *The Way to Calvary:* this presents many elements of composition and other details characteristic of the panel of the Way to Calvary in the Louvre, painted around 1340 by Simone Martini while he was in Avignon: the same surge to the right and the same acute curve of the throng flowing through the city-gate. Other similarities are: Christ looking backward, the group of the soldier and Mary, the executioner brutally shoving Christ. These formulae, inspired by the *Meditations on the Life of Christ* of the Pseudo-Bonaventura (Johannes de Caulibus, chap. 77), had become common stock in Siena, and they are found similarly on a panel of the Crucifixion polyptych, now attributed to Andrea de Bartolo, in the Stoclet Collection, Brussels. They were imitated in Florence (cf. the Way to Calvary, fresco by Andrea da Firenze in the Spanish Chapel, Santa Maria Novella), and in paintings of the International Style of northern Europe: the Way to Calvary in the Louvre, a painting on vellum lately attributed to Jacquemart de Hesdin; the miniature by the Limbourg Brothers in the Très Riches Heures of the duc de Berry, now in Chantilly; the panel by Master Hans in a private collection in Linz. However, the closest comparisons with the Walters panel are to be found in the Way to Calvary recently attributed to Andrea di Bartolo by Mrs. Coor (Fondazione Thyssen, Castagnola) and in a panel of the school of Rimini (Palazzo Venezia, Rome).

Giovanni has transformed the walls and sky-line of the city of Siena, as rendered in Simone Martini's panel, into a more visionary and fantastic form. He has kept the octagonal structure and the towers on the right, but added to the city-gate the protomes of rearing horses perched on capitals, which are copied from those carved by Giovanni Pisano for the façade of the Cathedral

of Siena. The round of putti holding swags on the cornice of the cupola to the left borrows a theme from late Hellenistic sarcophagi, which also inspired Jacopo della Quercia in his tomb of Ilaria del Caretto.

A reduced version of the Walters panel is a Way to Calvary in the John G. Johnson Collection, Philadelphia Museum of Art (with an even more fantastic city view, which almost equals a vision of Monsù Desiderio).

c) *The Descent from the Cross:* the figure of Mary derives from that in the Descent panel of Duccio's Maestà. The disciple highest on the ladder, helping to lower the body of Christ, repeats a detail in the little panel of Simone Martini, ca. 1340, now in the Museum of Fine Arts, Antwerp, and also is to be seen in a panel by an artist of the school of Rimini, in the Palazzo Venezia, Rome. The two children in the foreground of our panel, also, are Martinesque. However, the gaunt and gruesome body of Christ is more like that in the Pietà-Entombment in the collection of Mrs. Robert Benson (*Pictures of Siena*, London, Burlington Fine Arts Club, 1905, n. 20). Other motives, such as the posture of Christ's body across the ladder and the disciple extracting a nail from the feet of Christ, are reminiscent of Pietro Lorenzetti's Deposition in the Lower Church of S. Francesco, Assisi.

d) *The Entombment:* the iconography is unusual, for the scene depicted is actually that of Christ's body carried to the tomb. In the usual Entombment, we see the body laid out in the sarcophagus. The composition here is more commonplace in scenes of the funeral of the Virgin. The upsurging rocky formations, with a narrow pass to the right through which the holy women approach, repeat a device used by Simone Martini (cf. the fresco of St. Martin Leaving the Army, St. Martin's Chapel, S. Francesco d'Assisi). But their violent character is reminiscent of that of the rocks in two drawings on vellum by Lorenzo Monaco in the Kupferstichkabinett, Berlin. The emotional tension of the scene is increased by the shadow of Nicodemus cast against the cave filled with the glory of the setting sun. Here we may have one of the first post-classical attempts to paint a cast shadow.

CONDITION: All four panels had once been planed down and cradled. The cradles have been removed and warping, splitting and other defects in the supports have been corrected. Cleaning revealed that the paint film was in good condition except for scratches and minor losses. In three of the panels, however, entire areas of green paint had chipped off. These have been left without inpainting.

PROVENIENCE: The Conti Chigi-Saraceni Collection, Siena.

BIBLIOGRAPHY: Bossio, *Visita Pastorale,* 1575: ms. Cura Arcivescovile—Alessandro VII, *Guida da Siena,* 1625, ms. Biblioteca Vaticana, Rome—Ugurgieri, *Le Pompe sanesi,* 1649, II, p. 346—Van Marle, IX, p. 391, figs. 266, 267, 268—M. Gengaro, *La Diana,* VII (1932), p. 24— Berenson, *List,* 1932, p. 244—*idem, List,* 1936, pp. 210-211—C. Brandi, "Ricostruzione di un opera giovanile di Giovanni di Paolo," *L'Arte* (1934), pp. 462 ff. (cf. *Dedalo,* XI, pp. 722 ff.)—E. S. King, "Notes on the Paintings by Giovanni di Paolo," *Art Bulletin,* XVIII (1936), pp. 215 ff.—J. Pope-Hennessy, *Giovanni di Paolo,* London, 1937, pp. 6, 7, 9, 36 (pl. II), 45—Anon., "Painting Restoration," *Fortune,* (Nov. 1937), pp. 128, 130-31, 219—Gertrude Coor, "A Further Link in the Reconstruction of an Altarpiece by Andrea di Bartolo," *JWAG,* XXIV (1961), pp. 55-60, fig. 7.

PLATES XXIV-XXVII WALTERS ART GALLERY, inv. nos. 37.489 A-D

l'2 ITALIAN, second quarter of the 15th century

Triptych: The Virgin of Tenderness, and Four Saints

Tempera and gold-leaf on panel; 31 x 30 in. (.787 x .762 m.)

Central panel: the Virgin and Child seated upon a stone bench before a cloth of honor, in a garden. In the gable: the Crucifixion in a mountainous landscape. Left wing: St. Paul and St. Lucy. Right wing: St. Francis and St. Clare.

This very charming and rather disconcerting triptych eludes a definite attribution. The issue of its authorship should not be pressed too hard, because it appears to be unique of its kind in

Italian art of the second quarter of the fifteenth century. It seems to be an engaging blend of archaism (a late version of the International Style) and of progress (it shows a certain assimilation of the teachings of the early Renaissance). In size and mood it retains the intimacy of the small reliquary-triptychs which had been abundantly produced by the minor masters of Siena towards the close of the fourteenth century. In the central panel, especially, the palette of the artist involuntarily makes one think of Masolino. His draperies have undergone a process of relaxation from the intricately melodious patterns of the period around 1400, analogous to that also observed in the paintings of the Marchigan artist Peregrino. His flowery backgrounds have the poetical flavor of those of Alberti of Ferrara. By its style the group of the Virgin of Tenderness belongs to the early Renaissance and more to that of the Marches than of Florence. But the landscape behind the Crucifixion painted in the gable above the Virgin—which the Child is contemplating in anticipation—is still Sienese, with its mole-hills pin-pointed by dwarf trees. And in the fifteenth century so thin a Cross is met with only in the decorative arts, more retardataire than the paintings. The figures of the saints on the wings hark back to the Gothic past more than does the central group.

In color the group of the Madonna and Child shows a great delicacy of tones and the translucence of mother of pearl. A gold ribbon runs across the white veil of the Virgin, her blue mantle is lined with a woolly green material having a pile, which shows itself on her shoulder and across her lap. Her robe is red, the garment of the Child light beige. A piece of scarlet cut-velvet, revealing a white lining at the curling edges, is suspended behind the throne of the Virgin. The main figures as well as the secondary ones stand out against strips of ground strewn, tapestry-like, with all sorts of flowers. These flowery bands alternate with zones which in their pristine state were blue, but have turned dark olive-green from the accumulation of resins. Could the painter have appropriated a pattern of composition in which the "real" space is replaced by a fairy land, as in the French tapestries woven in Paris and Arras? Or, was the author also a miniaturist who painted flowery fields such as those encountered in the illuminations of the Southern Tyrol?

CONDITION: The paint film is in excellent condition. A crack on the central panel has been filled with gesso and inpainted with water color. The frame is original.

PROVENIENCE: Don Marcello Massarenti, Rome. Acquired by Henry Walters in 1902.

BIBLIOGRAPHY: *Massarenti Cat.*, No. 41, p. 9 (as School of Fra Angelico)—*Walters Cat.* (ca. 1929), p. 131 (as close to Masolino)—Berenson, *List*, 1932, p. 32—*idem, List,* 1936, p. 28 (as by Arcangelo di Cola da Camerino)—*idem,* "Quadri senza casa," *Dedalo* (1929), pp. 133 ff.—*idem,* "Missing Pictures by Arcangelo di Cola da Camerino," *International Studio* (July 1929), pp. 21 ff., ill. p. 24—Roberto Longhi in a letter to Federico Zeri, dated August 22, 1947, has attributed the triptych to Andrea Delittio II.

PLATE XXXI WALTERS ART GALLERY, inv. no. 37.715

13 LOMBARD, late 14th century

Sketchbook

Pen drawings in bistre ink with terra verde washes, a few touches of green, violet and red, on vellum; 15 folios, 9⅜ x 6¾ in. (.233 x .172 m.)

The drawings are on sheets of vellum folded to form a sketchbook. They betray an unusual talent for observation and fancy, and depict hunts, children's games, tournaments, the occupations of the months, grotesque musicians and dancers, amatory scenes and even bawdy ones.

The Lombard origin of the sketchbook is evident in its style and in the treatment of its subject matter. The latter may be compared in a number of instances with the illustrations in the north Italian treatises on hygiene and natural history called *Tacuina* (or *Theatra*) *Sanitatis* (Biblioteca Casanatense, Rome, mss. 459, 4182; Paris, Bibliothèque Nationale, ms. lat. nouv. acq. 1673;

manuscripts in the Kunsthistorisches Museum, Vienna, and the Ecole des Beaux Arts, Paris, and one in an American private collection).

The sketchbook is exhibited at pages which show a girl playing a tambourine, a man with drum and fife, a girl acrobat tumbling to the music, a female penitent kneeling before a mendicant monk and about to be scourged by a youth dressed as a jester. Opposite, lovers crown each other with garlands, and two mounted knights in full armor are engaged in a duel. The trappings and the shields bear the letters G and R.

On page 6vo is written the name Magatelli.

PROVENIENCE: Eugene Piot; C. Fairfax Murray

EXHIBITIONS: Pierpont Morgan Library, "Italian Exhibition," Dec. 1, 1936-March 31, 1937.

BIBLIOGRAPHY: C. Fairfax Murray, *Collection of J. Pierpont Morgan, Two Lombard Sketchbooks in the Collection of C. Fairfax Murray*, London, 1910, ill.—F. Malaguzzi Valeri, *La Corte di Lodovico il Moro*, vol. I, Milan, 1913, figs., pp. 511, 537, 550, 591-592, 726, 741—R. Belotti, *La vita di Bartolomeo Colleoni*, Bergamo, n.d., p. 72—Van Marle, VII, p. 122—*idem, Iconographie de l'art profane au moyen âge et à la Renaissance, I, La vie quotidienne*, The Hague 1931, pp. 72, 81, 145-146, figs. 62, 71, 83, 139—A. van Schendel, *Le dessin en Lombardie jusqu'à la fin du XVe siècle*, Brussels, 1938, pp. 69-70, figs. 58-62.

PLATE XXXIX THE PIERPONT MORGAN LIBRARY, no. II, 2

14 LOMBARD, ca. 1400

Animal Drawings

In brush with brown and black tempera heightened with white, on vellum; two sheets: 6⅜ x 4¾ in. (.172 x .122 m.)

a) A goat and a dog; on the verso: a leopard and a unicorn
b) A goat and a ram; on the verso: two birds

These two vellum sheets of animal studies are to be connected with another pair of leaves preserved in the British Museum, identical in style, technique and dimensions. The London leaves show cheetahs, dogs, an oriental goat and a ram. The four sheets must be remnants of a dismembered sketchbook, like one preserved in the Biblioteca Communale at Bergamo, ascribed to Giovannino de' Grassi (d. 1398). As in the latter, the animal drawings of New York and London are notable for the impression they give of acute observation and study from nature, such as only Pisanello was to equal a quarter of a century later. These drawings are, however, like the Bergamo sketchbook, not actually direct renderings from nature, but compilations of motives to provide patterns to be used by Lombard illuminators, such as those working for Gian Galeazzo Visconti. Pietro Toesca has pointed out the relation of the Bergamo sketchbook to the animals in the margins of the Breviary of Gian Galeazzo Visconti illuminated by Giovannino and Salomone de' Grassi (now in the Biblioteca Visconti di Modrone, Milan) and of the Missal illuminated by Anovelo da Imbonate which Gian Galeazzo presented to S. Ambrogio, Milan.

A comparable drawing exists in the collection of Italian drawings in the Musée Bonnat at Bayonne.

PROVENIENCE: William Mitchell; Lord Leighton; C. Fairfax Murray.

EXHIBITIONS: New York Public Library, "Drawings from the J. Pierpont Morgan Collection," Feb. 1-May 8, 1919; The Metropolitan Museum of Art, New York, "Spring Loan Exhibition," Feb. 1927; Cleveland Museum of Art, Oct. 1927; Albright Art Gallery, Buffalo, "Master Drawings," Jan. 1935, n. 4, ill. (I, 82, 83); Pierpont Morgan Library, New York, "Italian Exhibition," Dec. 1, 1936-March 31, 1937; Worcester Art Museum, "The Practice of Drawing," Nov. 15, 1951-Jan. 6, 1952; Wadsworth Atheneum, Hartford, "The Pierpont Morgan Treasures," Nov. 10-Dec. 18, 1960, n. 63.

BIBLIOGRAPHY: C. Fairfax Murray, *Collection J. Pierpont Morgan, Drawings by the Old Masters, formed by C. Fairfax Murray*, vol. I, London, 1905, nos. 82-85, ill.—A. van Schendel, *Le dessin en Lombardie jusqu'à la fin du XVe siècle;*

Brussels, 1938, pp. 65, 66, fig. 47—B. Degenhart, *Italienische Zeichnungen des frühen 15 Jahrhunderts*, Basel, 1949, p. 32, pl. 7—A. E. Popham and P. Pouncey, *Italian Drawings . . . in the British Museum, XIV-XV Centuries*, London, 1950, p. 184, n. 290—Jacob Bean, *Les Dessins italiens de la collection Bonnat*, Paris, 1960, n. 203—For the use in manuscript illumination, cf. P. Toesca, *La Pittura e la miniatura nella Lombardia*, Milan, 1912, pp. 298 ff.

PLATE XL THE PIERPONT MORGAN LIBRARY, I, 82, 83, 84, 85

15 LOMBARD, early 15th century

Madonna and Child with Saints and Donor

Tempera and gold-leaf on panel; 13⅜ x 9½ in. (.339 x .241 m.)

The Virgin and Child seated on a low cushioned bench on a curious dais of circular shape; both Mother and Child turn with gracious gestures toward a kneeling donor who is presented by St. John the Evangelist and St. Anthony Abbot. At the top, flying angels crown the Virgin and blow trumpets.

Dating originally from the early fifteenth century, this painting was altered after 1452, the date mentioned in the later inscription. Changes were made in the donor's portrait and the coat of arms, and the inscription, which is on an applied strip of paper and seems to have been printed with movable type, was added.

The original painting is in the International Style and obvious similarities to the style of Jacquemart de Hesdin have caused Dr. Panofsky to propose a classification of the work as Franco-Flemish. All other authorities, however, agree in considering the panel to be the work of an anonymous Lombard painter. A certain crispness of design, in the drapery of the Virgin's mantle in particular, the expression—wondering and withdrawn—of the faces, are reminiscent of certain pages of the sketchbook by Giovannino de'Grassi, in the Bibliotheca Civica, Bergamo. In that sketchbook also are found similar small angels, with the sleeves and tails of their garments twisted into a cork-screw design. However, such angelical figures are the common property of the International Style, especially in Cologne and the Lower Rhine regions. The painting, in which large areas of grey-blue are warmed by the splendor of the gold background, cannot be located too near 1400. Rather, it is the work of an anonymous Lombard painter who continued the traditions of design prevailing in Milan around 1400 and it should be placed not too far from the productions of Cristoforo de'Moretti (cf. the Madonna between St. Francis and St. Clare in the Museo Civico, Pavia).

Old photographs show the features of an old man painted over the head of the donor whom we now see and the X-ray shows that he once wore a scalloped cloak. The original coat of arms, partly visible in the X-ray, has not been identified; the present one, a lion rampant carrying a branch, is that of the Sforzas, thus agreeing with the inscription pasted at the bottom: SPECTABILIS AC STRENUUS VIR MATTHAEUS DE ATTENDOLIS BOLOGNINUS, TICINENSIS ARCIS PRAEFECTUS/CREATUS SANCTI ANGELI COMES A FRANCISCO SFORTIA MEDIOLANI DUCE ANNO MCCCCLII, COMMENDAN/TIBUS, SANCTIS JOHANNE EUANGELISTE, ET ANTONIO ABBATE, AB DEIPARA CLIENTELAM RECIPITUR. This states that "the outstanding and capable gentleman, Matthaeus de'Attendoli, Bolognino, commander of the Ticinian fortress, made Count of Sant' Angelo by Francesco Sforza, Duke of Milan, in 1452, is received by the Mother of God into her patronage, his sponsors being Saints John the Evangelist and Anthony Abbot." This Matthaeus de'Attendoli of Bologna, popularly known as Il Bolognino, was a member of the Attendolo (Sforza) family by adoption. The adoption, as well as the gift of the Castle of Sant' Angelo, near Lodi, was a token of Francesco Sforza's gratitude to Il Bolognino for having yielded to him the fortress of Pavia when that city found itself, in 1447, in the necessity of choosing between Venice and Milan.

PROVENIENCE: Julius Böhler, Munich; Count Trotti Collection, Paris; Samuel H. Kress Foundation, 1928; presented by the Kress Foundation to the North Carolina Museum of Art in 1961.

EXHIBITED: National Gallery of Art, Washington, D. C. from 1941 until recently; "Arte Lombarda dai Visconti agli Sforza," Palazzo Reale, Milan, April-June, 1958, n. 196.

BIBLIOGRAPHY: W. Suida, in *Monatshefte für Kunstwissenschaft,* (1909), pp. 473, 495, fig. 19—P. Toesca, *La Pittura e la miniatura nella Lombardia,* Milan, 1912, pp. 556 f., fig. 459—National Gallery of Art, Washington, D. C., *Preliminary Catalogue,* 1941, no. 130—F. R. Shapley, in *Art Quarterly* (1945), pp. 34, 37—E. Panofsky, *Early Netherlandish Painting,* vol. I, Cambridge, Mass., 1953, p. 392, note 82 (1)—G. A. dell'Acqua, *Arte Lombarda dai Visconti agli Sforza,* Milan 1959, p. 53, pl. XII—North Carolina Museum of Art, *The Samuel Kress Collection,* Raleigh, N. C., 1961, p. 52, which account provided the basis for the present exhibition catalogue entry. There exist also written opinions by B. Berenson, G. Fiocco, R. Longhi, F. F. M. Perkins, and A. Venturi, W. Suida, all as "Lombard School, fifteenth century."

PLATE XXI NORTH CAROLINA MUSEUM OF ART

16 LORENZO VENEZIANO (Workshop), Venetian, last quarter of the 14th century

Triptych: the Madonna of Humility

Tempera and gold-leaf on panel; 26½ x 21¾ in. (.672 x .552 m.)

The central subject of the Madonna of Humility is surmounted by the Crucifixion flanked by the Virgin and St. John, with the Magdalen at the foot of the Cross, the Pelican nesting on its top. On the left wing: under superposed moulded arches stand St. John the Baptist and St. Catherine. Right wing: St. James and St. Margaret. The summit of the two wings presents the Annunciation (above the Virgin are vestiges of the words of the angelical greeting).

The Madonna of Humility, nursing the Child, is seated without an intermediary cushion on a flowering hillock. The curve of this mound has a cosmological connotation which is reinforced by the glory of rays and stars bursting around the Mother and Child. The vision is supposed to take place in paradise or in the enclosed garden of the Song of Songs. It is a forerunner of the theme of the Virgin in the rose-garden, as the painters of Verona and Germany represented her later, around 1400. In the words of a contemporary German poet: "Mary, full of grace and delicate, she is seated in the rose-garden which God Himself has adorned with His divine majesty." This iconographical type was introduced into Venice by the painter Giovanni da Bologna (active 1359-1389), who settled there around 1377. The draperies of the small figures, the design of the kneeling angel in the left wing, are very close to the style of Lorenzo Veneziano; on the other hand, the features of the Virgin, with their dry, sucked-in expression, remind one somewhat of Caterino, who painted two signed Madonnas of Humility, one in the Walters Art Gallery (Cat. no. 8), the other in the Worcester Art Museum. Compare the motive of a head in a sunburst (cherub or Christ-Emmanuel?) on the chest of Mary with that of Caterino's Virgin in the Walters ancona, mentioned above. The stiff bundling of folds encasing the legs of the Virgin indicates an artist imitating rather awkwardly the mannered draughtsmanship of Lorenzo Veneziano and the style of the painter Giovanni da Bologna.

CONDITION: Gold-leaf and paint are in good condition. The robes of the Virgin and Child and of some of the figures on the wings had at some previous restoration been covered with paint and gilding simulating brocade. Although these additions have now been removed, the tempera has been slightly stained by the oil mordant used in applying the gilt, The frame is original, but had been regilded.

PROVENIENCE: Don Marcello Massarenti. Acquired by Henry Walters in 1902.

BIBLIOGRAPHY: B. Berenson, *Venetian Paintings in America. The Fifteenth Century,* New York, 1916, pp. 3-4, fig. 2 (as Venetian School, ca. 1400).

PLATE XXIII WALTERS ART GALLERY, inv. no. 37.744

17 LUCA di TOMME, Sienese (active 1355-1399)

Triptych of the Trinity

Tempera and gold-leaf on panel; open: 22¼ x 21 in. (.565 x .534 m.)

Central panel: Christ crucified against the image of the Trinity in a mandorla; on either side of the Cross stand the small figures of the grieving Virgin and St. John; St. Francis kneels at the foot of the Cross in the posture of receiving the stigmata; above in the gable, the Resurrection. Left wing: the Nativity and the Adoration of the Magi, surmounted in the half-gable by the Angel of the Annunciation bearing a banderoll inscribed with his greeting. Right wing: the Mocking of Christ and the Lamentation over His body; at the top, the Virgin annunciate.

The scenes of two Joys of the Virgin on the left wing correspond to two scenes of the Sorrows on the right in a diagonal interrelationship: the Nativity prefiguring the Pietà, while the Adoration of the Magi is a premonition of the Mocking of Christ.

The image of the Trinity is conceived as an abstract anthropomorphic composition, in some ways monstrous, since the Trinity is depicted as three identical persons furnished with a single body. The representation of the triune Godhead as three heads was not entirely unprecedented, but survives only in book-illumination (for instance, folio 178vo of the Sienese antiphonary now in the Fogg Museum, attributed by Berenson to Lippo Vanni, but perhaps closer to Niccolò Tegliacci; also an antiphonary in the Collegiata di Santa Maria, Impruneta, cod. A.14, fol. 113vo, and a leaf from a choral book in the Pierpont Morgan Library, M. 742—the latter two examples being attributed by Offner to a follower of Pacino di Buonaguida). Undoubtedly, Luca di Tommè knew such images and grafted the scheme on the trinitarian theme of the "Throne of Grace." By representing Christ twice, as dead on the Cross and as the divine Second Person of the Trinity, he intimated that Christ suffered on the Cross in His two-fold nature, the divine and the human—that is, He is liturgically the Victim sacrificed to God.

The round faces with small, fleshy, slightly puckered mouths are characteristic of the hand of Luca di Tommè. The manner in which the mandorla is pushed up into the median gable of the triptych occurs again in the Assumption by Luca at Yale University. This present triptych must date from around 1370, when the painter was still strongly under the influence of Pietro Lorenzetti. The dark, pathetic figure of the Virgin turning her eyes away from the Cross reminds one of the Crucifixion painted by Luca di Tommè in 1366, now in the Gallery at Pisa. The Annunciation introduces just a slight variation on the type Pietro Lorenzetti had used atop his polyptych in the Pieve, Arezzo. The risen Christ in our triptych has the same stern impassivity, the same almost menacing glance cast sideways, as in the Resurrection painted by Pietro in the refectory of S. Francesco, Arezzo. The four scenes painted on the wings are remarkable in their Giottesque sense of plasticity, for their restrained emotion, expressed more in terms of mass than of line— qualities which can be accounted for only by assuming as models works by Pietro Lorenzetti and his immediate followers, such as the Ovile Master (cf. the St. Joseph of our Nativity with that in the Nativity in the Fogg Museum).

The state of the painting is exceptionally good; its intense, enamel-like coloring also derives from Pietro Lorenzetti, with some influence coming perhaps from the illuminations of Niccolò Tegliacci. Inasmuch as the iconography of the Crucifixion-Trinity illustrates the mystery expressed in the prayer of the Mass that follows the Consecration and offers the Victim to the altar of God on high, one must assume that this triptych was set upon the altar of a private chapel.

PROVENIENCE: Acquired from Duveen (as by Lippo Vanni)

BIBLIOGRAPHY: Millard Meiss, *Painting in Florence and Siena after the Black Death*, Princeton, 1951, pp. 34, 35, n. 104, p. 38, fig. 50 (as by an associate of Luca di Tommè)—W. Braunfels, *Die Heilige Dreifaltigkeit*, Dusseldorf, 1954, p. xli, fig. 42 (cf. pp. xxxv-xl, figs. 38-39).

PLATE IX MR. AND MRS. T. S. HYLAND

18 MARIOTTO di NARDO, Florentine (recorded from 1394 to 1424, but active earlier)

Four Saints

Tempera and gold-leaf on panel; 10½ x 11⅝ in. (.265 x .295 m.)

St. Lawrence, St. Christopher, St. Sebastian and a bishop saint, depicted as standing side by side.

These four figures are by a Florentine artist who, in the first quarter of the fifteenth century, continued the post-Giottesque style of Taddeo and Agnolo Gaddi that in Florence had preceded the International Style. They evince also a link with the block-like figure style and linear surface modelling of fourteenth-century sculptors like Nino Pisano, the helpers of Orcagna, and artists traditionally reported to have been sculptors as well as painters, like Jacopo di Cione. The four saints may be reasonably given to Mariotto di Nardo, who was the son of a stone-cutter; they betray almost nothing of the influence of Lorenzo Monaco, which did not gain importance until the late period of Mariotto's activity. The way of delineating the faces recalls strongly that of Niccolò di Pietro Gerini, while the contrast between the bulky but elongated bodies and the very small heads is a mannerism which Parri Spinelli was to inherit.

The young-looking bishop, being in company of martyrs, may have been a martyr himself, perhaps St. Apollinaris, the bishop of Ravenna, to whom a church in Florence was dedicated. The words inscribed on the book he is holding open and which read: *Jamq(ue) su(btus) rudibus p(er) itu (rus) dura antistes arte,* might allude to one of the many torments inflicted upon St. Apollinaris during his apostolate.

CONDITION: Diagonal split through the center of the panel. Part of the head of St. Sebastian is damaged and there is extensive abrasion over his vestment, but the condition of the painting is otherwise good.

PROVENIENCE: Don Marcello Massarenti, Rome. Acquired by Henry Walters in 1902.

BIBLIOGRAPHY: *Massarenti Cat.,* p. 12, n. 56 (as by Giottino, i.e. Tommaso di Lapo, 1324-1356)—*Walters Cat.* [ca. 1909], same attribution—*idem* [ca. 1929], p. 158 (as by Niccolò di Pietro Gerini)—Berenson, *List,* 1932, p. 330 (as by Mariotto di Nardo)—*idem,* 1936, p. 293 (same attribution).

PLATE XIII WALTERS ART GALLERY, inv. no. 37.746

19 MARIOTTO di NARDO (attributed to), Florentine (mentioned from 1394 to 1424, but active earlier)

The Flagellation of Christ

Tempera and gold-leaf on panel; 14¾ x 6⅝ in. (.380 x .165 m.)

One of a series of eight panels, four relating to the early life of Christ and four to the Passion, from the upper register of an ancona (polyptych). For the present location of the seven other panels, see the two articles by Marvin J. Eisenberg quoted in the bibliography. The silhouette of the lost architectural frame is visible in unpainted areas at the sides and upper corners of the panel.

The column of the Flagellation brought to Rome from the East in 1223 as a holy relic by the legate of Pope Honorius III, Johannes Columna, was in fact a low cippus corresponding to what was used by the Romans for the punishment of scourging. The column relic was kept in the church of Santa Prassede. It is conceivable that on the present panel the artist has fused this low historical column of the Passion of Christ with the support of the ciborium which enshrined it. Drawn as it is on an angle, it constitutes a device for establishing space.

CONDITION: The original tempera surface is in good condition.

BIBLIOGRAPHY: R. Offner, "The Mostra del Tesoro di Firenze sacra, II," *Burl. Mag.* LXIII (1933), p. 169, n. 4— M. J. Eisenberg, "A Flagellation by Mariotto di Nardo and Some Related Panels," *The Record of the Art Museum,*

Princeton University, VIII, 1 (1949), pp. 6-14, fig. 1—*idem*, "An Addition to a Group of Panels by Mariotto di Nardo," *ibid.*, XVIII, 2 (1959), pp. 61, 64.

PLATE XVII THE ART MUSEUM, PRINCETON UNIVERSITY, no. 33.21

20 MASTER OF GUIMERA (Lorenzo Zaragoza?), ca. 1400

The Madonna and Child Enthroned

Tempera and gold-leaf on panel; 5 ft. 10 in. x 3 ft. 4¾ in. (1.78 x 1.035 m.)

This painting is a masterpiece of northeastern Spanish painting and an excellent exponent of the International Style arising in Aragon, Catalonia and Valencia, just as a French trend began to supersede the lingering Sienese influence, towards 1400. It has so far resisted a definite attribution. One school of criticism would recognize in it a painting of the school of Valencia of the first half of the fifteenth century; another considers it a "frontier case," that is, a work related to paintings executed around 1400 in the region between Aragon and Valencia by a master or by a workshop situated athwart the two regions. An ideal solution would be to give it to Lorenzo Zaragoza, a painter known to us only by documents. He was born in Aragon, but came early to Barcelona, where he became a member of Queen Eleanore's household. In 1373 he was acclaimed by King Pere IV the best painter in Barcelona and praised by the Catalans as *"molt sobtil e apte."* He settled in Valencia in 1377, after having worked in Teruel, on the border between Aragon and Valencia. Lorenzo Zaragoza is documented in Valencia until 1402 and exerted there a decisive influence on Pedro Nicolau (1390-1408) and his followers. Unfortunately no signed or certain work of Lorenzo Zaragoza remains. The best working hypothesis is to attribute to him paintings in the manner or the circle of the anonymous Master of Guimerà, named after the retable from Guimerà in the Museum of Vich, which is the last and the most florid of the series (1412?).

The colors of the Walters painting have a sharp delicacy that is not due entirely to the fact that the surface of the pigments is worn in some places, so that the green underpainting of the flesh tones shows through. The keynote of their harmony lies in the sumptuously patterned gold background, the balance of the pale rose and green, the scarlet fillets meandering where the lining of the mantle of the Virgin is visible and a flaming orange revealed by the activity of the broken folds of the mantle near the ground. This vivid brightness, and the flamboyant handling of the orange red are characteristics of the retable of Guimerà. The flaming upturned folds are found in a painting of the Madonna and Child in the manner of the Master of Guimerà in the Museum of Vich.

A Madonna and Child in the Plandiura Collection, Barcelona—a panel of a retable of similar proportions—has the same composition, but reversed. The outward spreading throne, the sweep of the Virgin's mantle and the emphasis on its precious hem, the gesture of her hand proffering the flowers, are all the same. In the Plandiura panel the Child plays with a bird tied to a string instead of pulling the cord of a mechanical toy as in this picture. The daintiness with which the Virgin of the Walters painting holds the spray of roses and lilies is one of the traits of the International Style. It is found, for instance, in a Madonna by Stefano da Verona in the Palazzo Venezia, Rome.

Another trait which links the present painting with works by the Master of Guimerà and his circle is the facial type of the Virgin, with high, curving forehead and long thin nose, which characterizes the Madonna of Mercy in the sacristy of the Cathedral of Teruel and the Madonna of Cervera in the Museum of Montjuich, Barcelona. These paintings also show the upsurging agitation of the draperies, while the pearls trimming the orphreys of the mantle are likewise a hallmark of the Master of Guimerà. The same winsome Child, pertly jerking back His head, occurs in three paintings of the Madonna and Child with Angels attributed to Pedro Nicolau or the Valencian school: in Sarrion, the Gaulino Collection, Turin, and in the Louvre.

The gold background of the Walters panel is a compromise between Catalan-Aragonese and Valencian decorative formulas. Foliate ornaments stamped and stencilled in the gold, designed after silk brocades, were used to make overall diaper patterns in Catalonia and Aragon, whereas in Valencia only the two strips at the sides of the background were decorated in that manner. In our picture it will be observed that left and right of the incised foliate background hung as a cloth of honor behind the throne of the Virgin, there are two decorative borders as in Valencian painting.

Summing up, the converging evidence seems to indicate that the Walters panel was painted in Valencia in the style of the Master of Guimerà. Its attribution to Lorenzo Zaragoza is thus the most plausible solution.

CONDITION: The warping of each of the original five boards of which the panel is composed had resulted in a disturbing surface effect. Gradual straightening of the boards was undertaken, and consolidation and reinforcement of the panel were successfully accomplished. Considerable overpainting and regilding had been applied in the course of former restorations. The cleaning off of the modern blue paint on the robe of the Virgin with its stencilled design of birds has now revealed the original folds of the drapery as well as the original floral pattern. The faces of the Virgin and Child were found to be damaged so that the greenish underpaint showed through. No attempt has been made to restore the flesh tones. The frame has been recently constructed for the painting from fifteenth-century elements.

PROVENIENCE: Louis Quer, Barcelona. Acquired by Henry Walters around 1915.

BIBLIOGRAPHY: *Catalogue de peintures anciennes, collection Louis Quer, gravé et imprimé par J. Thomas*, Barcelona, n.d., n. 1 (Ecole française, XVe siècle)—C. R. Post, *History of Spanish Painting*, Cambridge, Mass., 1930, I, p. 25; III, pp. 50-53, as a "masterly specimen of this frontier manner," cf. 54, 330 and fig. 266—A. L. Mayer, "En torno a Lorenzo Zaragozano," *Archivo Español de Arte y Arqueología*, no. 29 (1934), pp. 105-108—José Gudiol, *Spanish Painting*, The Toledo Museum of Art, 1941, p. 30, and fig. 19 (as circle of Marçal de Sas and Pedro Nicolau, ca. 1425)—J. C. Kirby, "The Care of a Collection," *JWAG*, XV-XVI (1952-53), pp. 8-19, figs. 1-9—E. Lafuente-Ferrari, *Breve historia de la pintura española*, Madrid, 1953, p. 87 (hypothetically as by Lorenzo Zaragoza)—J. A. Gaya Nuño, *La pintura española fuera de España*, Madrid, 1958, pp. 334-5, n. 2974 (as by Lorenzo Zaragoza).

PLATE III WALTERS ART GALLERY, inv. no. 37.747

21 MASTER of the STRAUS MADONNA, Florentine, ca. 1400

Celestial Madonna of Humility

Tempera and gold-leaf on panel; 51⅛ x 25 in. (1.298 x .634 m.)

The Madonna of Humility surrounded by four angels and Saints Bernard, John the Baptist, Pontianus and Nicholas. Above, God with the Dove of the Holy Ghost, flanked by flying angels, and in the summit of the frame the Crucifixion with the Virgin and St. John crouching on the ground.

The Master of the Straus Madonna, an unidentified artist belonging to the circle of Agnolo Gaddi and Lorenzo Monaco, represented in Florence the neo-Gothic tendencies of Siena against the new naturalism, as well as against the northern French brand of the International Style. Possibly he is the creator of a new iconographical type: the celestial vision of the Virgin of Humility, in which the Madonna, seated against the gold field of the painting, is suspended above the ground plane. She is surrounded by saints and angels in a new compositional type that will develop later into the group known as the *Sacra Conversazione* of the early Renaissance, in which the Madonna is enthroned on high.

Three visionary treatments of the Madonna of Humility by the Master of the Straus Madonna are known: one in the Kaiser Friedrich Museum, Berlin, another in the Museo Nazionale, Florence, and this example in the Walters Art Gallery. The composition of the Walters Art Gallery panel resembles very closely that of a fourth panel by the same master in the Philadelphia Museum of Art: the Madonna between St. Nicholas and St. Francis, two maiden saints and two angels. In these two panels the artist appears to have used the same cartoon, but reversing it. In

the group of the Madonna and Child, a contrapposto is achieved by the position of the Child reclining in His mother's arms and turning His head outwards, while His hand plays with her veil. This group is oriented to the left in the Philadelphia panel, and to the right in the Walters panel. The figure of St. Nicholas, holding three golden balls, is the same in both panels, but on the left in the Philadelphia one, on the right in the Walters one. The figures of the angels above the saints are also interchanged. In the Walters panel St. John the Baptist has replaced St. Francis. St. Bernard and St. Pontianus (the patron of Spoleto) have replaced the two maiden saints of the Philadelphia version. Two angels are kneeling, adoring the vision of the Madonna of Humility, in the Walters panel—a feature also to be seen in Berlin. The Philadelphia panel, which must represent a preparatory stage in the evolution towards the exaltation of the Madonna of Humility, shows the Virgin seated on a podium covered with a brocade carpet.

At the top of the Walters panel angels sway to the left and right of God in the posture of adoration—proskynesis—as in the Berlin panel, but instead of proffering, as they do here, the instruments of the Passion, one bears a palm, the other a flowering twig. God does not bless, but His right hand extended downward towards the Dove and the Virgin and Child conveys to it the connotation of the Apocalyptic vision of the "woman who brought forth the man child" (Revelation 12).

The decorative pattern is simple but very graceful. The figures are clustered like an arch around the Virgin and delicately bend the verticals of the composition into the movement of the pointed frame which in its turn is echoed by the pensive inclination of the head of the Virgin.

The usual characteristics of the Master of the Straus Madonna, such as the pouting faces with drooping lips, the small arms, the too-short hands, the haloes punched with small circles or with the design of a stem having leaves springing symmetrically from it—all are to be noted here.

CONDITION: The frame is the original one, except for four small new pieces (capitals and bases) carved and gilt in the style of the originals. The gold-leaf and paint film are in good condition.

PROVENIENCE: Don Marcello Massarenti, Rome. Acquired by Henry Walters in 1902.

BIBLIOGRAPHY: *Massarenti Cat.*, p. 6, n. 13 (as by A. Cecino, ca. 1437)—*Walters Cat.* [ca. 1909], n. 729 (as by Cennino di Drea Cennini)—*idem* [ca. 1929], p. 133 (as by a follower of Agnolo Gaddi)—R. Offner, *Burl. Mag.*, LXIII (Oct. 1933), pp. 69-170, note 14 (list of the works attributed to the Master of the Straus Madonna, named after a panel in the Percy S. Straus Collection, New York)—M. Meiss in *Art Bulletin*, XVIII (1936), p. 447, note 30—*idem*, *Painting in Florence and Siena after the Black Death*, Princeton, 1951, p. 139 and note 26.

PLATE XIV WALTERS ART GALLERY, inv. no. 37.729

22 MICHELE di MATTEO, Bolognese (active 1425-1448)

Madonna and Child

Tempera and gold-leaf on panel; 17¾ x 12 in. (.450 x .305 m.)

The theme of this panel, the Virgin in Glory crowned by angels, was diffused by French art during the fourteenth century, where it is notably frequent in small reliefs carved in ivory. Here the two angels performing the Coronation are not painted, but incised in the gold background.

The type of the Virgin, with the coquettishly languorous tilt of her small head, comes from the tradition of the "Beautiful Madonnas" of South Germany and Austria. The facial type, mixing "soft style" with angularity, the small, pretty nose, the cherry-like lips, as well as the treatment of the folds of the veil, the embroidered mantle, and also the gesture of the Child, with forefinger to mouth, should be compared with the panel of the Madonna and Angels in the Chiaramonte Bordonaro Collection in Palermo. This is a work attributed to Michele di Matteo of Bologna.

To the right and left of the Virgin are incised the Apocalyptic sun and moon-crescent. Most interesting is the gesture of the Child which derives ultimately from the Romano-Egyptian statuettes of the child Horus.

CONDITION: The painting had become somewhat discolored with age; recent cleaning revealed an over-all abrasion which had exposed the red bole in the gold background and the green under-painting of the flesh tones, as well as the surface modelling of the draperies. No overpainting has been applied.

BIBLIOGRAPHY: *Walters Cat.*, 1929, p. 107 (as "Guaroleagrele [sic] Venetian School, 14th cent." The name was confused with that of Nicholas of Guardiagrele—a little town near Sulmona in the Abruzzi—who signed a Madonna of Humility in the Uffizi, Florence).

PLATE XXII WALTERS ART GALLERY, inv. no. 37.513

23 MONACO, LORENZO, Florentine, ca. 1370-ca. 1425

Man of Sorrows

Drawing in pen and brush, with brown ink and water-colors on fine silk or linen; 3¾ x 3 3/16 in. (.097 x .082 m.)

In this wash drawing on a fine textile, Christ is represented standing in His tomb, His arms crossed, His head drooping to His right, showing His wounds, dead but at the same time alive, or rather expecting the Resurrection, because His clouded eyes remain open. This image of devotion, known as the "Man of Sorrows," was created around the time of the Jubilee year of 1300. It is based on a Greek icon, at that time preserved in the Church of Santa Croce in Jerusalem, Rome, and also on the legend that Christ appeared in this way to Pope Gregory the Great, while he was celebrating the Mass in the basilica of Santa Croce.

Hans Tietze has compared the drawing with two compositions by Lorenzo Monaco: one made for the Hospital "degli Oblate," now in the Accademia Carrara, Bergamo, the other (later, 1404) in the Galleria Antica e Moderna, Florence. There is a third Man of Sorrows in the middle of the predella of an early altarpiece by Lorenzo Monaco (Biblioteca Communale, Pescia), but it seems to have been painted by a helper who was a retardataire follower of Taddeo Gaddi.

Christ is alone in the drawing, not, as in the paintings by Lorenzo Monaco, between Mary and Saint John, so that one is lead to wonder if it could be related to the gold morse which Pope Martin V commissioned Ghiberti to execute in Florence (1419-1420). Masolino copied this brooch in the figure of St. Martin in a panel of the polyptych from Santa Maria Maggiore, Rome, which is now in the John G. Johnson collection, Philadelphia Museum of Art. This represents Pope Martin dressed in his pluviale adorned with columns—the heraldic arms of the Colonna Pope— and clasped with the morse executed by Ghiberti. The similarities with the drawing in the exhibition are striking, except for the position of the arms. It seems that after the end of the Great Schism, Martin V and his successor, Eugenius IV, gave special consideration to the theme of the "Man of Sorrows." When Bicci di Lorenzo in 1423 or 1424 painted a fresco in S. Egidio, Florence, of Martin V consecrating the Hospital of Santa Maria Novella, he depicted a glazed terracotta lunette of the Man of Sorrows in the portal of the hospital. It was again this same image of devotion which Donatello carved in a wreath in the gable of the marble tabernacle executed for Eugenius IV in the sacristy of St. Peter's.

CONDITION: Cut out along the contours and laid down on paper.

PROVENIENCE: Stossel Collection, Vienna.

EXHIBITIONS: "Master Drawings of the Italian Renaissance," Detroit Institute of Arts, 1960; "Drawings from Tuscany and Umbria," Mills College Art Gallery, Oakland, California (1961).

BIBLIOGRAPHY: P. Grigaut in *Catalogue*, 1960, of the Detroit exhibition, no. 2—A. Neumeyer and J. Scholz, *Catalogue*, 1961, of the Mills College exhibition, no. 51—cf. L. Vayer, "*L'Imago Pietatis di Lorenzo Ghiberti*" in *Acta Historiae Artium, Budapest*, VIII, 1-2, pp. 45-53 (for the Ghiberti morse).

PLATE XVI JANOS SCHOLZ

24 NETHERLANDISH, ca. 1400

Three Scenes on Two Panels from a Small Altarpiece

Tempera and gold-leaf on oak panel; each panel: 14 5/16 x 10 3/16 in. (.363 x .259 m.)—see under "Condition."

The Annunciation, with the Baptism of Christ on the reverse (or outside) of the panel; the Crucifixion.

These two panels are part of a small altarpiece which is now dismembered and divided between the Walters Art Gallery and the Museum Mayer van den Bergh in Antwerp. Erwin Panofsky was the first to propose what is doubtless the correct order of the scenes. When open, the altarpiece originally showed: the Annunciation (Baltimore), the Nativity (Antwerp), the Crucifixion (Baltimore), and the Resurrection (Antwerp). When closed, the altarpiece presented the Baptism (Baltimore) and St. Christopher (Antwerp). The present confused association of the panels must date from the time the polyptych was divided in the eighteenth or nineteenth century.

Originally this little altarpiece may have been a quadriptych of four hinged panels forming a sequence (*"tableaux cloant de quatre pièces"*), such as Gérard d'Orléans is recorded to have painted for Charles V, King of France, and of which two other examples are mentioned in the inventories of the Duke of Berry. On the other hand, it may have consisted of two diptychs enclosing a statuette or a reliquary, as is the case of a pair of diptychs painted by a follower of Melchior Broederlam, which also is now in the Museum Mayer van den Bergh, or of the Cardon polyptych in the Louvre, a product of a Dijon workshop under Paris and Netherlandish influence, of about 1400. It is interesting to note also two diptych wings separated by a statue, depicted above an altar in the Triptych of the Seven Sacraments from the workshop of Roger van der Weyden (Antwerp Museum of Fine Arts). We know that such assemblages of panels *"portatifs et mobiles"* were sent from Dijon in 1393 by Jean de Beaumetz to Duke Philip the Bold of Burgundy in Paris.

The Annunciation: this is composed like the painting of the Cleveland Museum formerly in the Arthur Sachs Collection, usually attributed to Paris at the end of the fourteenth century. In both pictures, the Virgin is seated under a lofty canopy (curiously pinnacled in the Walters panel with crenellations in the English Perpendicular style). In the Walters picture she recoils shyly, in the tradition established by Simone Martini. In the upper left hand corner the Dove of the Holy Ghost issues from the mouth of the Father (in the Cleveland painting God the Father sends the Logos in the shape of a minuscule infant). The annunciate Virgin of the Walters panel holds her hands crossed before her breast in obedient thankfulness—an attitude exceptional in northern painting before the Cologne master Herman Wynrichs and Jan van Eyck, but which derives from Giotto's fresco of the Annunciation in the Arena Chapel, Padua.

God holds an open book inscribed "alpha et ω" (i.e. the Beginning and the End) —a detail which occurs also on the fourth panel of the quadriptych, the Resurrection now in Antwerp. Thus the open altarpiece initiated the cycle of the Redemption mysteries with the Annunciation and concluded it with its fulfillment in the Resurrection.

The pristine glow of the colors is rendered more luminous by the gold background tooled with delicate scrolls, tendrils and crisp leaves, and, on the cloth of honor behind the Virgin, by the golden sun-bursts—an ornament which occurs in the medallions of the Virgin in Glory painted in the manuscripts. The diamond points of the tesselated floor also are common in manuscript illumination.

The Crucifixion: The iconography of this scene is extraordinary. Christ is represented still living. In other examples of the period this would be at the moment when He entrusted His mother to St. John or when stabbed by the lance. Here, however, neither episode is implied; Christ throws back His head in anguish—almost in protest. The words on the scroll issuing from His mouth spell out the Hebrew verse which begins Psalm 21 (22): "my God, my God, why hast

Thou forsaken Me?" which Christ uttered in loud voice at the ninth hour of the Crucifixion (Mark 15:34). True, expatiations on the Passion of the Lord at the Ninth Hour occur in two widely current medieval texts: the *Meditations on the Life of Christ* (ch. 79) of the pseudo-Bonaventura (a mysterious thirteenth-century Italian Franciscan named Joannes de Caulibus) and in the *Revelations* of St. Bridget (Book 4, ch. 70), a Swedish saint who lived in Rome in the mid-fourteenth century. But it is improbable that the Crucifixion panel directly illustrates a literary source. On the contrary, it evinces the freedom of approach to religious subject matter which characterized the artists of around 1400.

The hands of Christ are clenched over the nails, the feet forcibly crossed into an internal rotation; the suppedaneum, their support, has been suppressed; the Cross is still thin but no longer high, the position of Christ crucified is perpendicular, no longer sagging and broken; His arms do not slope acutely; His body and limbs are outstretched but not excessively; a fluttering lappet of the loin cloth uncovers the left knee, as in the Bohemian Crucifixions and the small diptych in the Bargello, but the volume of the folds betrays a knowledge of Italian models. Insect-like angels collect the blood dripping from the five wounds of Christ, as they do in Bohemian painting, and on the altar-cloth called the "Parement of Narbonne," as well as in the Calvary painted (by Jacques Cavael of Ypres?) around 1400 for the Corporation of the Tanners, in Bruges. They remind one even more of the elfish, vibrating little angels engaged in the same duty on a panel of the Crucifixion by the Master of St. Veronica, early fifteenth-century school of Cologne, in the National Gallery, Washington (Kress Collection).

In their restraint the Virgin and St. John reveal to us an artist psychologically subtle. The Virgin unostentatiously wipes away a tear and St. John in reflective sadness presses two fingers to his chin.

The magnificent ground stippled with floral patterns forms a golden cliff behind the Cross, and on high appears God blessing in a crescent of deep blue sky crowded with little blue angels. A similar crescent was used by a master of the Franco-Burgundian school in an illuminated Crucifixion on a detached leaf now in the Library of Heidelberg University. The device occurs later in the Dortmund triptych by Conrad of Soest, as well as in its copy in the Retable by the German Master of the Ten Commandments in the Landesmuseum, Hannover.

The Baptism of Christ: All of the unusual characteristics of this scene—the jug from which John the Baptist pours the water, rather than letting it drip from a bowl or from the palm of his hand; the pose of Christ covering His nakedness with His left hand and blessing with His right; the tunic displayed reverently by the angel—all of these details already occur around 1390 in the Baptism miniature of the *Petites Heures* of the Duke of Berry—a miniature painted probably by Jacquemart de Hesdin. But the landscape in this miniature, with its shallow stream, looks Italian, whereas in the Walters panel it is transformed into a delightful cove teaming with fish and a slope carpeted with flowers. In our panel the curving horizon conveys a cosmological significance to the scene, even while adding its rhythmical contribution to the overall decorative effect. Beyond this hill the background is not gold, as in the four panels of the quadriptych which shone when the altarpiece was open—but it is red. Red also is the background of the companion outside panel of St. Christopher now in the Mayer van den Bergh Museum. Red backgrounds are found also in Bohemian painting (the Master of the Trebon Altarpiece), in the famous Apocalypse tapestries woven in Paris in 1375-80 by Nicolas Bataille after cartoons by Jean Bondol of Bruges, and in the Calvary retable painted by an artist from Guelderland between 1401 and 1415 for Adolf II of Cleves and his mother, Margaret van Berg (in the church of Kranenburg, Cleves).

The juxtaposition of the Baptism and of St. Christopher—obtained when the Baltimore-Antwerp quadriptych was closed—is not common. This choice of subjects may derive from the back panels of the diptych which the Duke of Burgundy is recorded to have bought in 1383 from Jean d'Orléans, painter to King Charles V and Charles VI of France. These are described as showing the Lamb of God on one and St. Christopher on the other. Another version of a diptych

with the same iconography and by the same artist was in the collection of Charles V. The Lamb of God is present in the Baptism miniature of the *Petites Heures,* which we have indicated may have been the model of the Walters scene. It should be remembered that St. Christopher was held to be a symbol of the sacrament of Baptism under the New Dispensation (see catalogue no. 30), whereas John the Baptist, having been the last of the Prophets, assumed the meaning of its typological figure under the Old Dispensation.

The panels now shared between Baltimore and Antwerp were until around 1772 in the church of the Carthusian monastery of Champmol near Dijon, the foundation of which was officially ratified by Philip the Bold, Duke of Burgundy, on March 15, 1385. The monastery was named the "House of the Trinity." The Trinity thus was an iconographical hall-mark of many paintings from Champmol (e.g., the Large Circular Pietà and the Martyrdom of St. Denis in the Louvre, the Trinity in a quatrefoil in the Berlin Museum), and may explain why in our Baptism the Dove does not hover over the scene, but darts across the halo of Christ, in the same way that it flutters close to Christ's Crown of Thorns in the Louvre Pietà, or penetrates the nimbus in the Berlin quatrefoil.

Panofsky has established in the most convincing way that the author of the Baltimore-Antwerp quadriptych must have been an artist from Guelderland, because only such an origin would account for some Germanic characteristics, coming from the lower Rhine, which emerge through the Parisian brilliance and elegance of color and form. Some of these features will reappear later in Germany: compare for instance the Resurrection panel in Antwerp with the corresponding scene of the Middle Rhenish altarpiece in the Archbishopric Museum in Utrecht. The connection of the quadriptych with Champmol associates it in view of its style with Jan Malwael, the artist of Nijmegen, who directed the works of painting at Champmol as painter and "varlet de chambre" of Philip the Bold, Duke of Burgundy, from 1397 to 1404, and of his successor, John the Fearless, from 1406 to 1415.

The uncouth figure of the hermit having a pull from his gourd in the St. Christopher panel in Antwerp may derive from the St. Joseph whom Melchior Broederlam caricatured as a yokel drinking from his canteen in the Flight into Egypt. This he painted on a wing for one of the two carved retables which Jacques de Baerze began in 1392 and which were installed at Champmol in 1399. In the Resurrection panel of Antwerp the sleeping soldier on the left wears exactly the same kind of basinet (without the pig-faced visor) and chain camail as does the St. George carved by Jacques de Baerze. The superb quality of the tooling of the gold backgrounds of our quadriptych might be attributed to the painter-gilder Herman of Cologne, whom Malwael engaged at Champmol in 1401. It would be plausible to suggest the name of Herman of Cologne as the author of the quadriptych, which is a greater work of craftsmanship even than of art and follows with more grace than strength in the footsteps of the great masters active towards the end of the fourteenth century in Paris and Dijon—in the give and take of influences, Italian, French, Flemish, and Netherlandish.

CONDITION: The dimensions of the original oak panels, because of engaged modern moldings, can only be estimated from x-rays. The Annunciation-Baptism panel measures $14\frac{5}{16}$ x $10\frac{3}{16}$ in. (.363 x .259 m.). The original Crucifixion panel measures $13\frac{3}{8}$ x 10 in. (.34 x .254 m.), but the application of mortised wood strips at top and bottom give it overall dimensions corresponding to those of the Annunciation-Baptism panel. Sight measurements for each panel are $12\frac{3}{4}$ x $8\frac{5}{16}$ in. (.324 x .211 m.). Thickness: Annunciation-Baptism, $\frac{9}{32}$ in. (.007 m.); Crucifixion, $\frac{1}{2}$ in. (.013 m.).

The ground and paint film are exceptionally thin, but are well preserved. The few minor losses have been inpainted in water color.

PROVENIENCE: the Chartreuse at Champmol until around 1772-1774; removed from the church of the monastery, with the permission of King Louis XV, by Charles Antoine de la Roche-Aymon, Great Almoner of France, Archbishop of Reims (1762), cardinal (1772). After the French Revolution the panels are reported to have been in the chateau of Champigny near Chinon (Indre et Loire). It is not clear whether the Antwerp panels also were taken by Roche-Aymon or could possibly have been left in Champmol at the time of the eighteenth-century dispersal. At any rate the present Antwerp panels came into possession of the Dijon antiquarian, Bertholomey, who collected paintings

and sculptures from Champmol, and at the first sale of his effects, Paris, Jan. 23, 1843, lot 73, were sold to Charles Micheli, head of the cast atelier at the Louvre, and bought from his daughter after his death, by Fritz Mayer van den Bergh in 1898. The history of the Baltimore panels at this period is not clear. The sale-catalogue descriptions are too imprecise to determine whether they might possibly have figured as part of lot 73 in the 1843 Bertholomey sale, or even in a second sale of his property in Paris, Dec. 15, 1849, which also included paintings from Champmol. At any rate, the present Walters panels had passed into the Cuvillier Collection at Niort, Deux Sèvres, when they were displayed at the "Exhibition des Primitifs Français" in Paris in 1904. They were bought from the firm of Arnold Seligmann, Rey and Co. by Henry Walters in 1919, were inherited by his widow after his death in 1931; purchased from her by the Walters Art Gallery in 1939.

EXHIBITIONS: "Les Primitifs Français," Paris, 1904; "Flanders in the Fifteenth Century. Art and Civilization," The Detroit Institute of Arts, October-December 1960, Catalogue n. 2, pp. 58-63, ill. pp. 59-61.

BIBLIOGRAPHY: (common to the Baltimore and Antwerp panels): H. Bouchot, *L'exposition des primitifs français, la peinture en France sous les Valois*, Paris, 1904, pl. XX (as French)—*Collections du chevalier Mayer van den Bergh, Catalogue des tableaux exposés dans les galeries de la Maison des Rois Mages*, Antwerp, 1904, pp. 19 ff.—P. de Mont in: *Kunst en Leven*, Ghent, 1904, n. 9, pp. 20-23, ill.—*idem*, *L'évolution de la peinture néerlandaise aux XIVe, XVe, XVIe siècles*, Harlem, 1905, pp. 15-16, ill.—S. Reinach, *Répertoire de peintures du Moyen Age et de la Renaissance*, II, Paris, 1907, pp. 66, 85, 492, 599—G. Hulin de Loo, *Heures de Milan*, Paris-Bruxelles, 1911, p. 17—L. van Puyvelde, in: *Handelingen van het eerste taal—en geschiedkundig Congres te Antwerpen 1910*, Antwerp, 1911, pp. 65, 67—P. Durrieu, "Une Pitié de Notre Seigneur," *Monuments et Mémoires, Foundation Eugène Piot*, XXIII (1918-19), p. 92 (as from the school of Dijon)—M. Conway, *The Van Eycks and their Followers*, London, 1921, p. 113—E. Michel, "La collection Mayer van der Bergh à Anvers," *Gazette des Beaux-Arts*, II (1924), pp. 41-42, 58, ill.—Fierens-Gevaert, *Histoire de la peinture flamande*, I, Paris-Bruxelles, 1927, p. 32 (as by a painter of Broederlam's workshop)—A. Weese, *Skulptur and Malerei in Frankreich im XV und XVI Jahrhundert*, Potsdam, 1927, p. 93, ill. (as by Melchoir Broederlam)—W. Cohen, "Die Malerei auf der Ausstellung altflämischer Kunst in Antwerp," *Pantheon*, VI (1930), p. 429, ill. (as by Broederlam)—P. A. Lemoisne, *La peinture française à l'époque gothique, 14 et 15e siècles*, Munich, 1931, p. 52, ill. (as Franco-Burgundian, 1390-1400)—*idem*, *Gothic Painting in France, Fourteenth and Fifteenth Centuries*, (translated from the French by R. Boothroyd), Florence-New York, n.d., p. 59, pls. 26, 27—A. Cornette, in: *Trésor de l'art flamand, Mémorial à l'exposition . . . à Anvers, 1930*, I, Paris, 1932, pp. 18-19, 100, n. 31 (by a Flemish artist of Northern France, with influences from the school of Avignon)—A. Dezarrois, "L'art français à Londres," *Revue de l'art ancien et moderne*, LXII (1932), p. 76 (as Burgundian around 1400); cf. Constable and other authors, *Commemorative Catalogue of the Exhibition of French Art 1200-1900, London, 1932*, London, 1933, p. 4, ill.—K. Smits, *De Iconografie van de Nederlandsche Primitiven*, Amsterdam, 1933, p. 52, ill.—L. Baldass, "Das Ende des Weichen Stiles in der österreichischen Tafelmalerei," *Pantheon*, XIV (1934), p. 379 (as Broederlam's workshop)—C. Sterling, *Catalogue de l'exposition des chefs d'oeuvre de l'art français*, Paris, 1937, p 4, ill.; cf. L. Dimier, "Les oeuvres des écoles des Pays Bas en France, l'exposition des chefs d'oeuvre de l'art français," *Oud Holland*, LV (1938), p. 173 (denies the attribution to Broederlam)—J. Dupont, *Les primitifs français, 1350-1500*, Paris, 1937, p. 18, ill. (as Burgundian, Dijon); cf. "Les peintures de la Chartreuse de Champmol," *Bull. de la Société de l'Histoire de l'Art Français*, II (1937), p. 156—C. Sterling, *La peinture française, les Primitifs*, Paris, 1938, pp. 36, 37, 40, 150, figs. 26-31 (as by a Franco-Flemish atelier in Paris)—M. H. Ghéon, *Mère de Dieu*, Paris, 1939, pl. 11—L. Réau, *La peinture française du XIVe au XVIe siècle*, Paris, 1939, p. 12 (as school of Paris)—E. P. Spencer, "The International Style and Fifteenth Century Illumination," *Parnassus*, XII (1940), p. 30 (publishing for the first time the correct reconstitution of the quadriptych, based on a paper by Dr. Erwin Panofsky: "International Style in Painting circa 1400," read at the Walters Art Gallery on the occasion of the acquisition of the two panels)—*Art News* (March 2, 1940), frontispiece and p. 15—C. Jacques, *Les peintres du Moyen Age*, Paris, 1941, p. 24, Répertoire A, p. 6, n. 26, ill.—C. Sterling, *La peinture française, Les peintres du Moyen Age*, Paris, 1942, p. 24, pl. 24, 27 (as by an atelier of Hainaut)—E. Lotthé, *La pensée chrétienne dans la peinture flamande et hollandaise de van Eyck à Rembrandt*, Lille, 1947, I, p. 48—C. Janson, *La peinture française dans les musées de Belgique*, Bruxelles, 1947, pp. 6, 11-12, ill.—C. Sterling, *Le style gothique international (Les peintres célèbres)*, Genève, 1948, p. 39—G. Ring, *A Century of French Painting 1400-1500*, London, 1949, p. 194, n. 19 and 20 (rather Flemish than Franco-Flemish); cf. *The Art Quarterly*, XIII (1950), p. 263—J. Schaefer, *Les primitifs français du XIVe et du XVe siècle*, Paris, 1949, pp. 30-31 (in the vicinity of Broederlam)—R. M. Tovell, *Flemish Artists of the Valois Court*, Toronto, 1950, pp. 35-36, pl. 20-21 (the statement that the original tempera surface has been transferred to new panels is inaccurate)—Anonymous, "La Nativité avec Saint Joseph raccommodant son bas," *Aesculape* (1953), pp. 235-236, ill.—E. Panofsky, *Early Netherlandish Painting*, Cambridge, Mass., 1953, I, pp. 93-95, 97, 127, 394-395 (notes, 93:2 and 94:2), p. 447 (note 218:4), II, figs. 108-109 (as by an artist of Guelderland, 1400-1410); cf. *Art Bulletin*, XXXVII (1955), p. 211—J. Dupont, C. Gnudi, *La peinture gothique*, Genève, 1954, p. 147, ill.—St. Axters, *Geschiedenis van de vroomheid in de Nederlanden*, III, Antwerp, 1956, pp. 404-405—J. de Coo, "De unieke voorstelling van de 'Josefskousen' in het veelluik Antwerpen-Baltimore," *Oud Holland*, LXXIII (1958), pp. 186-198, ill.—*idem*, *Museum Mayer van den Bergh, Catalogus*, I, Antwerp, 1960, pp. 27-32, ill. (as from the circle of Broederlam)—*idem*, "De voorstelling met de 'Josefskousen' in

27

het veelluik Antwerpen-Baltimore toch niet uniek," *Oud Holland,* LXXV (1960), pp. 222-228—*Europäischer Kunst um 1400,* Vienna, 1962, n. 12: the Antwerp panels (as Burgundian, ca. 1390-1400)—P. Verdier in *Art News,* Sept. 1962, p. 27, figs. 9, 10, p. 51.

PLATES IV-V, and frontispiece WALTERS ART GALLERY, inv. no. 37.1683

25 NICCOLO DI BUONACCORSO, Sienese (1356-1388)

Triptych: The Madonna of Humility with Saints

Tempera and gold-leaf on panel; open: 26 x 21 in. (.661 x .536 m.)

Center: The Virgin seated on the floor in front of a marble bench, holding the Child on her right knee; above, the Crucifixion with Mary and St. John standing, St. Francis kneeling at the foot of the Cross. Left wing: St. Catherine; the announcing Angel above in the half-gable. Right wing: St. Christopher carrying the Christ Child, who points to the globe of the world in His hand; above, the Virgin annunciate, again seated as a Virgin of Humility on a cushion on the ground.

This exquisite triptych remained unknown to scholarship until now. Its attribution to Niccolò di Buonaccorso is certain, because its central panel is entirely similar to a panel by this minor master which Berenson signalled in 1931 (*International Studio,* January, p. 29, fig. 2). St. Christopher, on the right wing, and the Annunciation, in the half-gables, are the same as in the triptych in the castle of Konopište, near Prague, which Millard Meiss has recognized as a work by Niccolò di Buonaccorso.

In the panel cited by Berenson in 1931, the nursing Virgin of Humility is seated on the pavement of her room. Behind her, on a bench decorated with panels inlaid with intarsia, are laid a closed prayer book, a cushion for bobbins and little bags used for embroidering. In the central panel of the triptych presented for the first time in this exhibition, the Child is also seated on the right knee of the Virgin and we see an open book on a cushion on the floor and, on a bench with inlaid panels, a stand for the bobbins, a tricot that has been started, and knitting needles. These humble objects refer to the life of the Virgin as a housewife, as alluded to by the Pseudo-Bonaventura in the *Mirrour of the blessed lyf of Jesu Christ.* Delightful is the Vermeeresque juxtaposition of the blue and yellow bobbins on their stand and the contrasting notes of red and blue of the tricot. The introduction of this particular domestic paraphernalia is an early appearance of a theme that was to be treated later in German painting—as in the panel of The Doubt of Joseph painted by a Strasbourg master around 1420, and in Italy in a fresco by Andrea Delittio in the Cathedral of Atri. The pavement of striated marble is also found in the Marriage of the Virgin signed *"Nicholaus Bonachursi De Senis me pinxit"* in the National Gallery, London.

The same mood of intimacy and interest in details of furniture and objects of daily use characterize panels by Paolo di Giovanni Fei, a contemporary of Niccolò di Buonaccorso and working in the same vein, so that their productions are difficult to separate. Both artists hark back to the Lorenzetti. In fact, the same Virgin of Humility, with the bobbins and the open book on a bench inlaid with intarsia, is encountered in the left panel of a diptych in the Philadelphia Museum (John G. Johnson Collection, n. 153) which Berenson gave to a Sienese master close to Andrea di Bartolo and dated ca. 1390, and which Mrs. Shorr retains as by a follower of Ambrogio Lorenzetti (rather than accepting the attribution to Tommaso da Modena proposed in the 1953 edition of the Johnson Collection catalogue, and which is difficult to understand).

CONDITION: The painting is in an excellent state, except for some restorations on the Virgin's robe and St. Christopher's beard. The frame is original and intact.

PLATE XV MR. and MRS. T. S. HYLAND

26 PAOLO di GIOVANNI FEI (?), Sienese, last quarter of 14th century

Triptych

Tempera and gold-leaf on panel: 19½ x 19⅝ in. (.495 x .499 m.)

Central panel: the Madonna and Child enthroned between St. Catherine and St. Anthony Abbot. In the pediment above: the Crucifixion with the Virgin and St. John. Left wing: St. Nicholas of Bari and St. Bartholomew. Above, the angel of the Annunciation, with a scroll inscribed *Spiritus scs sup(er)*. Right wing: St. Francis of Assisi and St. Lucy. Above, the Virgin annunciate.

This small triptych is the work of a conservative and modest artist who was a retardataire follower of Simone Martini, as may be seen in the facial types: puffy for female characters, and strongly emphasized jaws for the men, retaining even traits of the school of Duccio, such as the markedly aquiline noses. As there is no perceivable connection with the Lorenzetti, there is no reason to attribute it to a small master of Siena, like Niccolò di Buonaccorso. The way the throne of the Virgin is separated from the dais recalls works attributed to Paolo di Giovanni Fei (cf. the Madonna, Saints and Angels in the Chigi Saraceni collection, Siena; also the triptych, no. 183, and the diptych, no. 146, in the Academy, Siena). The Crucifixion, with the Virgin and St. John seated on the ground in the "humility" iconography (a Sienese type of meditation on the sufferings of Christ used by the followers of Duccio and Simone Martini), is very similar to that in the Chigi Saraceni triptych. Also, the unusually sharp angle formed by the arms of Christ recalls the Crucifixion with Mary and John seated on the ground appearing in the gable of the triptych attributed to Cola di Petrucciolo da Orvieto, in the Metropolitan Museum. Berenson has compared the Walters triptych with a number of works that he grouped around the triptych of the so-called Panzano Master in the Pieve of Panzano, Chianti.

CONDITION: Original frame. The painting is in excellent condition, except for a few minor losses.

PROVENIENCE: Don Marcello Massarenti, Rome. Acquired by Henry Walters in 1902.

BIBLIOGRAPHY: *Massarenti Cat.*, p. 13, No. 64 (as "School of Siena," early fifteenth century)—*Walters Cat.* (ca. 1929), p. 158 (as Fei)—Berenson, "Lost Sienese Paintings. Part IV" in *International Studio* (Jan. 1931), p. 35, fig. 22 (cf. 23, 16) as by the Panzano Master—*idem*, "Quadri senza casa," in *Dedalo*, XI (1930), pp. 329-362.

PLATE VII WALTERS ART GALLERY, inv. no. 37.728

27 PELLEGRINO di MARIANO ROSSINI (?), Sienese, ca. 1440

The Crucifixion with Attendant Saints

Tempera and gold-leaf on panel; 21½ x 15¼ in. (.546 x .387 m.)

This painting retains a number of elements inherited from the Ducciesque tradition of representing the Crucifixion as it survived in Sienese painting of the fourteenth century: the high and narrow cross towering above the witnesses of the Calvary drama, the transparent (here almost nonexistent) loin cloth of Christ, the heavy suppedaneum, or bracket, supporting the nailed feet of Christ that are twisted slightly inwards, the crown of thorns (which in many Sienese Crucifixions is optional), the figure of the Magdalen kneeling at the foot of the Cross and clinging to its wood in a desperate effort to reach the feet of Christ.

The wiry, attenuated figure of Christ recalls a similar distortion (perhaps influenced by German painting or illumination of the early fifteenth century) in the Crucifixion panel from the predella of the Pecci altar piece painted by Giovanni di Paolo in 1426, now in the Lindenau Museum, Altenburg (n. 77). In contrast to three other predella panels representing the Crucifixion that were executed by Giovanni di Paolo between 1436 and ca. 1445: one in Altenburg (n. 78), another in the Academy at Siena (n. 175) and the one formerly in the Kaiser Friedrich Museum in Berlin, the scene on the Walters panel has been reduced to four historical figures—

Christ, Mary, Magdalen, St. John the Evangelist. Here in a frieze-like composition four devotional figures of saints—St. Jerome, St. John the Baptist, St. Ansanus and St. Francis of Assisi—are substituted for the compact groups of Roman soldiers, gesticulating Jews and holy women which Giovanni di Paolo used in various relationships with a feeling for asymmetrical balance in receding space. Neither the draperies, serrated and stiff, nor the rather harsh coloring, are characteristic of Giovanni. If the painting is indeed, as asserted by Pope-Hennessy, by the mysterious follower of Giovanni di Paolo. Pellegrino di Mariano Rossini, it may be dated around 1440. The Virgin of the Walters panel drops her arms with a gesture of hopeless despair similar to that of the holy women in the Berlin Crucifixion, and the pathetic movement of St. John the Evangelist striding towards the Cross seems to have been inspired by the Crucifixion in Siena.

The Walters panel exaggerates certain neo-gothicizing or Byzantinizing tendencies, already seen in the art of Giovanni di Paolo, but it holds closer to the Sienese painting of the fourteenth century than Giovanni di Paolo ever ventured to do. Even the figure of St. Ansanus, patron of Siena—a martyr of the persecution of 303 A.D., whose remains were venerated in the cathedral of the city—is depicted as a youth holding a banner as on panels painted in Siena in the first third of the fourteenth century (cf. the Lippo Memmi panel in the Uffizi, Florence, n. 452, the Meo da Siena panel in the Detroit Institute of Arts).

CONDITION: During a former restoration the original wood of the panel had been replaced on either side by new sections, two on the left and one on the right. The figure of St. Jerome, half the figure of John the Baptist and the figure of St. Francis had been transposed onto these new panel sections. The left side of St. Jerome's figure evidently had lost more of its character and so received a greater degree of repainting than the rest of the figure. The Virgin's cloak, the tunic of John the Baptist, and the dark reverse of the banner of St. Ansanus had been repainted, and the gold background and haloes renewed.

PROVENIENCE: Don Marcello Massarenti, Rome. Acquired by Henry Walters in 1902.

BIBLIOGRAPHY: *Massarenti Cat.* n. 75 (as School of Fra Angelico)—Berenson, *List,* 1932, p. 244—*idem, List,* 1936, p. 211 (as by Giovanni di Paolo)—E. S. King, "Notes on the Paintings by Giovanni di Paolo," *Art Bulletin,* XVIII (1936), pp. 216-217, 223, 235 (tentatively as an early work of Giovanni di Paolo)—J. Pope-Hennessy, *Giovanni di Paolo,* London 1937, p. 160, and n. 31, p. 166 (tentatively as by Pellegrino di Mariano)—*idem,* "The panel paintings of Pellegrino di Mariano," in *Burl. Mag.,* LXXIV (1939), pp. 214-217 (as by Pellegrino di Mariano ca. or soon after 1450).

PLATE XXVIII WALTERS ART GALLERY, inv. no. 37.727

28 SALIMBENI BROTHERS: LORENZO I and JACOPO da SANSEVERINO, School of the Marches, ca. 1425

The Funeral and Canonization of Saint Francis

Tempera and gold-leaf on panel; 11¾ x 19¾ in. (.298 x .501 m.)

A panel, probably the middle one, of the predella of a lost altarpiece dedicated to St. Francis of Assisi. Juxtaposed in the same picture are the representations of his funeral and of his canonization by Pope Gregory IX. With an almost impressionistic technique, both events are recorded as vivid and confused episodes taken from life.

The bothers Lorenzo and Jacopo Salimbeni da Sanseverino were two realist painters of the Marches who worked together from about 1416 on, sometimes with the collaboration of a certain Oliviero. They were endowed with a shrewd sense of observation which gave itself free rein, especially in recording the piteous deformities of the maimed human body. The death of St. Francis afforded the opportunity to depict Doctor Gerome pointing out the Stigmata on the feet of the saint and to feature the unfortunates who sought a healing miracle at the death-bed: amputees, cripples with crutches, a blind man with a swollen leg. In contrast to this human misery are the Pisanellesque figures of fashionable youths wearing large beaver hats and coats heavily trimmed

with fur—a contrast also made by Gentile da Fabriano in his Presentation in the Temple, now in the Louvre.

Among the other works of the Salimbeni, the best comparison with the Walters predella is afforded by the frescoes of the Martyrdom of St. Andrew in the chapel of St. Lorenzo in Doliolo, Sanseverino. The device of thin screen-walls supporting a coffered ceiling employed in our St. Francis scene recurs in the fresco of the Nativity and Circumcision of St. John the Baptist at S. Giovanni Battista, Urbino, which was signed by the Salimbeni brothers in 1416. A similar impressionistic technique, but a weaker style, characterizes four panels with scenes from the life of St. Augustine in the Vatican Gallery, attributed to the School of the Salimbeni.

CONDITION: The paint film is in good condition except for damages along both sides and a few scattered losses.

PROVENIENCE: Unrecorded. Acquired by Henry Walters in 1915.

BIBLIOGRAPHY: *Walters Cat.*, 1929, No. 456, as School of (Angelo di Cola da) Camerino—Berenson, *List*, 1932, p. 29 —idem, *List*, 1936, p. 25 (as Antonio da Fabriano)— Van Marle, XV, p. 127, No. 5 (disagreeing with Berenson, as School of Lorenzo da Sanseverino)—O. Neustatter, "A Record of Orthopaedic Devices in the Middle Ages," *JWAG*, VI (1943), pp. 109-112, figs. 1-3.

PLATE XXX WALTERS ART GALLERY, inv. no. 37.456

29 SIENESE, second third of the 14th century

The Crucifixion

Tempera and gold-leaf on panel; 25⅝ x 10¼ in. (.65 x .26 m.)

This painting was given by Berenson to Barna of Siena—an attribution that is hardly possible to accept. It echoes the complex iconography of the Crucifixion first conceived by Duccio in his Maestà (1308-1311) as a scene having two antithetic groups—the mourning Christians on the right of the Cross (i.e., the left side of the picture) and the throng of gesticulating Jews and armed Romans on its left—which developed into the turmoil of a crowd in the fresco painted around 1320 by Pietro Lorenzetti and his workshop in the Lower Church of S. Francesco, Assisi. The theme was reduced to a more restrained composition by Pietro Lorenzetti himself in 1331 for the Chapter-room of S. Francesco, Siena. A further reduction of the composition was achieved by Simone Martini on one of the little panels of the polyptych he painted in Avignon around 1340 (now in the Musée des Beaux-Arts, Antwerp).

Like the Antwerp panel, the Walters one is characterized by great crowding, the figures being compressed to the sides so as to leave the Crucifix aloof and isolated. The same features occur in Lippo Memmi's Crucifixion (Vatican Gallery), which, like the Walters panel, frames the Cross within a cinquefoil arch, while the Pelican in a roundel above occupies the apex of the gable.

The composition is bristling with banners and spears. Stephaton, the sponge-bearer, has been shifted with other soldiers to the background of the Christian group, whereas Longinus, just miraculously healed of his blindness by the blood from the pierced chest of Christ, has been moved to the right side, where he stands near the Centurion. Both wear the nimbus which denotes their sudden conversion to the Christian faith. The mourning angels fluttering under the arms of Christ are a Byzantine theme first introduced into Italian painting by Cimabue and Giotto. They are referred to in the verse of Isaiah: "Behold, they that see shall cry without, the angels of peace shall cry bitterly" (33:7).

The children among the bystanders appear also on the panel by Simone Martini and they are to occur again later on two panels of the story of the Crucifixion from the predella of the Pecci Altarpiece by Giovanni di Paolo (Cat. no. 11). Such a detail as the acanthus pattern on the soldier's shield is reminiscent of the cuirass ornament of two Roman soldiers on the panel of The Way to Calvary by Ugolino da Siena in the National Gallery, London. While the lettering of the

SPQR inscription on the other shield resembles closely that in the panel attributed to "Ugolino Lorenzetti" (Biagio da Siena or Biagio di Masarello, active between 1320 and 1363) in the Berenson Collection at Settignano.

A Crucifixion comparable to the Walters example and to the "Ugolino Lorenzetti" panel, from the point of view of composition and details of military costume, is in the John G. Johnson Collection, Philadelphia Museum of Art. Like the Walters panel, it derives from the iconography established by Pietro Lorenzetti and Simone Martini—but less strongly. Formerly attributed to Barna by Berenson, the Philadelphia picture is recognized today as the work of a Bolognese artist of around 1375 to 1400. Although the Walters panel still bears the hallmarks of the school of Simone Martini (who died in 1349), in terms of date it must be a testimony to the long-range influence of Simone and those who adapted his formulae in Siena after he left for Avignon in 1339—a case not unlike that of the well-known illuminations by the northern artists working for the Duke of Berry in the early fifteenth century. However, some features—such as Christ's face and the modelling of His body—point toward the Giottesque tradition of Taddeo Gaddi or even earlier (Pacino di Buonaguida). The influence of the Sienese painters of the first half of the fourteenth century was nevertheless the strongest one; the type of the Magdalen's face here, for instance, is very reminiscent of that in the Crucifixion by Ambrogio Lorenzetti in the Fogg Museum.

CONDITION: The gold-leaf and paint film are in good condition. Minor losses have been inpainted in water color, but the Virgin's robe, where large areas of the original paint are missing, has been inpainted in a neutral color.

BIBLIOGRAPHY: Berenson, *List,* 1932, p. 43, and *idem, List,* 1936, p. 35 (as Barna)—cf. Van Marle, II, p. 297.

PLATE VIII WALTERS ART GALLERY, inv. no. 37.737

30 SIENESE (or FLORENTINE UNDER SIENESE INFLUENCE), end of the 14th century

The Crucifixion and Saint Christopher

Tempera and gold-leaf on panel; each panel: 14⅞ x 9⅞ in. (.377 x .252 m.)

Two wings from a triptych. The paintings are on the inside faces of the wings: St. Christopher on the left one, the Crucifixion on the right. The exterior faces are decorated with floral arabesques. The slope of the tops indicates that the lost central panel had a gable of low pitch—a formula then already antiquated.

In Tuscan painting of the fourteenth century, St. Christopher was sometimes depicted as a companion figure to the Crucifixion (cf. the triptych by Taddeo Gaddi in the Museum of Berlin, where the two subjects are on the obverse and reverse of the same wing; also two wings of a triptych in the Museum at Dijon, by a follower of Pietro Lorenzetti, where the subjects are disposed on the inside surfaces in the same position as on the Walters pair). The type of the Crucifixion is Sienese. The crucified Christ derives, through a long series of repetitions, from the Crucifixion by Simone Martini now in the Fogg Art Museum; the figures of Mary and St. John exhibit the almost grotesque features and the tormented gestures of the hands which are found in minor masters of Siena, such as Francesco di Vannucio. St. Christopher is presented in full face instead of looking up at the Child Christ as in the mid-century representation of St. Christopher by Niccolò di Tommaso in the Walters Art Gallery and on the right wing of a triptych by Niccolò di Buonaccorso in this exhibition (no. 25). St. Christopher is represented here as "Christ-bearer," according to the medieval legend which took form in the southern Germanic countries to interpret literally the Greek name of the saint: Christo-phoros. He is holding the staff on which he leaned while carrying the Child Christ across the dangerous stream. When at the bidding of Christ, he stuck it in the river bank, it sprouted leaves and became covered with fruit. Since the legend tells that Christ baptized Christopher during the crossing of the stream, that aspect of the Christopher story was interpreted in the fourteenth century as a symbol of baptism. It is even possible that

the two Walters wings—like those in Dijon—were looked upon as symbols of the two main sacraments of the Church: Baptism and the Eucharist. But the belief also developed that Christopher was the helper of travellers and that a glimpse of his image had power to ward off any accident all day long. Thus, on images of devotion, such as the small triptych of which these Walters wings are the relics, the meaning of the image of St. Christopher was twofold: sacramental and magical.

CONDITION: On both panels gold leaf and paint film are in good condition, except for the blue of the Virgin's mantle in the Crucifixion, which has deteriorated badly.

PROVENIENCE: Don Marcello Massarenti, Rome. Acquired by Henry Walters in 1902.

BIBLIOGRAPHY: *Massarenti Cat.*, p. 8, n. 28, 29 (as 14th century, author unknown)—*Walters Cat.* (ca. 1909), n. 724 (as Tuscan School, 14th century)—*Walters Cat.* (ca. 1922), p. 141 and *idem* (ca. 1929), p. 132, have both substituted another panel (no longer traceable) under the number 724 which belonged to the present wings in the earlier Walters catalogue; this seems to have caused confusion in Berenson, *List*, 1932 p. 339 and *idem*, 1936, p. 276, where under no. 724 he attributes these two wings and the panel all to the Maestro del Bambino Vispo, as parts of a single triptych—G. Pudelko, "The Maestro del Bambino Vispo," *Art in America*, XXVI (1938), p. 59, note 27, rightly eliminates the Walters wings from the list of works by the Master of the "Lively Child" (Bambino Vispo).

PLATE XII WALTERS ART GALLERY, inv. no. 37.724

31 SPINELLI, PARRI, Tuscan (Arezzo), 1397-1453

The Navicella

Pen drawing in brown ink with brown wash on two joined leaves of paper; 10¾ x 15⅜ in. (.275 x .385 m.)

This drawing is a copy of the mosaic which Cardinal Jacobus Gaetani de Stephanescis commissioned of Giotto as a remaking of a ruined early Christian one, which was located on the western wall of the entrance into the atrium of the early Christian basilica of St. Peter's at Rome. The mosaic, 43 feet high and 60 feet wide, which Giotto executed at a time when Pope Clemens V (1305-1314) had already moved the Apostolic Seat to Avignon, illustrated the last chapter of the Gospel of St. John. It showed how St. Peter cast himself into the Sea of Galilee to meet the Lord, Who had appeared to His disciples on the shore after the Resurrection.

The original mosaic dated back to the time of Pope Damasus (366-384), when the theme had been chosen as a symbol of the primacy of the seat of Rome and of salvation by water. But in the early fourteenth century its sense had become obscured and Giotto, whose iconographical programs are always straightforward and human, changed it into the miracle of the Sea of Galilee, in which Christ, walking on the wave-tossed waters, rescued Peter who had gone out of the boat to meet Him. "But seeing the wind strong, he was afraid and when he began to sink, he cried out, saying: Lord, Save me. And immediately Jesus stretching forth His hand took hold of him and said to him: O thou of little faith, why didst thou doubt" (Matthew 14: 30-31). It will be noted, however, that in this drawing Christ stands on the shore, as in the relation of St. John and does not walk on the waters as in the miracle told by St. Matthew.

The mosaic of Giotto, known as the "Navicella," after the boat represented in it, lasted scarcely three centuries. Its progressive destruction, through a series of removals rendered necessary by the construction of the Baroque façade of the basilica of St. Peter, began in 1605. Its souvenir survives however in two sketches and a print of the sixteenth century, which serve also as a measure of the accuracy of the Parri Spinelli drawing. The drawing faithfully records, in their Gothic transliteration by Giotto, certain early Christian elements of the composition: the building on the left, which was the lighthouse of Ostia, the fisherman, the winged wind-god blowing on the unfurled sail. The shape of the hull of the ship is the Roman one. The main group, that of Christ and St. Peter, impinges upon the central part of the composition, while in the original it was isolated at the extreme end. The draughtsmanship, with its quick, sharp lines and its nerv-

ous accents of shadows coagulated at intervals in the folds of the garments, is characteristic of the hand of Parri Spinelli. The drawing was not executed as a sketch on the spot, but was copied after a master-drawing which was reproduced often in the fourteenth and fifteenth centuries for circulation in the workshops of Florence. On the bulwark of the ship the copyist has written an inscription which connects it specifically to its prototype, the mosaic by Giotto: *"la nave di Giotto ch i santo pietro a roma di musaicho."* The figure of Christ is remarkably close to that in the quatrefoil bronze relief of Christ in the Storm, cast around 1415 in the workshop of Ghiberti for his first doors for the Baptistery at Florence.

The Parri Spinelli drawing was included by Vasari in the collection he gathered in the album called *Libro de' Disegni.* It must have been inserted belatedly, since Vasari does not mention the drawing (attributed to Giotto by the inscription in the left corner) in the second edition of his *Vite* (1568). On the right edge of the drawing may still be seen traces of the architectural frame which Vasari designed for it on the mat and which slightly overlapped onto the sheet.

PROVENIENCE: Giorgio Vasari, Florence; Earl of Pembroke and Montgomery, Wilton House near Salisbury.

BIBLIOGRAPHY: Jonathan Richardson, Sr. and Jr., *An Account of the Statues, Bas Reliefs, Drawings and Pictures in Italy, France . . . with Remarks,* London, 1722, p. 293 [2a, 1754 (ed. in French, Amsterdam, 1728)]—S. A. Strong, *Reproductions in Facsimile of Drawings . . . in the Collection of the Earl of Pembroke*—A. Muñoz, "Reliquie artistiche della vecchia Basilica Vaticana a Boville Ernica," *Bollettino d'Arte,* V (1911), pp. 161 ff.—*Collection of Reginald Herbert, Earl of Pembroke:* Sale Catalogue, London, Sotheby, Wilkinson and Hodge, July 1917, n. 515—L. Venturi, "La data dell'attività romana di Giotto," *L'Arte,* XXI (1918), pp. 229 ff.—*idem,* "La Navicella di Giotto," *L'Arte,* XXV (1922), p. 50, ill.—B. Berenson, *The Drawings of the Florentine Painters,* Chicago, 1938, I: p. 326. II: n. 1837j, p. 254. III: fig. 7—W. Paeseler, "Giottos Navicella und ihr spätantikes Vorbild," *Römisches Jahrbuch für Kunstgeschichte,* V (1941), pp. 49-162, fig. 85—C. Refice, "Parri Spinelli nell'arte Fiorentina del secolo XV," *Commentari,* II (1951), pp. 196-200—C. Virch, "A Page from Vasari's Book of Drawings," *Bull. MMA* (1961), pp. 185-193—B. Berenson, *I disegni dei pittori Fiorentini,* 1961, vol. II.

PLATE XXXIV METROPOLITAN MUSEUM OF ART, no. 19.76.2, HEWITT FUND, 1917

32 SPINELLI, PARRI (?), Tuscan (Arezzo), 1397-1453

The Navicella

Pen drawing on two joined leaves of paper; 10⅝ x 14⅝ in. (.271 x .371 m.)

This drawing interprets the "Navicella" of Giotto in terms of the many variations it inspired in Italian art of the fourteenth century—in particular the mid-fourteenth century fresco by Andrea da Firenze in the vault of the Spanish Chapel at Santa Maria Novella, Florence. In this drawing the multiplied figures of the wind-gods and the balconied medieval deck at the stern of the boat, the relative isolation of the group of Christ and St. Peter, all derive from the Florentine fresco.

The drawing acquired by the Cleveland Museum was a part of the collection assembled by Vasari and, like that in the Metropolitan Museum (see Cat. no. 31), it was drawn across two leaves of paper, with studies of ships sketched on the reverse. A third drawing in the Bonnat Museum, Bayonne (France), also attributed to Parri Spinelli (and certainly Tuscan), executed on one leaf only, also has a ship sketched on the back. There is still a fourth drawing attributed to Spinelli in the Museum of Chantilly; a fifth in the Louvre (n. 1245) may be a post-Renaissance copy of an earlier one. The Bayonne drawing incorporates into the scene of St. Peter walking on the sea (not sinking) the miraculous draught of fish (Luke 5: 4-9), which is to be interpreted symbolically as the mission given by Christ to the Church (St. Peter and the Apostles) to be fishermen of souls. It will be observed that in the Cleveland drawing St. Peter seems to kneel before Christ as in the relation of the miraculous draught of fish in Luke: ". . . Simon Peter . . . fell down at Jesus' knees, saying: Depart from me, for I am a sinful man, O Lord. For he was wholly astonished and all that were with him at the draught of the fish . . ." (5: 8-9).

Comparison of the drawings in New York, Cleveland and Bayonne suggests that the fundamental meaning imparted in the fourth century to the gigantic mosaic installed in the atrium of St. Peter's at Rome—that of an image symbolical of the primacy of the Church of Rome through the direct delegation given by Christ to St. Peter—was not completely lost to view. Consequently these drawings are very important as documents representing the trend of Christian humanism in the early Renaissance, even if they are couched in the artistic idiom of the Gothic International Style, as it triumphed for a short period of time in Florence. They illustrate the immense fame of Giotto's Roman mosaic. Ghiberti, who may have made use of some of the sketches that were later collected by Vasari when he designed his own "Navicella" for the first doors of the Florentine Baptistery, places the mosaic first in his list of Giotto's works and praises the artist for having "introduced the new art" (*Commentari* II, 3-4).

Around 1400, Filippo Villani in his book on the glories of Florence (*De origine ciuitatis Florentiae et eiusdem famosis civibus*) mentions the "Navicella," as well as Giotto's portrait of Dante, as typifying the renaissance of humanism. Giotto is the only non-antique painter mentioned by Alberti in his treatise *On Painting* on account of the "Navicella," because "each one of the eleven disciples [in the boat] expresses with his face and gesture a clear indication of a disturbed soul in such a way that there are different movements and positions in each one." There is no doubt that it was essentially the correlation between composition, movement and expression in the "Navicella" that claimed the admiration of the circle of Ghiberti around 1415.

PROVENIENCE: Giorgio Vasari, Florence; Jonathan Richardson, Sr., London; Sir Joshua Reynolds, London; Conrad Martin Metz, Rome and London; W. Young Ottley, London; Marquess of Northampton, Castle Ashby.

EXHIBITIONS: Royal Academy, Burlington House, London (1930); The Cleveland Museum of Art, "Year in Review 1961"

BIBLIOGRAPHY: Jonathan Richardson, Sr. and Jr., An A*ccount of the Statues, Bas Reliefs, Drawings and Pictures . . .* London, 1722, p. 293—Conrad M. Metz, *Imitations of Ancient and Modern Drawings . . .* London, 1798, p. 5 (reproduces reversed facsimile etching)—W. Y. Ottley, *The Italian School of Design*, London, 1823, p. 9 (facsimile engraving by J. Vivares)—L. Venturi, in *L'Arte*, XXV (1922), pp. 49-69, p. 51 (IV, fig. 4)—A. E. Popham, *Italian Drawings Exhibited at the Royal Academy*, London, 1931, n. 1, pl. I—B. Berenson, *The Drawings of the Florentine Painters*, Chicago, 1938, I, p. 326. II, n. 1837k, p. 254. III, fig. 8—B. Degenhart, *Italienische Zeichnungen des frühen Jahrhunderts*, Basel, 1949, pp. 42-43, n. 26 (cites the Bayonne drawing as Tuscan, but not by Spinelli)—C. Virch, "A Page from Vasari's Book of Drawings," *Bull. MMA* (1961), p. 189, ill.—Cleveland Museum of Art, "Year in Review 1961," *Bull. Cleveland*, XLVIII (1961), p. 251, n. 93, illus. p. 239—L. S. Richards, "Three Early Italian Drawings," *Bull. Cleveland*, XLIX (1962), pp. 167-169.

PLATE XXXV CLEVELAND MUSEUM OF ART, no. 61.38
Purchase from the J. H. Wade Fund

33 STEFANO da VERONA (or da ZEVIO), Veronese, ca. 1375-1451

Five Figures

Pen drawing in brown ink on white paper; 7¾ x 5¾ in. (.196 x .147 m.)

Vasari praised Stefano da Verona for his ability to draw old people, and four of the figures here are of patriarchs. The shading is made of pen strokes wide apart, like rope ladders when they are jotted down in vertical stripes. Together with these folds, which resemble ropes, and the outlines, around which a sort of thread is unravelled in loops, they conjure up a strange impression. A similar method of draughtsmanship is found in a signed drawing in the Lugt collection, Maartensdyk (Holland), and in that of the old man reading a book in the Ambrosiana, Milan. The overlapping figures recall those of the old men in the crowd of onlookers in the painting of the Adoration of the Magi, Brera Gallery, Milan, dated 1435 and signed by Stephano. However, this drawing is probably earlier and its particular "graphology" has to be compared with that of certain drawings of Pisanello, such as the Riders in a Landscape (Louvre).

The growing influence of Pisanello on Stefano da Verona, from about 1426 on, explains the drier but more grandiose aspect of at least his late drawings, because these new tendencies coexist in the Brera painting with a "soft style" influenced by Austrian and Tyrolian painting.

CONDITION: Partly restored. In upper left corner, traces of a Gothic inscription.

PROVENIENCE: Triqueti Coll. (Lugt 1304)

EXHIBITIONS: "Five Centuries of Drawings," Montreal Museum of Fine Arts, 1953; "Disegni Veneti della collezione Janos Scholz," Fondazione Giorgio Cini, San Giorgio Maggiore, Venice, 1957; "Drawings of the Italian Renaissance from the Scholz collection," Indiana University Art Center, Bloomington, 1958; "Venetian Drawings," Mills College Art Gallery, Oakland; "Venetian Drawings," M. H. de Young Museum, San Francisco, 1959.

BIBLIOGRAPHY: Schoolman-Slatkin, *Catalogue*, Montreal Exhibition, n. 19—B. Degenhart, "Di una publicazione su Pisanello e di altri fatti, II," *Arte Veneta*, VIII (1954), pp. 96-118—L. Grassi, *Il disegno Italiano*, Rome, 1956, fig. 55—M. Muraro, *Catalogue*, Venice Exhibition, 1957, n. 1—C. Gilbert, *Catalogue*, Indiana University Exhibition, 1958, n. 1—A. Neumeyer and J. Scholz, *Catalogue*, Mills College Exhibition, 1959, n. 67.

PLATE XXXIII JANOS SCHOLZ

34 TUSCAN, third quarter of the 14th century.

Figures and Decorative Elements

Pen drawing on vellum; 12 x 30 in. (.305 x .762 m.)

This leaf is one of the earliest relics of Italian draughtsmanship in existence. The artist has recorded here all sorts of objects, sketches taken from life, as well as jotting down the products of his own imagination. We see architectural details, a fortified town (of the kind represented in frescoes), a running horseman, a statue of Prudence (a woman with the mask of an old man on the back of her head), studies of movement and of drapery, a wild man, grotesque scenes and drolleries as well as flying birds, the prototypes of which are Chinese and were copied in the textiles of Lucca. On the verso of the sheet is a deed of Tuscan origin, dated 1321.

PROVENIENCE: Private collection, Los Angeles, California.

EXHIBITIONS: "Drawings from Tuscany and Umbria," Mills College Art Gallery, Oakland, 1961, and University of California Art Gallery, Berkeley, 1961 (A. Neumeyer, J. Scholz, *Catalogue*, n. 86).

PLATE XXXVIII JANOS SCHOLZ

35 TUSCAN, ca. 1400

St. John the Baptist

Pen drawing in light brown ink on white paper; 9⅞ x 4⅞ in. (.25 x .23 m.)

Owing to the scarcity of drawings by Tuscan masters of the period, this one is difficult to attribute. Richard Offner showed in the catalogue of the recent New York exhibition an inclination to place it rather in Florence than in Siena. Apart from stylistic considerations, it should be pointed out that the drawing must be an element of a scene in which St. John the Baptist was announcing Christ as the Lamb of God (the words *Ecce Agnus Dei* were certainly to be inscribed on the scroll). The sketch may have been used for or copied after a polyptych in which the scenes of the Baptist's history were depicted left and right of a central panel representing the Saint. This arrangement in which the Saint—and in particular Saint John the Baptist, who was the patron of Florence—occupied the place of honor, is one of the particularities of Florentine painting in the last decades of the fourteenth century (cf. the polyptych by Giovanni del Biondo in the Contini Collection, Florence). Furthermore, in this drawing the hair of St. John the Baptist curls into a curious knot, the evolution of which can be traced in Florence from the By-

zantinizing mosaics of the Baptistery, through the altarpiece of Orcagna in the Strozzi Chapel, Santa Maria Novella, to the works of Lorenzo Monaco and the Master of the "Bambino Vispo." Saint John is not represented here as a prophet or as a hermit, but as a melancholy, middle-aged aristocratic figure. He bears a strange resemblance to Virgil in a Florentine illumination of the *Commedia* of Dante copied in 1398. The short tufts of beard on his chin are met in a miniature of the Resurrection in a liturgical book of the Biblioteca Laurenziana, which is dated 1396. The smaller figure, in the lower corner of the sketch, compares with figures in three other contemporary drawings, one from the Matthiesen Galleries (now in Holland), the others in the Paul Hatvany and Victor Block collections.

CONDITION: Some restorations.

PROVENIENCE: House of Savoia, Aosta (Lugt 47 a)

EXHIBITIONS: "Five Centuries of Drawings," Montreal, Museum of Fine Arts, 1953 (Schoolman-Slatkin catalogue, n. 15, ill.); "Great Drawings of Seven Centuries," Knoedler Galleries, New York, 1959; "Drawings from Tuscany and Umbria," Mills College Art Gallery, Oakland, and University of California Art Gallery, Berkeley, 1961.

BIBLIOGRAPHY: Schoolman-Slatkin, *Catalogue*, 1953, of Montreal exhibition, n. 15, ill.—R. Offner in R. Wittkower, *Catalogue*, 1959, of New York exhibition.—Neumeyer and Scholz *Catalogue*, 1961, of Mills College and University of California Exhibitions, no. 89, ill.

PLATE XXXVI JANOS SCHOLZ

36 TYROLESE, Brixen, ca. 1400

Coronation of the Virgin

Tempera and gold-leaf on pine panel; 30¼ x 18½ in. (.770 x .470 m.)

In this painting the artist did not aim at linear stylization, but used a free, fluid brushwork, and a quick, almost impressionistic, application of color. The hues are warm and rather heavy, with sandy brown flesh tones and a mulberry brown heightened by ochre yellow, joyful reds and the sparkle of gold—but toned down also by blue, olive green and grey. The modelling is somewhat doughy, but relieved by the calligraphy of folds. It is obtained by shading the local color or adding white to it, in an illuminator's technique.

The space does not contain the scene, but radiates from the main group of the Virgin flanked by the First and Second Person of the Trinity. Although the perspective lines of the ceiling beneath the twin canopies are approximately correct, the architectural backdrop is just a conventional setting for a mystical performance and a stage for the four little angels. Above the scene, a fluted ribbon of clouds denotes heaven, as it had done earlier in the sculptured tympana of Gothic churches, and passed from there into the tapestries and paintings of the fourteenth century.

The iconography of this Coronation of the Virgin marks a completely new departure from the time-honored treatment of the theme in Gothic art where, until around 1400, only Christ, the bridegroom of the Song of Songs, crowns the Virgin, who is the Church, His Bride. Here the Trinity is associated with the crowning of the Virgin. Christ is seated on the left of the Virgin, the Father on her right. The two Persons of the Trinity are almost duplicates of each other, only differentiated in age by the color of hair and beard. Above them, the Dove descends between the two strange spiralling pavilions which top the double throne of the Majesty of God. Such symmetrical compositions of God the Father and the Son crowning the Virgin constitute an iconographical creation of the International Style. They were propagated in two main regions: in England, by the Nottingham alabasters, and in Germany, by painting. The focus of the diffusion may have been the highly international milieu of Paris, towards the end of the fourteenth century. The earliest surviving example of the new type of the Coronation of the Virgin is to be

seen in the French drawing in the Louvre (Cabinet des Dessins Inv. No. 9832), representing the Death, Assumption and Coronation of the Virgin. Preparation for the fusion of the Trinity with the Coronation was laid by a new iconography of the Trinity in the late fourteenth century French art at Paris and Dijon, in which the two Persons of the Trinity sit or stand side-by-side, with the Dove between them. That composition was the matrix in which Mary was introduced to be crowned by the entire Trinity. In this new Coronation, the Virgin, frontally shown, was envisioned as "Mediatrix" between God and Man.

It will be noted that on the Tyrolian panel here exhibited, the Virgin does not exactly kneel, but pays a childish curtsy. She has neither veil nor mantle and is simply dressed, like a girl chosen as Queen by the Minnesingers. Her high-wasted greenish-blue dress, with the neckline off the shoulders, was a fashion which was initiated around 1400. Her unsophisticated gown and childish appearance relate to the symbolism of the soul which, throughout the Middle Ages, was represented as a child when carried by angels to heaven, and especially in the scene of the Assumption. The pattern of the ceiling above her head evokes the tapestried rooms chequered with white and red lozenges as heraldic trappings of the ladies, mentioned in the Dijon accounts of Philip the Bold, Duke of Burgundy.

PROVENIENCE: Eugene Bernat, Milton, Mass.; Frank Gair Macomber, Boston.

BIBLIOGRAPHY: Georg Swarzenski, "A German Primitive," *Bull. Boston*, XLII (1944), pp. 42-50, ill.

PLATE XXXII MUSEUM OF FINE ARTS, BOSTON, no. 44.77

37 VANNI, LIPPO, Sienese (active 1344-1375)

Reliquary Triptych

Tempera and gold-leaf on panel; open: 17¼ x 17½ in. (.439 x .445)

Central part: A recessed panel with the Virgin and Child between St. Aurea and St. John the Baptist. Left wing: at top, the angel of the Annunciation, holding a scroll with a few words recognizable of the Magnificat verse: ". . . et virtus Altissimi (obumbrabit tibi)" sung at the First Vespers of the Feast of the Annunciation; below: a military saint and St. Dominic. Right wing: at top, Virgin annunciate; below, an Apostle and a Cardinal saint.

The relics were encased behind round apertures in the gable and the base of the central section, as was the custom for the medieval reliquary triptychs executed by goldsmiths.

The radiance of the color and the gleam of the golden background give the impression of a work executed in a more precious medium than tempera painting—an impression reinforced when one observes the way in which the pigments are radiantly blended with gold: for instance the golden matting of the tunic of the Child (similar to the tunic of Christ in the Madonnas by Lippo Vanni in the Pinacoteca, Perugia, and in the Städelsches Kunstinstitut, Frankfurt am Main) is picked up by the luminous drapery of the same material on the throne of the Virgin.

The Walters triptych was attributed to Lippo Vanni by Bernhard Berenson, an opinion in which Richard Offner concurred in a verbal statement. St. Aurea holding a vase and St. Dominic, as well as the precarious stance of the Child on the lap of the Virgin, are found on the triptych signed by Lippo Vanni in 1358, in the Monastery of St. Dominic and St. Sixtus in Rome. Compare also a reliquary triptych by Lippo Vanni dating ca. 1372 in the Vatican Gallery, Rome.

It is possible that the Walters triptych was executed as a devotional object for some member of the Sienese colony in Rome who was a parishioner of a church dedicated to St. Aurea, a Christian Virgin martyred at Ostia in the third century. The faint traces of the painted inscription under the military saint do not seem to identify him either with a Sienese military saint.

In the Walters triptych the early manner of Lippo Vanni as a miniaturist working after the formulas of Pietro Lorenzetti and of the Lorenzetti school is still noticeable, for instance in the

Madonna of the Annunciation. But the triptych is a masterpiece of the artist, wherein the preciousness of Simone Martini and of Lippo Memmi, which took the upper hand as Lippo Vanni grew older, is most obvious and most beautifully recaptured.

CONDITION: The gold-leaf and paint are in fair condition, except for losses in the foreground and the Virgin's robe. The original frame is preserved. The receptacles for relics have been fitted with new glass.

PROVENIENCE: Don Marcello Massarenti, Rome. Acquired by Henry Walters in 1902.

BIBLIOGRAPHY: *Massarenti Cat. Suppl,* n. 49 (as School of Fra Angelico)—B. Berenson, *Essays in the Study of Sienese Painting,* New York, 1918, pp. 38-41 (fig. 16)—cf. *idem,* "Due nuovi dipinti di Lippo Vanni" (the Perugia and the Vatican ones) in: *Rassegna d'Arte,* 1917, pp. 100 ff.—Van Marle, II, 462-463 (as Lippo Vanni)—Berenson *List,* 1932, p. 588—*idem, List,* 1936, p. 506 (both as Lippo Vanni)—G. Kaftal, *Iconography of the Saints in Tuscan painting,* Florence, 1952, p. 124, n. 37 c.

PLATE VI WALTERS ART GALLERY, inv. no. 37.750

ILLUMINATED MANUSCRIPTS

38 PARIS, ca. 1365-70

Jacobus de Cessolis, *Le Jeu des Echecs Moralisé,* translated by Jean de Vignay

In French. Written in two columns on 56 vellum leaves. 12 x 8¾ in. (.305 x .220 m.). 1 large and 28 smaller grisaille drawings. Binding: French 15th century calf tooled in blind.

This book, originally a sermon composed in Latin by friar Cessolis (ca. 1290) deals not with the technical problems of chess—on which the Middle Ages produced many treatises—but uses the features of the game allegorically. The game symbolizes life and society. Each piece stands for a particular rank or class, or for a trade or profession.

Before each chapter, a tinted grisaille drawing depicts one or more of these social groups. At the head of the work a drawing in a somewhat softer and more subtle style than the rest shows the translator Jean de Vignay in the habit of a hospitaler of the Order of Haut-Pas in the midst of twelve figures personifying the ranks of society, i.e. the playing pieces of the game. The modish figures, slim and with torsos of exaggerated length, are characteristic of the figure-style of the painters of the period of Charles V, and the style of the foppish costumes of the upper ranks suggests a date toward 1370.

The volume exhibited is believed to be one of the earliest copies of Vignay's translation, which probably was made just before mid-century.

EXHIBITIONS: New York, The Pierpont Morgan Library, *"Manuscripts from the William S. Glazier Collection,"* 1959.

BIBLIOGRAPHY: John Plummer, *"Manuscripts from the William S. Glazier Collection,"* New York, published by the Pierpont Morgan Library, 1959, n. 29, pl. 25.

PLATE XLII WILLIAM S. GLAZIER, ms. 52

39 PARIS, ca. 1370-80

Psalter

In Latin, written on 185 vellum leaves, with four original ruled leaves at beginning and end. 6⅝ x 4¾ in. (.167 x .120 m.). 8 historiated initials; 8 illuminated full ivy-borders with drolleries, numerous half borders. Binding: Italian 17th century vellum.

This manuscript is typical of the elegant little devotional books executed in the Paris ateliers at the time of Charles V. In the large initials at the eight divisions, the usual subjects are rather delicately drawn against backgrounds alternately red and blue, ornamented with fine golden rinceaux or with geometrical ornament. There seem to have been two hands, one which executed the initial on folio 41 verso, much sharper and harder in his coloring than the more delicate artist who executed most if not all of the rest. A problem arises in connection with several of the miniatures by this latter painter. Some of them appear to be unfinished, especially in respect to the faces and hands. These have been drawn in, but carried no further. The same is true in regard to the drapery in some of these miniatures—those that might be regarded as the most "important" subjects—the illustration to Psalm I and Christ enthroned beside God the Father at Psalm 109. In both of these only the thinnest ground color and incipient shadows have been entered in the drapery, and the gold of haloes, crowns, etc., is lacking its final detailing. In view of the finish of the accompanying borders and drolleries on these pages, it seems possible that the book was awaiting the attention of still a third artist, probably the master of the atelier, who planned to pull the work together and especially to finish up the two miniatures mentioned, in his more authoritative

41

style. Such accidental survivals of unfinished productions give us a precious insight into the workings of the studios at this period.

Every effort had been expended to make the book one of quality—the vellum is carefully selected, the script is fine and regular, the ivy borders and the smaller illuminated initials are of first-rate execution. Well executed birds, insects and little drolleries occur here and there, reviving a mode initiated earlier in the century by Jean Pucelle. As often occurred in elegant productions of this period, the scribe concentrated so intently on the perfection of his script that he made a fair number of mistakes in copying. These were caught by the corrector, but the scribe was loathe to spoil the beauty of his page by erasures and by insertions which might crowd parts of the script. So sometimes he ignored the notes lightly written by the corrector in the margin. Other times he scored out a superfluous word with a finely ornamented line of red. Later owners noted the errors, however, for there are careful and neat marginal corrections in a fifteenth-century Italian humanist hand and in Italian script of the next century.

PROVENIENCE: Apparently was in Italy as early as the fifteenth century; on folio 2 the erased ex-libris of a Carthusian house written in a seventeenth-century Italian hand. Acquired by Henry Walters in Paris.

EXHIBITIONS: Baltimore, "Illuminated Books," 1949.

BIBLIOGRAPHY: De Ricci, I, p. 773, no. 104 (erroneously relating it to the style of the atelier of Jacquemart de Hesdin)—*Walters Exhibition Cat.*, no. 73.

PLATE XLII WALTERS ART GALLERY, ms. W.119

40 PARIS, ca. 1380

Missal for Paris Use

In Latin; musical notation. Written in 2 columns on 295 vellum leaves 10¼ x 7⅛ in. (.260 x .180 m.). 17 historiated initials; illuminated ivy-borders with drolleries. Binding: modern vellum over boards with brass mounts; edges gilt and painted with floral rinceaux, probably in the fifteenth century.

This Missal continues or revives a style of illumination that had been inaugurated by Jean Pucelle in the 1320's. Each of the main pages is surrounded by a border of ivy sprays in burnished gold and colors, populated by little birds, small animals, insects, people in various activities, hybrid and other fantastic creatures, and so on. These are all diversions unrelated, usually, to the adjacent text, the main illustrations for which are contained within the larger initials. In these, against ornamental backgrounds of tessellation or of red or blue, finely patterned with golden rinceaux, the little figures enact the scenes with graceful mannerism. The colors are delicate and translucent, with light modelling in the draperies. Faces and hands are scarcely tinted and are drawn in reddish outline, not modelled. The whole effect is light and very pretty—but on inspection one sees that the execution of the figures is somewhat hasty and not nearly as perfect as the other characteristics of the book would lead one to expect. It certainly yields in this respect to the Psalter described under Cat. no. 39, despite the fact that that one is unfinished. The best productions of this type around 1380 were miraculously refined and jewel-like in their finish.

Otherwise the manuscript displays all the characteristics of a luxurious production. The silky vellum is flawless and so thin as to be transparent. The writing in brown ink is fine and regular. The subordinate ornamental initials, alternately of azure and of burnished gold, are excellently executed and are filled with the finest pen-work of red or blue. The very elegant pen flourishes which surround these initials and sweep into the margins are of a type that is practically a signature of the Paris ateliers from the 1320's to this period.

PROVENIENCE: On the opening page of the text the arms of the Dorigny family were inserted in the 16th century; Chartreuse de Beaune (17th century bookplate).

EXHIBITIONS: Baltimore, "Illuminated Books," 1949; Toledo Museum of Art, "Medieval and Renaissance Music Manu-

42

scripts," Jan.-Feb., 1953; Los Angeles County Museum, "Medieval and Renaissance Illuminated Manuscripts," Nov. 1953-Jan. 1954.

BIBLIOGRAPHY: De Ricci, I, p. 776, n. 119—*Walters Exhibition Cat.*, n. 72—Toledo Museum of Art, *Medieval and Renaissance Music Manuscripts*, 1953, n. 58 (erroneously referred to as ms. W. 214)—Los Angeles County Museum, *Medieval and Renaissance Illuminated Manuscripts—a Loan Exhibition*, no. 44.

PLATE LIII WALTERS ART GALLERY, ms. W. 124

41 PARIS (atelier of Jean Bondol), ca. 1380

Saint Augustine, *La Cité de Dieu* (XI-XXII), translated by Raoul de Presles

In French. Written in 2 columns; 318 vellum leaves, 18¾ x 13¼ in. (.475 x .335 m.). 12 miniatures; illuminated borders. Binding: modern red velvet, now in 3 vols. (of which only the last is exhibited).

The translation of St. Augustine's *De Civitate Dei,* one of the most influential books of the Middle Ages, was commissioned by King Charles V as part of an extensive program of converting the important literature, sacred and profane, of all epochs into the vernacular, so as to be available to a wider circle of readers—". . . for the profit and use of your realm, of your people and of all Christianity," as the translator states in his preface. Raoul de Presles was one of several distinguished scholars of the day whom the King pressed into this service. He had translated several other works for the King before Charles ordered him to turn into French the *magnum opus* of St. Augustine, and to elucidate it with a commentary, especially explaining Augustine's references to ancient history and classical authors. On October 28, 1371, the King assigned to Raoul an annual stipend of 400 *livres* to finance this work. Three days later, on All Saints Day, as the translator's colophon tells us, the scholar commenced his task, which occupied him for four years thereafter, being finished on September 1, 1375. In the course of the work the royal annuity was raised to 600 *livres,* for Raoul had to buy an extra house across the street and connect it by a bridge to his dwelling, to provide room for the thirty or so different manuscripts of the *De Civitate Dei* on which he drew, and the approximately three hundred volumes of other authors he borrowed in connection with his commentary.

A fine presentation copy of the finished translation was prepared for the King as soon as possible. This is now in the Bibliothèque Nationale in Paris (ms. fr. 22912-22913). It is illuminated with the royal arms and illustrated with twenty-four miniatures in tinted grisaille, of varying quality—as so often in the manuscripts prepared for Charles V. The finest, however, are in a most accomplished style, and are generally attributed to Jean Bondol, an artist of Bruges who was the King's painter at least as early as 1371. The great importance of this painter is attested in the records, but only one signed work from his hand has survived—a very remarkable presentation portrait at the front of a large *Bible Historiale* (now in the Museum Meermanno-Westreenianum at The Hague), which a court official, Jean de Vaudetar, offered to Charles V in 1371. The portrait is hard to compare with anything else, but it is on the basis of the other miniatures in the Bible that must be judged the style of this artist and of the large atelier which he obviously headed. A further document of his style, though only in reflection, consists of the famous Apocalypse tapestries in Angers commissioned by the King's brother, Louis I of Anjou, for which Bondol designed the cartoons. These, woven in the Paris atelier of Nicolas Bataille, present us with the interpretation of the various weavers, whose sensitiveness to the designs varied greatly. The series retains numerous archaic features reflecting the miniatures of the thirteenth-century Apocalypse manuscript which had been furnished to Jean Bondol as a model.

Shortly after the presentation volumes of the *Cité de Dieu* were completed for the King (around 1376), another splendid copy was prepared in the same atelier for his second brother, Jean, duc de Berry (1340-1416), who was to become the foremost princely bibliophile of the epoch. This is the manuscript the last section of which is exhibited here.

The miniatures, of column width, at the head of each Book are in *grisaille*—that is, drawn and modelled in warm grey—but various details are tinted in color: the flesh, hair, landscape elements, clouds, while crowns and haloes are gilt. Any indication of landscape or other setting is in the foreground only, while the backgrounds retain the purely ornamental character that had been in favor throughout the fourteenth century—rose or blue, overlaid with delicate golden vine-spirals or with geometrical designs and diapering. Much in evidence are the mushroom-shaped trees which the great scholar Henry Martin thought to be the "signature" of a studio which he dubbed that of the "Maître aux boqueteaux." As in other works from this atelier which produced so many splendid books for Charles V, the illustrations reveal different hands and they vary considerably in quality. Some are harder and more linear than others. Some show the energy and dramatic forthrightness of Bondol—as reflected, say, in the tapestries—without grasping fully his concern for plasticity. The most compelling miniatures of this book are the beautiful Creation at the beginning of Book XI, the Fall of the Angels at Book XII, the Human Justice at Book XIX (which Dr. Panofsky suggests is by an artist influenced by André Beauneveu more than by Bondol), and the final miniature of the Coronation of the Virgin. This—perhaps the most beautiful in the manuscript—is, it seems to me, very close indeed to works generally accorded to Bondol himself. The scene takes place not against a tessellated or foliate background, but against a field crowded with little red angels—a device invented by Jean Pucelle in the 1320's, and which, like other influences from Pucelle, occurs in other works of Bondol. Music-making angels and saints emerge from fluffy clouds tinged a luscious blue, and trimmed with fluted edges—an archaic device which makes one think of the Angers tapestries. Christ and the Virgin sit side by side on a bench, while an angel swoops down to place the crown. The full richness and modelling of the draperies, heavy and plastic, graceful but not mannered, separate this miniature from the rest in the book, and relate it to the predilections of Bondol. Associated with him, too, are the intensity, almost anxiety, of expression on the face of Christ and of some of the angels, the characteristic long-nosed profile of the corner one, the gestures of the hands. Very close in composition to this miniature, although perhaps not as strong, is one of the same subject, but surrounded by symbols of the Evangelists, in a *Legende Dorée* (Paris, Bibl, Mazarine, ms. 1729), which is believed to have been made for Charles V.

Other indications, if such were needed, of the close relationship of this manuscript to the original one prepared for Charles V is the character of its fine script—a *lettre de forme* rather smaller than customary for so large a book, but very similar to that used for the royal example—and the special manner in which the scribe inserted corrections, writing them, full-size, in the adjacent margin, framing them ornamentally with red and blue points, and using a little rose-colored flower as a signal to connect each with its location in the text. Exactly this same system occurs in the copy for Charles V.

Another St. Augustine was illustrated in the same atelier at about the same time (London, Brit. Mus., Add. Ms. 15,244-5). This one, however, is not the translation of Raoul de Presles, but the *De Civitate Dei* in Latin, the first volume of which is incompletely illustrated in an earlier style, while only the second relates to the Bondol atelier. Many of the miniatures are especially close to those in the copy made for the duc de Berry, and share with this various details that differ from the royal manuscript. The Comte de Laborde, who has given us the most profound study of the *City of God* manuscripts, has theorized that this third specimen may have been started for Charles V, but was abandoned at the prospect of the new version in French with explanatory commentary. It must have then been procured by a member of the court (it carries the arms of Hugues Aubriot, a provost of Paris active in the service of Charles), who then had it illuminated by the artists who were at work on the example for the duc de Berry.

CONDITION: The duc de Berry's copy of the *Cité de Dieu* was, like the King's, prepared in two volumes. These became separated at an early date, and only the contents of the original volume II is in Mr. and Mrs. Hofer's collection. Volume I, in imperfect state, has been recognized as ms. fr. 162 in the Municipal Library of Angers.

PROVENIENCE: Jean, duc de Berry (his arms on fols. 1 and 2)—not recognizable in his inventories; Sotheby sale, London, Aug. 6, 1889, n. 2762; Sotheby sale, London, Feb. 26, 1900, n. 224; Henry Yates Thompson; his sale, London, March 23, 1920, II, n. 54, pl. 35; A. Chester Beatty; his sale, London, June 7, 1932, I, n. 19, pl. 25; acquired by present owner in 1933.

EXHIBITIONS: Baltimore, "Illuminated Books," 1949; Cambridge, Mass., Houghton Library and Fogg Art Museum, "Illuminated and Calligraphic Manuscripts," Feb. 14-Apr. 1, 1955.

BIBLIOGRAPHY: L. Delisle, *Recherches sur la librairie de Charles V,* Paris, 1907, II, p. 317—A. de Laborde, *Les manuscrits à peintures de la Cité de Dieu,* Paris, 1909, I, pp. 241-244, n. 7; III, pls. VI-IX—Henry Yates Thompson, *A Descriptive Catalogue of the Second Series of Fifty Manuscripts,* Cambridge, 1902, pp. 206-209, n. 80 (descr. by S. C. Cockerell)—idem, *Illustrations from One Hundred Manuscripts,* V, London, 1915, pls. VI-VII—H. Martin, *La miniature française du XIIIe au XVe siècle,* Paris and Brussels, 1923, p. 49—E. G. Millar, *The Library of A. Chester Beatty, a Descriptive Catalogue of the Western Manuscripts,* Oxford, 1930, II, pp. 144-147, n. 73, pls. CLIX-CLXI —De Ricci, II, pp. 1695-6, n. 17—*Walters Exhibition Cat.* 1949, n. 70, pl. XXXIII—Panofsky, *Neth. Painting,* note p. 47:4—Harvard College Library, *Illuminated and Calligraphic Manuscripts, an Exhibition held at the Fogg Art Museum and Houghton Library* . . . Cambridge, Mass., 1955, n. 46, pls. 11, 12.

PLATE XLVIII PHILIP and FRANCES HOFER

42 PARIS (atelier of the painters of Jean de Berry), ca. 1385

Book of Hours for Paris use

In Latin and French. Written on 186 vellum leaves, 5⅜ x 4 in. (.136 x .105 m.). 11 miniatures; illuminated ivy-borders on each page. Binding: Belgian 17th century red morocco, gold tooled.

Despite the sadly worn and damaged condition of this little book, one can see that it was originally a fine manuscript with miniatures of some distinction. They are by the hand of one of the three chief illuminators of the *Petites Heures* of the Duke of Berry (Paris, Bibl. Nat., lat. 18014), the earliest and most delicate and imaginative of a series of four sumptuous manuscripts produced for the duc de Berry in an atelier that is generally thought to have been headed by Jacquemart de Hesdin. Several of the miniatures in the present book, in fact, use the same designs as corresponding illustrations in the *Petites Heures*. Millard Meiss, in his review of the great Paris manuscript exhibition of 1955, alluded to our manuscript among a group of those that he considers show the work of an artist whom he calls Hand B of the *Petites Heures*. He believes that B perhaps first worked for Charles V, for he sees early work by his hand in a *Bible Historiale* probably made for that King, which by 1383 was in the possession of Jean de Berry (Bibl.Nat., fr. 20090) ; Dr. Meiss also considers that B was one of the artists illustrating the Psalter of the duc de Berry (Bibl.Nat., fr. 13091), the most important miniatures of which were the work of the sculptor-painter André Beauneveu. He also was among the illuminators of the *Grandes Heures* (Bibl.Nat. lat. 919) produced for the Duke under the direction of Jacquemart de Hesdin (as we know from the inventories) shortly before that painter's death in 1409.

The artist of our little manuscript, who collaborated on so many magnificent projects, was formed in the Parisian workshops influenced by Bondol and the late Pucelle tradition, and during the long period of his activity for the duc de Berry and others he remained conservative in regard to the new effects of space and light introduced by the innovators of the first decade of the fifteenth century. His work, however, has charm and dignity, as well as narrative effectiveness.

CONDITION: Badly worn throughout; the edges severely cropped, cutting into the borders. Pages missing, including at least one miniature and probably more. A few of the miniatures have been retouched, but not to any great extent.

PROVENIENCE: The miniature introducing the Seven Joys of the Virgin shows a lady kneeling before the Virgin and Child. This figure of the owner was overpainted around 1500 to represent a woman in a black dress (a nun or a widow?). An inscription on a paper flyleaf at the end, recording the purchase of the book in 1754, has been scratched out and is for the most part illegible.

EXHIBITION: Baltimore, "Illuminated Books," 1949.

BIBLIOGRAPHY: De Ricci, I, p. 784, n. 174—Walters Exhibition Cat., n. 74—M. Meiss, "The Exhibition of French Manuscripts of the XIII-XVI Centuries at the Bibliothèque Nationale," *Art Bulletin*, XXXVIII (1956), pp. 191-192.

PLATE L WALTERS ART GALLERY, ms.W.94

43 PARIS (atelier of the painters of Jean de Berry), ca. 1390

Book of Hours for Paris use

In Latin. Written on 348 vellum leaves, 6⅛ x 4¼ in. (.154 x .108 m.). 14 miniatures; illuminated ivy-borders throughout. Binding: French gold-tooled calf, ca. 1600.

The silky, transparent vellum of this book, as well as the beauty of its miniatures, illuminated borders and script, proclaim it to be a special production. The two artists responsible for the illustrations belonged to the atelier that was engaged on many projects for the duc de Berry. Certainly the hand of the first one—he who painted the lovely Annunciation miniature—is to be found among the illustrations of the *Petites Heures* of the Duke (Paris, Bibl. Nat., ms. lat. 18014). Our miniature, in fact, is a replica of the Annunciation on folio 141 verso of the Paris manuscript, although the two pictures are not by the same hand. As Dr. Panofsky has pointed out, the Annunciation in the *Petites Heures* is a descendant of the type established in the tiny Hours of Jean d'Evreux (in The Cloisters, New York) around 1325. However, the increased interest in cubic space and the grasp of its rendering achieved in painting by the last decade or so of the fourteenth century, have caused the artist to set the scene in a little box-shaped loggia, seen a little from the side so that the exterior of one wall is visible. This device strongly reinforces the impression of volume in the painting. The only significant difference between our miniature and that in the *Petites Heures* is that here the Virgin presses her hand against her chest, instead of raising it in a gesture of surprise as in the Paris manuscript.

The second artist, who executed most of the miniatures in this book, was more conservative than his colleague and preferred tessellated or foliated backgrounds to effects of perspective, as well as having a slightly more linear style, although a fine one.

As in the *Petites Heures,* many of the borders of this manuscript are inhabited by delicately painted little birds of recognizable varieties, as well as butterflies here and there. This also was an inheritance from the Pucelle tradition. Something new, however, is the fact that many of the borders are beginning to include fresh little flowers and grasses amidst the conventionalized ivy —a motif brought to Paris from Italy by the northern illuminators who had visited there, and which was to have a delightful development in the hands of the Limbourg brothers and others during the first fifteen years of the fifteenth century.

Textual evidence that seems to confirm a date not much after 1390 is found in the last prayer in the book, written in the same hand as the rest of the text. It is a supplication to the Virgin and to the blessed Pierre de Luxembourg for intercession on behalf of "thy vicar Clement, our Pope" for the concord and peace of the Church and that he may be victorious over his enemies. This interesting reference to the Great Schism which began in 1379 with the election of the antipope Clement VII, with whose faction the French rulers sided, would seem to limit the possible date of the book to the few years between the death of Pierre de Luxembourg in 1387, and the death of Clement VII in 1394. Cardinal Pierre de Luxembourg was not actually canonized until 1527, but his cult developed in France immediately after his death. Not only prayers, but miniatures representing him as a saint are, for instance, included in two other books in this exhibition (Cat. nos. 48 and 71).

CONDITION: Pristine.

PROVENIENCE: Around 1600 belonged to Jacques Aubin (his name, arms and monograms tooled in gold on the binding, and his monograms on the silver clasps); in 1742 belonged to P. Le Suéur, "curé de Menillerreux" (inscription on end pastedown).

EXHIBITIONS: Baltimore, "Illuminated Books," 1949; Los Angeles County Museum, "Medieval and Renaissance Illuminated Manuscripts," Nov. 1953-Jan. 1954: Oberlin, Ohio, Allen Memorial Art Museum, "Netherlandish Book Illumination", Apr. 22-May 12, 1960.

BIBLIOGRAPHY: De Ricci, I, p. 785, n. 177—*Walters Exhibition Cat.*, no. 80, pl. XXXVI (erroneously captioned n. 88) —Panofsky, *Neth. Painting*, note 34:4—Los Angeles County Museum, *Medieval and Renaissance Illuminated Manuscripts—a Loan Exhibition*, n. 48, ill.—David Diringer, *The Illuminated Book*, London, 1958, p. 398, pl. VII-14— Oberlin College, "An Exhibition of Netherlandish Book Illumination," *Allen Memorial Art Museum Bulletin*, XVII, 3 (1960), p. 95, n. 4.

PLATE LI WALTERS ART GALLERY, ms. W.96

44 PARIS, ca. 1400

Missal for the Use of the Cathedral of St. Stephen, Chalons-sur-Marne

In Latin. Written in 2 columns on 312 vellum leaves, 12 x 8½ in. (.300 x .215 m.). 2 full-page and 19 column-width miniatures; illuminated ivy-borders. Binding: spine and corners of French brown morocco, gold tooled ca. 1840, the boards covered with 19th century red velvet embroidered with the arms of Colbert-Falletti.

This very fine Missal must date from just around the turn of the century. It is a particularly interesting and puzzling example of the confluence of styles and personalities which characterized the artistic ateliers at this period. The layout of the book, the vellum, script, fine burnished-gold initials sprouting ivy sprays, the full borders of golden ivy vines, the beautifully executed diapered or scroll-work backgrounds, all are characteristic of first-rate Paris work of the period. The artist of the chief miniatures, however, the confronted Canon pictures of the Crucifixion and the *Majestas Domini*, does not seem to be a Parisian and quite likely he was not even a Frenchman. Dainty and refined as the execution of these paintings surely is, there is an undercurrent of worry and tension which contradicts the extraordinarily delicate drawing and the carefully manipulated and lyrical drapery. Despite the sensitiveness of the outlines, the facial expressions of the sorrowing Virgin and St. John just escape being grimaces. In fact, the few other manuscripts with which one can find some ground for comparison carry this tendency to a more obvious degree. One may compare a Missal in the Mazarine Library in Paris (ms. 411), a fine book, which still does not achieve the excellence of the Morgan manuscript. Here the type of the crucified Christ, of the Virgin, and especially of St. John, are quite similar to the present example, and the drapery also has some similarity. But the figures of the Mazarine manuscript are squatter, and the drapery has a Flemish aspect which is expressive rather than lyrical. Yet the Mazarine Missal was bought in 1403 for the nation of France in the University of Paris. A little later on, the heavy-lidded eyes, the nearly grimmacing lips, the long pointed noses and the heavy drapery which sweeps in long folds onto the ground, was going to be developed into a definite mannerism by a group of artists working in Paris, such as the illuminator of a Missal in the Arsenal Library (ms. 622), which before 1426 had been given to Notre Dame of Paris. The elegance which enchants us in the Morgan Missal has now yielded to an expressionism that seems nearly grotesque, no matter how brilliantly executed. The Arsenal hand is to be found also in a manuscript in the Walters Art Gallery, W. 276.

But such a development has not yet taken place in the two beautiful Canon pages of the manuscript exhibited. The artist handles his colors like jewels and his backgrounds of polished gold, tooled with esquisite *pointillé* spirals or tessellated in two tones of the burnished metal, suggest the work of a goldsmith. Equally fine are the foliate rinceaux painted in gold on the red or blue grounds behind the four Evangelists who occupy the corners of the *Majestas Domini* page.

The artist is perhaps a little old-fashioned for his time. His figures and faces are scarcely modelled, the shadows being almost imperceptible, while the outlines are the important thing. And, in general, he prefers to treat his draperies in the same way. The main figures of his two

Canon pages, however, called for a special effort, and here he surprises us with the deep richness of the azure mantles of the Virgin at the Crucifixion and of the Christ in Majesty. They are modelled heavily, but not in grey or black or with white highlights—but always with the azure itself, more intense in the shadows, and only slightly lighter in the highlights. The mantle of St. John also is a study in the convolutions of drapery, in this case a cool, pale grey-blue is handled similarly. The selection of a green of nearly the same value for the lining revealed by the meandering folds gives almost an iridescent impression. The only sharp note is the minium used for his book, and for the few visible parts of his tunic. The color scheme of St. John makes us think of the more provincial illuminators of Flanders just before and after 1420, especially those who worked in the manner of the Book of Hours executed for John the Fearless (Bibl. Nat., lat. n.a. 3055) and of the manuscript described under Cat. no. 69. But these are simple productions of an uncourtly quality, and it is only the color sense that makes us speculate about an ultimate relationship of our artist to such a region.

The smaller miniatures are executed by several hands, mostly not quite of the very notable standard of the two Canon pages.

CONDITION: Very nearly pristine; a few slight smudges in some borders.

PROVENIENCE: 19th cent., the Marquise Juliette Colbert-Falletti. Acquired by J. P. Morgan in 1907.

EXHIBITIONS: New York Public Library, "The Pierpont Morgan Library Exhibition of Illuminated Manuscripts," Nov. 1933-April 1934; New York, The Pierpont Morgan Library; Cleveland Museum of Art; Chicago Art Institute; San Francisco, California Palace of the Legion of Honor; San Marino, California, The Henry E. Huntington Library and Art Gallery; Kansas City, Nelson Gallery and Atkins Museum; Houston, Museum of Fine Arts; Cambridge, Mass., Fogg Art Museum, "Treasures from the Pierpont Morgan Library," 1957.

BIBLIOGRAPHY: Belle da Costa Greene and Meta P. Harrsen, *The Pierpont Morgan Library, an Exhibition of Illuminated Manuscripts held at the New York Public Library*, New York, 1934—De Ricci, II, p. 1428, no. 331—Pierpont Morgan Library, *Treasures from the Pierpont Morgan Library, Fiftieth Anniversary Exhibition*, New York, 1957, n. 25, pl. 21.

PLATE XLV THE PIERPONT MORGAN LIBRARY, ms. M. 331

45 PARIS, ca. 1380

Petrus Comestor, *La Bible Historiale*, translated by Guyart Des Moulins

2 volumes. In French. Written in 2 columns on 299 and 278 vellum leaves, 17 x 13⅝ in. (.430 x .345 m.). 72 miniatures; illuminated ivy-borders. Binding: modern limp vellum.

This text is a thirteenth-century translation of the Latin *Historia Scholastica*, a sort of biblical "histories," as retold and expounded in the twelfth century by Peter nicknamed "Comestor," a theological teacher in Paris. The present late fourteenth-century copy is handsome in format, but the pictures, mostly of column-width, that precede each book, are relatively rough in style. There are several hands. The action takes place against diapered or other ornamental backgrounds, with no interest in the rendering of perspective or any setting except the most meager elements necessary for the story. The outlines are generally drawn quite dryly in black ink, and the interior details of folds, etc., modelled in color. The first miniature in volume I—a scene of the translator at work in his study—is badly worn, but it seems to be by a better hand than the others.

The main interest of this copy of the *Bible Historiale* is that it belonged at one time to the greatest bibliophile and art-patron of the era, Jean duc de Berry, and its history through the centuries from the time of his ownership is recorded in detailed entries on the flyleaf of volume I. These entries begin with the highly ornamental inscription of the Duke's secretary, Flamel, as in so many of his books: "This is a *Bible Historiale* which belongs to Jehan, son of the King of France, Duke of Berry and of Auvergne, Count of Poitou, of Etampes, of Boulogne and of

Auvergne. Flamel." Immediately below in the same hand, but less elaborately flourished, Flamel records: "Which Bible my said lord the Duke gave in the month of June 1410 to the noble and powerful lord Monsieur Jehan Harpedenne, lord of Belleville, Counsellor of Montagu and Chamberlain of the King our lord and of my lord the Duke of Berry. Flamel." The rest of the book's history is recorded step by step in entries which cover both sides of the flyleaf, up to the time it was given in 1785 by Godefroy duc de Bouillon to his adopted son, Philip d'Auvergne, a captain in the British Navy.

This book does not appear in any of the inventories of the Duke of Berry, which would indicate that he did not yet own it when his first inventory was drawn up in 1402, and, of course, it had already been given away by the time of the inventories of 1413 and 1416.

Jean de Berry doubtless was stimulated in his love of fine books by the example of his brother, King Charles V. While the Duke did not have as large a library as Charles V assembled in one of the towers of the Louvre, in general his books reflected a far more delicate and luxurious taste in their embellishment. Some of the most beautiful books ever created were produced to satisfy his discriminating eye. However, not all the volumes that came into his possession were commissioned by him. Many were gifts from relatives or diplomats or court officials who knew of his consuming passion. Most of these were truly worthy of the recipient, but doubtless a well-meaning donor would sometimes offer a volume that did not reach the standard of the others. Perhaps that is how this present set of the *Bible Historiale* reached his possession. The Duke thought enough of it to write his own signature on the last leaf of volume II: *"Ceste Bible est au duc de Berry: Jehan D"*—as well as to have Flamel engross the formal ex-libris at the front, as mentioned. But the Duke often made presents of books, himself, and no doubt he found it easy to give this one away in 1410 to Jean Harpedenne of Belleville. The latter was later on to marry the Duke's niece, Marguerite de Valois, an illegitimate daughter of King Charles VI.

CONDITION: Volume I: five leaves lacking in the first gathering, including the opening illustration of the text, probably a half-page miniature as at the beginning of volume II. The miniature to the prologue, on folio 1, much rubbed. Volume II: a gap in the text between the present 28th and 29th quaternions.

PROVENIENCE: Jean duc de Berry (his ex-libris and signature); given by him in 1410 to Jean Harpedenne, lord of Belleville; inherited by M. d'Auzances, who gave it on July 2, 1566 to François de Scipeaux de Vieilleville, Count of Durestal and Marshal of France; inherited by his son-in-law, Jean d'Espinoy, who gave it on Christmas, 1571, to M. de Villeroy, Counsellor and Secretary of State to King Charles IX; who gave it to Nicolas de Verdun, first President of the *Parlement* of Paris; who on September 2, 1625, gave it to his cousin Jean Habert, lord of Montmor; who gave it to Henri Louis Habert, Master of Requests at the Hôtel du Roi; Godfroy duc de Bouillon; given by him, Jan. 8, 1785, to his adopted son, Captain Philip d'Auvergne; Gore-Ousely collection; Morier and Budd sale (London, July 8, 1853); Earl of Ashburnham (Appendix, n. 7); Henry Yates Thompson, n. LXXVI; his sale (London, 1920, n. 53).

BIBLIOGRAPHY: Barrois, *Bibliothèque protypographique* . . . Paris, 1830, p. 100, n. 593—L. Delisle, *Cabinet des manuscrits*, Paris, 1858-61, III, p. 172, n. 10—S. Berger, *La Bible francaise au moyen âge*, Paris, 1884, pp. 416-17—L. Delisle, *Recherches sur la librairie de Charles V*, Paris, 1907, II, p. 225* n. 10 and pp. 272*-273*—H. Yates Thompson, *A Descriptive Catalogue of Twenty Illuminated Manuscripts* . . ., Cambridge, 1907, pp. 16-22, n. LXXVI—idem, *Illustrations from One Hundred Manuscripts in the Library of Henry Yates Thompson*, V, London, 1915, pls. II-V—De Ricci, I, p. 845, n. 501—*National Geographic Magazine* (December, 1960), p. 815, color ill.

PLATE LII WALTERS ART GALLERY, mss. W. 125-6

46 PARIS (atelier of the "Luçon Master"?) , ca. 1400-1405

Book of Hours for the use of Paris

In Latin. On 234 vellum leaves 6¾ x 5 in. (.172 x .125 m.), 11 miniatures; illuminated borders. Binding: 19th century stamped calf.

This little book, considerably worn and now incomplete, is executed in an extremely delicate and tender style which betrays the influence of the personality who is believed to be Jacquemart de Hesdin. Handling of the figures in most of the miniatures is refined and stately, but beneath

this aristocratic composure an innate emotional quality betrays itself. This is to be noted, not only in the extreme pathos of the Pietà on folio 34 (an image which has been almost kissed away by a devout owner), but in the surprising violence in which the head of an Evangelist is jerked back to receive his message or as a Magus regards the Child to Whom he offers his gift. The most extreme expression of this underlying impulse occurs in the remarkable Pentecost scene in which everything is surrendered to the emotion of the event, even aristocratic figure-proportions being abandoned in enlarging the intensely expectant heads of the crouching participants. This last miniature seems indeed to be by another hand than most of the others in the manuscript, but not unrelated to them.

The major artist seems to be the same as he who executed the two miniatures in an unfinished Aristotle, *Ethiques et Politiques,* in the Bibliothèque Royale in Brussels (ms. 9089-90), which by 1420 was among the works inventoried in the estate of John the Fearless of Burgundy, and which MM. Gaspar and Lyna dated ca. 1405 on the basis of costume. The same ultra-fashionable *houppelandes* with wide dagged sleeves are worn by the Magi in the present manuscript, and one notes in both the expressive tilting of heads, the faces gently modelled over a greenish tint beneath. Millard Meiss considers that the Brussels manuscript is by the same master as he who produced an extraordinary rich Missal and Pontifical for Etienne Loypeau, Bishop of Luçon (1388-1407), now in Paris (Bibl. Nat. ms. lat. 8886) and which, around 1407, Jean duc de Berry gave to the church of Ste. Chapelle at Bourges. Neither the Brussels manuscript nor this Walters one shows the artist as intense in his mannerisms as he was to become (see Cat. nos. 47, 48), but as we have indicated, this current was running beneath.

CONDITION: Much worn. Some leaves missing in the Hours of the Virgin including at least two miniatures.

PROVENIENCE: Around 1800 at Mars-la-Tour.

BIBLIOGRPHY: *De Ricci,* I, p. 785, n. 179—M. Meiss "The Exhibition of French Manuscripts of the XIII-XVI Centuries at the Bibliothèque Nationale," *Art Bulletin,* XXXVIII, (1956), p. 193, note 23. For the Brussels ms., cf. C. Gaspar and F. Lyna, *Les Principaux Manuscrits à Peintures de la Bibliothèque Royale de Belgique,* I, Paris, 1936, n. 185, pl. CIII.

PLATE L WALTERS ART GALLERY, ms. W.100

47 PARIS (the Luçon Master), ca. 1405

Book of Hours

In Latin. Written on 167 vellum leaves, 7⅛ x 5⅛ in. (.180 x .130 m.). 20 miniatures; richly illuminated ivy borders on all pages. Binding: 19th century stamped violet velvet.

This manuscript appears to have been executed entirely by the hand of a single artist of exquisite refinement and coloring and of jewel-like finish, who yet knew how to imbue his figures with movement and even excitement. He worked at times for the duc de Berry and members of his court, but also for other patrons. His most famous production is the very richly illuminated Missal and Pontifical (Paris, Bibl. Nat., ms. lat. 8886) that he executed at the beginning of the fifteenth century for Etienne Loypeau, Bishop of Luçon (1388-1407). Around 1407 Duke Jean de Berry had this manuscript in his possession and gave it to the Ste. Chapelle in Bourges, as he had already given two other service books illuminated in the same atelier. Since this miniaturist's name is thus far unknown, Millard Meiss has proposed calling him the "Luçon Master."

This artist evidently directed one of the most active ateliers of the time, and his hand is to be found in many fine manuscripts, often in association with other miniaturists of distinction. Dr. Meiss considers that he was essentially formed by the influence of one of the great men of the period—he who was the chief illuminator of the famed *Très Belles Heures de Jean de Berry* now in Brussels (ms. 11060-61), and who also, around 1385, played a leading part in the illustration

of another of the *joyaux* of the duc de Berry, the prayer-book known as the *Petites Heures*—perhaps to be identified with Jacquemart de Hesdin.

There is much plausibility in the theory that the special qualities of the Luçon Master hark back to such a formation. This is less easily seen in the present manuscript, where his predilection for refinement often inclines toward mannerism, but it appears more clearly in the somewhat more composed and monumental style of many of his pictures in the Missal and Pontifical for the Bishop of Luçon. Exactly the same qualities are to be seen in an unpublished Book of Hours now in the Philadelphia Free Library (Widener Ms. 4). There the master still retains a serenity and even something of an interest in plasticity which he was soon to move away from in the direction of mannered expressiveness. There is even a specific link with Jacquemart—if it be he—in that the Baptism of Christ retains some of the special iconographical peculiarities of that in the *Petites Heures*, such as the water being poured from a jug—a feature to appear later not only in the *Grandes Heures*, but in some of the works of the Bedford Master and others (cf. mention of this iconography under Cat. no. 24). However, the Luçon master did not share the interest in landscape and architecture displayed in the *Très Belles Heures* (whose exact date is disputed), but generally preferred tessellated grounds with the minimum of indications of setting. [If, as Millard Meiss suggests, he was one of the artists in the *Térence des Ducs* (Arsenal ms. 664), there at least the format required that his scenes have gradated skies and often considerable architectural setting. Whether these were by his hand or supplied by a collaborator might be studied.]

The manuscript displayed is presumably slightly later than the Luçon Missal-Pontifical, and the Philadelphia *Horae*. The heavy, beautifully studied drapery characteristic of these books has here become lyrically sweeping folds under which no form is felt; the graceful movements have become exaggerated in some of the miniatures, occasionally verging upon intensity. Our artist had in his studio pattern-sketches perhaps made in his years of formation. In the Walters book, the Nativity scene repeats closely the exceptional one in the *Très Belles Heures* in Brussels: the Virgin kneels in adoration of the nude Christ Child, but, contrary to the Bible story, the shed has been made comfortable with a bed, complete with bolster and pillows, and on this the Virgin kneels before her Child. As Professor Panofsky has noted, the introduction of the bed occurred elsewhere in northern painting of this time, possibly invented by the Boucicaut Master, but in his representations the Virgin kneels beside it on the ground.

Among other miniatures of especial interest may be mentioned the page of Evangelist pictures, the lyrical Annunciation, the full-page Death of the Virgin, and an angel supporting the dead Christ. The original owner of the book is unknown, but that her name was Catherine is suggested by the miniature on folio 89, in which a very fashionably dressed lady is presented to the Virgin and Child by St. Catherine and St. John the Baptist.

CONDITION: The order of some of the pages has been altered in the rebinding. Below three miniatures, the original text has been erased and other prayers inscribed (except for folio 1, which was then left blank). This appears to be an eighteenth-century alteration.

PROVENIENCE: ca. 1745, Roussin de Saint-Nicolas.

EXHIBITIONS: Baltimore, "Illuminated Books," 1949; Los Angeles County Museum, "Medieval and Renaissance Illuminated Manuscripts." Nov. 1953-Jan. 1954.

BIBLIOGRAPHY: De Ricci, I, p. 791, n. 214—*Walters Exhibition Cat.*, n. 84, pl. XXXVII—Panofsky, *Neth. Painting*, note p. 48:4—Los Angeles County Museum, *Medieval and Renaissance Illuminated Manuscripts—A Loan Exhibition*, 1953, no. 52—M. Meiss, "The Exhibition of French Manuscripts of the XIII-XVI Centuries at the Bibliothèque Nationale," *Art Bulletin*, XXXVIII (1956), p. 193, n. 23.

PLATE LV WALTERS ART GALLERY, ms. W.231

48 PARIS (Luçon Master and the Bedford Master), ca. 1410

Book of Hours

In Latin. Written on 198 vellum leaves, 6¾ x 5¼ in. (.170 x .135 m.). 16 minatures; illuminated ivy borders on every page. Binding: French gilt calf, ca. 1580.

This book is interesting evidence of the collaboration of artists of diverse styles in the early years of the fifteenth century. The best miniatures of this manuscript are divided fairly evenly between two artists (excepting for a third interesting painter who contributed one miniature). One of these hands is obviously that of the Luçon Master (see Cat. 47). Dr. Otto Pǽcht was the first to recognize that the other is the youthful style of the miniaturist known as the "Bedford Master" after two extraordinary manuscripts he and his assistants illuminated later on, around 1424-1435, for John of Lancaster, Duke of Bedford and Regent of France, and his wife (Paris, Bibl. Nat. lat. 17294 and London, Brit. Mus. Add. Ms. 18850).

The tendency toward aristocratic mannerism and exaggerated gesture noted in Cat. no. 47 has here advanced further in the miniatures by the Luçon Master, so perhaps we may conjecture that this book is slightly later in time. However, as usual, this artist maintains his glittering tessellated backgrounds, allowing only an element of furniture in archaic perspective or a stylized hill to locate his scenes. To this formula, the Bedford Master evidently had to conform (he was doubtless the younger of the two), but the interest in elaborate setting which was to mark his developed works cannot help pushing its way in. St. Pierre de Luxembourg prays in a wilderness of tree-topped hills, albeit under a tessellated "sky" (fol. 93), while the Virgin of Humility sits on a cushion in a charming garden enclosed with a flowering fence (fol. 191). It is possible even that, as Dr. Paecht has suggested, certain miniatures show the combination of the two artists —the Luçon Master executing the drawing and then turning the work of painting over to the Bedford Master: i.e. the Annunciation (fol. 19) and the Visitation (fol. 42 *vo*).

The Annunciation to the Shepherds appears to be by a third artist who shows much influence from the style of the Luçon Master. He, however, has not felt obligated to limit himself to the diapered backgrounds. In this miniature, alone of those in the book, we find a gently modulated sky giving the picture a surprising sense of air. Except for his boldness, he does not seem to be an artist of the calibre of the other two (cf. the theory alluded to in Cat. no. 47 that the Luçon Master participated in the Térence des Ducs, which has no tessellated grounds). Two other miniatures (Nativity and Adoration of the Magi) are by an inferior hand.

EXHIBITIONS: Baltimore, "Illuminated·Books," 1949; Buffalo, Albright Art Gallery, "Art in the Book," Nov. 1953-Jan. 1954.

BIBLIOGRAPHY: De Ricci, I, p. 786, n. 181—*Walters Exhibition Cat.*, n. 85, pl. XXXVII—M. Meiss, *Painting in Florence and Siena after the Black Death*, Princeton, 1951, pp. 140, 142, n. 45, fig. 153—*idem*, "The Exhibition of French Manuscripts of the XIII-XVI Centuries at the Bibliothèque Nationale," *Art Bulletin*, XXXVIII (1956), p. 189, n. 8.

PLATE LV WALTERS ART GALLERY, ms. W. 232

49 PARIS, ca. 1410

Saint Augustine, *La Cité de Dieu* (I-V), translated by Raoul de Presles.

In French. Written in 2 columns; 173 vellum leaves 17⅛ x 12¼ in. (.433 x .310). 5 large and 59 small miniatures; richly illuminated borders. Binding: gold-tooled russia by Scott of Edinburgh (his ticket).

The translation and commentary made by Raoul de Presles in 1371-5 at the order of King Charles V (see Cat. no. 41) remained in favor for two centuries. It was, however, especially during the period from 1376 to 1410, which corresponded to the era of artistic patronage of Charles V and his brothers, that illustrated copies *de grande luxe* were in demand for the libraries of the aristocratic bibliophiles—an enthusiasm that was not to have its counterpart until after 1470, when a

new vogue for luxuriously illustrated volumes of this text sprang up. During the period just before and after 1400, a number of magnificent copies were undertaken on special order by the foremost ateliers.

One of the most richly illustrated of the early fifteenth-century examples is the one here exhibited, which was unknown to the great specialist in the field, the Comte Alexandre de Laborde, whose exhaustive study of the illustrated manuscripts was published in 1909. At that time the manuscript was in the library of the Marquess of Lothian, where it had been since at least the eighteenth century. This copy, of which, unfortunately, we have only the first five books, is remarkable not only for the quality, but for the abundance of its illustrative program. Characteristically, these early *Cité de Dieu* manuscripts were illustrated with one picture at the head of each book, making a total of twenty-four in a complete copy. In this splendid example, we have a large illustration at the beginning, occupying three-quarters of the page, and half-page miniatures at the head of the subsequent four books; but, furthermore, there are fifty-nine smaller miniatures placed at each chapter throughout the first two books. This abundance was not continued after Book II, and perhaps was due to a special interest on the part of the owner in the episodes of ancient history and custom which are dwelt upon in this part of the treatise, and with which most of these illustrations deal. Of especial interest in this connection may be cited the delightful representation of an ancient theatrical performance with masked players, the lyrical rendering of Arion riding a dolphin and playing his harp, and the two-column miniature showing on one half the building of Troy, with the workmen busy about their several tasks, while the other half represents the fiery destruction of the city, with the victorious Greeks sailing away, and many others. Everything is very carefully labelled so as to be understood readily. This in itself suggests that we have here not some elegant copy of a previous work, but for these miniatures, at least, a newly developed illustration in which each element was carefully directed by a *chef d'atelier* who knew the text well. None of the early manuscripts of this text embarks on a comparably extensive program of illustration. The manuscript now at Brussels (Bibl. Roy. ms. 9005-6) is erroneously dated by the Comte de Laborde ca. 1410, when actually it is from the atelier of the Master of the Privileges of Ghent and ca. 1440. This Brussels copy set out to have an extensive program of historiated initials, but finally ended up with a series of thirty-one. Here, also, the artist has used labels on many pictures.

The great frontispiece miniature uses a scheme which was archaic in 1410: it is divided into four scenes in quatrefoils with tricolor frames. The two scenes to the left represent the City of God guarded by angels, while below is the Earthly City threatened by devils. To the right, God the Father, seated in a glory of red cherubim against a blue heaven made up of little angels, presides over the fall of the wicked angels into a fiery Hell where Antichrist is finally chained. All four medallions, despite their archaic organization, take our breath away with the sense of air and implied distance in the rendering. It is as if they were traceried windows piercing the solidity of the glittering mosaic ground into which they are set.

This quality of light and air pervades the miniatures throughout the book. The artists here are certainly not to be described as realists, but they have abandoned completely the use of tessellated backgrounds (except in the dedication scene and four or five interiors), in favor of landscape or architectural renderings. They do not concentrate upon atmospheric perspective or illusionistic handling of distance, as the Boucicaut Master was doing by this time, but their skies are carefully stippled and lightly striated with the brush, increasing in intensity from a pale horizon to a deep blue zenith. There is througout a joyousness and jewel-like harmony of color. Fortunately, these miniatures are magnificently preserved, presenting every brush-stroke with undiminished freshness, so that we are able to enjoy the whole impression of clarity and gay color. This must be at least in part due to the care with which one of the eighteenth-century Marquesses of Lothian protected each painting with a little curtain of fine paper.

Who were the artists responsible? This cannot be answered until the studies now under way by Dr. Meiss and Mrs. Morand will help to disentangle the intricacy of the artistic situation in the great ateliers of Paris at this time. The dominant artist of this marvellous book seems to have had some kind of influence from the Luçon Master in his formation, but he is a very distinct personality of an entirely different vision. Dr. Meiss and Mrs. Morand have found his hand in a group of other manuscripts, among them an Orosius (Paris, Bibl. Nat. fr. 301)—after which they will nickname him the "Orosius Master," in the study of the works of this period which they are preparing.

CONDITION: The minatures and illuminations are pristine; slight water-staining at the foot of the first pages. One of the early owners has scrawled "Ancram" on a number of pages as in many of the Lothian books. Book V incomplete at end.

PROVENIENCE: The shield at the foot of the opening page has never been filled with armorial bearings. Marquess of Lothian, Blicking Hall (sale, New York, Jan. 27, 1932, n. 10); Cortlandt Bishop (sale, New York, April 5, 1938, n. 155); Philip S. Collins, Philadelphia; presented to the Museum in 1945.

EXHIBITIONS: Baltimore, "Illuminated Books," 1949.

BIBLIOGRAPHY: *Statistical Account of Scotland*, 1794 (new edit. 1845, I, p. 68)—Sir Robert Kerr, *Correspondence*, 1875, II, p. 537—Catalogue of the Lothian Sale, 1932, no. 10, with color-plate—DeRicci, II, p. 2323, no. 56—*Walters Exhibition Catalogue*, no. 82, pl. XXXIX.

PLATE **XLIX** THE PHILADELPHIA MUSEUM OF ART

50 PARIS (the Bedford Master), ca. 1410

Book of Hours for Paris use

In Latin. Written on 272 vellum leaves, 5½ x 3½ in. (.140 x .90 m.). 12 miniatures; illuminated ivy borders throughout. Binding: 19th century French calf, gilt in pattern of ca. 1570.

The miniatures in this very delicate little book on the silkiest vellum seem to be the early work of the anonymous gifted and very productive artist whose pseudonym comes from two remarkable lavish manuscripts for which he was responsible in his maturity, as the head of a large studio: a Breviary (Paris, Bibl. Nat. lat. 17294) and a Book of Hours (London, Brit. Mus., Add. ms. 18850), executed between 1424 and around 1435 for John, Duke of Bedford, Regent of France, and his wife. These productions are characterized by brilliant but masterfully handled color, and by complicated scenes often involving a multitude of figures and incidents, as well as a rich apparatus of subsidiary marginal scenes in little squares or medallions. The inventions of all his contemporaries and of the innovators of the first decades of the century were, in a way, "compiled" by the Bedford Master in his mature works, so that one recognizes compositions and landscape devices of the Boucicaut Master, the exotic costumes and spiralling hills of the Limbourgs, as well as the naturalistic flowers which they introduced into their borders, domestic details borrowed from the painters of the lower Rhine, and so on. So inevitably did all these elements characterize the considerable production of the Bedford Master's atelier in the '20's and the '30's, that it is only relatively recently that scholars have searched for the evidence of his formative period.

Researches by Jean Porcher, Otto Paecht, Rosy Schilling, Millard Meiss and others, have now discovered the aspect of his youthful style, during the years between about 1405 and 1420. Furthermore, it has been noted that at this period he worked often in collaboration with other artists, some of whom were to emerge as distinctive individuals. Projects executed jointly with the Boucicaut Master, the Luçon Master, and the Rohan Master—to name the most interesting—explain much of the ultimate character of the Bedford Master's mature work, as well as the influence that he unquestionably had upon them (cf. Cat. no. 48).

The miniatures in this little book, refined, tender and delicate, show the young Bedford Master as a sensitive and able artist, following in his coloring, at this stage, the gentle and often

translucent hues inherited from the late fourteenth-century illuminators, and repeating still their bird-inhabited margins. Already, though, he is introducing a few of the new-fangled Italian conventions, such as a bit of entwined acanthus in some of the borders, and certain architectural elements. As for landscape, a few of the fluffy dwarf trees (that are to be his hallmark for this early period) and a sharp craggy hill of Limbourg type suffice for the present. The backgrounds are still tessellated. He borrows a compositional idea or two from the Boucicaut Master (as in the Visitation here). Nothing of the complication of his mature work is visible in this little *Horae*, but already the general characteristics of his facial types may be discerned, and the drapery, modelled, not in simple planes like that of the Boucicaut Master, but composed in a lot of little folds that are sometimes almost messy. [It was Dr. Otto Paecht who first suggested the present attribution of this manuscript.]

CONDITION: excellent.

EXHIBITION: Baltimore, Illuminated Books, 1949.

BIBLIOGRAPHY: De Ricci, I, p. 789, n. 207—*Walters Exhibition Cat.*, n. 81, pl. XXXV—Rosy Schilling, "The Nativity and Adoration of the Child Christ in French Miniatures of the Early Fifteenth Century," *Connoisseur*, CXXX (1953) [Amer. ed.], p. 168, note.

PLATE LI WALTERS ART GALLERY, ms. W. 209

51 PARIS (the Bedford Master and associate), ca. 1410-1415

Book of Hours for Paris use

In Latin. Written on 247 vellum leaves, 7⅜ x 4⅞. (.187 x .123 m.). 14 miniatures, illuminated ivy-borders throughout. Binding: old violet velvet.

The young Bedford Master is seen here working at a slightly later stage in his development than in the manuscript just described. He retains his tessellated backgrounds for certain scenes, but in others he already is experimenting with atmospheric skies finely stippled to dim the outlines of distant spires. In the scene of the Flight into Egypt, he has appropriated the homely motif of St. Joseph quenching his thirst from his canteen, which Melchior Broederlam of Ypres had introduced into a wing of the altarpiece he painted around 1394 for the Chartreuse at Champmol, and which occurs also in a little Book of Hours now in the library of Rouen (Bibl. de la Ville, ms. 3024) which belongs to a group of manuscripts that Dr. Panofsky proposed to locate in the region of Ypres because of Broederlam influences. In any case, the occurrence shows that this humble conception of the scene was one which "caught on" sufficiently to figure in the pattern-drawings circulating in workshops in Paris as well as in Flanders.

CONDITION: Several leaves transposed in the binding. The state of the illumination is excellent.

PROVENIENCE: In 1679 belonged to Hanns Ullrich Kraft (inscription).

EXHIBITIONS: Baltimore, "Illuminated Books," 1949; Montreal, Museum of Fine Arts, "Six Centuries of Landscape," March 7-Apr. 13, 1952, n. 2, ill.

BIBLIOGRAPHY: De Ricci, I, p. 790, n. 213—*Walters Exhibition Cat.*, n. 88, pl. XXXV (erroneously captioned n. 80) —Panofsky *Neth. Painting*, notes 48:4 112:5—D. Diringer, *"The Illuminated Book,"* London, 1958, p. 399, pl. VII-14.

PLATE LIV WALTERS ART GALLERY, ms. W.265

52 PARIS (Bedford Master), ca. 1415

Gradual with Paris calendar

In Latin with musical notation. Written in 2 columns on 593 vellum leaves, 14½ x 10½ in. (.370 x .265 m.). 17 historiated initials; illuminated borders. Binding: 15th century Paris blind-stamped calf over wood boards; original gilt edges painted with flowering rinceaux.

This sumptuous volume must have been executed for a royal or ducal chapel, but the original

owner has not yet been determined. Its possession by the family of Montmorency-Laval is attested by numerous coats of arms added to the borders of the main pages and by these same arms, crested, mantled and supported by armored archangels, which are inserted at the foot of the last page of the calendar, a page which also has been furnished with a striking embellishment of the emblem of the *Buisson ardent* in repetition. The style of this work would suggest that these insertions date around 1490.

The original illuminations consist entirely of quite small miniatures enclosed within initials. A larger one at the beginning has been cut out, unfortunately. The work is fine and shows the Bedford Master approaching his mature style. However, the colors are still clear and luminous, and the very restriction of the program of illumination to the initials, with no marginal multiplication of scenes, suggests that we should locate this work not too long after the book described under Cat. n. 51. The illuminated borders, finely executed, but, except for the first, not especially elaborate, mix with the usual ivy-leaves, a few conventionalized flowerets and also scrolls of red and blue acanthus, and are thus of a later type than the borders of Cat. nos. 50 and 51.

The Nativity scene combines the shed with a suggestion of the rocky cave of Italian iconography, and the Child, lying on a fine bed, is worshipped by the Virgin who kneels on the ground. This same theme (without the suggestion of a cave) occurs in Cat. no. 51. Cf. also Cat. no 47, for another variation.

CONDITION: The first initial cut out. Condition in general otherwise excellent.

PROVENIENCE: Montmorency-Laval (ca. 1490).

EXHIBITION: Baltimore "Illuminated Books," 1949.

BIBLIOGRAPHY: De Ricci, I, p. 776, n. 121—*Walters Exhibition Cat.*, n. 95, (the date 1429 cited in it is an error), pl. XXXVIII—Panofsky, *Neth. Painting*, note 61:3 (repeating the spurious date 1429).

PLATE XLII WALTERS ART GALLERY, ms. W. 302

53 PARIS (atelier or follower of the Bedford Master), ca. 1430

Book of Hours for Paris Use

In Latin. Written on 177 vellum leaves, 8⅝ x 6¼ in. (.22 x .16 m.). 12 large miniatures with 42 historiated medallions; illuminated borders throughout. Binding: yellow velvet.

This abundantly illustrated manuscript is a characteristic example of the books produced as a result of the great popularity of the Bedford Master's mature works. It may well have been done in the master's atelier, which was obviously a very large and busy one during the third and fourth decades of the fifteenth century, or it may be the reflection of his success as felt by an imitating shop. It certainly is not by his own hand. Appropriated, however, are his gay colors—here harsher and less luminous than in his own work—his face and figure types, the spiral hills and the trees with branches and leaves carefully picked out, as in those miniatures in the Breviary of the Duke of Bedford (Paris, Bibl. Nat. ms. lat. 17294) which were done by assistants in the studio. The borders take over the colorful and rather over-rich decoration of acanthus mingled with a few naturalistic flowers and set with historiated medallions which expand upon the theme of the main picture.

The predilection for appealing details of daily experience is seen in these miniatures, as in others of this group. In the Nativity, for instance, we find all the paraphernalia of the shabby shed, furnished with a bed and a rich cloth of honor, the crumbling masonry, the angels joining the parents kneeling in adoration, and a charming little gayly-painted cradle waiting for the naked Child. This detail reminds one of the miniature cradles to hold a figurine of the Christ Child, called *repos de Jesus*, which were popular objects of devotion in the fifteenth and sixteenth centuries. These little cradles, of which only a few have survived, were often of wood or ivory polychromed, or even of silver set with gems.

CONDITION: Pristine.

PROVENIENCE: Seguin Collection.

EXHIBITION: Dallas Museum of Fine Arts, "Religious Art of the Western World."

BIBLIOGRAPHY: De Ricci, I, p. 790, n. 208—Panofsky, *Neth. Painting*, note 48:4.

PLATE LXII, and cover jacket WALTERS ART GALLERY, ms. W. 288

54 PARIS (Boucicaut Master), ca. 1410

Saint Augustine, *La Cité de Dieu* (XI-XXII), translated by Raoul de Presles.

In French. Written in 2 columns; 272 vellum leaves; 17 x 12½ in. (.433 x .315 m.). 11 miniatures; illuminated borders. Binding: late 17th or early 18th century French sheepskin stained olive.

This sumptuous copy of the *Cité de Dieu* comes from the atelier of an artist whom Dr. Panofsky has termed "the most brilliant genius of pre-Eyckian painting." This personality, first discussed in 1905 by the great French scholar, Paul Durrieu, takes his pseudonymn from the most monumental and remarkable production associated with his style—a large and exceptionally elaborate Book of Hours executed for Jean Le Meingre *dit* Boucicaut, maréchal de France, and for his wife, which is now one of the treasures of the Musée Jacquemart-André in Paris (ms. 2). A special problem is that this key manuscript, despite its definite associations, is difficult to date precisely, since the maréchal led a soldier's life full of adventure and misadventure—having been prisoner of the Turks in 1396, then home in 1398 for only three years before he was made governor of Genoa from 1401 to 1409; then, after a short period presumably at home, he was taken prisoner at Agincourt in 1415 and died in captivity in England in 1421. In an effort to find a time when Boucicaut would have been in a situation to commission so luxurious a book, scholars have dated it all the way from the end of the fourteenth century to 1410-1415. Durrieu had sought to identify the artist with a Bruges painter, Jacques Coene, known to us from the records as greatly esteemed in Paris at the beginning of the fifteenth century. From 1402 to 1404, Jacques was one of the northern artists attracted to Italy by the tremendous projects under way at Milan, so the possibility of his being identical with the Boucicaut Master (who shows many elements of obviously Italian inspiration) again turns around the problem of the exact date of the Hours now in the Jacquemart-André Museum.

In any case, the artist was an innovator in many ways. Taking the narrative skill and the grace of form conventional at the end of the fourteenth century, as well as the luminous coloring, he fused these with novelties of detail and a more realistic vision that turned decorative illustration into true painting. Although he by no means ever achieved anything even approaching scientific perspective, he was a pioneer in space-rendering. In both indoor and outdoor scenes, he studied ways to make the picture plane recede, improving various old devices or inventing new ones, which were to become standard for half a century. Among these may be mentioned the arch or architectural element in the front plane which intercepts the scene, as if one were peering into a room only one part of which was visible, a diagonal interior perspective likewise to suggest vast space that has been intercepted; in landscapes, trees or hillocks in the immediate foreground, and overlapping crags and hillsides to cut the scene into receding stages. However, one of the most important devices for the "painterly" effect of his pictures is his handling of light and of aerial perspective. He was one of the first to notice that objects in a distant landscape are not only smaller, but duller in coloring; and that what takes place indoors is lit more dimly than events in the full sunshine. Especially intriguing are these indoor scenes with muted colors, sometimes given even greater reality by the trick of throwing open a window in the room, through which the luminous blue of the outside sky is seen. This device of the open window, which he invented to emphasize the enclosed nature of a room, was to become in the hands of the Master of Flemalle

and the Van Eycks one of the most fascinating developments of the Flemish school—the scene through a window.

It was largely his aerial perspective which made his landscapes seem so much more modern than those of the late fourteenth-century Burgundian school or of his contemporaries, the painter (Jacquemart de Hesdin?) of the *Très Belles Heures* in Brussels or the Limbourg brothers. Like them, he invested his landscapes with the circumstantial reality of distant towns and windmills, peasants and fishermen, woods and lakes. But to this he added a special treatment of distant prospects and especially of the sky, which brought air and light into the picture.

As Durrieu noticed, the Boucicaut Master had a certain technique which was no doubt an aspect of his sensitiveness to effects of light—he liked to work up his surfaces with innumerable little brush strokes, which resulted in a shimmering quality.

The Boucicaut Master was the head of a large atelier. This is obvious not only from the great number of works in his manner which were produced, but from the very considerable range in quality of these. The Boucicaut Master himself seems to have varied in quality of execution also, sometimes even in the great Book of Hours after which he takes his name. Another indication of an active and highly organized atelier is the use of compositional patterns over and over again. These served the Boucicaut Master himself and also his assistants, and furthermore copies were circulated in workshops, not only in Paris, but in northern France, Flanders and Holland. The inventions and compositions of the Boucicaut Master "caught on" and became a tremendous factor in the development of painting in western Europe almost at once.

This copy of the *Cité de Dieu* was first described in 1909 by the Comte de Laborde, who responded warmly to the beauty and quality of the illustrations. He immediately recognized that they belonged to the work of the Boucicaut Master. The miniatures provide us with excellent samples of this artist's various preoccupations, although the small area of the column-width pictures means that the subjects are not always developed with as full a display of incident as in some of his other productions. For landscape, we can study the illustration of "Homicide" at the beginning of Book XV, or the exceptional rendering of Abraham (not Noah as described by de Laborde) at Book XVI; for his interiors, David composing his Psalms at Book XVII, and especially Varro lecturing, at Book XIX. In the latter we see the muted coloring, stressing greenish flesh-tints and garments of violet and rose, rather than of azure and red, while door and window open to the surprising brightness of the sunlight outside. One of the most extraordinary miniatures in the book is the complex rendering of Hell at Book XXI, as fantastic as Bosch and just as beauti-full in its irridescent color. The three scenes of Adam and Eve are executed in a shadowy palette, quite different from the rich brilliance of coloring in the two landscapes mentioned, and they are the only scenes in which a diapered background replaces a sky. A study of the miniatures in this manuscript suggests that the Boucicaut Master had a special iconography of color for his skies. Aside from the skylessness in the unreal land of the Garden of Eden, just mentioned, the two miniatures which refer to episodes not on Earth — those of Hell and of the Coronation of the Virgin — take place against as deep and rich an azure field as possible, with no shading to a lighter blue toward the bottom. This is in contrast to the skies over his landscapes, in which he is always careful to observe the paleness of the horizon, graduating to a deeper blue at the zenith. That there is a definite ideology behind these two types of rendering may be confirmed by two supernatural events in which the action takes place between Heaven and Earth — that is, the Fall of the Angels and the Last Judgment. In both cases, the sky becomes pale as it nears the terrestrial part of the scene.

Comparisons may be made, as usual, between several of these miniatures and closely similar designs in others of the Boucicaut Master's works. Especially is this so of the Last Judgment and the Nativity (the latter uses the cartoon of the Hours of maréchal de Boucicaut).

CONDITION: First and third leaves of the first gathering lacking, including the first (probably larger) miniature. Condition of other miniatures pristine.

PROVENIENCE: de Laborde suggested that the original owner was a member of the Baudricourt family, on the basis of shields held by angels in the Fall of the Angels—but this red cross on a white ground is often an attribute of St. Michael and is not significant; Abbé de'Orléans de Rothelin; his sale (Paris, 1746, no. 456—when volumes I and II were still together); bought ca. 1830 by Sir Thomas Phillipps (vol. II only), in Paris, probably from De Bure; his collection n. 4417 at Middlehill and later at Cheltenham. Acquired by the Walters Art Gallery in 1960.

BIBLIOGRAPHY: Comte A. de Laborde, *Les manuscrits à peintures de la Cité de Dieu de Saint Augustine*, Paris, 1909, vol. II, pp. 323-327, n. 31; vol III, pl. XXVIII—P. Durrieu, "Les Heures de maréchal de Boucicaut du Musée Jacquemart-André," *Revue de l'art Chrétien*, LXIV (1914), p. 29—Quaritch, *Catalogue 767*, London 1957, n. 1, illus.

PLATE XLVIII WALTERS ART GALLERY, ms. W.770

55 PARIS (Atelier of the Boucicaut Master), ca. 1415

Book of Hours for Paris Use

In Latin with the calendar and some rubrics in French. Written on 298 vellum leaves, 7⅝ x 5⅝ in. (.200 x .140 m.). 13 large and 28 small miniatures; illuminated borders throughout. Binding: modern recovering in old red velvet.

This manuscript was executed in the shop headed by the anonymous master discussed under **Cat. no. 54.** It is an interesting example of the way in which the atelier system operated, organizing as it did efforts of various artists of diverse temperaments and capacity to produce works according to a formula which had met with general favor.

The main miniatures of the book use not only the figure-style and other conventions developed by the Boucicaut Master, but every single one uses patterns that are his. The same designs for the most part occur in another Hours from this atelier, Paris, Bibliothèque Nationale, ms. lat. 10538, as Dr. Panofsky has noticed, although there are variations in some details and several of the scenes are reversed in direction. This last point is of special interest because it proves that the outlines of such "shop" miniatures were sometimes produced by the time-saving method of tracing from a pattern sheet which was transparent, and thus could be turned to either side. An especially appealing scene that appears in both manuscripts, but in reverse, is that of the Bath of the Christ Child, several aspects of which Dr. Panofsky has discussed. As he noted, St. Joseph is present in the Paris version, but is absent in the Walters scene. This same peculiarity characterized another Book of Hours from the Boucicaut atelier which was in the collection of Paul Durrieu, and which is very close to the Walters manuscript in various other scenes, also, notably the Annunciation and the Pentecost.

In comparing this manuscript with such a product of the atelier as Paris, ms. lat. 10538, one notes at once that the latter shows much more interest in modelling and ingenious suggestions of receding space—a special concern of the Boucicaut Master himself. The present manuscript, confining itself closely to the patterns of the atelier as it does, still reveals in its execution an artist of a different temperament. It is of exceptionally delicate execution, of fine outlines and almost imperceptible modelling, as if the forms were breathed upon the vellum. We do not find the network of tiny brush strokes wherewith the Boucicaut Master himself developed his effects of plasticity. The beautiful Death of the Virgin has a tenderness of surface and restrained modelling that makes one think of the most delicate early Mughal miniatures.

Most of the main miniatures are surrounded by elaborate borders featuring scrolls of Italian acanthus, which the Boucicaut Master seems to have been the first to introduce into the repertoire of Paris marginal decoration, and which was to experience a vogue not only in French, but in German and Flemish book illumination. Other features of Italian origin inhabit these borders, especially realistic birds very like those in the Lombard sketch-books (cf. Cat. no. 14).

The pages without important miniatures are all furnished with decorative borders too, but these are in a very different style—drolleries and music-making angels done in sketchy outline with flat washes of color and no modelling at all. Numerous small miniatures in the front and back portions of the volume are executed in the same style as the drolleries, and this sketchy hand invades even the borders of a few of the main miniatures.

BIBLIOGRAPHY: De Ricci, I, p. 786, n. 185—*Walters Exhibition Cat.*, n. 86—E. Panofsky, "A Parisian Goldsmith's Model of the Early Fifteenth Century," *Beiträge für Georg Swarzenski*, Berlin, 1951, p. 83, fig. 16—*idem, Neth. Painting*, notes pp. 59:2, 125:2, p. 173:1, fig. 73—Los Angeles County Museum, *Medieval and Renaissance Manuscripts—A Loan Exhibition*, 1953, n. 53 ill.—Detroit Institute of Arts, *Flanders in the Fifteenth Century: Art and Civilization*, 1960, n. 196.

PLATE LIX WALTERS ART GALLERY, ms. W. 260

56 PARIS (atelier of the Limbourg Brothers), ca. 1405-1410

Saint Christopher carrying the Christ Child: a leaf from a Book of Hours

Latin prayers on the verso (19 lines). 1 full-page miniature; illuminated ivy-borders on both sides. 1 leaf, 8 x 5⅞ in. (.205 x .150 m.).

St. Christopher is fording a bay, rather than a stream, of turbulent water, seen between craggy pinnacles. He leans on a rustic staff and with his left hand holds the foot of the Christ Child, Who rides astride his shoulders. The Child makes the gesture of blessing. A diminutive hermit waits on the shore under a little shed, lifting his lantern as a guide. In the background are spiralling hills topped by castles, and, away off in the blue distance, the towers and spires of a city. The golden radiance at the top streams down against a very deep azure sky—almost as deep as those in the *Très Belles Heures* in Brussels (by Jacquemart de Hesdin?), except that, in contrast to that work, there is a slight lightening of the blue as it approaches the horizon.

Very similar to this St. Christopher in pose and style is the smaller miniature of this subject on folio 165 of the *Belles Heures* painted around 1410 by the Limbourg brothers for the duc de Berry, and now in The Cloisters New York. It was probably the first work that they undertook for him. In that manuscript the general rendering of St. Christopher is the same as to the facial type and the twisted headband, the general arrangement of the drapery, and especially the sharp, almost ungainly, angle of the right knee. There, however, his staff slants across the front of his body and he grasps it with both hands, while the Child rides "piggy-back," holding tight with both hands, so that He does not bless. The curious effect of "boiling" white water which occurs in this and other miniatures of the *Belles Heures,* is also present in the painting exhibited, although the slightly damaged surface has suppressed the sharpness of the pattern. It being more restricted in size, the Cloisters miniature omits the hermit and the fairyland landscape of distant towers and castled hills, and substitutes a patterned background for the sky. In both examples the type of the ivy-borders is very similar, although the vines on this leaf are sparser.

CONDITION: The leaf has suffered from dampness, which perhaps has reduced the details of modelling in some areas.

BIBLIOGRAPHY: *Walters Exhibition Cat.*, n. 78—Los Angeles County Museum, *Medieval and Renaissance Illuminated Manuscripts—a Loan Exhibition*, 1953, n. 51—M. Meiss, "The Exhibition of French Manuscripts of the XIII-XVI Centuries at the Bibliothèque Nationale," *Art Bulletin*, XXXVIII (1956), p. 195, n. 34, fig. 10.

PLATE XLI NATIONAL GALLERY OF ART, WASHINGTON, D.C., ROSENWALD COLLECTION

57 PARIS (atelier of the Rohan Master), ca. 1425

Book of Hours for Paris Use

In Latin and French. 197 vellum leaves, 9¼ x 6½ in. (.232 x .165 m.) 20 large and 62 small miniatures; illuminated borders on each page. Binding: English black morocco, ca. 1680-1730 with, at head and tail, the original gilt edges painted with a flowering rinceau and arms, now indistinct.

This Book of Hours is the most important addition to the works of the so-called "Rohan atelier"

to have been brought to light since the publication of Dr. Adelheid Heimann's exhaustive study of the manuscripts of this group in 1932. The leading artist takes his name from an extraordinary Book of Hours (Paris, Bibl. Nat., ms. lat. 9471), which by the mid-fifteenth century belonged to a member of the family of Rohan, who inserted his arms. Monsieur Jean Porcher, however, has brilliantly demonstrated that this key manuscript, and the most important related ones, were commissioned by a member of the house of Anjou—probably Yolande of Aragon, wife of Louis II, King of Sicily and Duke of Anjou.

The Rohan Master was one of those geniuses of individual temper who, although formed by the traditional collaborative practices of the medieval workshop system, managed eventually to burst away from the conventional and to give form to a unique personal vision. Recent researches have determined that the Rohan Master was in the first years of the fifteenth century in association with two other artists later to become the heads of important and influential studios: the so-called "Bedford Master" (see Cat. no. 50-53) and the "Boucicaut Master" (see Cat. no. 54-55). These three artists appear to have participated in the illumination of de luxe copies of secular texts in which the illustrative program was so extensive that the work had to be parcelled out to various painters. It is Monsieur Porcher's theory that the flowering of the peculiar genius of the Rohan Master was only possible when a sympathetic and encouraging patron arrived to release him from such hack work and give him projects to fire his imagination. This patron, he believes, was Yolande of Aragon, who with her husband was resident in Paris around 1414, and who must have felt a kinship of temperament in this special artist. Working on her commissions, first in Paris and later in Anjou, he was able to develop a workshop of assistants formed according to his ideas. These in later years produced less luxurious books for commercial demand, especially in Troyes and other centers in western France.

The developed style of the Rohan Master stands out distinctly amidst the elegant and refined painting of his most accomplished Paris contemporaries. Where they aim for polish and grace, he startles us with the intensity and even brutality of his presentation; where they are gay, he is moody and tortured, with a definite predilection for anguish and for the maccabre; where they seek innovations of realistic setting and perspective, he multiplies elements of architecture or landscape in a fantastic decorative expressionism. In his most memorable paintings he endows the chief figures with a distortion and exaggeration of scale which gathers the spiritual intensity of the scene into a crescendo of emotion. The birth place of this contradictory genius has been a cause for speculation for three-quarters of a century. It is impossible to believe him French. A German origin springs naturally to mind—but most recently M. Porcher has suggested that, like his patroness, he may have been Catalan.

With so passionate an artist, one forgets to dissect his creations to find the sources of his ideas. However, it is clear that he gathered up material from his contemporaries, to be reincarnated by his own prodigious imagination. His trick of amplifying the main scenes of the manuscript by subordinate ones in the margins doubtless derived from the predilections of the Bedford Master. Long ago it was noticed that he owed many of his figures and even fundamental compositions to the Limbourg brothers—and lately Monsieur Porcher has demonstrated in some detail that the major influence from this source is to be traced to the miniatures of the *Belles Heures* of Jean de Berry (now in the Cloisters, New York). Since we have no reason to suppose that he ever was associated with the brothers or worked himself for the duc de Berry, the transmission to him of these Limbourg compositions is explained by the recorded fact that his patroness, Yolande of Anjou, bought the *Belles Heures* from the estate of her uncle-by-marriage, after the duc de Berry's death in 1416. It may have been at her specific direction that the Rohan Master studied this marvellous manuscript before embarking on the luxurious prayer books commissioned by Yolande for three of her children. The fact that the artist—as was the custom in the ateliers—compiled from this study a series of drawings, to be used and reused by himself and his assistants in other work, is proven by the manuscript here exhibited, as well as by lesser ones, produced by the shop.

61

The present manuscript, known as the de Buz Hours because of its sixteenth-century possessor, is organized in a series of main miniatures each amplified by a smaller one at the side and another at the foot of the page, expanding upon episodes of the main picture. As in all the works of the Rohan atelier, the illustrations vary in quality of execution and power of presentation, but the finest show that this book was not just a commercial production, such as the atelier turned to in its later years.

Of especial beauty are the Flight into Egypt, the Trinity page, the crowned Madonna with the Child leaping from her arm, and, most of all, the moving rendering of the Madonna holding the sleeping Child in a premonition of the Pietà. As in the case of the books done for the Anjou family, compositions and individual details from the *Belles Heures* of the Limbourg brothers are to be found. Dr. Panofsky in his study of this manuscript has cited several, notably the Virgin seen from the back in the Flight into Egypt, which the Rohan Master also used in the Hours of René of Anjou. To this may be added the scene of the Annunciation to the Shepherds transcribed literally from the *Belles Heures,* even including many details of landscape, and the extraordinary Trinity on a crescent in the lower miniature on folio 114. This theme, combining in half length a white bearded God the Father, a younger Christ, and a Child for the Holy Ghost, is also found in an initial of the St. Geneviève Hours by this atelier (Paris, Bibl. St. Geneviève, ms. 1278), but had its origin in a closely similar miniature on folio 155 of the *Belles Heures,* where the moon crescent is replaced by a crescent-shaped swag of drapery.

Another influence reflected in the de Buz Hours is that of the Rohan Master's early collaborator, the Boucicaut Master. His compositions lie behind the Annunciation, the Visitation, and the Nativity scenes, but also have contributed a number of small details of architecture and furniture, as well as the pots of flowers perched on window sills—almost a hall-mark of the Boucicaut atelier.

PROVENIENCE: Antoine de Buz, Seigneur de Villemareule and his wife, Barbe de Louen (contemporary family records inscribed on last leaves of the ms.); English 17th century owner; acquired ca. 1900 in England by George C. Thomas, Philadelphia; William King Richardson, Boston, acquired 1947.

EXHIBITIONS: Baltimore: "Illuminated Books," 1949; Cambridge, Mass., Houghton Library and Fogg Art Museum, "Illuminated and Calligraphic Manuscripts," Feb. 14-April 1, 1955.

BIBLIOGRAPHY: Walters exhibition cat. 1949, no. 96, pl. XLIII—Erwin Panofsky, "The de Buz Book of Hours," *Harvard Library Bulletin,* III (1948-49), pp. 163-182, with 15 illus. and also comparative plates—*idem, Neth. Painting,* p. 73; notes 61:1, 133:1, 137:6, 287:3; fig. 96—Harvard College Library, *Illuminated and Calligraphic Manuscripts, an Exhibition held at the Fogg Art Museum and Houghton Library* . . ., Cambridge, Mass., 1955, n. 64, pl. 29. For the latest statement of the *status questionis* of the Rohan Master see: J. Porcher, *The Rohan Book of Hours,* London, 1959 and the catalogue, *Europäische Kunst um 1400,* Vienna, 1962, n. 118.

PLATE LXI HARVARD COLLEGE LIBRARY, ms. Richardson 42

58 PARIS, ca. 1415-20

Book of Hours with Paris Calendar

In Latin. Written on 265 vellum leaves, 5¼ x 4 in. (.135 x .99 m.). 26 miniatures; illuminated borders and half-borders throughout. Binding: French calf over wood boards stamped with a pictorial plaque, edges gilt and painted with floral designs and heraldic arms (Paris, ca. 1480).

This very unusual little book is illuminated by two artists completely different in style and place of origin. The artist who apparently planned the illumination and executed all but five of the miniatures seems to be Italian, as Millard Meiss has remarked. His style, crisp and delicate, without lyrical mannerisms, would connect him with Lombardy and perhaps even more specifically with Milan. Most remarkable is his selection of scenes, which in the Lessons of the Evangelists and the Hours of the Virgin, especially, is completely exceptional. The Lessons are illustrated not by the usual representations of the Evangelists themselves, but by some incident drawn from

their Gospels. The miniatures of the Hours of the Virgin select their themes from the contents of the Psalms for the respective office, sometimes representing Old Testament subjects such as the victory of David over Goliath at Laudes or the Crossing of the Red Sea at Vespers, at other times allegorically rendering some verse in the contingent Psalms, such as Mercy and Truth meeting each other, and Peace and Justice kissing (Psalm 84:11), at Prime. To clarify the significance of such scenes a little historiated initial, introducing the text below, often encloses a prophet with a banderoll inscribed with the pertinent words. The Hours of the Cross, and of the Holy Ghost are not so exceptional in the selection, at least, of the themes for the illustrations.

The artist, despite the calmness of his manner, has an extraordinary ability for narrative and the organization of often complex subject matter. The miniatures are tiny (2¼ by 1⅝ inches), and yet many of them depict throngs of figures. That this is successful is due to his use of a proportionately minute scale, and to his light colors with restrained modelling, depending largely on clear, incisive outline. Above all, his success is due to his astonishing mastery of perspective and foreshortening, both of space and in figure-rendering. He has notable skill in the use of the nude.

A few other French manuscripts having at least some miniatures in this style are known, and have been discussed by Otto Paecht and Millard Meiss: an *Horae* for the use of Besançon formerly in the Sir Thomas Phillipps collection, another, for the use of Chalons-sur-Marne, lately in the Dyson Perrins collection, and a third with a Paris calendar in the Chester Beatty collection, Dublin. Another manuscript in the Walters Art Gallery (W. 290), connected with Sens, is related to this style.

The last five miniatures of our manuscript show an entirely different personality—a northern hand who exploits the charm of lyrical gothic drapery over unsubstantial anatomy, and, instead of linear perspective and foreshortening, the use of stippling to obtain something in the way of atmospheric perspective. Nothing could provide a more telling contrast to the style of his north Italian colleague, and epitomize better the very elements of the international melting-pot that was Paris at this time. This artist has been recognized by Millard Meiss as the same who is referred to as the Master of the Breviary of Jean Sans Peur (d. 1419), because of his participation in a now imperfect manuscript for that Duke of Burgundy (London, Brit. Mus. Harley ms. 2897; Add. ms. 35311). He also seems to have worked with the Limbourg brothers, as his hand has been noted in some of the historiated initials of the *Très Riches Heures* at Chantilly, The painting of St. Christopher on fol. 251 of our manuscript is, indeed, very close to the same subject in the Breviary of Jean Sans Peur.

The borders of the Walters manuscript throughout are in a French style, but the north Italian master has contributed to them special elements in his own style: little nude children in various activities, as in so many Lombard manuscripts, and naturalistic flowers, leaves or berries, quite carefully studied and often in large scale.

CONDITION: Excellent.

PROVENIENCE: A still unidentified coat-of-arms has been inserted in the margins at several points, and this is the same as that painted on the foredges around 1480.

EXHIBITIONS: Baltimore, "Illuminated Books," 1949; Oberlin, Ohio, Allen Memorial Art Museum, "Netherlandish Book Illumination," Apr. 22-May 12, 1960; Baltimore Museum of Art, "History of Bookbinding . . .," Nov. 12, 1957-Jan. 12, 1958.

BIBLIOGRAPHY: De Ricci, I, p. 791, n. 215—*Walters Exhibition Cat.*, n. 87, pl. XXXVIII—M. Meiss, "The Exhibition of French Manuscripts of the XIII-XVI Centuries at the Bibliothèque Nationale," *Art Bulletin* (1956), p. 196, figs. 8, 9—C. D. Cuttler, "Some Grünewald Sources," *Art Quarterly*, XIX (1956), p. 109, fig. 5—Rosy Schilling, "Ein Gebetbuch des Michelino da Besozzo," *Münchner Jahrbuch der bildenden Kunst*, VIII (1957), p. 79, n. 25—Walters Art Gallery, *The History of Bookbinding . . . an Exhibition held at the Baltimore Museum of Art*, Baltimore, 1957, n. 179, pl. XXXV—Oberlin College, "An Exhibition of Netherlandish Book Illumination," *Allen Memorial Art Museum Bulletin*, XVII, 3 (1960), p. 98, n. 12, fig. 2—W. Wixom, in *Bull. Clev.*, Sept., 1961, p. 188, fig. 24. For the manuscripts relating to the north Italian hand, see Burlington Fine Arts Club, *Exhibition of Illuminated Manu-*

scripts, London, 1908, pp. 99-100, pls. 131-132—sale cat., *Bibliotheca Phillippica* . . . Sotheby & Co., London, July 1, 1946, n. 20, ill.—O. Paecht, "Early Italian Nature Studies," *Journal of the Warburg and Courtauld Institutes*, XIII (1950), p. 44.

PLATE LVI WALTERS ART GALLERY, ms. W. 219

59 PARIS, ca. 1420-25

Book of Hours

In Latin. Written on 200 vellum leaves, 8⅞ x 6½ in. (.203 x .168 m.). 39 large miniatures; 24 small calendar illustrations; illuminated borders on every page. Binding: modern red velvet.

The artist of this richly illustrated Book of Hours studied closely the compositions of the Boucicaut Master, and appropriated many of his devices, such as architectural tricks to enhance perspective effects, a cloth screen hanging between pillars behind a personage to suggest by its interception the depth of the room beyond, little pots of flowers on the sill of an open colonnaded loggia seen through a door, overlapping crags and hills in receding landscapes, and so on. In fact, at least two of the miniatures in this book, the Visitation and St. George killing the Dragon, are derived directly from the corresponding scenes in the Hours of the Maréchal de Boucicaut (cf. Cat. no. 54), only they are reversed. The background of the St. George miniature is simplified in detail, but in the Visitation nearly all of the wealth of incident on the distant hills beyond the lake is retained.

However much the artist of our book was indebted to the Boucicaut Master for patterns and ideas, he certainly did not adopt his style. He is essentially more gothic in spirit and manner, and his predilection for decoration tends to overcrowd some of his scenes, and even to render them somewhat confusing (note especially the Coronation of the Virgin, fol. 81, the Crucifixion, fol. 108, and the Mass for the Dead, fol. 149). His luscious use of color is his special charm.

CONDITION: Excellent, except for some rubbing of the surface in the miniatures of the Coronation and the Mass for the Dead.

EXHIBITIONS: Baltimore, "Illuminated Books," 1949; Los Angeles County Museum, "Medieval and Renaissance Illuminated Manuscripts," 1953-1954.

BIBLIOGRAPHY: De Ricci, I, p. 791, n. 217—E. Panofsky, in *Medieval Studies in Memory of A. Kingsley Porter*, Cambridge, Mass., 1939, II, p. 486—*Walters Exhibition Cat.*, n. 100—Los Angeles County Museum, *Medieval and Renaissance Illuminated Manuscripts—a Loan Exhibition*, n. 60, ill.

PLATE LXIII WALTERS ART GALLERY, ms. W. 287

60 PARIS (or Northwestern France?), ca. 1425

Book of Hours

In Latin. Written on 242 vellum leaves, 8 x 5½ in. (.202 x .140 m.). 27 miniatures; illuminated borders throughout. Binding: 17th cent. Belgian rose morocco, gold tooled.

This manuscript has hitherto been dated around 1430 to 1435 by the scholars who have alluded to it, because of the fact that it contains the arms of Thomas Malet de Berlettes, a prominent citizen of Lille, and his wife Jeanne de Lannoy. The exact date of their wedding is not known, but other records of Thomas and his family seem to suggest that the couple's marriage might have occurred around the dates mentioned. The supposition that it may well be a wedding manuscript arises from the prominence given the full-page scene of the Marriage of the Virgin, opposite the Annunciation miniature at Matins. However, on close inspection, it appears that the Malet-Lannoy arms were inserted in the manuscript after the illumination was complete, and thus give evidence only of an approximate date *ante quem*.

The style of the manuscript seems rather too early for a date in the thirties, and whatever influence may be due to the Bedford Master seems perhaps closer to his productions of about 1415 to 1420 or so, than to the later phases of his studio. However, this manuscript—it seems to me now—cannot be attributed to the atelier of the Bedford Master, as has so often been done. The figures and especially the facial types are not at all those upon which the Bedford Master had put his unmistakable stamp. The faces are more "classical," rather than having the touch of Flemish homeliness standardized by the Bedford Master, and are painted over a greenish base. The landscapes are closer to those of the Boucicaut Master in many respects. It is true that the fine borders of ivy and acanthus sometimes incorporate a few naturalistic flowers as the studio of the Bedford Master learned to do, but these had been introduced earlier by the Limbourg brothers, in their own way. And there are other details that remind one of influence from that atelier—such as the Flight into Egypt which repeats the version in the *Belles Heures de Jean de Berry* in the Clóisters, New York—the Virgin being seen from the back.

The reputation of the manuscript for having some connection with the Bedford Master's atelier—however unsupported by its gentle style and light palette—has some corroboration iconographically in certain scenes. The Trinity, for instance, illustrated on our plate is close to the upper part of the scene on folio 8 of the Breviary of the Duke of Bedford in Paris (Bibl. Nat., ms. lat. 17294). There, in a glory of cherubim, Christ, carrying His cross against His shoulder, sits beside God the Father who is crowned with a papal tiara, and joined by the Dove of the Holy Ghost, Whose wings touch the mouth of each Person. However, even closer to our miniature in most details is the earlier representation in the Breviary at Châteauroux (Bibl. munic. ms. 2), a book showing the Bedford Master in collaboration with the Boucicaut Master, and which may be as early as ca. 1415. The Trinity on folio 106 is the work of the Bedford Master. There the figures sit side by side on a throne with a canopy as here, God wearing a tiara, and the Dove connecting the lips of the Two Persons. The cross held by Christ is between Them, rather than over His shoulder, but the most striking feature of our miniature, the apparent conjunction of the lower limbs into one body by the single mantle over the knees—is exactly the same. In Châteauroux a book lies open on the lap of the Two, as in ours, while in the Bedford Breviary, a globe is between them. An exceptional feature, and very medieval, is the use in our miniature of tiny figures of Church and Synagogue as caryatids to support the throne. It is interesting to note that the Trinity in the present manuscript reverses the composition of the two by the Bedford Master that have been mentioned. The portrait of St. Luke on folio 17 is one of the earliest representations of him painting the Virgin.

PROVENIENCE: Thomas Malet de Berlettes and his wife, Jeanne de Lannoy of Lille.

EXHIBITIONS: Baltimore, "Illuminated Books," 1949; Los Angeles, "Medieval and Renaissance Illuminated Manuscripts," 1953-54; Oberlin, Ohio, Allen Memorial Art Museum, "Netherlandish Book Illumination," 1960.

BIBLIOGRAPHY: De Ricci, I, p. 797, n. 261—*Walters Exhibition Cat.*, n. 99, pl. XL—Panofsky, *Neth. Painting*, notes 61:3, 123:1, 254:1—Los Angeles County Museum, *Medieval and Renaissance Illuminated Manuscripts—a Loan Exhibition*, n. 59, ill.—Colin Eisler in *Art News*, LVIII (1959), pp. 27, 55, fig. 2—Oberlin College, *Allen Memorial Art Museum Bulletin*, XVII, 3 (1960), p. 100, n. 14, fig. 3.

PLATE LVIII WALTERS ART GALLERY, ms. W. 281

61 FRANCE (Northeastern?), ca. 1420

Fragment of a Book of Hours

In Latin. 17 vellum leaves, 6½ x 5 in. (.165 x .125 m.). 17 full-page miniatures; illuminated borders. Binding: early 19th century dark green morocco by Giroux of Paris.

A collection of miniatures cut from a Book of Hours, in a style which seems to be a provincial version (albeit a fine one), of the style and compositions of Paris painters of half a decade

earlier and more. The artist draws with great delicacy and models so very lightly that there is little variation in plane, and there is a very decorative distribution of clear and luminous color almost like that of a Persian miniature. The borders are carefully done, but far more routine than the miniatures, and have not the energy of the Parisian ones of this period.

A group of miniatures very close in style is in the Victoria and Albert Museum, and they may well be from the same book. They are not all by the hand of our miniatures.

CONDITION: The borders are severely cropped and are stained, probably from water. The miniatures themselves are undamaged.

PROVENIENCE: The arms of a lady, barruly argent and vert of six pieces, have been nearly erased from the page bearing the miniature of St. Catherine of Alexandria.

EXHIBITION: Baltimore, "Illuminated Books," 1949.

BIBLIOGRAPHY: De Ricci, I, p. 789, n. 203—*Walters Exhibition Cat.*, n. 90, pl. XL.

PLATE LX WALTERS ART GALLERY, ms. W. 221

62 FRANCO-FLEMISH (Northeastern or Meuse region?), ca. 1400

Book of Hours

In Latin. Written on 181 vellum leaves, 5½ x 3⅞ in. (.138 x .97 m.). 29 miniatures, of which 6 are framed in initials; illuminated borders and drolleries. Binding: early 18th century Belgian red morocco, gold tooled.

The location of this little book is very puzzling. The miniatures, not very fine but of a naïve charm, remind one of lower Rhenish painting, especially around Cologne. The feathery penlines for the ivy stems in the borders suggest such a location also, as does the general character of the drolleries. However, there is nothing in the calendar or the liturgy to confirm such an origin. These seem to refer to northeastern France. The book is not very pretentious, so perhaps we have here the work of an itinerant miniaturist-illuminator who picked up commissions in the provinces west of the lower Rhine.

Several of the miniatures are shaped like triptychs or little altarpieces, which is another unusual feature.

The illustrations of special interest are the Trinity of a Netherlandish type, the Christ in Judgment, the strangely contorted Way to Calvary, the Rhenish type of the Pietà, and the Madonna of Humility.

CONDITION: Imperfect. Some repainting in the miniature on fol. 20 (Madonna of Humility). Some notes of 1585 are written in French on several pages of the calendar and partly erased.

PROVENIENCE: Owned in 1729 by Cl. Fr. Rebouchu of the *Parlement* of Lorraine and Bar; Charles-François Dumars de Vaudoncourt; around 1800 by Sigisbert Nicolas Charrouyer. Acquired by Henry Walters in 1903.

BIBLIOGRAPHY: De Ricci, I, p. 787, n. 188—M. Meiss, *Painting in Florence and Siena after the Black Death*, Princeton, 1951, p. 142, n. 46.

PLATE XLVI WALTERS ART GALLERY, ms. W. 215

63 FRANCE (Avignon?), ca. 1400

Book of Hours

In Latin. Written on 188 vellum leaves, 6¼ x 4½ in. (.160 x .110 m.). 118 miniatures; illuminated borders. Binding: modern stamped pigskin in a velvet chemise.

The calendar of this book celebrates a number of Cluniac saints and points to a localization between the High Alps and Provence. The style of the miniatures combines certain Italianate features, such as swarthy complexions and expressive gestures, with a provincial note in the figure-

proportions with their over-large heads, angular poses, and a certain intensity that reminds one of German or Spanish temperament. The multiplication of folds of drapery on figures such as Christ in Majesty, the preference for lavendar, rose and muted greens, spiked here and there with scarlet—all are qualities found in a special group of books, as has been noticed by Otto Paecht and Jean Porcher, several of which have definite connections with Avignon.

In addition to the present book, the group consists of a more extensively illustrated *Officium* in the Spencer Collection of the New York Public Library (ms. 49), an *Horae* formerly in the Firmin-Didot Collection and now in Vienna (Nat. Bibl. Cod. ser. n. 9450), a Missal in the National Library at Madrid (ms. E e 27), the so-called Pontifical Hispalense in the Biblioteca Colombiana, Seville, a Missal in the public library of Cambrai (ms. 150), and another in the Cathedral of Narbonne. The Missal in Madrid carries a contemporary inscription in Catalan recording that it was made in Avignon in 1409 at the order of Bertram de Casals, as a gift to the Confraternity of La Sainte-Croix in Avignon. The latter seems especially close in style to the Spencer Collection manuscript, while the Book of Hours now in Vienna appears to be by the same hand as the Walters example. The Madrid and Seville Missals are related somewhat in respect to composition and other details to a fine Missal in Paris (Bibl. Nat. lat. 848), which was apparently done in Avignon for Robert of Geneva, the antipope Clement VII (d. 1394). The latter Missal is a little removed from the group of works listed above.

Monsieur Porcher has suggested that these manuscripts were made in Avignon, possibly by Spanish artists who worked especially on commissions of foreigners.

EXHIBITIONS: Baltimore, "Illuminated Books," 1949; Los Angeles County Museum, "Medieval and Renaissance Illuminated Manuscripts," 1953-54; Oberlin, Ohio, Allen Memorial Art Museum, "Early Netherlandish Book Illumination," 1960.

BIBLIOGRAPHY: De Ricci, I, p. 786, n. 186—*Walters Exhibition Cat.*, n. 79, pl. XXXIV—Los Angeles County Museum, *Medieval and Renaissance Manuscripts—a Loan Exhibition*, n. 47, ill.—*Allen Memorial Art Museum Bulletin*, XVII, 3 (1960), n. 6.

PLATE XLVI WALTERS ART GALLERY, ms. W. 237

64 FRANCE (Rouen), 1412

Breviary for Rome use

In Latin. Written in 2 columns on 576 vellum leaves, 8½ x 6¼ in. (.215 x .158 m.). 1 half-page miniature; 24 small calendar illustrations; 67 historiated initials; numerous marginal drolleries; illuminated ivy and floral borders. Binding: modern tan calf.

This thick book, fine of vellum, script and illumination, perhaps took some years to complete, since the Easter Calendar at the beginning starts with the year 1398, and the colophon at the end states that the writing of the text was completed in 1412. Certain features of the calendar indicate that the volume was executed for a Franciscan house in Rouen.

Since not too much is known about fine manuscript production in France outside Paris and the court circles at this time, this book provides opportunity for speculation. The style certainly is not Parisian. There seem to be at least two hands responsible for its illustration, one of these has Italianate characteristics, even if he may not be Italian. The other, L. M. J. Delaissé has suggested, is Germanic or Netherlandish. He compares it with the artist of the very vigorous and exceptional *Pèlerinage de la vie humaine* in Brussels (Bibl. roy. ms. 10176-78).

The iconography is unusual throughout. The only large illustration is that at the opening of the text, which represents the Last Judgment. Against a tessellated background, Christ sits upon the rainbow blessing and showing His wounds. Ranged around Him on festoons of fluted clouds are the kneeling Virgin and Apostles, while angels bring the Emblems of the Passion. Two trumpeting angels swoop down to rouse the dead from the verdant earth below. So far, all this is

contained within the rectangular frame. But the aftermath spills over into the margins at the sides, bottom and top of the page. Angels tenderly usher the blessed into little hammocks to lift them to heaven, floating up the lateral margins. At the top, the souls join a throng around the Trinity in a gothic loggia. At the foot of the page are the gaping jaws of Hell and a fiery pit, and into this inferno horrible devils, who busily clutch the damned as they rise from their graves, are carrying them down the margins.

Both in style and concept, as Monsieur Delaissé has noted, there is nothing French about this. For the general idea of it he cites a Spanish example, the Missal of Saint Eulalia in Barcelona Cathedral. One should remember too, the Book of Hours of Paris use (London, Brit. Mus. Add. 29433), illuminated by an Italian, who also worked upon the Hours of Charles the Noble. The London manuscript represents only the Fall of the Damned, not the entire Last Judgment, so that it is, in a way, only the bottom part of our scene. There the top of the miniature is free and unframed, but the action respects the borders on the sides and bottom of the painting, as ours does not. In my own opinion, the character of the Last Judgment composition in the Baltimore manuscript owes more to Italy than to the Netherlands, even if the style does not. One might remark that the nude contrapposto figure of a man in the lower left corner of our Resurrection, stepping out of his grave, and out of the frame as well, repeats the figure (or its prototype) of Adam receiving the apple in the miniature of the Fall of Man in the *Très Riches Heures*. This figure has often been commented upon because of its classical or Italian Renaissance nature, and it is clear that the Limbourg brothers borrowed it from some Italian source. The pose is much more suited to the circumstances of our Resurrection than to the event in the Garden of Eden.

On some of the pages very naturalistic and charming flowers, blue-bells, roses, daisies, bluets, and so on—replace the conventional ornament—an Italian contribution which probably had not been taken up by the Limbourgs themselves much before this time.

PROVENIENCE: Made for a Franciscan house in Rouen.

EXHIBITIONS: Baltimore, "Illuminated Books," 1949; Los Angeles County Museum, "Medieval and Renaissance Illuminated Manuscripts," 1953-54; Santa Barbara Museum of Art, "Fruit and Flowers in Painting," 1958; Oberlin, Ohio, Allen Memorial Museum, "Netherlandish Book Illumination," Apr. 22-May 12, 1960.

BIBLIOGRAPHY: De Ricci, I, p. 778, n. 132—*Walters Exhibition Cat.*, n. 83, pl. XXXVI—Los Angeles County Museum, *Medieval and Renaissance Illuminated Manuscripts—a Loan Exhibition*, n. 50, ill.—L. M. J. Delaissé, "Les miniatures du 'Pèlerinage de la Vie Humaine' de Bruxelles et l'archéologie du livre," *Scriptorium*, X (1956), pp. 244-249, pl. 25—M. Meiss, "The Exhibition of French Manuscripts of the XIII-XVI Centuries at the Bibliothèque Nationale," *Art Bulletin*, XXXVIII (1956), p. 189, n. 8—Oberlin College, *Allen Memorial Art Museum Bulletin*, XVII, 3 (1960), p. 97, n. 7, fig. 1.

PLATE LIV WALTERS ART GALLERY, ms. W. 300

65 AUSTRIA (Vienna, atelier of Nikolaus of Brünn), between 1403 and 1406

Thomas Aquinas, *Hystoria de Corpore Christi*

In Latin. Written in 2 columns on 43 vellum leaves, 15¾ x 11¼ in. (.400 x .285 m.). 1 large miniature, 1 historiated initial, illuminated borders. Binding: 18th cent. Austrian blind-stamped pigskin over pasteboard with the imperial arms of Austria, executed by H. Claus in 1718 (inscription).

The artistic interest of this manuscript resides in its frontispiece, which appears to have the value of being a true portrait of a historic artistic personage and is the work of a celebrated court artist of the Hapsburgs, Nikolaus of Brünn.

This frontispiece shows us Wilhelm "the Affable" of Hapsburg, Duke of Austria (1370-1406), kneeling before a rustic *prie dieu* set up on a verdant hillside and covered with a blue cloth. He is harnessed in full armor, rendered in burnished silver (now tarnished) over which is a close-fitting doublet displaying the colors of Austria (red and white). He wears a crown of tall spikes,

connected by an arch of crockets with a finial. This crown is shaped exactly as those on other early portraits of the fourteenth and fifteenth-century Dukes of Austria, as seen in the panel-painting of Rudolf IV (ca. 1365) belonging to the museum of Vienna Cathedral and on the stone figure of Duke Albert II carved for the Cathedral tower around 1370-80, now in the Vienna Historical Museum.

In the hands of the Duke is a banderoll on which is inscribed his prayer, *Ave verum Corpus Christi*. This is addressed to the half-figure of Christ showing His wounds painted within the initial S opening the text on the next page. Lying on the hillside near Duke William is an escutcheon bearing his arms, gules a fesse argent, and the same charge is on the fine banner held by an armored squire standing at the left, who is carrying the Duke's crested helm. The young squire himself wears a doublet emblazoned with his own arms: gules, two battle-axes argent addorsed, the handles or (Lesch). The same bearings appear on a shield and crested helmet in the left corner.

All this brave heraldic pageantry is reinforced by a magnificent display of arms below the scene. On a delicately painted golden grille, gracefully meandering acanthus leaves of many colors enframe five escutcheons. The central one is charged with the arms of the Duke's wife, Johanna of Anjou, whom he married in 1403. The others bear Carinthia, Carniola, Styria and Tyrol.

Very delicate is the quality of the painting which has some features related to Bohemian work, but with somewhat more Italianate coloring of the flesh. The flowering hillside, patterned stiffly like a verdure tapestry, the exquisite golden rinceaux that fill the azure background, and the clear yet delicate heraldic colors contribute a jewel-like quality. As in Bohemian manuscripts, the network and flourishes of liquid gold stand a little in relief on the surface of the vellum and suggest goldsmithswork.

The heavy but pale-colored acanthus border on the opening page frames an exceptionally large script. The text is the full office for the feast of Corpus Christi, which had been observed at the monastery of Klosterneuberg, near Vienna since 1288.

Among the other manuscripts illuminated by Nikolaus von Brünn is a German translation of the *Rational* of Duranti (Vienna, Oester. Nationalbibl. cod. 2765), which, among its more than 140 miniatures, contains Duke Wilhelm's portrait. This was begun for Duke Albert III and finished for his successor, Duke Wilhelm and his wife.

PROVENIENCE: Wilhelm, Duke of Austria, Carinthia, Styria and Tyrol, Count of Hapsburg; the Princes of Liechtenstein. Presented 1951 by Mr. Louis M. Rabinowitz.

EXHIBITIONS: Baltimore, "Illuminated Books," 1949; New York, Pierpont Morgan Library, "Central European Manuscripts," 1958.

BIBLIOGRAPHY: K. Oettinger, "Die gotische Buchmalerei in Oesterreich," in *Die bildenden Kunst in Oesterreich: gotische Zeit*, ed. K. Ginhart, Baden b/Wien, 1938, p. 154—*Walters Exhibition Catalogue*, n. 142—F. B. Adams, Jr., *Second Annual Report to the Fellows of the Pierpont Morgan Library*, New York, 1951, pp. 17-19—Meta P. Harrsen, *Central European Manuscripts in the Pierpont Morgan Library*, New York, 1958, n. 42, pl. 62.

PLATE XLIV THE PIERPONT MORGAN LIBRARY, ms. M. 853

66 BOHEMIAN, ca. 1430

The Trinity

Historiated initial U, probably cut from an antiphonary. Tempera and gold leaf on vellum, 6¼ x 7⅛ in. (.152 x .177 m.)

God the Father, represented as a gentle, white-haired giant, His downcast eyes glancing thoughtfully to one side, places His hands lightly on the dimunitive figure of Christ standing before Him, holding the Cross, on which alights the Dove of the Holy Spirit. The mood is gentle and with-

drawn, and, as in all Bohemian painting of the group to which this belongs, the style and the coloring are extremely delicate. All strongly plastic effects are avoided, and only a very delicate modulation of the planes exists, subtly accented here and there with gold highlights.

CONDITION: excellent.

PROVENIENCE: Edward Schultze (Lugt, *Les marques de collections. de dessins & d'estampes*, 906); Robert Forrer (Lugt, *ibid, Suppl.* 941a); Lessing J. Rosenwald.

EXHIBITIONS: Baltimore, "Illuminated Books," 1949; Washington, D.C., National Gallery of Art, "The Rosenwald Collection: an Exhibition of Recent Acquisitions," 1950; Los Angeles County Museum, "Medieval and Renaissance Illuminated Manuscripts," 1953-54; Vienna, Kunsthistorisches Museum, "Europäische Kunst um 1400," May-July, 1962.

BIBLIOGRAPHY: *Walters Exhibition Cat.,* n. 141, pl. LII—National Gallery of Art, *The Rosenwald Collections—an Exhibition of Recent Accession,* Washington, 1950, n. 11, ill.—Los Angeles County Museum, *Medieval and Renaissance Illuminated Manuscripts,* 1953, n. 89—Kunsthistorisches Museum, *Europäische Kunst um 1400,* Vienna, 1962, n. 184. Cf. the group of miniatures described by Edith Hoffmann, *Cseh Miniaturok,* Budapest, 1918.

PLATE LXVIII NATIONAL GALLERY OF ART, Washington, D.C.
Rosenwald Collection

67 NETHERLANDS (Utrecht), ca. 1404-5

Dirc van Delf, *Tafel van den Kersten Ghelove*: Winter Part (I-XI; XIV-XXXIV)

In Dutch. Written on 167 vellum leaves, 7⅜ x 5⅜ in. (.187 x .137 m.). 35 historiated initials. Binding: modern red velvet.

This work, a treatise on Christian faith, was composed for Albert, Duke of Bavaria and Count of Holland, by his chaplain, Master Dirc van Delf. The treatise is in two portions—a Winter part and a Summer part—corresponding to the division of the liturgical year. The first part of the text was the *Winterstuc,* consisting of fifty-seven chapters.

This is the earliest manuscript of the treatise that has come to light, and in the opinion of Miss Margaret Rickert, who has published a complete study of the manuscript, this is actually the copy prepared for Duke Albert. This theory is supported by several indications, both textual and artistic. On folio 1, the arms displayed near the kneeling figure of the owner are those of Bavaria quartered with Flanders and Holland, as borne by Duke Albert and his son, William, who succeeded him as Count of Holland. The treatise is known to have been composed in 1404 specifically for Duke Albert, who died December 12, 1404, and Dirc is not recorded as remaining in the service of William. It seems likely, then, that the personage represented on folio 1 is Albert himself. This is substantiated by the text, in which chapters XXIII and XXIV have been transposed, as if the pages of Dirc's autograph manuscript got out of order—an error which was copied about 1410, along with corrections inserted into our manuscript, and other pecularities, in a volume in the British Museum (Add. ms. 22288). The latter manuscript, much larger in format, also exactly copies all the miniatures of our book (except the portrait and arms of the Duke). The style of the miniatures also corroborates the early date, since the first of the two illustrators in this Walters manuscript seems to be the same as the artist who painted a picture of the Death of Alexander in a Bible in Brussels, which was completed by the scribe, Henricus of Arnheim, in 1403.

The miniatures of the present manuscript, invariably enclosed within the initial D, are by two hands (Miss Rickert finds three). One, who is responsible for the first twenty-eight, is by far the more gifted person of the two. Although he is by no means a powerful artist, he is a sensitive and thoughtful one, and handles his themes with a directness which is somehow very moving. In many miniatures he shows an interest in volume and perspective, simply established; but above all, it is by his handling of light and shade with which in certain instances he creates the form entirely in paint, working from the darkest tones to the highlights, and dispensing with outlines.

He tends to avoid strong colors, preferring greyish whites and soft rose for draperies, dull green for ground and trees, which are modelled in brown or grey, highlighted sharply with white..

The second hand is less expressive, preferring brighter colors and more clear-cut outlines.

A manuscript of the Summer part of this treatise in the Pierpont Morgan Library (M. 691) is very similar in format to our volume, although it does not show the work of the more subtle of our two miniaturists. The style is close to that of the second hand. Despite certain differences, as in the greater size of the initials, it may well be the companion volume to ours. Its date must be close to that of the Walters book.

CONDITION: Chapters XII and XIII missing; incomplete at end, lacking chapters XXXV to LVII.

PROVENIENCE: Albert, Duke of Bavaria and Count of Holland.

EXHIBITIONS: Baltimore, "Illuminated Books," 1949; Oberlin, Ohio, Allen Memorial Art Museum, "Early Nether-landish Book Illumination," Apr. 22-May 12, 1960

BIBLIOGRAPHY: De Ricci, I, p. 823, n. 397—G. J. Hoogewerff, *De Noord-Nederlandsche Schilderkunst*, I, The Hague, 1936, pp. 583f. (note to p. 112, line 9); V, p. 229—A. W. Byvanck, *La miniature dans les Pays-Bas septentrionaux*, Paris, 1937, p. 21, 22, note 1—L. M. Daniels, *Tafel van den Kersten Ghelove*, I, Antwerp-Utrecht, 1939, pp. 72-76, 122-123 passim, pl. 5—A. W. Byvanck, "Kroniek der Noord-Nederlandsche Minituren, III," *Oudheidkundig Jaarboek*, 4th ser., IX (1940), p. 35, figs. 8, 9—C. Sterling, *La peinture française—Les peintres du moyen âge*, Paris, 1942, notes 10, 11—A. W. Byvanck, *De Middeleeuwsche Boekillustratie in de Noordelijke Nederlanden*, Antwerp, 1943, pp. 17-18, figs. 5, 6—*Walters Exhibition Cat.*, n. 119, pl. L—Margaret Rickert, "The Illuminated Manuscripts of Meester Dirc van Delf's Tafel van den Kersten Ghelove," *JWAG*, XII (1949), pp. 79-108, illus.—Panofsky, *Neth. Painting*, I, pp. 98-99 and note 98, II, fig. 115—Dorothy Miner, "Dutch Illuminated Manuscripts in the Walters Art Gallery," *Connoisseur Yearbook 1955*, pp. 66-68, figs. 1, 2.

PLATE XLIII WALTERS ART GALLERY, ms. W. 171

68 NETHERLANDS (Utrecht), ca. 1415

Book of Hours for use of Utrecht

In Latin and Dutch. Written on 283 vellum leaves, 5 x 3¾ in. (.125 x .95 m.). 12 full-page miniatures, 1 historiated initial. Binding: 18th century vellum.

This little volume belongs to a small group of early Utrecht Books of Hours, the illumination of which is characterized by a fluent and expressive style and delicate, translucent coloring. The miniatures are in simple frames ornamented only with sparse sprigs of golden trefoils or scattered daisy-blossoms, which became a hall-mark of Utrecht ornament. The luscious coloring and supple draperies retain a heritage of French or Franco-Flemish style, which Dr. Panofsky believes to have reached Utrecht by way of the courtly painting of Guelders, rather than directly from Flanders. Inherently Dutch or Lower Rhenish, however, is the emotional intensity implied by the sketchy technique, the expressive action, the frequently complex figure groupings and the general mood of pathos—which is the more haunting for being understated. The scenes are presented with the minimum of accoutrement. The backgrounds are of burnished gold or flat ornament. Often the austere rectangle of the frame does not suffice to contain the action, which breaks beyond it.

The members of the group to which this book belongs have been listed by Dr. Panofsky. The closest relatives to our manuscript are two other Books of Hours, one in the Bodleian Library (Ms. 18,392 or Clarke Ms. 30) and another formerly in the late Sir Sydney Cockerell's possession, which now belongs to Major J. R. Abbey.

PROVENIENCE: Death notices of the Definnes family of Orlencourt, near St. Omer (1520-1637).

EXHIBITION: Baltimore, "Illuminated Books," 1949.

BIBLIOGRAPHY: De Ricci, I, p. 787, n. 191—A. W. Byvanck, "Kroniek der Noord-Nederlandsche Miniaturen, III," *Oudheidkundig Jaarboek*, 4th ser. IX (1940), pp. 35-36, figs. 10. 11—Charles Sterling, *La peinture française—Les peintres du moyen âge*, Paris, 1942, note 10—*Walters Exhibition Cat.*, n. 120—Panofsky, *Neth. Painting*, I, p. 99 and

note 4, fig. 118—idem, "Guelders and Utrecht," *Konsthistorisk Tidskrift*, XXI (1953), p. 97, note 12—Dorothy Miner, "Dutch Illuminated Manuscripts in the Walters Art Gallery," *Connoisseur Yearbook*, London, 1955, pp. 68, 70, fig. 3 —David Diringer, *The Illuminated Book*, London, 1958, p. 443, pl. VII-30.

PLATE XLVII WALTERS ART GALLERY, ms. W. 185

69 FLANDERS (Ghent), ca. 1420

Book of Hours

In Latin. Written on 183 vellum leaves, 6½ x 4¾ in. (.165 x .120 m.). 27 full-page miniatures; 8 historiated initials. Binding: early 16th century calf, stamped with plaques signed by Joris de Gavere in Ghent.

This book is a member of a group of manuscripts executed in a Flemish atelier that often worked for export. The style of the illuminations developed out of that of an earlier atelier that Dr. Panofsky tentatively located in Ypres, and there are also obvious English connections. The most firmly dated manuscript of this atelier is a Book of Hours illuminated for John the Fearless who was Duke of Burgundy between 1404 and 1419 (Paris, Bibl. Nat. ms. lat. n.a. 3055). The present manuscript is so close in style to the latter that it cannot be far removed in date. Other manuscripts from the same atelier include that described under Cat. no. 70, made for a Ghent patron, two in the Pierpont Morgan Library (M. 46 and M. 439), one in the John Carter Brown Library, Providence, Rhode Island (ms. 3), and a manuscript formerly in the Arenberg collection, now in Paris (Bibl. Nat., n.a. lat. 3112, Boisrouvray gift).

The members of this group display exceptional variety in the border ornament. The figure-style is gentle, even moody, and still gothic, but tends to be not at all courtly. The perspective of tiled floors and bits of architecture, as well as stippled "atmospheric" skies are introduced in alternation with old-fashioned patterned backgrounds of tessellation or rinceaux. Some of the homely novelties of Lower Rhenish iconography occur from time to time. The artist will often violate his frame to expand his scene, even spilling events over into the margin (cf. in this respect Cat. nos. 64, 68). The coloring is clear and charming, sometimes achieving a sort of iridescence by stippling. In the course of time, many features of this atelier were inherited by a Flemish workshop called that of the Master of Gilbert of Mets.

EXHIBITIONS: Baltimore, "Illuminated Books," 1949.

BIBLIOGRAPHY: De Ricci, I, p. 787, n. 189—V. Leroquais, *Un livre d'heures de Jean sans Peur, duc de Bourgogne*, Paris, 1939, p. 53—*Walters Exhibition Cat.*, n. 126—Panofsky, *Neth. Painting*, pp. 119 ff., 128, notes 119:3, 128:12, fig. 190—M. Meiss, *Painting in Florence and Siena after the Black Death*, Princeton, 1951, p. 142, note 46.

PLATE LVII WALTERS ART GALLERY, ms. W. 170

70 FLANDERS (Ghent), ca. 1420-25

Book of Hours for use of Arras

In Latin and Flemish. Written on 186 vellum leaves, 6¼ x 4⅝ in. (.160 x .112 m.). 13 full-page miniatures; historiated initials; numerous drolleries; illuminated borders. Binding: modern pink leather with earlier (14th cent.?) blind-stamped panels inlaid, which were not connected with this book previously.

The drolleries of this book, which comes from the same atelier as Cat. no. 69, have a light and unexpected character of great charm and are similar in type to those that appear in several other manuscripts of this group. The introduction into some of the borders of naturalistic flowers of irrelevantly large scale, delicately and lightly painted, has an uncanny quality in relation to the diminutive drolleries often associated with them. The same features occur in the *Horae* of the John Carter Brown Library (ms. 3) and on a separate leaf in the Lewis Collection of the Philadelphia Free Library.

This book is important in fortifying the evidence for locating this atelier in Ghent. It was made for Daniel Rym (d. 1431), a prominent patrician of Ghent, and his wife Elizabeth van Munte, as we know from the arms. They both appear on separate pages kneeling to their respective patron saints.

PROVENIENCE: Daniel Rym and Elizabeth van Munte of Ghent.

EXHIBITIONS: Baltimore, "Illuminated Books," 1949; Los Angeles County Museum, "Medieval and Renaissance Illuminated Manuscripts," 1953-54; Oberlin, Ohio, Allen Memorial Art Museum, "Early Netherlandish Book Illumination," April-May, 1960; Detroit Institute of Arts, "Masterpieces of Flemish Art: Van Eyck to Bosch," Oct.-Dec., 1960.

BIBLIOGRAPHY: De Ricci, I,p. 787, n. 190—V. Leroquais, *Un livre d'heures de Jean sans Peur*, Paris, 1939, p. 63 (erroneously referred to as W. 170)—A. W. Byvanck *Oudheidkundig Jaarboek*, ser. IV, IX (1940), p. 32, fig. 1, 2 (again erroneously called W. 170)—Panofsky, *Neth. Painting*, pp. 119-121, notes 114:6; 118:8; 119:2; 6, 8, 120:5; 121:1, 2, 6; figs. 186-189—M. Meiss, *Painting in Florence and Siena after the Black Death*, Princeton, 1951, p. 143, note 47—D. Diringer, *The Illuminated Book*, London, 1958, p. 440, pl. VII-29—Detroit Institute of Arts, *Flanders in the Fifteenth Century—Art and Civilization*, 1960, pp. 377-79, n. 197, ill. Concerning the binding see: Walters Art Gallery, *The History of Bookbinding . . .*, Baltimore, 1957, n. 125, pl. XXXI.

PLATE LVII WALTERS ART GALLERY, ms. W. 166

71 FRENCH FLANDERS, ca. 1425

Book of Hours for use of Rouen

In Latin, with a French rubric. Written on 234 vellum leaves, 4⅝ x 3½ in. (.118 x .86 m.). 21 miniatures; illuminated borders. Binding: modern red velvet.

This little book is not a luxurious one, but it is an exceptionally interesting example of the kind of illumination carried out, as Dr. Panofsky says, by the Flemish artists who stayed at home, or worked in the provinces of northern France, rather than following the golden trail to the courts of Paris, Burgundy and Berry.

It is especially notable for its iconography, which reflects some of the themes of the Lower Rhineland, drawn often from the visionary writings of St. Bridget, or from other sources. One may mention the Adoration of the Child, taking place not in the shed, but in a cave, to which St. Joseph brings his candle, or the charming details of the Flight into Egypt, where a tree bows down to offer its fruit to Mary, and the weary donkey drinks from a stream, from which St. Joseph fills his canteen. This last feature, as Dr. Panofsky has noted, is the prelude to the incident recorded on Broederlam's altarpiece at Dijon when St. Joseph quenches his thirst as the Holy Family proceeds to Egypt (see also Cat. no. 51). A picture of St. Pierre de Luxembourg, with his arms, precedes a prayer attributed to him (cf. Cat. nos. 43 and 48).

Although the book has certain similarities to the style developed in the mass-production ateliers known as the 'gold-scroll' group, it does not come from one of these, being more individual in style and quality. Close to it is a manuscript in the Pierpont Morgan Library (M. 455).

Many of the backgrounds show a *semée* of double y's and flaming crowns, but the significance of this has not been discovered.

EXHIBITIONS: Baltimore, "Illuminated Books," 1949; Oberlin, Allen Memorial Art Museum, "Early Netherlandish Book Illumination," April-May, 1960.

BIBLIOGRAPHY: De Ricci, I, p. 789, n. 201—*Walters Exhibition Cat.*, n. 129—Panofsky, *Neth. Painting*, pp. 89, 126, notes 61:3; 89:1; 123:1; 126:2; fig. 191, text ill. 48—M. Meiss, *Painting in Florence and Siena after the Black Death*, Princeton, 1951, p. 142, note 46—Oberlin College, *Allen Memorial Art Museum Bulletin*, XVII, 3 (1960), p. 10, n. 27.

PLATE XLVII WALTERS ART GALLERY, ms. W. 211

72 ITALY (Genoa or Naples?), late 14th century

Accidia and her Court: from a Treatise on the Vices

In Latin. Written (on the verso) in 2 columns on 1 vellum leaf, 7½ x 4¹¹⁄₁₆ in. (.163 x .103 m.). 1 miniature; illuminated border.

This interesting leaf is a fragment of a treatise on the Vices which is said to have been composed by a member of the Cocharelli family of Genoa. Two other fragments of what must surely be the same manuscript are in the British Museum (Add. mss. 27695, 28841).

The illustrations of both sets of leaves show the same extraordinary character: a rather dry and somewhat crude style of drawing rendered quite gorgeous, however, by the exotic, decorative use of bright colors and gold and by lavish surface patterns. The whole effect is oriental, and indeed actual oriental motifs occur in the illustrations and ornament.

The picture represents the vice of Accidia (melancholy or boredom). A group of ladies magnificently dressed in high-waisted robes of richly brocaded silk and wearing jewelled headdresses, sit on cushions around a polygonal gaming table. They are casting dice, and the gold coins of the winners are plainly shown. One lady holds a parakeet and a page-boy in parti-colored tunic plays with a bird. Another page, standing near a gayly painted bird-cage holds a hooded falcon on his gloved wrist and plays with one of the tiny white dogs that are scampering over the red coverlet of a bed. The dogs wear belled collars—a favorite harness in the Middle Ages for these pets. Leaning on the bed, a man in scholar's garb addresses himself to the only soberly dressed lady in the room—a woman seated at the far left, veiled and robed simply in light tan, who reads a book. The teacher points to the upper zone—a crenellated open loggia on top of several lines of script. Workmen seen in the arcade appear to be carving and embellishing the structure, which a fellow at the far right is meanwhile destroying with a pickaxe.

On the verso, the text of the chapter is written in a light brown ink within a frame of historiated roundels which for the most part are clearly imitations of Moslem illustration. The sentences are picked out with gold initials and by way of line-fillers we see a variety of rather informally drawn little drolleries: a hawk attacking a man who has climbed to his nest, hounds chasing various animals, little birds.

These same characteristics appear in the British Museum fragments, which include the Vice of Gluttony represented as a Tartar chieftain and his court, attended by musicians of all sorts. The emphasis on flat patterning, rather roughly executed but very rich, is like that on the Cleveland leaf, and again there is an upper zone above a few lines of script. The verso presents, instead of the oriental roundels, an amazing collection of very realistically drawn insects—a spider, a grasshopper, a fly, etc. and the line-fillers here are limp grasses and weeds which wind their way wherever there is room.

The attribution of the manuscript to Genoa is founded only on the connection of the author with that city. In addition, the naturalistic insects, etc., had reminded scholars of the so-called "Monk of Hyères" of the Genoese family of Cybo, who is reputed to have been a great miniaturist, designing his work from the study of nature. He had been a poet, writing in Provençal, and connected with the court of Naples and Anjou before retiring to a monastery on one of the isles of Lerins, off the southern coast of France. However, no work by this monk is known.

CONDITION: Some damage apparently from dampness, which has affected the veiled figure on the far right, as well as parts of the verso.

PROVENIENCE: C. Czeczkowiczka, Vienna; his sale (Berlin, May 12, 1930). Acquired 1953.

EXHIBITION: Columbus, Ohio, Gallery of Fine Arts, "Aspects of Late Medieval Art," Medieval Conference, Ohio State University, Oct. 31-Nov. 22, 1958, n. 20.

BIBLIOGRAPHY: Cleveland Museum of Art, *Handbook*, 1958, n. 160, ill. Cf. British Museum, *Reproductions from Illu-*

minated Manuscripts, Series IV, 1928, p. 13, pls. XXX, XXXI. For the Monk of Hyères, cf. J. W. Bradley, *A Dictionary of Miniaturists and Illuminators* . . ., London, 1887, I, pp. 268-271.

PLATE LXIV CLEVELAND MUSEUM OF ART, no. 53.152
 Purchase from the J. H. Wade Fund

73 ITALY (Florence), last quarter of the 14th century

Antiphonary

In Latin with musical notation. Written on 56 vellum leaves, 24 x 16½ in. (.608 x .418 m.). 8 miniatures in initials; numerous initials elaborately ornamented with pen-work. Binding: 19th century half-morocco.

A very handsome choir book executed in Florence for a church dedicated to SS. Peter and Paul. The miniatures, some of monumental scale, are by three different artists, who were followers of Orcagna. Dr. Offner once suggested that they could have a general resemblance to the kind of work produced by Pietro Nelli and Tommaso da Mazza. A fine series of cut-out initials in a related style is in the Pierpont Morgan Library (M. 478).

CONDITION: In general very good, but there has been a little flaking of gold and pigment and in two figures there seems to be slight repainting of losses. Some of the text and musical notes erased and rewritten.

PROVENIENCE: A. Firmin-Didot; his sale (Paris, 1884, pt. VI, n. 8, ill.); Marshal C. Lefferts, New York (his *Checklist* by George C. Richmond, 1901, p. 55). Acquired by Henry Walters in 1901 or 1902.

EXHIBITIONS: Baltimore, "Illuminated Books," 1949; Buffalo, Albright Art Gallery, "Art in the Book," 1953

BIBLIOGRAPHY: De Ricci, I, p. 780, n. 148—*Walters Exhibition Cat.,* n. 162, pl. LXIII—D. Diringer, *The Illuminated Book,* London, 1958, pl. VI-16.

PLATE LXVII WALTERS ART GALLERY, ms. W. 153

74 ITALY (Florence; Don Silvestro dei Gherarducci), ca. 1390-1400

Christ and the Virgin in Glory

Historiated initial G painted on vellum, cut from an antiphonary, 13¾ x 13⅛ in. (.347 x .330 m.).

This superb painting has been lately attributed to Silvestro dei Gherarducci by Miss d'Ancona. The breathtaking clarity and strength of the color, in which orange red contrasts with azure, is kept in balance by the subtle use of accents of pale brownish rose or white in the garments of the principal figures and the throng.

CONDITION: Pristine.

PROVENIENCE: W. Y. Ottley; his sale (London, 1838, n. 182); Edouard Kann, Paris.

EXHIBITIONS: Cleveland Museum of Art, "Twentieth Anniversary Exhibition," 1936; Baltimore, "Illuminated Books," 1949; Los Angeles County Museum, "Medieval and Renaissance Illuminated Manuscripts," 1953-54.

BIBLIOGRAPHY: A. Boinet, *La collection de miniatures de M. Edouard Kann,* Paris, 1926, p. 25, n. XXVI, pl. XXIV and colored frontispiece—W. M. Milliken, *Clev. Bull.,* XVII (1930), pp. 131-133, ill.—De Ricci, II, p. 1932, n. 30.105 —Cleveland Museum of Art, *Catalogue of the Twentieth Anniversary Exhibition,* 1936, pp. 58-59, n. 135, pl. XIII— *Walters Exhibition Cat.,* n. 175, pl. LXVII—Los Angeles County Museum, *Medieval and Renaissance Manuscripts— a Loan Exhibition,* 1953, n. 100, ill.—Dorothy Miner, "The Development of Medieval Illumination as Related to the Evolution of Book Design," *Catholic Life Annual,* I (1958), p. 23, fig. 13, in color—Mirella Levi d'Ancona, "Don Silvestro dei Gherarducci e il Maestro delle Canzoni," *Rivista d'Arte,* XXXII (1959), pp. 23-24, fig. 8.

PLATE LXVI CLEVELAND MUSEUM OF ART
 Purchase from the J. H. Wade Fund

75 TUSCAN, late 14th century

The Crucifixion

Single miniature on vellum, 6¾ x 6¼ in. (.173 x .160 m.).

This illumination comes from a Missal of Tuscan origin. On the verso of the folio is written the second prayer of the Canon of the Mass. Its fine draughtmanship has the dignity and solid style of a fresco and comes close to the Giottesque tradition. But the sensitivity shown by the artist in the facial expression of Christ, the delicate modelling of His slightly elongated body, the restrained emotion of the bystanding figures, pertain to Sienese art. The Crucifixion may be compared with the fresco of the Crucifixion attributed to Barna in the Cathedral of Arezzo and with the illumination of Christ on the Cross in a Bible decorated by an artist from Siena in the Trivulzio Library, Milan (ms. 2139, fol. 435). The Virgin proffers her right hand as if to receive the blood spurting from the pierced chest of Christ. (Compare a Crucifixion attributed by Richard Offner to Nardo di Cione and his workshop in a Berlin private collection.) This iconographical feature comes from Byzantine art, where it fulfills the function of demonstrating that the blood of Christ remains hot and living after His death and is mystically collected by the Church, of which Mary is a figure. The gesture of St. John pressing his right hand to his cheek and the position of his left hand are also of Byzantine derivation and are encountered in the fresco of the Crucifixion in the Cathedral of Arezzo.

PROVENIENCE: Reichlen collection, Lausanne.

EXHIBITIONS: "Drawings from Tuscany and Umbria (1350-1700)", Mills College Art Gallery, Oakland and University of California Art Gallery, Berkeley 1961.

BIBLIOGRAPHY: A. Neumeyer and J. Scholz in the Mills College exhibition catalogue, n. 87, ill.

PLATE LXV JANOS SCHOLZ

76 ITALY (Northern; Belbello da Pavia), ca. 1430-40

The Annunciation: single miniature under the initial M

1 vellum leaf, 7⅞ x 6¾ in. (.200 x .170 m.). Full-page miniature.

This beautiful painting has been attributed to Belbello of Pavia, an enigmatic genius who was active in Lombardy and particularly for the court of Milan from before 1412 until 1460 or so. Especially in his earlier years, he seems to have been able to adapt his painting to various styles, as Charles Mitchell has pointed out, and thus he reflects the various masters with whom he collaborated. His essential distinction, however, consists in his jewel-like color, incredibly luminous but subtle, which gives even his most dramatic compositions a dream-like quality.

Although the scene of the Annunciation occupies two-thirds of the area of this miniature and dominates our attention, the pattern for the composition is set by the fantastic initial M above the main painting. A mysterious merman sits on a verdant hill, his fish-tail feet twined around a moon-face. In his hands he holds a pair of strange sea-creatures which curve to either side to form the bows of the M. Beyond the hill are ships in full sail and a tree-studded shore. Castles and a pair of rabbits add to the wealth of incident. The color-note for the entire painting is likewise established in this area. The merman seems to be undergoing a sea-change from green to a blue, and the blue, a luminous azure both light and deep, is picked up in the sky and in the garb of the boatmen, while the rose of his bonnet is echoed by the little castle towers here and there.

The curves of the M find a response in the lyrical pose of angel and Virgin in the Annunciation below, and the color develops more fully the theme just described. Rosy pink shot with blue is the color of the angel's robe, which reveals here and there a blue lining. This seems almost

translucent in conjunction with his wings of red, the sharpness of which is subdued by dull gold striations. The shrinking Virgin is wrapped in a mantle of luscious azure sprinkled with golden stars and lined with a dull green. There is just a glimpse of her rose dress.

All this is set before a typical Belbello landscape of glowing green, rendered almost metallic by the matt gold which picks out the leaves of the trees. Rose and blue castles dot the hills under the deep azure sky. In the left corner of the heavens, the grey-haired God the Father leans from a crowd of red and blue cherubim to send forth His Dove, which is trailed by tiny seraphs of gold.

In style this miniature belongs to a group, which also includes two miniatures in Mr. Robert Lehman's collection, that shows Belbello still essentially gothic in feeling. The disembodied curving figures, the bland oval faces with beady eyes, the subtle shredding of gold across the deep blue sky and the powdering of it over the trees—all were to be replaced in his later style by bulkier forms and menacing expressions, the gold highlights in sky and landscape becoming emphatic as lightning. The trees in the Cleveland Annunciation, while not as metallic as those in his productions of the middle of the century, still show the tapestry-like patterning of the leaves, which Belbello may well have picked up from collaboration with another Milanese court artist, the so-called Master of the Vitae Imperatorum. This would suggest a date in the 1430's.

CONDITION: Perfect

PROVENIENCE: Said to be from Church of SS. Giovanni e Paolo, Venice; W. Y. Ottley; his sale (London, 1838, n. 41).

BIBLIOGRAPHY: W. M. Milliken, in *Clev. Bull.*, XII (1925), p. 70—De Ricci, II, p. 1929, n. 24.431—*Walters Exhibtion Cat.*, n. 178 (comparative reference)—Meta P. Harrsen, *Italian Manuscripts in the Pierpont Morgan Library*, New York, 1953, p. 29 (comparative reference)—W. M. Milliken, *The Cleveland Museum of Art*, New York, 1958, p. 29—G. A. dell'Aqua (introd.), *Arte Lombarda*, Milan, 1959, pl. 85.

PLATE LXIX

CLEVELAND MUSEUM OF ART, no. 24.431
Gift of J. H. Wade

SCULPTURE

77 AUSTRIAN, late 14th century

Statuette of a Female Saint

Pine; 28½ in. (.723 m.), including socle, which may be later. Traces of the old gesso and polychromy in the folds.

The statue is one of the few remaining sculptures from the region of southeastern Austria. It is reported to have come from a church in Steiermark (cf. cat. no. 78).

CONDITION: Hands of the saint missing. A large crack through the wood in the back. Some tunnelling by termites.

PROVENIENCE: Kramer Collection, Graz (Styria).

PLATE LXXVII JANOS SCHOLZ

78 AUSTRIAN, ca. 1425

The Lamentation over Christ

Limestone with traces of polychromy; 22½ x 11 x 8 in. (.573 x .280 x .204 m.)

The mourning Virgin is seated on the ground between two holy women. Christ's body is laid across the lap of His mother and of one of her companions, while another kneels to support His head in her hands. The Magdalen crouches to caress the left foot of Christ, her long tresses falling over it. Behind the group of women are fragments of the figures of St. John, Nicodemus and Joseph of Arimathea. Their bodies above the waist have been lost.

The only other group comparable to this one is a larger sculpture in the Cathedral of S. Giusto, Trieste, which preserves the three male figures and exhibits variations in posture, as well as a heavier style. Stylistically our group must be ascribed to a little-explored section of Austrian sculpture—a section which was located in the region comprised by the duchy of Steiermark and the Kingdom of Hungary, the duchy of Carinthia and the region of Gorizia at the head of the Adriatic. It is quite distinct in character from other schools of Austrian sculpture such as are represented by the Pietà of Burg Kreuzenstein, and the purely Austrian examples of about 1425 in Bildechingen (Swabia) and Admont. The latter groups continue the elegance and fluidity, the rhythmic delineation of folds and other qualities of the Pietà from Baden (Vienna) in the Berlin Museum.

The Lamentation here exhibited has a quality of human simplicity and straight-forwardness. Possibly it owes something of its strength to Italy. In any case, we see here the reflections of an artistic current independent of Vienna and Salzburg (contrast, as examples of the Salzburg school of sculpture, the Pietàs in Altenstadt and Kloster Nonnberg).

PROVENIENCE: Collection of Count Bolms-Laubach.

BIBLIOGRAPHY: D. Westphal, "Eine gotische Gruppe der Beweinung Christi in der Kathedrale von Trieste," *Das Siebente Jahrhundert Festschrift zum 70 Geburtstag von Adolph Goldschmidt*, Berlin, 1935, pp. 64-66.

PLATE LXXV MUSEUM OF FINE ARTS, BOSTON, no. 61.158

79 BURGUNDIAN (School of Dijon), ca. 1425-1430

Virgin and Child

Limestone with traces of polychromy; 42¼ in. (.982 m.); base (max.) 16½ x 11 in. (.42 x .28 m.)

The author of this statue is unknown, but he is probably the sculptor who executed the famous

Virgin of Auxonne (Côte d'Or) —or at least he certainly belonged to his workshop. The sweeping movement and bulk of the draperies retain the richness and impetus of the works executed at Champmol under the leadership of Claus Sluter. The expansive width of the mantle, draped over the arms as if from brackets, the churning of the folds as they spread on the ground at the feet, evoke the characteristics of two statues of the "Well of Moses" in the cloister of Champmol—the Moses and the Zacharias—which exerted a long-range influence on the evolution of Burgundian sculpture, well after Sluter's death in 1406. As in the case of the Virgin of Besançon, an artist very close in style if not in temper to the author of the Detroit group, one may suggest—but only with much qualification—that a Virgin carved by Claus Sluter may have been its ultimate proto-type. Obviously, it bears little relation to the Virgin and Child carved for the trumeau of the portal of the church at Champmol, except for the way in which the free arm extends far from the body in a gesture which counterbalances the direction of the head. As for other Virgins carved by Sluter, nothing is known of the one he is recorded to have executed for the "Chapelle Notre Dame" opening off the south side of the choir of Champmol. The aspect of a third group carved by Sluter around 1400-1402 for the gateway to the monastery is preserved to us in a seventeenth-century engraving in P. Palliot, *La vraie et parfaite science des armoiries,* and it seems to have been a variation on the figure set against the trumeau of the church portal. However, in the figure over the monastery gateway the explosive movement of the right arm was muffled and enveloped by the heavy drapery, while the Child was naked and recessed in an opening of the mantle. Quite different is the Child of the Detroit group, Who has some kinship with that of the trumeau statue in pose and in His relationship with His mother. He is to a certain extent intermediate between the Child of the church portal of Champmol presented in a three-quarter view from the back, and the Child of the Virgin of Besançon, Who is frontal.

The vitality of the strong young body of the Madonna beautifully expressed in the pulsing vibration of the draperies, the gentle "hanchement" which does not upset the equilibrium of the figure (as it did in the "baroque" Madonnas of Bohemia and Salzburg around 1400) —these quali-ties are to be found also in the Virgin of Auxonne. Likewise both figures have in common the eyes almost closed in brooding sadness, the elegant nose, the lips shaded at the corners, the double chin (a Sluterian feature), the delicately rippling veil and the locks softly framing the cheeks. There is a difference, however. The mantle of the Virgin of Auxonne is open so that the Child may grope for the breast of His mother. The mantle of the Detroit Virgin is wrapped closely across her chest like that of the Virgin of Besançon. There is more maidenly grace in the Virgin of Auxonne, more matronly stateliness in the Virgin of Detroit. The latter shows the monumental heaviness which characterizes also the Virgin and Child in the choir of the collegiate church of Poligny, and which is not so much an inheritance from Sluter as it is a constant ethnical character in Burgundian art. It appears also in the Virgin of Viévy which may not be as late as the last third of the fifteenth century (as Henri David has dated it), but could still belong to the workshop of the master of the Virgin of Auxonne.

CONDITION: Good, but with many surface abrasions and various old breaks along edges of Virgin's veil and robe and of the Child's garment. Left hand of Virgin and part of Child's left hand missing. Repairs to chin and left toe of Virgin.

PROVENIENCE: Acquired 1928 by Edgar B. Whitcomb, Detroit; on loan to Detroit Institute of Arts 1928 to 1936; presented 1936.

EXHIBITIONS: Detroit Institute of Arts, "Loan Exhibition of French Gothic Art," 1928.

BIBLIOGRAPHY: Josephine Walther, *Bull. Detroit Institute of Arts,* X, 3 (Dec. 1928), p. 42, illus.—Walter Heil, *Cata-logue of a Loan Exhibition of French Gothic Art,* Detroit Institute of Arts, 1928, no. 44, illus.—*idem,* "Kunstwerke der Französischen Gotik, Leihausstellung in Museum zu Detroit," *Pantheon,* III (1929), pp. 75-76, illus. (as from the church of Rouvres which does not seem warranted)—G. Troescher, *Claus Sluter und die burgundische Plastik um die Wende des XIV Jahrhunderts,* Freiburg i/B., 1932, p. 80, pl. XXII—Aenne Liebreich, *Claus Sluter,* Brussels, 1936, p. 165, n. 1—W. R. Valentiner, "Late Gothic Sculpture in Detroit," *The Art Quarterly,* VI (1943), pp. 283,

SCULPTURE

284, 287, illus. p. 279, fig. 2 and 280, fig. 3 (cf. also his unpublished catalogue notes on the Detroit sculptures)—
E. P. Richardson, *Catalogue of the Paintings and Sculptures given by Edgar B. Whitcomb and Anna Scripps Whitcomb to the Detroit Institute of Arts*, Detroit, 1954, p. 119.

PLATE LXXXVII THE DETROIT INSTITUTE OF ARTS, no. 36.27

80 BURGUNDIAN, first quarter of 15th century

Virgin and Child with Donor

Stone; 42 in. (1.07 m.)

The Virgin standing holding the Christ Child at shoulder level. She wears a tall crown over a veil, and a heavy mantle. With her left hand she unrolls a scroll, on which traces of a painted inscription remain, toward a tiny figure of a monkish donor kneeling at her feet.

This sculpture, the provenience of which is completely unknown, has a remarkable quality. It belongs to that branch of the school of Dijon which became active in Franche-Comté after the death of Claus Sluter (1406). It particularly shows relations with the statues in wood of the rood-screen in the collegiate church of St. Hippolyte, at Poligny. The Virgin is of the same aristocratic type. Her mantle is carved with deep, simple folds, arranged on the side in a rhythmic descent of scooped out curves very like those on the statues of the Virgin and St. John at Poligny. The liveliness of the Child and His virile expression are also exceptional. The elaboration of the details of the bejewelled crown of the Virgin seems like a Flemish feature, as is the feeling of warmth imparted by the soft and heavy draperies. These do not merely bundle up the body in ample folds, but possess a tactile value.

The work in the new collegiate church of Poligny began in 1415 and was well advanced when the dedication took place in 1431. It had the financial support of the most highly-placed administrators of the dukes of Burgundy, John the Fearless and Philip the Good, and it is probable that the nephew of Claus Sluter, Claus de Werve, directed the program of sculpture and executed some of them. However, this group of the Virgin and Child with a donor stands apart from the personal creations of Claus de Werve. Its author may have been a sculptor from the region of the Jura. After the Champmol program of sculpture came to a standstill, the influence of these Jura sculptors may be traced not only at Poligny, but in the abbey church of Baume-les-Messieurs: see especially the statue of St. Michael above the tomb of Abbot Amé de Chalon (d. 1431) and the statue of St. Paul.

CONDITION: Arms of Child broken off along the elbows; draperies of Virgin cut at bottom of fold at one elbow; restorations to crown. Traces of polychromy.

BIBLIOGRAPHY: This statue is unpublished, but comparisons with the statuary at Poligny and Baume-les-Messieurs may be found in: J. J. Rorimer, "Une statue bourguignonne du XVe siècle au Metropolitan Museum de New York," *Bulletin Monumental* (1938), pp. 13-16—*idem,* "A Statue of Saint John the Baptist Possibly by Claus Sluter," *Bull. MMA* (1934), pp. 122-125—P. Quarré, "La collégiale de Saint Hippolyte de Poligny et ses statues," *Congrès Archéologique de France, CXVIIIe session* (1960), *Franche-Comté,* pp. 209-224—G. Duhem, "Baume-les-Messieurs," *ibid.,* pp. 189-200.

PLATE LXXXIX THE DETROIT INSTITUTE OF ARTS, no. 22.30

81 BURGUNDIAN (School of Dijon), ca. 1425-30

The Virgin from the Cathedral of Besançon

Limestone; 62 in. (1.577m.)

The Virgin of Besançon reflects the revolutionary trend which the Dutch sculptor Claus (Nicholas) Sluter had injected into the "international" art of western Europe in the last quarter of the four-

81

teenth century. The genial artist was invited to work in Brussels in 1380-1385, then in Dijon in 1385. In 1389 he became the first sculptor of the Dukes of Burgundy, Philip the Bold and John the Fearless—a post which he retained until his death in 1406. The art of Sluter at Dijon—the portal of the Carthusian church at Champmol, the Calvary in the cloister of the Carthusian monastery, the mourners carved for the tomb of Philip the Bold—is marked by a new realistic and dramatic approach to religious sculpture and by a sweeping, sumptuously heavy style in the carving of the draperies. The rendering of the mood of the personages and the design of their drapery folds are blended in a baroque exaltation that conveys to the creations of Sluter the pathetic unrest of the human soul. His sculptures are loaded with a sense—also to be expressed later by Rembrandt—of all the tragedies suffered by man, appeased by a sublime Christian acceptance. The nephew of Claus Sluter, Claus de Werve, proved himself somewhat inferior to the task of carrying on the grandiose conceptions of his uncle, but managed to maintain some activity in the workshop he inherited from him until his own death in 1439. It was there that the anonymous artist who carved the Virgin of Besançon received his artistic formation and may actually have been apprenticed.

That our artist was active in Dijon, there is plenty of evidence to prove. Very similar to the Besançon Virgin and Child are two groups now in the Louvre: the first adorned, until 1893, a niche of the façade of Hôtel Royer, near the ducal palace in Dijon; the second is from the steeple of the church of Plombières-lès-Dijon. There is another one in the Cluny Museum, Paris, which in the fifteenth century was set above the gate of the drawbridge of the castle of St. Apollinaire-lès-Dijon (cf. also the Virgin in the church of Bezouotte, Côte d'Or).

The statue of the Virgin, which we know that Claus de Werve carved and installed in 1426 behind the main altar in the church of Champmol, is destroyed. We can only surmise, with the help of the relief with the Virgin swooning at the foot of the Cross in the retable of Bessey-lès-Citeaux—a work by Claus de Werve—what may have been the relationship of his statue of the Madonna with those just mentioned, produced by the school of Dijon. These all certainly copied a monumental model, but this scale has survived only in the Virgin of Besançon. The other examples are little over half life size.

The sculptor of the Virgin of Besançon was also employed at Autun by Chancelor Rolin (1422-1462), as indicated by the statue of St. Mary Magdalen, today in the Rolin Museum at Autun, and especially by a remarkable fragment of a statue of the Virgin formerly in the Bulliot collection (present whereabouts unknown). From Autun the influence of our artist's workshop expanded in the region of the Loire (Virgins of Beaumont-sur-Loire and Verron). But it is essentially in Franche-Comté and in Besançon that his creations were centered. To cite only the groups of the Madonna and Child closest to the Virgin of Besançon, let us mention those in the churches of Rougemont and of Biarne, that of the Seminary in Besançon, the "Vierge du Prieuré" (Vesoul) and that of the "Soeurs Hospitalières de Saint Ferjeux," Besançon. There is furthermore the Virgin from the Franciscan Church in Dôle which may have been carved before 1429, the date of the consecration of the church. The county of Burgundy—Franche-Comté—had been incorporated in 1383 into the Duchy of Burgundy after the death of Louis de Male, when it was inherited by his daughter and sole heir, Margaret of Flanders. She had married successively two Dukes of Burgundy: Philip of Rouvres (d. 1361) in 1357, Philip the Bold in 1369. In terms of art history that incorporation was to mean that Franche-Comté became "porous" to the Northern Renaissance, the great art movement bridging over the possessions of the Dukes of Burgundy from Bruges to Dijon. Furthermore, it brought to Burgundo-Flemish art a contribution of its own: the influences from Lorraine, with which Franche-Comté was for centuries in contact. Features native to the stocky and severe sculpture of Lorraine are noticeable in the productions of the master of the Virgin of Besançon: the ponderous draperies that clog and weigh down the stance of his Virgins, their unusually pensive, and almost sad, withdrawn expression and the containment of the sweeping movement of the draperies between the verticals of falling folds.

The melancholy cast masking the face of the Virgin should be termed prophetic. The Child of the Walters group is holding a globe, on the top of which was fastened a cross (lost today) ; it is not the ordinary "T-globe" but a globe partitioned in four quadrants by an incised cross. The Christ Child is by anticipation designated as the Savior of the world and His infancy is made prophetic of His sacrifice. This latent symbolism explains why the Virgin looks like a standing Pietà. The same globe, as well as the same long garment of Christ, are found in the Vesoul group and also in another one, from an abbey of the Côte d'Or, which is now in the collections of the Wadsworth Atheneum, Hartford.

The long vestment worn by the Child in the groups by our master might be interpreted symbolically as an alb. His statues of the Virgin and Child generally illustrate the theme of the Virgin of Compassion, wherein the Virgin is shown by her own suffering to have shared since the very infancy of Christ the mystery of His redeeming Passion. Compare also the Burgundian statue of the Virgin and Child, now in the Liebighaus, Frankfort on Main. This compassionate iconography of the Virgin and Child was created in late Byzantine art and was channeled into the international art of western Europe around 1380. The fluted edge of the veil of the Virgin, one of the hallmarks of our master, seems to be connected with a Flemish fashion and perhaps, in the usage of the fifteenth century, carried a connotation of mourning.

The Virgin from Besançon, executed as it was for the Cathedral of the capital of Franche-Comté, represents the highest achievement of its sculptor, and inspired numerous imitations and derivations. Moreover, its very dimensions distinguish it. Compared to its height of 62 inches, the related groups in the Louvre, Cluny Museum, Rougemont, the Seminary of Besançon and at Hartford range in measurement from 37½ to 49 inches in height. All of these sculptures differ in stylistic handling from the Madonna and Child carved by Claus Sluter to stand against the trumeau of the Carthusian church of Champmol. Their draperies are heavier, if simplified; the emphasis is laid on the downward gravity of the drapery and on its extension in width. The slanting of the mantle across the body of the Virgin, falling no lower than the knees in front, like an apron, returns to a mid-fourteenth century formula. The mantle is wrapped across under the neck and over the head like a hood.

The Virgin of Besançon is certainly nearer in spirit and style to the statues of the prophets carved by Claus Sluter around the base of the Calvary in the cloister of Champmol. The "Virgo Dolorosa" of this Calvary is lost, but its souvenir seems to be preserved in a painting of the school of Dijon, possibly from Champmol, the Calvary with a Carthusian in the collection of the comtesse du Luart. The Virgin in this painting resembles the Virgin of Besançon in breadth of proportions and handling of drapery. The connection of the author of the Virgin of Besançon with the ducal workshop of Dijon is proved again, indirectly but unmistakably, by the diffusion of the type of his Madonnas to Spain after the sojourn of Jean de la Huerta in Dijon (1443-56). The Spanish sculptor had come to Dijon to take charge of the completion of the tomb of John the Fearless. The reflection of the type of the Virgin of Besançon after Jean de la Huerta's return to Spain may be seen in the Madonna of Santa Maria de Campos (Berga) and the Madonna and a female saint on the alabaster retable of the collegiate church of Daroca (Aragon).

The Virgin of Besançon has had an eventful history. In the middle of the sixteenth century, François Bonvalot, a canon of the Cathedral of Besançon and a friend of the powerful Cardinal Granvella who became Secretary of State to the Emperor Charles V, had our fifteenth-century statue of the Virgin enframed in an alabaster reredos. The reredos was erected in the chapel of St. Oyend—later dedicated to St. Denis—opening into the south aisle of the nave of the Cathedral. The sculptor of whom François Bonvalot commissioned the alabaster reredos flanked the statue of the Virgin with two smaller ones, one of St. Cecilia, the other of St. Barbara, also Burgundian sculptures of the fifteenth century, but of lesser quality. The assemblage of these three statues into a heterogeneous group was dictated by the desire to reuse venerated but outmoded works of art in a new decorative ensemble. This Renaissance reredos was dismantled towards the end of the

nineteenth century, because it was then deemed incompatible with the essentially Romanesque and Gothic structure of the Cathedral built in the twelfth and thirteenth centuries. The statues of St. Cecilia and St. Barbara may still be seen today in an aisle of the partly destroyed Gothic cloister of the Cathedral. At the beginning of the twentieth century, the statue of the Virgin was located there with them. Shortly after the enactment of the law separating the French State from the Church (1905), the Virgin of Besançon was disposed of and acquired by a French collector, M. Decailly, living in the Chateau St. Apollinaire, near Dijon. After the death of Decailly in 1932, the Virgin of Besançon was bought by a dealer and passed in 1938 into the hands of a Dutch collector, who had it expertized by Paul Gouvert. The French expert attributed the statue to Claus Sluter. From Holland it migrated to America at the outbreak of World War II and was kept in a warehouse in New York for twenty years.

Despite the fact that the statue left Besançon in 1907, the most highly qualified art critics, French as well as German, to have dealt with fifteenth-century Burgundian sculpture, wrote of it repeatedly between 1913 and 1950 as if it were still in the Cathedral.

CONDITION: Old photographs taken around 1904, when the statue was still in the cloister of the Cathedral, show dark polychromy on the faces, hands and hair of both figures, as well as on the Child's feet. This may well have been applied at the time of the sixteenth-century reinstallation of the statue. No evidence of polychromy on the garments shows in these old photographs. One of the subsequent owners removed the polychromy so far as possible (traces still remain), and covered the face of the Virgin with oil paint to match the stone color. Various damages had occurred to the sculpture—apparently subsequent to the 1904 photo: the edge of the mantle falling over the Virgin's left arm has been broken off; various other small areas and edges of projecting folds have been damaged or broken, as well as some of the folds near the feet. Some of these had (before 1959) been repaired with plaster and overpainted in oils to match the stone. Plaster repairs at the level of the forehead suggest that the top of the Virgin's head must have broken off and been replaced, and possibly the tip of the nose. Since coming to the Walters Art Gallery, the statue has been gently washed to remove grime; the modern oil paint over repairs, which had become discolored, was removed so far as possible. The yellowed oil paint on the face could not safely be removed, so the surface was lightly dusted with chalk.

PROVENIENCE: Cathedral of Besançon (Doubs); Decailly, Chateau St. Apollinaire (Côte d'Or); Simon Le Grand, Amsterdam; acquired in 1959 by the Walters Art Gallery.

BIBLIOGRAPHY: P. Vitry and G. Brière, *Documents de sculpture française du moyen âge*, Paris, 1904 (2nd ed. 1906), pl. CXI (4) (as second half of XV century)—Abbé P. Brune, "Statues de l'école dijonnaise à la cathédrale de Besançon," *Réunion des Sociétés des Beaux-Arts des Départements*, (Paris, 1906), pp. 114-118 and pl. XXIII opposite p. 116—R. de Lasteyrie, *L'architecture religieuse en France à l'époque gothique*, II, Paris, 1927, p. 426, 429—H. David, *De Sluter à Sambin, Essai critique sur la sculpture . . . en Bourgogne au XVème et au XVIème siècles*, Paris, 1933, I, p. XIV—G. Troescher, *Die Burgundische Plastik der ausgehenden Mittelalters*, Frankfurt a.M., 1940, I, p. 106, n. 277—M. Aubert and M. Beaulieu, *Musée National du Louvre, Description raisonnée des sculptures . . . I, Moyen Age*, Paris, 1950, pp. 224-5—*Connoisseur* (American edition), CXLVI (1960), p. 222, ill. p. 221—P. Verdier, "The Virgin from the Cathedral of Besançon," *Bull. WAG*, XIII, 6 (March 1961)—J. A. Schmoll gen, Eisenwerth, "Die Burgundische Madonna des Hamburger Museum für Kunst und Gewerbe und ihre Stellung in der Sluter-Nachfolge," *Jahrbuch der Hamburger Kunstsammlungen*, VI (1961), pp. 7-28—On the circle of the master of the Virgin of Besançon: L. Courajod, *La sculpture à Dijon*, Conférence faite à Dijon le 10 Juillet 1892, Paris, 1892—idem, *Monuments de la sculpture bourguignonne, Leçons professées à l'Ecole du Louvre*, II, Paris, 1901—A. Kleinclausz, *Claus Sluter et la sculpture bourguignonne au XVeme siècle*, Paris, 1905, p. 127—Abbé M. Ferry, *Vierges Comtoises*, Besançon, 1946—*Sculpture et Orfèvrerie de Franche-Comté* (Catalogue of the exhibition in the Palais Granvelle, Besançon, June-October 1960)—*Le Moyen Age et la Renaissance dans le nord du comté de Bourgogne* (Catalogue of the exhibition in the Musée Municipal, Vesoul, 14 May-16 October 1960).

PLATE LXXXV WALTERS ART GALLERY, inv. no. 27.560

82 BURGUNDIAN, ca. 1430

The Virgin and Saint John

Polychromed stone; 16¹³⁄₁₆ in. (.428 m.)

A group coming from a retable with the representation of Calvary.

The group differs from the traditional figures standing in sorrow on the right and left of Christ crucified, as it does also from the theme of St. John supporting the swooning Virgin, frequently repeated in Italian and German art of the fourteenth century. Mary and John are associated here in a synthetic expression of mourning. The unity of the composition and of the mood is so strong that it is only through a differentiation in the pattern, and an admirable one, that their heads droop in opposing directions. This sculpture testifies to the trend which isolated the different episodes of the Passion and treated them as images of devotion to be meditated upon separately. The great simplicity of the carving reduced to strong planes, separated by a few lines of monumental effect, evokes the tragic stone "Vierge Deuillante" of Flavigny in northern Burgundy, as well as the wood statue of the Virgin, in the same church, which is draped and hooded like a figure of a mourner. The group of the Virgin and St. John indicates to what extent Burgundian sculpture followed an evolution largely independent from the pictorial expressionism of Claus Sluter. The facial characteristics of St. John: minute and rather pinched features on a broad visage, recall those of the Burgundian statue of the same saint in the Liebighaus, Frankfort on Main. There is an energy in the construction of the group and a Germanic intimation in the ethnical rendering of the figures which suggests a connection with Lorraine, as does a similar group in the Museum of Fine Arts, Boston (n. 46.2).

PROVENIENCE: Acquired by Henry Walters in 1925.

BIBLIOGRAPHY: C. Sommer, "The Prophets of Saint Antoine-en-Viennois," *JWAG*, XIII-XIV (1950-51), pp. 9-19, fig. 1 (as close to the style of the archivolt figures of the portal of St. Antoine-en-Viennois. However, the author's attribution to a Netherlandish artist and to a date as early as 1411-25 is not substantiated by the documents.)

PLATE LXXXIV WALTERS ART GALLERY, inv. no. 27.274

83 BURGUNDIAN, second quarter of the 15th century

Saint John the Baptist

Limestone statuette with traces of red, blue and yellow polychromy; 24½ in. (.623 m.)

This statuette of St. John the Baptist demonstrates the enduring influence of the revolutionary school of sculpture established in Dijon by the Dutch artist Claus Sluter towards the end of the fourteenth century, and in particular the influence of the statues of the four prophets placed around the foot of the Calvary called the "Well of Moses," in the great cloister of the Carthusian monastery of Champmol. Like another statue of St. John the Baptist in the Rolin Museum, Autun, this one is an adaptation of the Zacharias of the "Well of Moses." But it recalls much more the statue of St. John the Baptist holding an open book in the chapel of Rouvres near Dijon—one of a set of three, with the Virgin and John the Evangelist, above the retable.

The retable of Rouvres is associated with the Mâchefoing family. Philippe Mâchefoing, "vicomte-mayeur" of Dijon, commissioned works of art of the Aragonese sculptor Jean de la Huerta who took over the completion of the tomb of John the Fearless in Dijon in 1443. The artist who carved the statue of St. John the Baptist at Rouvres was very probably the same who carved this statuette belonging to the Pierpont Morgan Library. It would be tempting to identify him with Jean de la Huerta if the attribution of the statues of Rouvres to that artist were proven by documents, rather than merely representing a plausible hypothesis.

It may be remarked that the statue of St. John the Evangelist at Rouvres compares in its turn with that carved above the tomb of Abbot Amé de Chalon (d. 1431) in the church of Baume-lès-Messieurs, so that there is substantial reason not to date the Rouvres and Morgan statues as late as ca. 1450. What is certain is that the artist, whoever he was, responded especially to that aspect of the genius of Sluter which was concerned with characterizing the individual features of old men. The wrinkles, the hair and beard delineated to the last detail, all the minute epidermic blemishes on face, arms and hands, which seem the physiological deposits of life experi-

ence, are registered almost *ad infinitum*. In the art of Sluter such an introspective crystallography never disturbs the ponderous mass of the carved block. Here the relationship has become somewhat loose between movement and monumentality. The modelling as expressed in the draperies has become glittering and brittle. The mood of the old prophet caressing the Lamb is more affectionate than ascetic. The gentle twilight pervading the group measures the distance between one of the most accomplished achievements of Sluterian art and the *terribilità* of Claus Sluter himself.

CONDITION: Damages to the top of the fourth finger on right hand; fold nearest forefinger of left hand; various breaks in long folds of garment, especially along ridges and ends of the drapery caught up over left arm, and the knot on the shoulder. The right foot and most of the base have been restored and a tip of the drapery.

PROVENIENCE: Collection of Felix M. Warburg, New York. Gift of Mrs. Warburg, in memory of her husband, June, 1941.

BIBLIOGRAPHY: W. R. Valentiner, *French Gothic Art*, Detroit Institute of Arts, 1928, n. 40—W. Heil, "Kunstwerke der französischen Gotik, Leihausstellung im Museum zu Detroit," *Pantheon*, III (1929), p. 76, ill. (as workshop of Claus Sluter)—G. Troescher, *Claus Sluter und die burgundische Plastik um die Wende des XIV Jahrhunderts*, Freiburg i.B., 1932, pp. 78-79, 179, n. 215—W. R. Valentiner and G. H. MacCall, *New York World's Fair: Catalogue of European Painting and Sculpture*, New York, 1939, p. 213, n. 428; cf. *Guide and Picture Book*, n. 10 (as by Claus Sluter)—The Pierpont Morgan Library, *Review of the Activities and Major Acquisitions . . . 1941-1948*, New York, 1949, p. 98, pl. 12—Cf. P. Quarré, "Une Vierge de Poligny attribuée à Jean de la Huerta," *Mémoires de la Commission des Antiquités de la Côte d'Or*, 1961 (for the discussion of the question of Jean de la Huerta authorship of the Virgin at Poligny and of the three statues at Rouvres).

PLATE LXXXVI THE PIERPONT MORGAN LIBRARY

84 ENGLISH (Nottingham), end of the 14th century

Trinity with Symbols of the Evangelists

Alabaster relief; 27⅝ x 20¾ in. (.701 x .502 m.)

This composition, symbolical of the Trinity, goes usually by the name of "Throne of Grace" which, however, is not medieval. The "Throne of Grace" is the Lutheran translation of what the King James version of the Old Testament renders as the "Mercy Seat." The "mercy seat of gold" was put in the Ark and in the ceremonies of atonement it was sprinkled with the blood of a bullock (Exodus 25:21; Leviticus 16:14). St. Paul referred to the "Throne of Grace" as a symbol of propitiation through faith in the blood of Christ for the remission of sins (Romans 4:25, cf. Hebrews 4:16 and 9:5). The same relationship had already been established in the twelfth century by theologians and expressed by artists in the decoration of portable altars and of the illuminations of the Canon of the Mass in manuscripts. It is therefore probable that this relief, which was carved in alabaster in the region of Nottingham, England, hung above the center of an altar, and that it was embedded in the wall before which the altar stood.

God the Father is represented with the cross-nimbus, attribute of Christ because He created the world through the Logos, and his features are those of Christ, as the theological rule would have it in the Middle Ages. He is blessing and holding the globe, emblem of the power of Christ on earth. In the globe, crenellations allude to the three continents circumscribed by the Ocean, schematized as waves. A similar globe of the universe held by Christ is to be seen on a stained glass window in the Cathedral of Chartres (window CXXXVIII in Houvet's catalogue). The "Throne of Grace" is set in heaven, signified by the mandorla, above the visible sky, represented by a rainbow on which God the Father rests His feet. Christ crucified is applied against the bosom of the Father. The Dove of the Holy Spirit, uniting the Father and the Son, also connotes the ghost which Christ gave up on Calvary, allegorized here by the skull at the foot of the Cross. As in the theophanies of the Majesty of the Lord, the vision is encompassed by the symbols of the Four Evangelists.

The face of God is still imbued with the idealism encountered in High Gothic art, which is found in the earlier alabaster Holy Trinity in the National Gallery, Washington (Kress Collection). The Decorated Style of English Gothic lingers also in the inverted ogee arch delineated by the mantle of the Father. But the draperies are not florid and the type of Christ crucified no longer broken, as in the first half of the fourteenth century, but hanging limp on the Cross, is one met in England only rather late in the second half of the fourteenth century. The square rosettes, descendants of the "ball flowers" of English Early and Decorated Gothic, studding the mandorla frame, betoken also a sculpture executed in the last quarter of the fourteenth century.

PROVENIENCE: Acquired by Henry Walters from G. R. Harding in 1919; cf. another Trinity in alabaster in the possession of G. R. Harding, *Archaeological Journal*, LXXI (1914), pp. 162-164, pl. IV, fig. 3.

BIBLIOGRAPHY: A. S. Tavender, "Medieval English Alabasters in American Museums," *Speculum*, XXX (1955), p. 65, n. 12—W. L. Hildburgh, "Seven Medieval English Alabaster Carvings in the Walters Art Gallery," *JWAG*, XVII (1954), pp. 30-33, figs. 11-13.

PLATE LXXII WALTERS ART GALLERY, inv. no. 27.307

85 ENGLISH (Nottingham), ca. 1430

The Annunciation

Alabaster relief with remains of polychromy; 15⅞ in. x 10¼ in. (.40 x .26 m.)

This panel with two others, the Resurrection and the Assumption of the Virgin, in the Walters Art Gallery (and two others, now missing), was part of an alabaster reredos in the chapel of the Chateau of Bruniquel (Tarn et Garonne). The original five-panel reredos must have been commissioned in the last period of the English occupation of southwestern France before the end of the Hundred Years' War (1453), dating probably in the early thirties of the fifteenth century. It is a notable example of the potentialities for rich and delightful decorative patterns that remained in the wake of the International Style.

The Virgin turns toward the Angel, who arrives from the left, in a contrapposto movement taken over from a time-honored iconographical feature in the representation of the Annunciation in early Christian art. She is designated as Queen of Heaven by her coronet. Gabriel wears on his headdress the cross, emblem of his archangelic status. God the Father, on whose breath the Dove of the Holy Spirit descends towards the Virgin, occupies a balcony painted with clouds, which was copied by the sculptor after a feature of the stage-setting in a mystery play. The composition is teeming with details in which realism and symbolism are blended. For instance, the turreted canopy above the reading desk of the Virgin alludes to the castle in heaven in which the angels rejoice, and it is draped with the curtains of the bridal bed of the Virgin. The tall lily in the vase between Mary and Gabriel denotes the supernatural purity of the conception of Christ, as well as the mystery of the Trinity, since it carries three blossoms.

PROVENIENCE: Chateau de Bruniquel (Tarn et Garonne); Collection of Mme. d'Ouvrier de Villeglay' (sale, Paris, Dec. 23, 1926); Ferdinand Schutz, (Sale, Paris 10 June, 1928). Acquired by Henry Walters in 1928.

BIBLIOGRAPHY: A. S. Tavender, "Medieval English Alabasters in American Museums," *Speculum*, XXX (1955), p. 65, n. 8—W. L. Hildburgh, "Seven Medieval English Alabaster Carvings in the Walters Art Gallery," *JWAG*, XVII (1954), pp. 19-33, fig. 3.

PLATE LXXIII WALTERS ART GALLERY, inv. no. 27.309

86 FLEMISH, ca. 1400

Statuette: The Virgin Nursing the Child

Walnut; 5¾ in. (.147 m.)

The Virgin is seated on a rounded bench, wearing a full dress gathered at the neck. The mantle

covering her head is draped in ample folds curving around her knees. The Child turns from His nursing to extend His blessing.

This charming group, which has been compared to French ivory carvings of the same period, is undoubtedly a Flemish work, as is shown by its mood and style. The pattern of the draperies, the sense of the form as an enveloping mass, are closer to that encountered in sculptures and paintings of western Flanders (cf. the corbels executed for the Town Hall in Bruges, as well as sculptures by Jean de Valenciennes or paintings by Melchior Broederlam and his school) rather than to works from Tournai or by artists of Brabant, such as the wood retable of Haekendover.

PROVENIENCE: M. T. Schiff (Sale Catalogue, Paris, 1905, n. 439, p. 50, as German, fifteenth century); George and Florence Blumenthal.

BIBLIOGRAPHY: S. Rubinstein-Bloch, *Catalogue of the Collection of George and Florence Blumenthal*, II, *Sculptures and Bronzes*, Paris, 1926, pl. II (as northern French or Flemish, early 15th century).

PLATE LXXIV METROPOLITAN MUSEUM OF ART, no. 41.100.203
Gift of George Blumenthal, 1941

87 FLEMISH, early 15th century

Apostles in Prayer (or Pentecost?)

Carved oak; without plinth: 19½ x 12¾ in. (.496 x .325 m.)

The subject of the Twelve Apostles gathered in common meditation and prayer is extraordinary. The group was probably part of a retable of the Passion. It may be compared to an analogous subject carved in ivory (Cat. no. 117), which is a fragment surviving from an ensemble of plaques illustrating the story of the Passion and forming a sort of ivory reredos.

The closest analogy in sculpture to this woodcarving of the Apostles in prayer is presented by a series of stone reliefs on a tabernacle in the choir of St. Martin's at Hal, Belgium. These depict the Last Supper, the Washing of the Feet, the Entry into Jerusalem and Gethsemane. The Hal tabernacle preserves an inscription on one of its brass doors giving the date and the names of three artists: "Henderic van Lattem + en de Meyere + en Claes de Clerc. ghedaen Yn Yar ons heren MCCCC en IX." The stylistic resemblances are so striking that one is justified in surmising that one of the three artists mentioned may have carved our wooden group of the Apostles. The circular composition, the tapering silhouettes, the way in which the figures overlap each other to reinforce the impression of close intimacy, the spiritual tension conveyed by the sweeping pattern of the garments breaking into waves at the feet of the Apostles which seem to belong to the community rather than to individuals—all these are characteristics which one notices on the stone carvings of the tabernacle of Hal. Concerning the latter, it has sometimes been noted that the feeling of their execution evokes the technique of woodcarving.

PROVENIENCE: George Hoentschel Collection; J. Pierpont Morgan.

BIBLIOGRAPHY: A. Pératé and Gaston Brière, *Collections Georges Hoentschel . . . I, Moyen-âge et renaissance*, Paris, 1908, p. 14, pl. III (as German, early 16th century)—Metropolitan Museum of Art, *Catalogue of Romanesque, Gothic and Renaissance Sculpture*, New York, 1913, n. 277.

PLATE LXXX METROPOLITAN MUSEUM OF ART, no. 16.32.214
Gift of J. Pierpont Morgan, 1916

88 FRANCO-FLEMISH, early 15th century

Head of an Angel

Marble; 5 in. (.128 m.)

This head, the provenience of which is unknown, reminds one of the angel of an Annunciation in the Julius Böhler Collection, Munich (cf. catalogue of the exhibition: "Europäische Kunst

um 1400," Vienna, 1962, n. 431). The expression and the structure of the face appear to be Flemish, although one could think also of those hybrid forms that resulted in Lombardy and along the Adriatic coast from the work of German or Netherlandish wandering artists interacting upon the Italian tradition. The type of hair, in which the spiral baroque locks enframing the face contrast with the simple incising of the strands on the crown of the head, remained a stereotyped Flemish formula. It still corresponds also to a treatment usual in French sculpture of the last decades of the fourteenth century, such as on the angel in high relief holding a scroll, in the Morgan Collection of the Metropolitan Museum. The head of an angel here exhibited is probably a work of the Franco-Flemish school.

CONDITION: A fault in the marble above the eyebrows and around the crown of the head.

PROVENIENCE: R. Heim Collection, Paris.

PLATE LXXVIII JACQUES SELIGMANN & CO.

89 FRENCH, ca. 1375

Madonna and Child

Marble relief; 14¼ x 8¼ in. (.363 x .21 m.)

The themes combined by the artist in this group are found in Tuscan art of the fourteenth century (the Child holding a bird and playing with the veil of His mother), and in French art (the Virgin holding a lily). The group reflects the style of monumental sculpture of the mid-fourteenth century, as it became mannered and reduced in the imitative small sculptures of ivory and boxwood of the second half of the fourteenth century. To confirm this process of adaptation, one may note the similarity between the stone sculpture in the Louvre (inv. R.F. 956) of the Virgin and Child under a canopy, from a church in the region of Nevers, and a small boxwood group of the Madonna and Child formerly in the Spitzer Collection (E. Molinier, *Catalogue Collection Spitzer*, Paris, 1892, III, p. 257, n. 10). Moreover, one may remark the resemblance of both sculptures with this marble relief. Notice in particular the posture of the Child and His nakedness or semi-nakedness in the three examples. The importance of ivory sculptures as intermediaries should also be mentioned. In structure the facial type of the Virgin is not unlike that of a group of ivory statuettes dated by Koechlin around 1400, but the expression is here serene and happy, not melancholy and pensive. Together with a less complicated handling of the draperies, it indicates a date earlier than the turn of the fourteenth century.

PROVENIENCE: Docteur L. de Saint-Germain (sale, Paris, 29-30 May, 1902, n. 83, as Italian, 14th century).

EXHIBITION: "Arts of the Middle Ages," Museum of Fine Arts, Boston, 1940, n. 164 (as North Italian, end of 14th century).

BIBLIOGRAPHY: *Bull. WAG*, VI, 3 (1953), ill.

PLATE LXXIV WALTERS ART GALLERY, inv. no. 27.14

90 FRENCH (Ile de France), ca. 1375

Virgin and Child

Limestone; 29⁷⁄₁₆ in. (.745 m.)

This statue is supposed to have come from the church of Meulan. It seems, indeed, to belong to a school of sculpture which includes—along with a part of the Ile de France northwest of Paris (old Vexin Français) —the bishopric of Evreux. The Virgin, standing, holds in her right hand

a broken lily. Her left arm supports the Child, Whose body is wrapped in a part of her mantle. The mantle also serves as a veil over the head of the Virgin, a combination which is a rule in fourteenth-century sculpture, when the Madonna is seated, but does not occur so frequently when she is standing. This dignified way of unifying the head and body in the ample move: ment of drapery befitting a matron was adopted by Gothic sculptors from Greco-Roman sculpture (statue of the Virgin in the Visitation group on the western façade of the Cathedral of Reims, wood statue—destroyed in June 1940—in the church of Montiérender). The Child plays with a fold of His mother's veil with His right hand, and clasps a prayer-book in the left. The graceful composure of the Virgin results from her stance, poised on the left leg, while the right is relaxed. The pose entails a lowering of the right shoulder, and a slight *hanchement,* balanced by the direction given to the head, so that the movement of the planes is like a graceful S running diagonally from the tip of the right shoe of the Virgin to the vertical axis of her face. These were current principles in northern French sculpture of the fourteenth century for the group of the Madonna and Child.

Other characteristics denote a date relatively late in the evolution of this school. The Virgin and Child turn towards each other in an intimate relation which, however, remains understated, because the gaze of the Virgin pensively strays beyond the Infant Christ. Her mantle is represented as of a delicate texture, allowing for effects of transparency. The folds, unrealistically multiplied, are thinly piled over each other. The artist was preoccupied more with a modelling of the surface in pictorial terms than in asserting plasticity. The statue was not conceived only from a single frontal point of view. Both side views are equally important in the definition of its depth and, as the fully carved back indicates, the figure was intended to stand isolated and bathed evenly by light.

The use of the mantle for wrapping the Mother and the unclad Child in a unity of covering was a preferred type of the Ile de France school in the region bordering Normandy, from the first decades of the fourteenth century (cf. statue of Mainneville, from the chapel of the chateau of Chancellor Enguerrand de Marigny, and that of St. Gervais, Gisors; statuette in *vermeil* given by Jeanne d'Evreux in 1339, today in the Louvre). The complexity of drapery in our statue of the Virgin, to some extent her facial type and especially the way in which the locks of her hair curl loosely in the recesses of the veil, are echoed in the statues of Chateaudun, Mézières (Eure) and Fosses (Seine et Oise). At this stage of slow transformation in the type of the Virgin, usually her mantle is tucked up in a sweeping movement toward the folds that cascade from her left arm, revealing the robe beneath. But we are confronted here with a rather uncommon contrapposto: the triangular organization of folds running across the torso and down the swaying left hip and leg, is echoed on the other side by a sunken zone, shaped like a second triangle wedged under the right hand of the Virgin, which leaves the robe uncovered, except for an overlapping point of the mantle along the leg. This method of distributing the drapery of the mantle and robe (which is a compromise with the more frequent formula of a mantle open on both sides) appeared soon in the fourteenth century (statue of St. Barbara, at the portal of the north transept of Rouen Cathedral), but especially in eastern France and Burgundy (statues of the Virgin at Dommarien, Haute-Marne, and St. Thibault-en-Aussois, Côte d'Or). It is met in a few ivory statuettes of the second half of the fourteenth century, which may have originated in Champagne, rather than in Paris.

CONDITION: Right hand of the Virgin, both arms of Christ, right corner of base and fragments of drapery restored in plaster. The head of Christ, which must have been carved separately, is missing.

PROVENIENCE: Acquired by Henry Walters in 1910.

PLATE LXXVI WALTERS ART GALLERY, inv. no. 27.271

91 FRENCH (Champagne), ca. 1410-1420

Head of Christ

Limestone; 10¼ in. (.260 m.)

In the distinctive features of this head there is a souvenir of the style proper to the sculptors employed by the duc de Berry: André Beauneveu (d. ca. 1408) and his successor, Jean de Cambrai. We may cite in this connection the prominent cheek bones and hollow cheeks, the delineation of the eyebrows and eyelids, the engraved pupil and iris and the wrinkles spreading from the corner of the eyes, and especially the carving of the under-lip and the pattern formed by the moustaches softly mingling with a short, rounded beard divided into two main tufts. We have here the aftermath of a school which was active at Bourges and Mehun-sur-Yèvre, but of which, outside of Berry, we know but little (cf. however the gilt bronze statuette of a kneeling prophet in the Louvre, Decorative Arts, Inv. No. OA 5917).

This head comes from a statue of Christ of the type called in the fifteenth century, "Dieu Piteux"—a creation of the school of Champagne. At any rate, such statues of Christ seated, crowned with thorns and stripped of His clothes, forlornly waiting for the Cross of martyrdom to be ready, are most frequently met with in Champagne. Their origin is two-fold: in the Mysteries of the Passion of Christ, in which a character of the drama impersonated Christ waiting to be nailed on the Cross, and the images of devotion which transformed in a western manner the theme of the Man of Sorrows created in Byzantium. The head on exhibition is probably one of the earliest surviving examples in sculpture of the late medieval iconographical theme of the *"Dieu Piteux."*

CONDITION: Abrasions of the nose and down to the upper lip and on both eybrows. The hanging locks of hair are broken off. Many damages around the crown of thorns. The absence of weathering confirms the relation of the head to an indoor statue of a *"Dieu Piteux."*

PROVENIENCE: Said to have come from the church of Ervy-le-Châtel (Aube). This statement probably indicates only an origin in Champagne. The church of St. Peter at Ervy is late fifteenth century (nave) and sixteenth century (chevet). The statues and the stained glass there date in the sixteenth century. The statues and statuettes—a score of them—constitute a celebrated ensemble of late Gothic and early Renaissance statuary of the school of Troyes. Joseph Brummer Collection (sale catalogue, New York, 1949, pt. III, n. 397). Acquired by the Walters Art Gallery in 1949.

BIBLIOGRAPHY: "A Portfolio of New Accessions, Selections from the Brummer Collection," *JWAG*, XII (1949), ill. (as ca. 1400).

PLATE LXXVIII WALTERS ART GALLERY, inv. no. 27.528

92 FRENCH, first quarter of the 15th century

Two Carthusian Monks in Prayer

Marble; each 10 in. high (.255 m.)

The great interest presented by these figures is that they belong to the extremely rare surviving examples of carved Carthusian monks in the history of fifteenth-century French sculpture. The two monks wear the *scapulaire* of the Carthusian order with its two panels connected on either side by a band between hip and knee—a feature seen also in the statuettes of the two Carthusians who participate in the pageant carved by Claus Sluter and Claus de Werve around the tomb of Philip the Bold in Dijon. The kneeling figures here exhibited are not, however, related to the art of Claus Sluter. They belong to the *idealistic* and not to the *realistic* branch of the International Style, and should rather be connected with the *angelets,* that is the small figures of angels interspersed between the pinnacles of the Dijon tomb, which Pierre Beauneveu began to carve in 1391. Possibly the two monks were kneeling on both sides of a Crucifixion or of a statu-

ette of the Virgin in the cell of a Carthusian monk. We know from a description of the Carthusian house of Paris (Vauvert-Gentilly), given by A. L. Millin in Volume Five of his *Antiquités Nationales,* that the cells might be adorned not only with paintings (as at Champmol) but with sculptures. In size and posture the two kneeling Carthusians recall a group set on brackets at the foot of the tomb of Pierre de Navarre and his wife Catherine d'Alençon (ca. 1412), that was installed in an *enfeu* (niche) in the Carthusian monastery of Paris. An engraving in the *Recueil* of Roger de Gaignières (1642-1715) has recorded for us the aspect of this tomb. The two *gisant* figures were carved lying in state on a slab of blue-black marble (Tournai marble), a fashion which had been established by the tomb of Philip the Bold. On a bracket at their heads Abraham, holding the two souls in a fold of his mantle, stood between four statuettes of Carthusians. At their feet, a bishop, or abbot, was delivering the final absolution between two kneeling Carthusians, reading their prayer-books. Since the two exhibited figures of Carthusians are flat on one side, they must have been applied against a background and, in view of their posture, they could not have been part of a moving funeral procession. Consequently, their original location was probably not the dado of a free-standing tomb, but the wall of an alcove sheltering the tomb, as in the example recorded by the Gaignières engraving—a very plausible suggestion which I owe to Mr. Germain Seligman. If such were the case, the two statuettes are unique documents, because no other sculptures intended for such a location in relation to the tomb have survived from a French Carthusian house. (The *gisant* figures mentioned are in the Louvre).

CONDITION: Heads broken at the neck and replaced; hoods chipped here and there. Small restorations on the cowls of each figure.

PROVENIENCE: Octave Homberg Collection.

BIBLIOGRAPHY: G. Migeon, "Collection O. Homberg," *Les Arts* (December 1904), p. 36, with an English translation.

PLATE LXXXII

JACQUES SELIGMANN & CO.

93 LORRAINE, last quarter of the 14th century

Statue of Saint Peter Enthroned

Polychromed limestone (polychromy renewed in modern times); 47 in. (1.19 m.)

The ultimate prototype of this statue of St. Peter is the famous bronze statue in the basilica of St. Peter, Rome, which showed to generations of medieval pilgrims St. Peter enthroned, draped as a Roman senator, holding the keys and blessing. The Roman statue of St. Peter may be a remarkable example of the renaissance of ancient sculpture in Italy around 1300, rather than an early Christian original, but the copies it inspired in northern Europe are purely Gothic in spirit and form. It should be noted, however, that this subject afforded a privileged theme for the new artistic ideal of the isolated statue, as opposed to the medieval tradition of the statue as a part of a monumental program. Some stylistic features of our statue, such as the hair and beard treated in conventional and symmetrical whorls, the concentrated and, as it were, anxious expression conveyed by the knit eyebrows, had their forerunners in a workshop of southern France (statues of around 1321-1348 from the Chapel of the Franciscan college of Rieux, now in the museum at Toulouse).

This statue of St. Peter has great importance in connection with the new iconography of the Popes that started with their exile in Avignon during the fourteenth century. First of all, it displays the tiara with the triple crown, the *triregnum,* which was adopted by the Avignon Popes and later brought to Rome. In a drawing by Montfaucon of the tomb of Benedict XII (1334-1342), preserved in the Bibliothèque Nationale, Paris, and in the effigies of the tombs of Clement VI (1342-1352) at la Chaise-Dieu and of Urban V (1362-1370) in Avignon, the Popes appear crowned with the new *triregnum.* The type of the *triregnum* of our statue of St. Peter

compares best with that of the Montfaucon drawing. However, instead of being made only of gold circlets and trifoliate finaials, it is enriched here with gems (*triregnum pretiosum*). The tiara itself is white (the alternative color was red). St. Peter blesses with his right hand covered with a glove. After his coronation, the new Pope would wear the pontifical gloves which designated him as Priest-King (*Ordo Romanus* 13, n. 8, 14 c. 19). He wears also the red pontifical mantle (*Cappa Rubea* or *Mantum*) and the pontifical shoes.

The meaning attached by the Popes of Avignon to the *triregnum* is demonstrated by a curious and little-known document: the fourteenth-century statue, also of the school of Lorraine, in the Saarland Museum, Saarbrücken, in which St. Peter, fully dressed in the Pontificalia of the Coronation has the *triregnum* tiara placed on his head by two angels.

PROVENIENCE: Acquired by Henry Walters in 1919, as coming from a church in the neighborhood of Verdun.

PLATE LXXXVIII WALTERS ART GALLERY, inv. no. 27.269

94 MOSAN, last quarter of the 14th century

Statue of an Apostle

Marble; 19¼ in. (.490 m.)

At the time this statue was exhibited in Boston in 1940 it was thought to have come from the choir screen of the Cathedral of St. Lambert, Liège, which was destroyed during the French Revolution in 1794-5. That supposition seems to be unwarranted, since the screen of the eastern choir (Choeur des Tréfonciers) was decorated in the seventeenth century by Robert Arnold, and we know almost nothing concerning another and Gothic jube, at the entrance of the western choir of the cathedral (Chapel of Sts. Cosmas and Damian).

This statue of an undetermined Apostle reminds one of the sculptures of the Bethlehem portal behind the choir of the Church of Our Lady at Huy, in the Meuse valley, and in particular of the Joseph of the Nativity tympanum and of one of the kings in the Adoration of the Magi tympanum there. The mood of the face of the Apostle, the dejected inclination of his head, the delineation of his hair with a cluster of short locks at the middle of the forehead, the strong nose and flaring nostrils, resemble features in the Huy St. Joseph. The cascading draperies, the gesture of the right hand with upturned thumb pressing against the chest, the cut of the mantle and the way it is held tucked up by the left arm, falling in a sinuous cascade, the strong V-shaped folds across the abdomen, are very much the same in our Apostle and the standing king of the portal.

The sculptures at Huy, in which an unmistakably Germanic accent is felt, were, however, executed in a freer vein. Their complicated modelling was realized through daring undercuttings and not by the method of linear relief, as in the case of the Apostle statue. On the other hand, other models and suggestions are to be considered, not in the range of monumental sculpture, but in the category of alabaster sculptures. In the Diocesan Museum at Liège are two alabaster Apostle statues, identified as Andrew and Paul, which approximate the exhibited Apostle in size and style. The two other Apostles from a private collection, once part of the same group, were exhibited with them at Liège in 1905 ("Exposition de l'art ancien au Pays de Liège"). Possibly these four pieces were executed in a workshop active in Lille during the reign of Philip the Bold, Duke of Burgundy. Perhaps one might attribute other alabaster statues to the Lille atelier, for instance the Flemish alabaster groups from a Passion series originally in the Collegiate Church at Huy, now in the Metropolitan Museum, New York.

NOTE: I am indebted for the information about the four Liège statues to Mr. John W. Williams, of the Fine Arts Department, Swarthmore College, Pennsylvania, and to M. Joseph Philippe, Conservateur des Musées d'Archéologie et d'Arts Décoratifs, Liège.

EXHIBITIONS: "Arts of the Middle Ages," February 17 to March 24, 1940, Museum of Fine Arts, Boston, Catalogue n. 188, p. 57, pl. LVII.

PLATE LXXVII THE UNIVERSITY OF MICHIGAN MUSEUM OF ART, 1957/2.3

95 PROVENCE, ca. 1373

Saint Elzéar of Sabran Healing Lepers

Fragment of tomb; marble relief formed of two pieces cemented together; 17³⁄₁₆ x 14¾ in. (.43 x .37 m.)

Of the reliefs depicting the miracles of St. Elzéar of Sabran and his wife, Delphine of Glandèves, three remain: one in the Louvre (Inv. R.F. 1676), one in the Metropolitan Museum (n. 27.78) and the present one in the Walters Art Gallery. Casts of two lost reliefs of miracles are preserved in the Borély Museum, Marseilles. In these and in the Walters relief, St. Elzéar wears the habit of the Capucine order, with the leather belt buckled low at the waist.

St. Elzéar, count of Arian, born in 1285, in the castle of St. John of Robians, in Provence, married Delphine of Glandèves. He died in Paris in 1323. His body was brought back to Provence on a stretcher covered by a pall strewn with silver tears, in a funeral pageant which deeply impressed the population of southern France and started rumors of miracles performed by the relics of the holy man. St. Elzéar (whose name is the same as that of Lazarus, the patron of lepers and beggars) was buried in the church of the "Cordeliers" (Franciscans) in Apt (Vaucluse). The remains of Delphine of Glandèves were laid beside his in 1358.

The couple's reputation for holiness was sanctioned by a bulla of Pope Urban V in Avignon, January 5, 1369 (new style). Elzéar was declared a saint and Delphine became the blessed Delphine. Cardinal Anglicus, Bishop of Albano, brother of the reigning Pope and a relative of Elzéar and Delphine, commissioned the erection of a tomb shaped as a tall pyramid, reaching the vault of the church behind the main altar. The relics were solemnly translated to the new monument on June 18, 1373. The commemoration of the translation of the relics of Elzéar and Delphine was inscribed at this date in the martyrology of the Franciscan third order. It was to ornament the base of this monument of 1373 that the reliefs which concern us were carved.

The surviving groups from Elzéar's tomb are important evidence of a school of sculpture in southern France showing little or no influence of the Italian artists then active in nearby Avignon. They may be compared with another south French tomb relief (Cat. n. 97) for the emphasis on repeated verticals only slightly varied by the rippling folds usual in the International Style. They have a popular, forthright quality of observation and a rather naive rendering. The dresses of the lepers, hardly different from the frock and mantle of St. Elzéar, record the uniforms worn in the "lazarets" or places of confinement assigned to them. The blisters of their disease are clearly marked on their faces. St. Elzéar, meek and gentle in manner, performs his miracle by touching the contagious hands.

PROVENIENCE: Aymard collection, Apt. Acquired by Henry Walters in 1925.

BIBLIOGRAPHY: Père Borely, *Les miracles de la grâce victorieuse de la nature ou vie de Sainte Delphine vierge et épouse de Saint Elzéar,* supplemented with Abbé Gay, *Précis historique sur la canonisation et le culte de Saint Elzéar,* Carpentras, 1844—Abbé Arnaud d'Agnel, "Fragments d'un bas-relief provement du mausolée de Saint Elzéar de Sabran," *Bull. archéologique du Comité des travaux historiques et scientifiques* (1907), pp. 416-423, pl. XLIX-L; *ibid.* (1911), pp. 361-386, pl. XXX-XXXI—J. Breck, "A Marble Sculpture of Saint Elzéar," *Bull. MMA,* XXIV (1929), pp. 213-215, ill.—Notice by Michèle Beaulieu in M. Aubert: *Musée National du Louvre, Description raisonnée des sculptures . . .* I, *Moyen Age,* Paris, 1950, pp. 184-185, n. 266, ill.—*Europäische Kunst um 1400,* Catalogue of the exhibition, Vienna, 7 May-31 July, 1962, n. 405.

PLATE LXXI WALTERS ART GALLERY, inv. no. 27.16

96 SLUTER, CLAUS and CLAUS DE WERVE, Netherlandish, first decade 15th century

Statuette of a Mourner from the Tomb of Philip the Bold

Vizille alabaster (Grenoble stone); 16¼ in. (.413 m.)

Philip the Bold (1342-1404), Duke of Burgundy and Regent of France, planned well ahead for the splendid tomb which he wished to be his memorial after death. As early as 1381 the original conception of the monument was initiated by Jean de Marville, and yet when Philip the Bold died in 1404, the tomb was still six years from completion. Jean de Marville died in 1389, and his workshop was reopened by one of his helpers, Claus Sluter, a sculptor from Haarlem in Holland, who had been invited in 1385 to participate in the ambitious program of sculpture at the Carthusian monastery of Champmol, which Philip the Bold founded that year.

The tomb which the duke planned for himself was to be set up in the choir of the monastery church. Like the other major undertakings inaugurated there by Philip the Bold—the sculptured portal of the church and the Calvary (so-called "Well of Moses") in the cloister—the tomb was a collective work undertaken in the anonymous spirit of medieval tradition. We know, however, the names of the carvers who were the companions of Sluter when he was under the authority of Jean de Marville and after he was promoted to be leader of the workshop on August 20, 1389. All the craftsmen and artists came from the regions across the boundary of northern France, especially from Tournai and Hainaut. Two deserve a special mention: first, Pierre Beauneveu—apparently a relative of André Beauneveu who had executed the tomb of Louis de Male, father-in-law of Philip the Bold, and been appointed sculptor to his brother, Jean de Berry—secondly, Sluter's nephew, Claus de Werve, who joined the workshop December 1, 1396.

The fundamental ideas which dictated the layout of the tomb of Philip the Bold are rooted in the funeral sculptures executed in the late thirteenth century for the court of France—in the abbey churches of Saint Denis and Royaumont—and in the tomb carvings in blue Tournai marble made in Tournai and the Mosan region in the fourteenth century. In the choir of Champmol, from 1411 until the French Revolution, Philip the Bold lay in state, as a monumental portrait carved and painted (the polychromy was added by Jan Malwael) on a slab of blue marble. Blue was also the base of the tomb. Between the two marble slabs was a dado in stone veneered with alabaster and surrounded by a miniature cloister in openwork made of sixteen double arcades with hanging key-stones and intermediate arcades supported by ringed shafts, all in alabaster and surmounted by fifty-four statuettes of angels and a continuous *orbevoie* (a sort of decorative balustrade).

Meandering in the shadowy recesses of the miniature cloister surrounding the dado and filling almost to the point of congestion the intervals between the pilasters of the double arcades, or dodging behind the slender shafts of the intermediate arcades, seemed to move the funeral procession, headed by the clergy and the Carthusian monks and consisting essentially of the family, the friends and the officers of the dead. In all there were forty-one statuettes. The procession, beginning on the right of the small side of the tomb, under the two angels holding the heraldic helmet near the crowned head of the recumbent figure of the duke, was supposed to reenact in carving the actual funeral ceremony of final absolution and the procession which took place at Champmol on the sixteenth of June, 1404. The idea of a funeral pageant rhythmically stressed by arcadings around the dado of a tomb was not new in Flemish or French art (witness, for instance, the tomb of Jean de Thil at St. Thibault, in Burgundy). The revolutionary departure, adopted by Claus Sluter—unless we should credit it to Jean de Marville—was to have conceived the procession as a succession of statuettes in the round, detached from the background and endowed with an eerie life by its appearance of actual movement in a pictorial surrounding half way between reality and dream. This ambiguity between life and art was at the core of the most daring achievements of the art of the International Style, and one meets it in all media, for instance, the stained glass

with the portraits of the Hapsburgs from the Cathedral of Vienna, as well as the calendar illuminations of the *Très Riches Heures* of the Duke of Berry.

Today in the museum of Dijon the pageant of mourners is reconstituted around the tomb of Philip the Bold almost exactly as it was before the French Revolution. Only two little acolytes are lost today out of the total of forty-one figures. However, four mourners—numbers 17, 18, 35 and 38, according to their place in the procession—are in other collections: the first one belongs to the Perey-Carnot family in France, the other three passed from the Clarence Mackay Collection to the Cleveland Museum of Art. The mourner exhibited is number 35 of the pageant. The precise attribution of the figures remains difficult because we know through the new contract of July 11, 1404 that by this date Claus Sluter had carved only two mourners. The artist fell ill late in 1405 and was dead in January, 1406. There is no sure way of judging how many statuettes he may have finished personally in a span of fifteen months, but he left a certain number of cartoons and some maquettes, cast in lead and brass, for Claus de Werve to execute. The mourners of the tomb of Philip the Bold fall into two main categories. In the first, they express or conceal their suffering by means of heavy draperies or hoods which are dramatic in themselves and cover the hands or the faces, partly or completely, leaving only a glimpse of them to the onlooker. In the second category, the expression of pain is fully stated, as is the case of the mourner here, with his clenched hands, the agonized grimace of his face and powerful jaws. It must be remarked that Claus Sluter by deepening the shadows between the folds has endowed the "soft style" of the aristocratic ateliers with the power of baroque movement and expressionistic anguish.

PROVENIENCE: From the Tomb of Duke Philip the Bold, Chartreuse de Champmol, near Dijon; collections of MM. Hocquart and Edouard de Broissia, Dijon, 1825; M. Legay, Nancy, 1876; Baron Arthur de Schickler, Martinvast, Normandy; Clarence Mackay, New York, 1939; Leonard C. Hanna, Jr., Cleveland.

EXHIBITIONS: *In Memoriam Leonard C. Hanna, Jr.,* The Cleveland Museum of Art, 1958; *25th Birthday Exhibition,* Virginia Museum of Fine Arts, Richmond, Virginia, 1961; *Europäische Kunst um 1400,* Kunsthistorisches Museum, Vienna, 1962 (catalogue n. 341).

BIBLIOGRAPHY: J. Ph. Gilquin, *Explication des tombeaux des ducs de Bourgogne qui sont à la Chartreuse de Dijon,* Nuits, 1736; Dijon, 1749—Dom U. Plancher, *Histoire générale et particulière de la Bourgogne,* Dijon, 1739 and ff., t. II and t. III—H. Drouot, "Le nombre des pleureurs aux tombeaux des ducs de Bourgogne," *Revue de l'Art Chrétien* (1911), pp. 135-141, ill.—*idem*, "De quelques dessins du XVIIIe siècle représentant les tombeaux des ducs de Bourgogne," *ibid* (1914), pp. 113-118—*idem*, "L'atelier de Dijon et l'exécution du tombeau de Philippe le Hardi," *Revue Belge d'archéologie et d'histoire de l'art* (1932), pp. 11-50, ill.—Georg Troescher, *Claus Sluter,* Freiburg, 1932, p. 137, n. 35, fig. 12—E. Andrieu, "Les tombeaux des ducs de Bourgogne au Musée de Dijon," *Bull. Monumental* (1933), pp. 171-193—*idem*, "La personnalité des pleurants du tombeau de Philippe le Hardi," *Revue Belge d'archéologie et d'histoire de l'art* (1935), pp. 221-230—Aenne Liebreich, *Claus Sluter,* Brussels, 1936, pl. XXXVI. n. 2—Georg Troescher, *Die Burgundische Plastik des ausgehenden Mittelalters,* Frankfurt am Main, 1940, pl. LXI, n. 238—Henri David, *Claus Sluter,* Paris, 1951, p. 126, pl. 35—*In Memoriam Leonard C. Hanna, Jr.,* Cleveland Museum of Art, 1958, n. 161.

PLATE LXXXIII THE CLEVELAND MUSEUM OF ART, no. 58.67
 Leonard C. Hanna, Jr. Collection

97 SOUTHERN FRENCH, 14th century

Tomb Relief

Polychromed stone; 26 x 65¼ in. (.660 x 1.657 m.)

The scene, composed of two slabs of stone joined together (as are certain alabaster altar frontals) represents the funeral blessing extended by a bishop standing between mourning women grouped on his right, and three tonsured acolytes, four knights and the child of one of the knights, on his left. The words REQVIESCAT IN PACE AMEN written on the prayer book, held open by a fourth acolyte kneeling at the bishop's feet, leave no doubt as to the funeral character of the ceremony. The women in mourning garb hold rosaries. The crozier of the bishop is of the type of the ivory ones still in use in Italy in the late thirteenth century, but his miter presents characteristics of the second half of the fourteenth century: greater height of the *tympana,* joined by flaring sides

to the "circle." The knights, equipped with great swords hanging from baldrics, wear hoods and long *surcots d'armes,* not over armor, but over cloth garments with long, close-buttoned sleeves. The ground is covered with a runner folded and refolded at regular intervals.

In the fourteenth century such funeral reliefs were usually set in a niche above the slab with the tomb-figure. Here, the presence of arcades perhaps indicates a stage in the evolution of the sepulchral monument in which the scene of final absolution began to be carved in bays divided by pilasters and arches around the dado supporting the slab on which the tomb figure rested.

According to an uncorroborated statement given by the dealer, this tomb relief came from the church of the Augustinians of Marciac (Gers), diocese of Auch, southern France. Possibly the arches with their ogee form betray the influence of the Decorated Style of English architecture in a region then occupied by the King of England.

PROVENIENCE: Acquired by Henry Walters in Paris.

PLATE LXX WALTERS ART GALLERY, inv. no. 27.11

98 VENETIAN, first quarter of the 15th century

Angel

Marble relief; 28½ x 18¾ in. (.725 x .477 m.)

The absence of weathering indicates that this relief comes from a monument erected inside a church. The mood of the figure and the acanthus leaves on which the hands of the angel rest— probably the relics of a range of foliage out of which his figure rises—suggest a funeral monument. The most likely location for the relief would have been the spring of an archivolt enframing a tomb and decorated with busts of angels on an acanthus border (cf. for instance the tomb of Beato Pacifico in Santa Maria dei Frari, Venice, 1432-37).

The angel can be compared with those of the antependium in the Mascoli Chapel, San Marco, Venice (before 1430) and, to a lesser extent, with those of the tympanum of the Cornaro chapel in Santa Maria dei Frari (after 1422). It is a work most characteristic of the International Style introduced into Venice, not so much by the Florentine sculptors invited there by the Doges in the years following the famous competition held in Florence for the gates of the Baptistery (1401), as by the Venetian and Lombard sculptors who had been prominently active in the most international *milieu* of Europe around 1400: the workshop of sculpture in the Cathedral of Milan. The beautiful larghetto rhythm of the angel's drapery recalls the statue of San Babila by Matteo Raverti inside the Cathedral of Milan (Raverti came to Venice in 1418) and evokes the style of Michelino da Besozzo and the draughtsmanship of the painters and illuminators who submitted projects to be carried out in sculpture in the same Cathedral. However, the fashion of his hair, with its fluffy and abundant curls, gathered in a superb rhythmical mass above the nape of the neck, is that which the German Walter Monich had adopted for his statue of St. Stephen also in the Cathedral (1406). At the same time, Niccolò da Venezia, Peter Monich and Matteo Raverti all were executing the angels decorating the central window of the apse of Milan Cathedral. Beginning in 1399, the program of sculpture at Milan had been supervised by Niccolò da Venezia and Walter Monich.

This Venetian relief of an angel comes close to the carvings executed in the Mascoli Chapel by an unknown artist who may be Giovanni Buon and of whom only a very small number of works are known. The relief, as Miss Gómez-Moreno demonstrated, takes its place in the vicinity of the so-called "Mascoli" Master. But the cool purity of the face of the angel with his flat cheeks and slanting eyes—more Germanic than neo-classical—derives from the contacts of Venice with Austrian sculpture and possibly Bohemian art.

CONDITION: Nose restored, left hand broken and repaired.

PROVENIENCE: Said to have been acquired in Venice for an English collector.

BIBLIOGRAPHY: C. Gómez-Moreno, "Wandering Angels," *Bull. MMA* (1961), pp. 127-134, ill. (as a combination of Florentine and Venetian trends, 1425-1430).

PLATE LXXIX
<div align="right">METROPOLITAN MUSEUM OF ART
Rogers Fund, 48.184</div>

99 WEST GERMAN (Middle Rhine), ca. 1425

Pietà

Alabaster, 13½ x 10⅜ x 4⅜ in. (.343 x .263 x .111 m.)

This Pietà was in the art market of Rome in 1913 and very probably comes from a church of Italy. But it is a German work. In composition and expression it compares with the alabaster Pietà coming from the Hilligenhaus in Lorch, today in the Landesmuseum, Wiesbaden, a work dating around 1430. The Lorch Pietà may be compared in its turn with a similar group which was exported from Germany to Rimini, in Italy, in the fifteenth century for a church of a German fraternity or guild, and is still venerated there in the church of S. Francesco under the name of "Madonna dell'Acqua." The Rimini Pietà signals a stage of the imminent disintegration of the International Style, while the Lorch Pietà bears the incipient hallmarks of the "hard style", the successor to the "soft style". The group on exhibition must be slightly earlier than either, because it shows rather the drying up of the "soft style" than its replacement by the broken and characteristically angular patterns noticeable in the Wiesbaden Pietà. Georg Swarzenski tentatively attributed these three alabaster Pietàs, together with a fourth one, formerly in a collection at Bonn (whereabouts unknown) to an artist whom he identified with a German goldsmith from Cologne, Master Gusmin. This artist is currently named the Master of the Rimini Crucifixion, after the groups of the Crucifixion of Christ and the two thieves with other figures of the Calvary, that come from a little church near Rimini and is today in the Liebighaus, at Frankfort on Main.

The identification of the Master of the Crucifixion of Rimini with Master Gusmin is no longer accepted today. Instead of supposing a German artist wandering in Italy and carving alabaster groups there, one must now admit the existence of an active export trade of German alabasters. These were carved in the Middle Rhine region, as is the case for our group of Pietà alabasters, but also other statuettes, groups and reliefs, were carved in Westphalia and Swabia, and sold in eastern Germany, Italy, northern and northeastern France. All this is abundantly proved by documents. A fifth Pietà, now in the Louvre, may also have been a German export to northern Italy. The facial characteristics of Christ and of the Virgin are similar to those of the group here exhibited. Still a new addition to this group of Pietàs is one acquired by the Victoria and Albert Museum in 1960 and loaned to the Vienna exhibition of 1962 ("Europäische Kunst um 1400," n. 388).

Important alabaster sculptures connected with the Pietà on exhibition have their provenience in Rimini because in that town there was, at the time of the tyrant Sigismondo Malatesta (1417-68), a colony of German tradesmen who commissioned images of devotion in their native land. The German alabasters, which appeared first around 1380, became rapidly produced in series, like the English alabasters of Nottingham. Like them, they are to be considered the agents of diffusion of certain stock formulae which reinforced unity of design in the International Style after 1400.

CONDITION: The condition of the alabaster is excellent (the German alabaster being harder than that of Nottingham); only small parts of the base are chipped off.

PROVENIENCE: Acquired by Henry Walters in Rome in 1913.

BIBLIOGRAPHY: G. Swarzenski, "Deutsche Alabasterplastik der 15. Jahrhunderts," *Städel-Jahrbuch*, I (1921), p. 175 and 205, fig. 99—W. Körte, "Deutsche Vesperbilder in Italien," *Kunstgeschichtliches Jahrbuch der Bibliotheca Hertziana*, I (1937), p. 47, n. 1, catalogue n. 41, p. 122—G. Schoenberger, "Alabaster Plastik," in: O. Schmitt, *Reallexikon zur deutschen Kunstgeschichte*, I, 1937, col. 304.

PLATE LXXXI
<div align="right">WALTERS ART GALLERY, inv. no. 27.349</div>

DECORATIVE ARTS

Verre Eglomisé

100 ITALIAN (North), ca. 1375

Half of a Reliquary Diptych

Tempera on panel set with *verre églomisé;* 17¾ x 8¼ in. (.454 x .210 m.).

The right wing of a diptych: the Crucifixion, with Mary and John, in *verre églomisé,* flanked by half-length figures of saints painted on panel; at the top, the Virgin annunciate in *verre églomisé* above two small panel-paintings of saints. The lost left wing would have shown the Nativity and the Angel of the Annunciation in the corresponding *verre églomisé* panels.

In his *Libro dell'Arte,* the fourteenth-fifteenth century artist and art-critic, Cennino di Drea Cennini, described the art of *verre églomisé* (cf. Cat. no. 101) as "a branch of great piety for the embellishment of holy reliquaries." Only a few dozen fourteenth-century reliquaries in this technique survive out of a production which must have been considerable, motivated as it was by the cult of relics as objects of private devotion. However, only two Italian reliquaries exist on which the *verre églomisé* plaques are combined with painted panels: one, a processional picture signed by the Sienese, Francesco di Vanucci, in the 1370's; and, second, the Walters Art Gallery reliquary here exhibited.

The great quality attained in the designs in *verre églomisé* is seen here at its best in the drawing of the Crucifixion—and is not unworthy of Altichiero. In fact, the rare gesture of St. John beside the Cross lifting up both hands in a gesture as if of a priest consecrating, rather than merely of a witness, occurs also in the fresco of the Crucifixion above one of the entrances of S. Fermo, Verona, a work of the school of Altichiero.

Enframing the Crucifixion are twelve busts of saints in the same technique, flanking cavities within which are the little labelled relics: bits of the loin-cloth of the Crucifixion, of the stone of the Holy Sepulchre, of four Apostles (Peter, Paul, Andrew, James), St. Mark, the Eleven Thousand Virgins, the Holy Innocents. The bust-figures do not always relate to the adjacent relics. That of St. Peter may be copied after an early Christian "gold-glass," since he carries a cross-staff, an attribute that became obsolete in Medieval art.

Although the main center of diffusion of *verre églomisé* plaques is not known, it is almost certain that they have a north Italian origin. One should not rule out the possibility of a center in Padua, near the glass production centers of Venice and Murano.

A feature of this reliquary leaf is the series of ten little painted panels encased in the carved and gilded frame. These are in the forceful and buoyant style of Tommaso da Modena (1325-1379), an artist of central Italy north of the Apennines, who was one of the most active ambassadors of the incipient International Style, and travelled through the Germanic countries as far as Prague. The little paintings depict, at the top, full-length figures of St. Frances and St. Michael; below at either side, half length representations of St. Anthony Abbot opposite St. Anthony of Padua, St. Cosmas opposite St. Damian. In the corner quatrefoils are the symbols of the Evangelists.

PROVENIENCE: Borghese Collection, Rome; Don Marcello Massarenti, Rome; acquired by Henry Walters in 1902.

BIBLIOGRAPHY: *Padiglione dell' orologio a Villa Borghese* (sale cat.), Rome, 1893, n. 385—*Massarenti Cat., Supplement,* n. 51 (as by Taddeo Gaddi)—F. Rossi, "Un reliquiario con vetri dorati del Museo Nazionale in Firenze," *Dedalo,* IX (1928-29), p. 73; Georg Swarzenski, "The Localization of Medieval Verre Églomisé," *JWAG,* III (1940), pp. 35-68, figs. 1,4; E. Sandberg-Vavalà, "Panels by Tomaso da Modena," *ibid,* pp. 69-74, figs. 12-13, 16-19.

PLATES XC, XCI WALTERS ART GALLERY, inv. no. 37.1686

101 ITALIAN (Umbria), ca. 1400

Reliquary Diptych

Verre églomisé; each leaf: 7¼ x 4⅜ in. (.184 x .111 m.).

Left wing: The Crucifixion with Mary and St. John; the angel of the Annunciation above in the tympanum. Right wing: the Nativity with the Annunciation to the Shepherds; above, the Virgin annunciate. Each central panel is framed with six busts of saints in *verre églomisé,* alternating with little relics carefully labelled.

The production of such reliquary diptychs, mounting panels of *verre églomisé,* was centered in the Franciscan monasteries in central Italy (Umbria and the Marches). They usually incorporate relics of Franciscan saints (among the relics on the left wing of this diptych are ones labelled as bits of the tunic and girdle-cord of St. Francis, and of the veil and robe of Saint Clare).

Cennino Cennini (see Cat. no. 100), who may have studied the technique of *verre églomisé* at Padua, explains how a piece of white glass, "with no green cast, free from bubbles," was first cleansed, moistened with the glair of the white of a fresh egg, and then lined with a leaf of dull gold. The drawing, made from the back of the piece with a needle, had to be very delicate, because the needle was to penetrate through the gold-leaf to the glass only for producing the outlines and the strongest shadows, while the modelling consisted in "not piercing through the gold all over." The drawing was subsequently backed up with colors ground in oil, generally black.

PROVENIENCE: Acquired by Henry Walters in Paris, 1928.

BIBLIOGRAPHY: Georg Swarzenski, "The Localization of Medieval Verre Eglomisé," *JWAG,* III (1940), pp. 65-68, fig. 8 (cf. also figs. 7, 9, 10).

PLATE XCII WALTERS ART GALLERY, inv. no. 46.2

Coffrets and Secular Objects

102 EASTERN FRANCE (or Switzerland), first quarter of the 15th century

Comb

Carved wood, coated with gesso and painted; 7¾ x 7⅝ in. (.197 x .195 m.).

On one side: (a) the tryst beneath the tree, an episode from the Romance of Tristram and Ysolt. On the other side: (b) the assault on the Castle of Love, a scene derived from the German poem: *Die Minneburg* (1320-1350). Monsters and beasts flank the teeth of the comb.

(a) Ysolt, the crowned lady at the left, and Tristram, both clad in *houppelandes* with dragging trains, the long sleeves dagged and slit, behold in the garden pool the reflection of King Mark hiding in the tree. On the swirling scroll encompassing Ysolt is engraved her warning to Tristram: *Tristram, gardes de dire vilane por la pisson de la fonteine* ("Tristram, avoid shameful speaking, on account of the fish in the fountain"). To which Tristram, aware of her meaning, answers: *Dame ie voroi per ma foi qu'i fu aves nos monsingor le roi* ("Lady, by my faith, I wish that my Lord the King were with us"). Above in the tree, the deceived King Mark mutters: *De deu sot il condana qui dementi la dame loial* ("God damn him who slandered my faithful wife"). The "fish" is not mentioned in any extant literary source of the romance, but it appears in the tryst-scene of the frescoed story of Tristram painted towards the middle of the fourteenth century in the chateau of St. Floret (Auvergne).

(b) The scene is an adaptation of the assault on the Castle of Love, not as it was represented on mid-fourteenth century French ivories, but on tapestries woven in Alsace at the same period,

representing its German version, *Der Kampf um die Minneburg.* In the tapestries the Queen of Love (*Königin Minne*) is banqueting in a tent in a forest. For the sake of symmetry in relation to the other side of the comb, the banqueting tent has been transformed into a tree-house.

The joke about the "fish" eliminates any doubt about the purely mundane and even profane meaning of the tryst beneath the tree. The interpretation which the moralizing literature tried to force upon it does not apply here. But an instance of such a redeeming attempt is worth quoting: "A Queen and a Knight were seated beneath a tree above a fountain to speak of light love; and they turned to speak of good and courtesy because they saw in the fountain the reflection of the King . . . If we guard ourselves from evil thoughts and evil doing for the love of our Lord, who sees all our thoughts, we could keep us in His peace" (*Cy nou dist,* Chantilly, ms. 1078-1079).

A similar version of the comb exists in boxwood in the Historische Verein, Bamberg. The models are to be looked for in the regions of the Middle and Upper Rhine. The influence of the tapestries, not only in the themes, but in style, is obvious. On the other hand, *Minnekätschen* may also have been used as models. However, the inscriptions in French and the tricky mention of the "fish" certainly indicate a French origin for this piece. The most plausible localization would be in the French-speaking region subjected to German influences which stretches from south of the Vosges to the *Suisse romande.*

CONDITION: A few breaks in the smaller teeth. Two holes pierced at one side, now used for mount.

PROVENIENCE: Graf Wilczek, Burg Kreuzenstein.

BIBLIOGRAPHY: Cf. for the other comb in Bamberg: R. S. Loomis, *Arthurian Legends in Medieval Art*, Oxford, 1938, pp. 68-69, fig. 133.

PLATE CII MUSEUM OF FINE ARTS, BOSTON, no. 57.7

103 FRANCO-ITALIAN (Piedmont), second quarter of the 15th century

Coffret

Wood covered with polychromed and gilt leather, the decoration embossed and incised; handle, lock, etc., of wrought iron; 8⅝ x 13⅛ x 7⅛ in. (.220 x .333 x .180 m.).

On the curving lid: the Annunciation to the Virgin (front) and the Annunciation to the Shepherds (back). On the box: two dancing jesters (front); an interlacing ribbon (back).

The two religious scenes on the lid are in relief against a background of incised, oblique twigs, the thin leaves springing symmetrically from the stems, as in manuscript illumination. Contours and inner details of the embossed figures also are incised.

The Angel of the Annunciation approaches from the right, an exceptional rendering which occurs occasionally in paintings and manuscript illuminations of the first quarter of the fifteenth century. The figures of jesters are forerunners of those which will appear on ivory chess-boards later in the fifteenth century—the location of which, whether in eastern France or northern Italy, is not clear. The presence in the decoration of the casket of a beribboned wand—a motif derived from Roman Hellenistic art—would reinforce the hypothesis of an Italian origin of the casket.

Culturally, Piedmont belonged to southern France and to the French-speaking part of present day Switzerland. The inventories of Lucca reveal that the importation of leather-work from Flanders and France gave birth there to the active production of works in gilt leather.

EXHIBITIONS: New York, Cooper Union Museum, "Leather in the Decorative Arts," 1950, cat, n. 63; Milwaukee, Wis. Milwaukee-Downer College, "Leather as an Art Medium," 1961.

PLATE CIV WALTERS ART GALLERY, inv. no. 73.33

104 FRENCH, second quarter of the 15th century

Coffret

Wood covered with polychromed leather; 6⅝ x 11¼ x 6½ in. (.169 x .285 x .167 m.).

The leather is incised with scrolls on a stippled ground. The straps and the lock are in iron with gilt designs. The ends of the lid are inscribed: *J ay bien choisy son vöulloir est le myen.* The handle is fixed at the center of two rosaces with a design similar to that of the casket exhibited under Cat. no. 103.

EXHIBITIONS: New York, Cooper Union Museum, "Leather in the Decorative Arts," 1950, n. 62—Milwaukee, Wis., Milwaukee-Downer College, "Leather as an Art Medium," 1961.

PLATE CIV WALTERS ART GALLERY, inv. no. 73.12

105 SOUTH GERMAN or SWISS, early 15th century

Two Minnekätschen

Wood covered with leather embossed and polychromed, mounted in metal; (a): 3¾ x 8¹⁄₁₆ x 4¼ in. (.096 x .205 x .111 m.); (b): 3⅝ x 6¾ x 4⅛ in. (.093 x .170 x .105 m.).

The *Minnekätschen* are coffrets so called, during the period of German Romanticism, after the poets of courtly love in the Middle Ages. *Minne* in medieval German corresponds to what we might translate as an "amatory train of thought." The medieval name for the *Minnekätschen* was *Kistlin* or *Ledlin,* emphasizing their form (a casket) and their usual decorative material (leather). The leather was vegetable-tanned and soaked, probably in warm wax dissolved in resin with the addition of certain sizes, and left to stand until it was *sammed,* that is, softened but drained. Then it was shaped and embossed and applied to the wooden box to receive its polychrome decoration. The corners of the box and the sides of its lid, shaped like a little four-gabled roof with a flat terrace, were reinforced with metal bands (iron or brass) and the two parts held together by metal straps nailed to the wood through rosettes. The inside of the box would be lined with gilt leather or parchment.

The *Minnekätschen* contained gifts from the man to the lady of his love. Their iconography is concerned with amatory scenes, allegories or symbols. On the two boxes on exhibition the lovers are represented either as seated in a meadow, with trees: (a) where, on one side, the lady holds the heart given by her lover, and on the other side a scroll, originally inscribed with a motto; or else as standing: (b) where the lady has received a ring from her lover. In the angles of the lid of (a) are embossed goldfinches. The goldfinch was an emblem of faithfulness.

PROVENIENCE: Acquired by Henry Walters in Paris, ca. 1924.

EXHIBITIONS: (a) New York, Cooper Union Museum, "Leather in the Decorative Arts," 1950, Cat., n. 60, fig. 5—(b) *ibid.,* n. 61—Norfolk, Va., Norfolk Museum, "Life in the Gothic Age," 1955.

PLATE CV WALTERS ART GALLERY, inv. nos. 73.8; 73.9

106 SPANISH (Catalan), ca. 1400

Casket

Stamped brass sheets on wood frame with brass mounts; 7⅞ x 17¾ x 8⅛ in. (.20 x .45 x .205 m.).

Rectangular casket with hinged cover of mansard form with sloping sides and flat top. In the centre of the cover is a scroll-loop handle of brass, the four ends chiselled with animal heads.

The overall decoration consists of plaques of brass stamped in relief with repetitions of three scenes, each with two figures, a standing maiden and a kneeling youth in the garb of a knight

with a sword. In the first scene the maiden is about to place a floral wreath upon the head of her lover; in the second, the wreath is replaced by a crested basinet and the knight crosses his hands on his breast as if waiting to be dubbed by his lady; in the last scene the lady shoots an arrow from a bow at the heart of the knight, which he covers with his right hand whilst the left one grasps the hilt of his sword. The scenes take place under flat trilobed arches with, in the spandrels, sprays of foliage alternating with flying birds, which refer to falcons and goldfinches. Curtains are drawn back on a rod and the background is strewn with flowering plants, rosettes and what appear to be bunches of grapes, the latter also occurring on the polychromed leather *Minnekätschen* (see nos. 104-105). The scene of the shooting of the heart occurs very often on the German *Minnekätschen*.

The Catalan caskets in stamped sheet-metal are copies, in a different material and a simplified technique, of the German coffrets of carved wood, or of painted and stamped or embossed leather, which were dedicated to courtly love. Under the panels of our casket runs as a *leit-motiv* in stamped letters against a dotted ground—imitating stippled leather—a Catalan motto: AMOR MERCE SI VS PLAV (Grant me your love if you wish to).

Caskets with the same scenes are in the Kunstgewerbemuseum, Cologne, the Episcopal Museum, Vich (Catalonia), the British Museum, the Jacquemart-André Museum, Paris, and the Apfelstädt Collection, Munster i. Westfalen. Similar caskets are in the Victoria and Albert Museum, the Cloisters, New York, the Museum für Kunst und Gewerbe, Hamburg, and the museums of Barcelona, Madrid and Nuremberg.

PROVENIENCE: Bought by G. R. Harding in Amsterdam, 1911. Acquired by Henry Walters in 1924.

EXHIBITIONS: New York, The Cloisters, "Spanish Medieval Art," 1954-55 (Cat. n. 17).

BIBLIOGRAPHY: W. L. Hildburgh, "Some Examples of Catalan Medieval Stamped Sheet Metalwork," *The Antiquaries Journal*, II, 2 (1933)—Burkhard Meier, "Ein Katalanisches Kätschen des 14 Jahrhunderts in der Sammlung Apfelstädt, Münster," *Festschrift für Adolf Goldschmidt*, 1923, pp. 45-51—H. Kohlhaussen, *Minnekätschen im Mittelalter*, Berlin, 1928, p. 35, fig. 17, p. 88 (n. 71)—A. D. Johnson, *Hispanic Silverwork*, New York, 1944, p. 29.

PLATE CV WALTERS ART GALLERY, inv. no. 53.29

Ivory Carvings

107 AUSTRIAN or SOUTH GERMAN, end of the 14th century

Diptych

Ivory; each leaf: 10¼ x 4¼ in. (.262 x .125 m.).

Only the right leaf of the diptych was carved in the fourteenth century. Its three scenes, starting from the top are: the Washing of the Feet; Gethsemane and the Betrayal; the Crucifixion. The complementary scenes on the original left leaf, which entered the Museum of Lyons with the Lambert bequest in 1850, are: the Entry into Jerusalem; the Last Supper; the Flagellation and the Way to Calvary. The existing left wing of our diptych is a forgery, probably concocted in the repair-workshop of Frederic Spitzer in the second half of the nineteenth century.

Together with a diptych almost identical with ours, preserved in the Museum of the Augustinian abbey of Klosterneuburg, near Vienna, and a fragment in the Bayerisches National Museum, Munich (Berliner, *Catalogue*, n. 45) the diptych shared between the Lyons Museum and the Walters Art Gallery represents a German adaptation of the French *grands diptyques de la Passion* of the second half of the fourteenth century, from which, in particular, the scene of Christ washing the feet of St. Peter is borrowed. The translation of the French type of composition into a

German stylistic idiom is marked by a violent pathos, by disregard for elegance and idealism, by the pursuit of realism and, even more, of expressionism. It evinces a great power of emotion if not of invention, echoed in the diversity of the figures, when compared with the large heads and monotonously inexpressive faces encountered in the French *grands diptyques de la Passion*. The diptych on exhibition is characterized by an intense dramatic power which makes the scenes— althought carved in small scale and in a dainty material—the successors in a minor key of the reliefs of the Passion of Christ on the enclosure of the western choir in the Cathedral of Naumburg, of the third quarter of the thirteenth century. The facial characteristics may be compared with those analyzed by C. R. Morey.

The difference in approach is obvious, if one compares the Crucifixion scene in the leaf of our diptych with that of other ivories in this exhibition. There is a greater degree of symbolical complexity and more psychological observation. At the foot of the Cross are the skull, which symbolizes Golgotha (cf. Koechlin, nos. 824 and 825), and the chalice standing for Adam or the church (cf. Koechlin, nos. 827, 828, 832). Also there is Longinus and Stephaton, the first miraculously healed of his blindness and garbed in the dress and cap of a doctor (cf. Koechlin, n. 833 and also 831), the second proffering the sponge in a jaunty manner, which one finds again in other examples of the same group of ivory carvings. Longinus and Stephaton are integrated in the scene of the Crucifixion with the regular groups of the swooning of the Virgin and of the Jews or prophets. The relative age of the characters is observed, the swooning Virgin being the youngest of the group of holy women. The soldiers on the left side of Christ in the Arrest scene have been given pre-Boschian porcine muzzels which make them look like beasts.

The diptych was probably carved by the same hand that executed the diptych with the Adoration of the Magi and the Crucifixion, which is preserved in the Abbey of Kremsmünster, near Linz, Austria. The best productions of the workshop are to be found, not in triptychs with three rows of scenes, but in those with two subjects only or with two rows of scenes. Thus the compositional and stylistic comparison of the Walters-Lyons diptych is with one in the Berlin Museum (Volbach Cat., no. 645-6). On the diptych at Kremsmünster and its duplicate (Koechlin, nos. 824 and 825) and the Berlin diptych (645-6), the decorative framework presents similar characteristics: rosettes with five petals decorating the string courses, pendent lion's-head bosses between the arches, the courses of ashlar delineated in the spandrels. In the group stylistically constituted by our diptych and Koechlin's nos. 824, 825, 833, 837, 838, Germanic features are predominant in the iconography. In three of these examples, one notes the jet of blood—or the sword—wounding and mystically uniting the Virgin and Christ in the scene of the Crucifixion (824, 825, 827), or (in 833) the Virgin supporting the Cross and the tormentor bearing the hammer in the Way to the Calvary. The two latter elements were introduced only belatedly in French art, probably through the channel of Flemish artists active in Paris (cf. a relief from la Sainte Chapelle in the Louvre). The style of the draperies is German, and even more so is the choppy and crumpled aspect of the sculpture which is riddled with shredded accents of shadow and looks instable, and is carried, as it were, by an intense but precarious movement. These traits evoke the German "baroque" style at the close of the fourteenth century. The origin of such ivories provisionally classified as "workshop of the diptych of Kremsmünster" is not known. Pending further research, its localization in Austria (or in southern Germany) could be argued because of the historical connection of two of them with the abbeys of Kremsmünster and Klosterneuburg.

PROVENIENCE: Frederic Spitzer; his sale, Paris, 1893, n. 101; Sigismond Bardac. Acquired in Paris by Henry Walters in 1912.

EXHIBITIONS: Paris, 1900.

BIBLIOGRAPHY: F. Spitzer, *Catalogue des ivoires*, n. 66—*Exposition de Paris*, Paris, 1900, n. 132, p. 18, ill.—Koechlin, *Ivoires*, I, pp. 299-305; II, n. 836, p. 310; III, pl. CL—D. Rosén, "Photomacrographs as Aids in the Study of Decorative Arts," *JWAG*, XV-XVI (1952-3), pp. 83-87, figs. 2-4.

PLATE XCVI WALTERS ART GALLERY, inv. no. 71.156

108 ENGLISH (?), first quarter of the 15th century

Eight Panels from a Casket

Ivory, carved and pierced; H.: 2¼ in. (.055 m.); L.: (a) 6¼ in. (.160 m.); (b) 6⅛ in. (.156 m.); (c) and (d) 6 in. (.153 m.); (e) ⅞ in. (.022 m.); (f) ¾ in. (.019 m.); (g) and (h) ⅞ in. (.022 m.).

(a) The Annunciation; the Arrival and the Adoration of the Magi; the Massacre of the Innocents. (b) The Flight into Egypt; the Presentation in the Temple; Christ among the Doctors; the Baptism. (c) The Miracle at Cana; the Entry into Jerusalem; the Last Supper; the Washing of the Feet. (d) The Agony in the Garden; the Arrest of Christ; Christ Buffeted before the High Priest; the Way to Calvary. Four small panels apparently from the ends of the casket remain: (e) an angel entering the house of Joseph (?) ; (f) a husbandman in a field of corn (miraculous episode of the Flight into Egypt) ; (g), (h) two scenes of the supernatural life of Christ after His death.

These little reliefs of the Life and Passion of Christ are executed in openwork, as well as their canopies of twin cusped arches and trefoiled spandrels. The scenes and their pierced traceries would originally have been set against a fabric covering the wooden core of the casket.

The preparatory stage for the type of tracery may be noted in two ivories in the British Museum (Dalton, *Cat.*, nos. 306, 313). One of these also shows the miracle of the corn field, rarely represented in ivory carving, but met also in an ivory formerly in the Schevitch collection (Sale Cat., 1908, n. 149). The ivory n. 313 in the British Museum which shows buttresses and low, almost rounded arches similar to ours, belongs to a series of carvings in openwork which Dalton, followed by Koechlin, classified as northern French or Flemish. Arguments have been presented by Donald D. Egbert (in *Art Studies* in 1929) for localizing the majority of the pierced ivories of the International Style period in northern Italy, explaining their decorative and iconographic features by the strong German influences at Milan (cf. Cat. no. 98).

The Annunciation, Adoration of the Magi and Presentation in the Temple of our dismembered casket are indeed like the three little panels with the same scenes in pierced relief above the figures of Christ between St. Peter and St. Paul, in an ivory carving in the Victoria and Albert Museum (213-1865) —a work considered as possibly Milanese in this catalogue (cf. Cat. no. 120). The decorative framework however does not present the characteristics of the Milanese Gothic style noticeable on the Victoria and Albert Museum plaque. The interpolation of the Presentation according to the Gospel of Luke, after the Flight into Egypt, which follows the relation of Matthew, suggests that the carver of our reliefs combined models of different sources. The Adoration of the Magi belongs to a composite type in which the Virgin, lying in her bed as in a Nativity scene, receives the Kings. The Adoration of the Magi combined with a landscape is a type frequent in Italy. Our ivory panel of the Adoration may be compared with an earlier manuscript illumination of the subject in the Ambrosiana, Milan (ms. 1. 58 sup.) which reflects the style of French miniature painting and to a certain extent perhaps that of the ivories carved in Paris in the third quarter of the fourteenth century. The detail of the bed belongs more properly to German iconography. But here, the wattle enclosure hiding the couch of the Virgin reminds one of the same type of rustic enclosure in miniatures of the Adoration painted for the Duke of Berry by Jacquemart de Hesdin (*Très Belles Heures de Notre Dame*, now in the Bibliothèque Nationale, Paris) or by the Limbourg brothers (*Les Belles Heures*, now at the Cloisters, New York). In the scene of the Baptism of Christ the angel holds the seamless tunic of Christ as in a miniature also attributed to Jacquemart de Hesdin in the *Petites Heures* of the Duke of Berry. In the panel of the Massacre of the Innocents and in those of the Arrest of Christ and of Christ before the High Priest, the low-belted jerkins, padded so as to bulge at the chest, are costumes found commonly in Lombardy (frescoes in the church of Mocchirolo, in the Brianza, by a follower of Giovanni da Milano, ca. 1375; those in the nearby Oratory of Lentate; miniatures by Niccolò da Bologna and Anovelo da Imbonate). For English examples, cf. for instance an ivory of Christ being nailed to the Cross in the Vatican (A. 105a), as well as an ivory with three scenes of the

Passion of Christ in the British Museum (n. 314). A French example is the miniature of the Coronation of Charles VI in a manuscript of the *Grandes Chroniques de France* (Paris, Bibl. Nat. ms. fr. 2813).

The details of the Way to the Calvary in which the Virgin supports the Cross and an executioner is holding a hammer are also met commonly in the illuminations of the Franco-Flemish or Limbourgish school of Paris from around 1400 and until 1416. Its source is German. It was transmitted to the Lowlands and to Italy and seems to have passed into the French International Style through Flemish and Netherlandish influences.

The number of pierced ivory carvings known from the period ca. 1400 amounts to some thirty pieces. The technique was not an innovation. It was sometimes practiced by Carolingian ivory carvers. It reappears sporadically in the fourteenth century ivories (nos. 58 and 283 of Koechlin, the latter possibly Italian), along with more monumental attempts in sculpture. One may cite the marble fragments of the main altar of the Cathedral of Cologne, ca. 1360, now in the Wallraf-Richartz Museum, and those of a reredos carved for the Sainte Chapelle of Paris, today in the Louvre, which seems to be a Franco-Flemish work. The style of the latter is, however, very different from that of our plaques. One may contrast the treatment of the Way to Calvary, despite the identity of iconography. In conclusion, the evidence for attributing such ivory plaques as ours to northern Italy is very circumstantial. Their style is definitely not the French nor the Franco-Flemish of the Paris workshops. They could be English. The figures of Herod and the High Priest with their legs aristocratically crossed, would be acceptable in the tradition of English sculpture.

PROVENIENCE: Acquired in 1923 by Henry Walters.

PLATE CI WALTERS ART GALLERY, inv. no. 71.222-29

109 ENGLISH, second quarter of the 15th century

Casket

Ivory, carved, pierced over a wood core; metal fittings; 4 x 5⅝₁₆ x 4⅞₁₆ in. (.102 x .134 x .112)

Scenes of the Life of Christ (on the four sides, lower row), of His Passion (lid), of His Supernatural Life after His Resurrection (on the four sides, upper row). On the front, right and left of the lock-plate, two varlets in close-fitting jerkins hold dogs on leash.

The narrative sequence of the scenes is as follows: In the *lower row*, around all sides: *Back,* from right to left under single arcades: the Annunciation; the Visitation; the Nativity; the Annunciation to Shepherds. *Side,* from left to right (under twin arches and a single arch spanning the space of two): Herod and a varlet holding the Magi's horses; the Adoration of the Magi. *Front,* from right to left under single arcades: Slaughter of the Innocents; the Flight into Egypt; the Presentation in the Temple; Jesus among the Doctors. *Side,* from right to left: Baptism and beginning of the scene of the Miracle at Cana (under twin arches); Miracle at Cana and Christ riding the ass (under a single arch spanning the space of two).

On the lid, from top to bottom and from left to right, in three rows: (a) the Hiring of Judas; Judas returning the money; the Stripping of Christ; Watchmen. (b) Christ, His hands tied, about to be scourged and the Flagellation; the Way to Calvary; Crucifixion. (c) Descent from the Cross; the Anointing; the Resurrection; the Harrowing of Hell (all under single arcades).

In the *upper row* on all four sides from right to left: *Side:* the Pilgrimage to Emmaus; the Supper at Emmaus (under twin arches and a single arch spanning the space of two). *Front,* from right to left: Christ manifesting Himself to His disciples "when the doors were shut," and the Doubting of Thomas (under single arches), both scenes according to chapter 20 in John. *Side,* from right to left: Christ manifests Himself to His disciples at the Sea of Tiberias; Christ gives

Peter the charge of His sheep (under a twin arch and a single arch of the span of two), both scenes according to chapter 21 in John.

The iconography of this casket is extraordinary, in particular the representation of the "Navicella" according to St. John (cf. Cat. nos. 31, 32). Might there be in that subject an indication of an Italian connection? The casket is, however, composed exactly as a casket from the Gibbs Collection in Tyntesfield, Somerset, which was exhibited in 1923 at the Burlington Fine Arts Club, London (*Catalogue*, n. 141; Koechlin, n. 1310 bis). The latter represents the *Romance of the Chevelere Assigne,* that is, the story of the Knight of the Swan, which also became famous in Italy around 1400. [The story is represented, according to Julius von Schlosser, on no less than six caskets from the workshop of the Embriachi in Venice.] The Gibbs casket was in England before 1793. Its panels are divided by vertical partitions (as is also the openwork plaque from a casket in the British Museum, Dalton, Cat. n. 314). Figures on the Gibbs casket wearing a cap with a *mentonnière* and a jerkin with collerets, belted low and with a row of buttons all the way down the front, occur also on the Walters casket (the watchmen on either side of the lock-plate).

On the Gibbs example the scenes are occasionally framed within recesses having four-center arches, the type of arch characterizing the Perpendicular Gothic of England. It is found also from the last decade of the fourteenth century and through the first quarter of the fifteenth in works which, if not English, have absorbed English design, such as the reredoses carved by Jacques de Baerze for Champmol, miniatures in the Bedford Hours and the ivory openwork panel in the British Museum (Dalton, Cat. n. 316) with scenes of the life of the Virgin and of Christ, copied after a set of Franco-Flemish illuminations and Franco-Flemish ivories. The panels of our casket have also horizontal transoms, and the traceries filling the interval between the transoms and the gables surmounting the flattened four-center arches are obviously patterned after English Perpendicular architectural motifs. One notes also that the supports of the rounded segmental arcades happen to be pairs of shafts with cushion-like bases curiously reminiscent of a feature in Anglo-Saxon architecture.

The date of our casket is the same as that of the Gibbs casket, around 1440. That the Gibbs casket is English is supported by the combined testimony of its subject matter and its early ownership in England, and so is the Walters casket. The localization of the latter in England does not preclude—on the contrary it would substantiate—the supposition of a model consisting of a set of Franco-Flemish miniatures, possibly executed in a workshop of Paris in the last period of the English occupation. The carving of the figures is rather coarse, but it should not be termed crude. It was effected by minute slashes which produced facetted and broken planes, an impressionistic technique which calls for an optical blend at the right interval between object and onlooker.

PROVENIENCE: Hollingworth Magniac; Charles Magniac; his sale (London, July 2, 1892, n. 259, ill); E. de Valero, his sale (Paris, Dec. 18, 1893, n. 52); the Russian sculptor Markus Antocolsky; his sale (Paris, June 10, 1901, n. 68). Acquired in Paris by Henry Walters in 1910.

BIBLIOGRAPHY: Mentioned by Koechlin, *Ivoires,* II, p. 325, n. 865. For the attribution to northern Italy of the Gibbs casket, cf. Donald Drew Egbert, *Art Studies* (1929), pp. 202, 203, fig. 64.

PLATE XCIII WALTERS ART GALLERY, inv. no. 71.271

110 FRANCO-FLEMISH, last quarter of the 14th century

Diptych: the Nativity; the Adoration of the Magi; the Crucifixion; the Last Judgment

Ivory: each leaf: 6 1/16 x 3 1/8 in. (.152 x .80 m.)

The remote prototype of this diptych is one formerly in the collection of Mgr. Schoolmeesters in Liège, which comes from the convent of the Welsch Nuns in Trier. The Liège diptych is in an excellent style, free from the stereotyped formulae of the ivories executed in the workshops of Paris after 1350, and is probably by the hand of a Mosan artist (cf. Koechlin, n. 783). The scenes

are the same as in our diptych, but start from the bottom, as happens commonly with models in ivory carving. The Last Judgment in the Liège piece is treated, however, very differently from that in our diptych. There Christ rests His feet on the Celestial Jerusalem, and, adding his supplications to those of the Virgin, is St. John the Baptist—a Germanic feature in the iconography of the Last Judgment, which derives from the Byzantine *Deisis*. In the Walters diptych, it is St. John the Evangelist, who is frequently substituted for the Baptist in French sculpture of the Last Judgment. Christ, His right hand raised to promise salvation, His left hand dropped to threaten condemnation, is enthroned above a flattened arch beneath which the dead are rising with gestures of confident or sorrowful anticipation. The composition of our Last Judgment is based on that in two diptychs with representations of the Nativity and the Last Judgment, Koechlin's nos. 775 and 776. In n. 775, St. John wears a short beard, but he is undoubtedly the Evangelist; in n. 776 he is, as in our Last Judgment, beardless. No. 775 is one of the early masterpieces illustrating the new tendency in ivory carving to characterize the figures individually. Christ enthroned in Judgment in our diptych shows a wrinkled brow and a worried expression which are found also in the Last Judgment on a Franco-Flemish diptych in the Vatican (Morey, *Catalogue,* A 97). In the latter the oblique position of the enthroned Christ is the same as in our diptych, and obviously the two scenes derive from the same source, if they do not come from the same workshop. [In the Vatican diptych the division of the scenes into squares, with no decorative arcading, reflects a compositional principle seen in caskets which have an English or, in some cases, a Flemish origin. A link of the Vatican diptych with France and the new Germano-Flemish iconography adopted in Paris and northern France is proven by the extraordinary panel of the Trinity, wherein God the Father holds against His heart not Christ crucified, but the Christ Child, as in miniatures of the Limbourg and Rohan ateliers and one of those in the Missal of Chalons sur Marne (Cat. no. 44).]

Stylistically, however, the Nativity scene of our diptych is very close to that in Koechlin's diptych n. 813. On the other hand, our diptych as a whole does not show the baroque exuberance animating the other, characteristic of the second atelier of the *grands diptyques de la Passion,* but rather it displays a dryness of carving and wiriness of forms which makes it comparable to the diptych n. A 554-1910 in the Victoria and Albert Museum. In that diptych the Coronation of the Virgin replacing the Last Judgment derives from Mosan sculpture (North Portal of St. James, Liège). The composition and pattern in the scene of the Adoration of the Magi of our diptych and that of the Victoria and Albert Museum diptych are alike. There is an almost excessive virtuosity in the attempt at complicated spatial relationships between the kneeling oldest king, the standing middle-aged king who looks back at his younger companion, the seated Virgin slightly recoiling, and the Child standing in a pose which is like the bent tip of an ivory tusk. Furthermore, a sophisticated interplay linking gestures and objects leads from the crown resting in the left hand of the kneeling king to the dish he proffers to the Child and thence to the globe, which the Virgin holds so that on it the Child may rest His left hand. In the earlier models of this scene, the left hand of the Child was at the same location but groping for His mother's breast (Koechlin, *Ivoires,* n. 488 bis). The globe thus replacing and yet also suggesting the mother's breast is a compromise with the iconography—more frequent in German than in French art—of according to the Child the globe as a symbol of the kingship of Christ. Another complication, met only in our panel, is the covered cup held at waist level by the middle-aged king, which repeats in a three-quarter view the feature of the cup held in the veiled right hand of the youngest king.

In the Nativity scene such details as the flaring mouldings of the trough-like crib and the expression of the face of the Virgin are encountered on a diptych of the Nativity and the Crucifixion in the National Museum, Copenhagen, which, judging from the type of Christ Crucified, cannot be dated earlier than ca. 1375 and is probably not the work of a French artist. The facial characteristics of St. Joseph and of the Three Kings in our diptych signal the emergence of what Koechlin called *"les ateliers novateurs"* and in particular *"l'atelier aux visages caractérisés."* Ref-

erences may be made to works of art of the International Style in Paris and central France, such as the Parement de Narbonne and the miniatures and sculptures attributed to the workshop of André Beauneveu, in which the dominating influence is that of Flanders. The cork-screw turning of the folds over the feet of the Virgin and in the mantle of St. John in the Last Judgment appear also in a Franco-Flemish drawing of the Death and Coronation of the Virgin, dating around 1400, in the Louvre, as well as in German painting of the first quarter of the century and was repeated for decades by the Nottingham alabaster carvers.

PROVENIENCE: E. Chappey; his sale (Paris, June 5, 1907, IV, n. 1682). Acquired in Paris by Henry Walters in 1925.

PLATE XCIX WALTERS ART GALLERY, inv. no. 71.201

111 FRANCO-ITALIAN (Piedmont?), last quarter of the 14th century

Box for writing wax, with sliding cover

Ivory; $3^{11}/_{16}$ x $2^{3}/_{16}$ in. (.093 x 0.54 m.)

The box contained tablets (*tables à pourtraire*), to be covered with wax, and a silver stylet (*greffe*) for writing on the wax. The ivory tablets are missing (only two fourteenth-century ivory boxes complete with their writing tablets survive today, and as for the silver stylet, it is known of only through medieval inventories). The tablets were held together by a cord, which passed through a hole (now plugged) pierced at the top of the box. Inside the box is a sunken receptable for the wax. At the center of the lid is a circular cavity for a mirror. The fanciful architecture decorating the back of the box and its lid may be associated with the *Histoire du Château d'Amour*. The amatory scenes belong to the hackneyed repertory of the secular ivories of the fourteenth century, such as the lover caressing the cheek of his lass, who holds a hawk on her wrist, the lovers holding a crown (*chapeau de fleurs*), and so on. The canopy of three cusped arches at the top of each leaf surmounted by gables with trefoiled tracery within and between them, the crockets and the leaf finials, all belong to the usual decoration of the boxes for writing tablets towards the end of the fourteenth century. Not many exist today, although the *tabletiers* and *pigniers* of Paris must have produced them in quantity for patrons who were educated people of the upper middle class and readers of romances. The subject of the back of the box (at the left in our illustration) is repeated on two other boxes catalogued by Koechlin (nos. 1181, 1182); but that of the cover seems to be unique. The Castle of Love, as well as similar costumes, occur on an ivory leaf in the Bargello (Koechlin, n. 1108), which Carrand probably bought after he left France to live in Italy. The same fashions and the same dry style of carving are to be noticed on the mirror-case in the Museo Civico, Bologna, which is certainly north Italian (Koechlin, n. 1113).

PROVENIENCE: In an anonymous sale, Cologne, Dec. 14, 1893, n. 92, ill.; Markus Antocolsky Collection; his sale, Paris, June 10, 1901, n. 73, ill. Acquired in London by Henry Walters in 1901.

BIBLIOGRAPHY: Cf. Koechlin, *Ivoires*, II, p. 420, n. 1181 (ex-coll. Stroganoff, Rome) and n. 1182 (coll. Krieg von Hochfelden).

PLATE CIII WALTERS ART GALLERY, inv. no. 71.283

112 FRANCO-FLEMISH (or Italian?), third quarter of the 14th century

Leaf of a writing tablet

Ivory; $3^{3}/_{4}$ x 2 in. (.095 x .051 m.)

The tablet is carved with scenes from two lusty French *fabliaus*, the *Lai de Virgile* and the *Lai d'Aristote*. In the upper compartment are two incidents from the bawdy story of Virgil the Magician. Under a canopy of four cusped arches with crockets on their entredos, we see the sor-

cerer Virgil, whom the daughter of the Roman emperor had promised to lift to her bedroom in a basket, ignominiously left hanging outside, exposed to the ridicule of the townsmen of Rome. On the right he takes revenge on his mistress through a scurrilous device for rekindling candles after his black magic has deprived Rome of all lights.

In the lower compartment, under the same decorative arcades, is carved the beginning of the story of Aristotle and Campaspe. King Alexander, pupil of the philosopher, offers a purse of money to the Queen's maid, Campaspe, in order to induce her to ensnare Aristotle. The maid is engaged in weaving at an upright loom and holds a batten for striking home the weft-threads. On the right in a secluded retreat, Campaspe has engaged the philosopher in amorous conversation. The rest of the story is reproduced in L. de Montfaucon's *L'Antiquité expliquée*, vol. III, Paris, 1722, pl. CXCIV, after an analogous work which formed the covers of a six-leaf ivory note-book. On the front leaf of the ivory note-book engraved in Montfaucon our *Lai de Virgile* was carved, while the back leaf showed Aristotle ridden by Campaspe, followed by a second bawdy scene, the companion-piece of the revenge of Virgil. The story of Aristotle—the *Lai d'Aristote*—was often represented on profane ivory carvings of the fourteenth century. But both the Virgil and Aristotle stories joined together are encountered elsewhere only on an ivory comb formerly in the Figdor Collection (Koechlin, n. 1150).

The earliest representation in art of the *Lai de Virgile* is found in the *Grand Chansonnier* of Heidelberg in the first half of the fourteenth century. The legend of Virgil the Magician was woven on the looms of Arras in the third quarter of the fourteenth century. Perhaps the scene of Campaspe at the loom indicates that our ivory traces its source to the designs of these Arras tapestries. However, the story of Virgil was adopted by Boccaccio in his *Filocolo* and became one of the favorite subjects in Italian illuminations of the Triumphs of Love in the fifteenth century. Scenes similar to the vengeance of Virgil are found in the Lombard sketchbook (see Cat. no. 13). Therefore, the supposition of a Franco-Flemish model does not exclude the possibility of a copy in a north Italian ivory plaque of around 1375. In style this leaf is far superior to practically all the north Italian imitations of French ivory carving made towards the close of the fourteenth century.

The right side of the leaf is pierced with five holes for the hasp. The left side is rabbeted and the back slightly sunken to receive the wax.

PROVENIENCE: John Lumsden Propert (1834-1902); Sir Thomas Gibson-Carmichael; his sale (London, May 12, 1902, n. 2). Acquired by Henry Walters in 1902.

BIBLIOGRAPHY: Koechlin, *Ivoires*, I p. 440, n. 2, II, n. 1150. For the subject matter, cf. R. Van Marle, *Iconographie de l'art profane au Moyen-Age et à la Renaissance*, II, *Allégories et symboles*, La Haye, 1932, p. 495.

PLATE CIII WALTERS ART GALLERY, inv. no. 71.267

113 FRENCH, last quarter of the 14th century

Diptych: Scenes of the Life and Passion of Christ

Ivory; each leaf: 7¾ x 4½ in. (.197 x .113 m.)

This diptych belongs to the aftermath of the "great diptychs" of the Passion of Christ (of which about fifteen are known, including a few variations on the type). Like them it is divided into three rows on each leaf by friezes of arches. It is not among those catalogued by Koechlin, but comes very close to his nos. 808 and 809, which, in the *Corpus* of Koechlin, lead the short series of diptychs in which scenes of the infancy and supernatural life of Christ after His death bracket the episodes of the Passion. In dimensions it is a replica of Koechlin's n. 809, but with the scenes arranged in a reverse order. In nos. 808 and 809 the scenes—Annunciation and Nativity (combined), Adoration of the Magi, Arrest of Christ (combined with the suicide of Judas), Crucifixion and Resurrection (combined), Ascension and Pentecost—follow from the bottom to the

top of the diptych and, in each row, from left to right. The treatment of the scene of the Crucifixion in the Walters diptych is considerably simplified, while in the other examples it follows the traditional formulation encountered in no. 118 of this catalogue. In the Resurrection the sarcophagus of Christ is pierced with quatrefoils (as in n. 809 of Koechlin—cf. *Les Arts*, no. 53, May, 1906, fig. p. 13), but here Christ grasps, instead of the cross-staff, a shaft inconsistently introduced as a support for the spring of the last two arches sheltering the Resurrection scene. This anomaly is justified by the exceptional amount of void between the figures and the frame in the Crucifixion-Resurrection zone. Such a device of an isolated column is otherwise exceptional. In another diptych in this exhibition (Cat. no. 116), it is fittingly used for the scene of the Flagellation. In Koechlin's diptych n. 808, such a column divides the scenes of the Annunciation and the Nativity. It is systematically repeated in the middle of the six zones of the diptych n. 290-1867 in the Victoria and Albert Museum. In our diptych the importance allowed to the blank spaces in the Crucifixion and the Resurrection seems to isolate the figures and the deep shadows produce a suggestion of pierced-work. A similar effect was aimed at only in exceptional productions of the school of stone sculptors of Paris, as in the fragments of the reredos from the Sainte Chapelle, now in the Louvre. It contrasts here only superficially with the ebullient congestion noticeable in the other scenes, because everywhere throughout the diptych the same tendencies prevail toward undercutting the carving and handling the figures pictorially, by making them independent of the background. Advantage was taken of the deeper recession thus obtained in order to multiply the billowing curves of the draperies with contrasting values of light and shade, more picturesque than dramatic. Compared with the aristocratic mannerism of the earlier fourteenth-century Gothic ivories, this diptych represents a baroque stage of evolution. It is not sure whether the work is French—although French models are certainly behind it, and not only among the ivories, but in sculpture also. Compare, for instance, the angel of the Annunciation with the beautiful marble statue of an angel, also half kneeling, in the Metropolitan Museum of Art, New York.

PROVENIENCE: John Malcolm of Poltalloch (1805-1893), county Argyll, Scotland; John W. Malcolm, his eldest son, created Baron Malcolm of Poltalloch in 1896; Colonel Edward-Donald Malcolm (born 1837), the third son of John Malcolm of Poltalloch; his sale (London, May 1, 1913, n. 21, ill.). Acquired by Henry Walters in 1922.

PLATE XCV WALTERS ART GALLERY, inv. no. 71.272

114 FRENCH (or north Italian?), third quarter of the 14th century

Leaf of a writing tablet

Ivory; 4⁹⁄₁₆ x 2½ in. (.116 x .063 m.)

Two scenes from a romance. In the upper compartment, under a canopy of three cusped pointed arches surmounted by crockets and finials, with trefoils in the spandrels, a youth riding a prancing horse and carrying a falcon on his left wrist is greeted by a young lady standing in a doorway, her right hand raised in salutation. The youth is accompanied by a servant mounted on a horse bearing an oblong covered coffer. In the lower compartment, under the same decorative arches, we again see the youth, girt with a sword and his head covered by a *chaperon*, bearing his falcon and a purse embroidered with a rose. With a gesture of salutation, he approaches a goldsmith wearing a skull-cap, who sits behind a cloth-covered table on which are seen two covered cups and rolls of minted coin. The youth is followed by a lady, whose hair is also covered, and her lady-in-waiting.

The fashion is that of the period around 1375. The long dress of the youth and the surcoat with low-cut bodice of the young lady both have lappets hanging from the elbow (*manches à coudières*). The insertion of the decorative trefoils in the arcades would indicate a date theoretically later than that of the leaf which is no. 112 of this catalogue. If the work is an Italian copy of a French model, it remains close in quality to the excellence of its prototype. It can be compared,

not only for the style, but for the type of costume, with the writing tablets carved with representations of games (*jeux de la grenouille et de la main chaude*) in the Louvre (Koechlin, nos. 1173-74), which date around 1370.

The meaning of the subjects represented is not clear. It is possible that, in the second compartment, we have to do with the "Lover's Choice" between covered receptacles (cf. Shakespeare's *Merchant of Venice*, II, vii, the source of which is medieval), but a more plausible alternative is a visit of the lovers to the goldsmith's shop.

A fictile cast of the leaf is preserved, without mention of the name of the owner of the original, in the Victoria and Albert Museum: cf. Westwood's *Fictile Ivory Casts*, p. 193, n. 440.

PROVENIENCE: Max and Maurice Rosenheim (sale, London, May 9-11, 1923, n. 294).

BIBLIOGRAPHY: Koechlin, *Ivoires*, II, p. 427, n. 1213.

PLATE CIII WALTERS ART GALLERY, inv. no. 71.279

115 FRENCH, ca. 1375

Statuette of the Virgin and Child

Ivory; 8⁷⁄₁₆ in. (.22 m.)

The upper part of the body of the standing Virgin is slightly inclined backwards, with an aristocratic tilt which also seems to express a motherly pride. She holds an open flower in her upturned right hand and supports on her left arm the partly draped Christ Child Who plays with an apple while He caresses His mother's neck. She wears an open coronet with four large and four small fleurons. Her mantle covers the wavy hair enframing a rather plump face with bulging eyes, fleshy chin and long nose. At the back her hair falls nearly to the waist. On the right outline the hem unfurls in a trill of twisted folds which beautifully continues the slanting sweep of the drapery covering the legs of the Child. On the right side it is tucked under the elbow and expands apron-like in the front. The figure of the Virgin presents the noticeable·elongation, which appears in the ivory Virgin and Child in the National Museum, Florence, dating around 1360 (Koechlin, n. 633). The style of the drapery is a preamble to that of the ivory statuette of St. Catherine in the Louvre (ca. 1400). But there is an absence of characterization and an emptiness of mood that contrast with later works, like the Virgin of the Heugel collection (Koechlin, n. 702). Otherwise the structure of our statuette is of a more conservative type that that of the Virgin of Meulan (Cat. no. 90). Her face is very much like that of the Virgin in a similar group belonging to the National Museum, Munich (Koechlin, n. 659). The latter group of the Virgin and Child is in the traditional line of fourteenth-century sculpture, small as well as monumental, in the *domaine royal* around Paris, but graced with the inflections and variations occurring in the third quarter of the century.

CONDITION: Some recutting at the base and on the drapery of the Virgin.

PROVENIENCE: Charles Micheli, Paris; Octave Homberg (cf. G. Migeon in *Les Arts*, December 1904, ill. p. 35); Dr. L. de Saint-Germain. Acquired in Paris by Henry Walters in 1922.

BIBLIOGRAPHY: Koechlin, *Ivoires*, II, n. 665, III, pl. CIX.

WALTERS ART GALLERY, inv. no. 71.287

116 FRENCH, last quarter of the 14th century

Diptych: Scenes of the Passion and Resurrection of Christ

Ivory with traces of polychromy; each leaf: 9¾ x 4½ in. (.248 x .114 m.)

The scenes are arranged in three zones, under canopies of four cusped arches with sparse crockets

and developed foliated finials, the spandrels being pierced with trefoils. The series of scenes starts at the top of the left leaf: (a) Entry into Jerusalem; Christ is accompanied by two disciples, a youth spreads his garment, another has climbed a tree to cut branches, and a scribe and a pharisee stand in the gateway to the city. (b) : the Washing of the Feet and the Last Supper, in which latter scene only eight Apostles and Judas are present and in which St. John is represented with a beard. (c) : Christ and the Twelve Apostles in the Garden of Gethsemane, and Christ led away by two marshals, armed with long clubs—a scene unique in ivory carving. (d) : The suicide of Judas, the Flagellation and the Way to Calvary—in which episode the Virgin helps Christ to bear His Cross and an executioner proffers a hammer. (e) : The Crucifixion and the Descent from the Cross in which Joseph of Arimathea alone is receiving the body of Christ. (f) : Nicodemus anointing the body of Christ in the presence of Joseph of Arimathea and of another Jew, Christ with the cross-staff of the Resurrection appearing to Magdalene in the garden, and the Harrowing of Hell—a scene in which Christ has pried open with His cross-staff the jaws of Leviathan and liberates Adam and Eve.

The iconographic program of the diptych combines that of the "diptychs of the Passion" and that of the *succédanés des grands diptyques de la Passion,* namely the Passion diptychs supplemented by scenes pertaining to the supernatural life of Christ after His crucifixion, which were carved in various French (Parisian?) workshops in the last third of the fourteenth century and imitated in ateliers outside of France. In four out of the six panels are juxtaposed two scenes in each; while three events are condensed on the final one. Even the Entry into Jerusalem which occupies the entire first panel is composed according to the prevailing principal of dichotomy. The number of the figures in each episode is reduced so that they stand out very clearly and are harmoniously outlined against the background. The proportion of empty areas is high, if compared with the congestion noticeable in the diptychs of the Passion and their derivatives. The only exceptions are in panel two: the Washing of the Feet and Last Supper, and in the left half of panel three: Christ and the Twelve Apostles in the Garden of Gethsemane, where the artist aimed for the sake of expression at a crowded and overlapping effect. This is very successfully contrived in the Gethsemane scene, where the figures are gathered into a lozenge formation set in perspective, and in which, after the departure of Judas, a twelfth Apostle was superfluous. The composition of each scene in itself could be enclosed within a square or a quatrefoil. The division of scenes into square units contradicts the frieze principle which is basic in the pictorial and dramatic diptychs of the Passion. It is found in two other pieces, both of which in their way are as exceptional as our diptych. One is a diptych in the Vatican Museum (n. A 97) which Morey has classified as a German imitation of a French work, but which should finally be retained as French or Franco-Flemish. In it the *Noli me tangere* scene is close in feeling and execution to the similar scene of Christ appearing to the Magdalene in our diptych, although less refined. The other ivory carving in which the scenes are simplified as a result of the adoption of the square unit for each composition, is a diptych in the Louvre (Koechlin, n. 819) in which the squares, under the influence of manuscript illumination, have been transformed into quatrefoils.

The trees in our diptych have a function which they seldom received in the "great diptychs of the Passion." One is used to divide into two parts the scene of the Entry into Jerusalem. One is symbolically sufficient to conjure up the Garden of Gethsemane. A third is used in the *Noli me tangere* scene as a moral barrier between Christ and the Magdalene, a device in which decoration and sentiment are fused in a unity of purpose. This device had already occurred in the *Noli me tangere* of a Resurrection series in stained glass at Königsfelden (Switzerland) —a work of about 1330-35, already intimating the International Style.

The artist of our diptych was a traditionalist (compare the Anointing of Christ with the earlier treatment of the subject in a triptych in the Fitzwilliam Museum), who welcomed the formulae of the new iconography developed in the workshops of the "great diptychs of the Passion." His style, even if couched in a sober and somewhat academic idiom, is the new style charac-

terized by manneristic traits: elongated figures and small heads, which in larger sculpture is essentially Franco-Flemish around 1400. He is not far from the master, a north-French artist or one who came from a region athwart northern France and southern Flanders, who executed the reliefs of the Passion for the reredos of Sainte Chapelle (now in the Louvre). The way he sometimes handled overlapping heads, for the sake of creating a psychological tension, is akin to the treatment signalled in the woodcarving described in no. 87 of this catalogue. The sweeping triangular folds of Christ walking to the right in the middle zone and of Joseph of Arimathea in the scene of the Descent from the Cross, resemble the drapery patterns in that woodcarving and in the scene of the Way to Calvary in the *relief d'applique* coming from the Sainte Chapelle. Another resemblance to the Sainte Chapelle relief is in the Flagellation scene, in which Christ and the executioner on His right are comparable in both works. The carver was a great master in managing a subtle modification in pattern to convey a mood. Observe, for instance, how a slight variation between the arms of the crucified Christ succeeds in embracing the Virgin mystically in the Salvation performed on Calvary (cf. in this instance the Crucifixion, n. 808 in Koechlin). It would be worth investigating whether the historical connection of the present diptych with the Cathedral of Vich and the early presence of certain other ivories in the south of France may not indicate an origin in Avignon. The Kingdom of Aragon remained until 1416 the last bulwark among the Christian states of the schismatic Pope, the Aragonese Peter of Luna (Benedict XIII).

PROVENIENCE: Cathedral of Vich (Catalonia), where it is mentioned in an inventory of 1430; Episcopal Museum of Vich (until 1903).

BIBLIOGRAPHY: E. Lefèvre-Pontalis, "Deux monuments du musée de Vich," *Centenaire de la Société des antiquaires de France*, pl. XIV—Koechlin, *Ivoires*, I, p. 295; II, n. 814, p. 296-7; III, pl. CXLI.

PLATE XCVIII WALTERS ART GALLERY, inv. no. 71.179

117 FRENCH, end of the 14th century

Meditation on the Passion

Carved ivory group; 3¾ in. (.095 m.)

Six bearded Apostles, their feet bare, are seated in two rows in attitudes of dejection, their heads covered by their mantles. The group comes from an altarpiece, and was a part of the story of the Passion narrated as a series of *groupes d'applique* carved in ivory and possibly mounted in a frame made by a goldsmith.

Its iconography is puzzling. It combines the sleep of the Apostles—which is appropriate to the scene in the Garden of Gethsemane, preceding the arrest of Christ—with Pentecost, which is the only occasion on which the Apostles are traditionally represented as seated in a group and holding books. The motives have been blended from the related episodes carved in the ivory diptychs of the Passion. The group betrays the influence of such diptychs of the late fourteenth century. It will be noted that in the diptychs only a few Apostles are shown with their mantles covering their heads in their sleep at Gethsemane, and that this feature is even rarer in the scene of Pentecost. It does however, occur again in that of the death of the Virgin. The group is distinguished not so much by an increased realism—a general trend in the French ivories after the middle of the fourteenth century—as by the isolation of the subject and its treatment as a theme of meditation. The mood, mournful and tense, is akin to that of the wood sculpture of the Apostles in prayer (Cat. no. 87).

The ivory retables of the Passion survive only in scattered fragments which have been little studied, owing to the scepticism evinced by Koechlin as to the authenticity of many pieces. Koechlin in his *Corpus* of ivories retained (with the qualification of *pièces douteuses*) only four fragments of retables (his nos. 846 *bis, ter, quater,* and *quinter*). Our group of the Meditation on the Passion compares in dimensions and style with two groups in the Musée du Ponthieu (Abbe-

ville) and in the Victoria and Albert Museum, but is far superior in quality. On the back is pasted a fragment of paper with a statement signed by Didier-Petit, an early owner, to the effect that this group came from an altarpiece which was destroyed, according to tradition, by the Baron des Adrets, and was found in the Loire. An inscription in a later handwriting reads: "Baron de Theis."

PROVENIENCE: Didier-Petit?; Baron de Theis (1765-1842); his sale (Paris, May 6-13, 1874). Acquired by Henry Walters in 1922.

EXHIBITION: Paris, "Exposition 1867"; London, South Kensington Museum, 1876 (Westwood, *A Descriptive Catalogue of the Fictile Ivories in the South Kensington Museum*, London, 1876, p. 402, as "fragment of the Descent of the Holy Ghost").

BIBLIOGRAPHY: R. Koechlin, "Quelques ateliers d'ivoires français," *Gazette des Beaux-Arts*, XXXV (1906, I, p. 61 ff.—idem, "Les retables français en ivoires du commencement du XIVe siècle ," *Fondation E. Piot, Monuments et Mémoires*, XIII (1906), p. 67 ff.—idem, *Ivoires*, I, pp. 306, 308 with the long note 1, where the author recants the views he expressed in 1906. [*Contra:* M. H. Longhurst, *Victoria and Albert Museum . . . Catalogue of Carvings in Ivory*, II, London, 1929, p. 33 (n. 211-1876) cf. p. 15-16 (n. A.99-1927).]

PLATE XCIV WALTERS ART GALLERY, inv. no. 71.288

118 GERMAN (under French influence), ca. 1370

Diptych: the Vierge Glorieuse; the Crucifixion

Ivory; each panel: 8 x 5$\frac{1}{16}$ in. (.203 x .128 m.)

Each scene is carved under a canopy of three cusped arches, the central one being higher and wider. These are surmounted by gables with vigorous crockets and finials, alternating traceried pinnacles repeating the design of the arches. The pinnacles stand against a slate-tiled roof or a wall. The style of this decoration indicates a period already late in the third quarter of the fourteenth century. It is found in two ivory plaques with similar Crucifixion reliefs in the Berlin Museum (Koechlin, nos. 608, 638), and also, with more embryonic pinnacles, on the right wing of a diptych, n. 294-1867, in the Victoria and Albert Museum.

An indication of derivative work is afforded by the lack of correspondence in proportion and spacing between the two subjects: the *Vierge Glorieuse* and the Crucifixion. At an earlier stage in this category of diptychs the *Vierge Glorieuse* was balanced by a Crucifixion of simple type, in which only the Virgin and St. John were present. Subsequently, characters were added to the Crucifixion (cf. another diptych of the *Vierge Glorieuse* and Crucifixion in the Walters Art Gallery, inv. no. 71.178, which was carved soon after 1350). The iconography of our Crucifixion is not only complex, but rather mysterious. The blood from Christ's pierced chest spurts forth and strikes the heart of His mother (the detail of the jet has been broken off on our ivory). The three Jews near St. John, with their characteristic hats and strongly emphasized Semitic features, may represent symbolically the prophets of the Old Testament in accordance with some mystery play, and consequently the Old Dispensation as opposed to the New one that is embodied in the group of the swooning Virgin, type of the Church, assisted by the three holy women. The crowded design of the Crucifixion derives from certain small diptychs of the Passion comprising four scenes or integrating the Glorification of the Virgin and the Crucifixion. Of these Koechlin's nos. 290, 292 and 293 present a strong case for an origin in Germany or in an Italo-German milieu of northern Italy, after French models (cf. also the Crucifixion in an extraordinary and unique diptych in the Rhode Island School of Design, Providence, and the Walters diptych described under no. 107 of this catalogue). Koechlin's n. 292 shows also the detail of the blood spurting from the chest of Christ and striking the breast of the Virgin. The detail of the jet of blood is the crux of the contention made by Morey for attributing to Germany or to Italo-German art twenty-two

115

ivories previously classified as French. Of these the diptych considered here, as well as three others, are in the Walters Art Gallery.

The closest comparison with our Crucifixion is presented by the diptych n. 235-1867 in the Victoria and Albert Museum. In both carvings, the right side of the mantle of the Virgin is tucked up in her belt in the same way, an unmistakable sign of origin in the same workshop. The companion piece to the Crucifixion in the Victoria and Albert Museum diptych is the Adoration of the Magi, in which, contrary to the usual French formulation of the scene, the middle-aged king uses his left hand, instead of his right, to point to the star of Bethlehem as he turns his head back toward the youngest king. This substitution of a more emphatic gesture for the subtle contrapposto found usually in the Adoration of the Magi in French ivories, was considered by Morey a German feature. But that substitution also occurred on purely French works: on the enamelled plaque on the socle of the parcel-gilt statuette of the Virgin presented to the abbey of St. Denis by Queen Jeanne d'Evreux in 1339 and on the embroidered altar-cloth given to the Cathedral of Sens by the countess of Etampes in 1389. It appears in French manuscripts, such as a Psalter dating around 1380 in the library of Avignon (ms. 121). The French "contrapposto gesture" of the middle-aged king is still found in the last years of the first half of the fourteenth century in Germany (in certain manuscripts of the *Speculum Humanae Salvationis* before the German type became general and in the tympanum of the north portal of the eastern choir of the Cathedral of Augsburg). However, the same type of Adoration of the Magi with the direct and emphatic gesture of the middle-aged king and the Crucifixion with the jet of blood appear on a diptych in the Vatican Library, Museo Cristiano (Morey, *Catalogue*, n. A 99 as German—but it could be Italian with German influence). The jet of blood is certainly not an innovation of the fourteenth century (cf. the Crucifixion panel in the Catarino ancona, n. 8 of this Catalogue). It originated in the Byzantine iconography of Christ represented dead on the Cross, which Germany adopted early. The meaning of the jet of living blood gushing forth from the dead body of Christ was a sacramental one in Byzantium, but it became transformed in Germany by the overtones of individual mysticism. Suso (d. 1366) wrote in his *Büchlein der ewigen Weisheit*: "Woe, oh woe, how runnest thou pure blood down to the mother who bore thee . . . pure hearts, let pour into your deepest that blood that besprinkled the immaculate mother."

A French model is the remote source of the Crucifixion represented on the right leaf of our diptych. A French model directly inspired the *Vierge Glorieuse* on the left of the diptych. Its iconography and composition are French. The duality of models justifies the remark of Koechlin that each leaf betrays a different style. Morey described the facial types of the bystanders of the Crucifixion as allied to Rhenish sculpture of the fourteenth century with their "eyes . . . marked with a blocky iris or eyeball and set so close together as to produce a cross-eyed effect . . . the ridge of the nose curves inward so that the nose itself seems to turn up at the extremity, the eyebrows are arched and tilted . . ." The Virgin, on the contrary, resembles in facial expression the French Virgins (cf. Cat. no. 90 and no. 115). Her mantle in a diagonal fold slanting from the right hip to the left hip is of the late fourteenth-century type. However, the angels, as well as the face of the Virgin, show a Germanization of French models.

The attribution of the diptych to German art seems to be reinforced by the rapid evolution of a parallel type of diptychs in the small (perhaps Austrian) school named after the master of the diptych of Kremsmünster in the last quarter of the century. In that school also—in which baroque and realistic tendencies replaced the refined articifiality of which the still exquisitely mannered diptych on display is the best exponent—the *Vierge Glorieuse* was substituted for the Adoration of the Magi. The diptychs of the "Kremsmünster" series are also the only ones in which the imitation of a wall with simulated courses of ashlar is found behind the pinnacles of the decorative arches.

In spite of its apparently German characteristics, our diptych is connected to southwestern France by an inscription in medieval handwriting in faded ink on the back of the right leaf

which reads: *Ardenus Grassus de Morario loci de Burossa Lascurensis diocesis.* Buros, near Pau, was then in the diocese of Lescar. Could the diptych have been carved by a German in the international milieu of Avignon? The almost unreadable first part of the inscription has been interpreted by Charles Stein as relating to an endowment for commemorative ceremonies. That inscription, which is medieval, if not actually contemporary with the ivory, is extremely interesting, because it indicates that the small diptychs of the fourteenth century were not exclusively images of devotion, but could be used in connection with the commemoration of the dead, as the late antique and early Christian diptychs had been used since the Dark Ages.

CONDITION: The jet of blood has been broken off, leaving its extremities.

PROVENIENCE: Georges de Waroquier, Toulouse; Sigismond Bardac. Acquired by Henry Walters in 1922.

BIBLIOGRAPHY: Baron de Bouglon, "Note sur un diptyque d'ivoire du XIVe siècle," *Bulletin de la Société archéologique du Midi* (1901), p. 326—Koechlin, *Ivoires*, I, p. 223, n. 1; II, n. 569, pp. 218-9; III, pl. C—C. R. Morey, "A Group of Gothic Ivories in the Walters Art Gallery," *The Art Bulletin*, XVIII (1936), pp. 199-212, fig. 5 (the references to fig. 3 and to fig. 5 are interchanged)—idem, *Gli oggetti di Avorio e di Osso del Museo Sacro Vaticano*, 1936, p. 39 (cf. p. 83, A 99, A 100)—idem, "Italian Gothic Ivories," *Medieval Studies in Memory of A. Kingsley Porter*, I, Cambridge, Mass., 1939, p. 191, n. 13.

PLATE XCVII WALTERS ART GALLERY, inv. no. 71.276

119 ITALIAN (under German influence)?, ca. 1375

Quadriptych with eight scenes of the Passion of Christ

Ivory with traces of gilding and polychromy; each leaf: 7¼ x 2¼ in. (.187 x .059 m.)

The Raising of Lazarus; the Entry into Jerusalem; the Washing of the Feet; the Last Supper; Gethsemane; the Arrest of Christ; the Way to Calvary; the Crucifixion.

The layout of these eight small reliefs of the Passion is very uncommon. Usually the decorative frame made of cusped pointed arches under crocketed gables is present only in a certain category of smaller diptychs. It seems as if we had two diptychs arranged here in a pair to constitute a quadriptych. The two leaves of each pair are hinged together, according to the method constantly followed in the French ivory workshops of the fourteenth century, by diagonally inserted silver flanges. The scenes read from left to right, starting from the top. Such quadriptychs composed of two diptychs are encountered also in panel painting from the last quarter of the fourteenth century (see Cat. no. 24). In ivory only one other similar and complete arrangement exists: a quadriptych with the story of the Passion in the Metropolitan Museum (Koechlin, n. 282) with leaves topped by free gables in the manner of the Italian ivories of the middle of the fourteenth century. A diptych in the British Museum (Dalton, *Cat.*, n. 268) is the surviving member left of a similar quadriptych of the Passion. There is also in the Lyon Museum (Koechlin, n. 285) a leaf which is the left and only surviving part of a diptych that had formerly been assembled with a companion diptych to form a quadriptych of the story of the Passion.

There are three iconographical singularities or rarities in this quadriptych of the Passion: the Raising of Lazarus is introduced as a premonition of the death and Resurrection of Christ (cf. Koechlin, nos. 787, 789, 819). In the Way to Calvary an executioner carries the three nails and the Virgin Mary helps Christ to bear the Cross—iconographical features which come from Germany and were adopted in the Italian ivory triptychs and polytychs of the "tabernacle" type. In the Crucifixion a sword darting from the wounded chest of Christ stabs the breast of the Virgin, materializing the prophecy to the Virgin made by Simeon when the Infant Christ was presented in the Temple: "Yea, a sword shall pierce through thy own soul also . . ." (Luke 2:35). These two last scenes emphasize an idea which in literary and visual documents was new: that of the co-suffering of Mary, or her "co-Passion," parallel to the Passion of Christ. According to Hanns Swarzenski, that idea was born in the German circles dominated by the mysticism of the Domini-

can order. For instance, we read in the *Piissima Exercitia*, which have been attributed for no good reason to Tauler (d. 1361), but which nevertheless reflect, as C. R. Morey recalls, the "Dominican thought and expression in the Rhenish monasteries of the fourteenth century": "Thy Holy Mother, racked by inward compassion in like manner with Thee upon the Cross, and fastened thereto by nails, and her tender heart and true mother's breast, pierced with the sword of sharp sorrow." But there must have been a deeply rooted motivation justifying the new iconography of the Compassion of the Virgin, in order to share with her the feelings which excruciated her on Calvary. Mary was traditionally equated to the Church as the body of the faithful. We know that the feast of the Seven Sorrows of the Virgin was established by the Church in 1423 as an expiation of the heresy of the Hussites and to symbolize the wounded body of the *Ecclesia militans*. Essential in the imagery connected with the cult of the Seven Sorrows of the Virgin was to be the sword piercing her heart. If the theory of Dominican origin for the symbolism of the sword stabbing the heart of the Virgin at the foot of the Cross holds true, it raises the hypothesis of a symbolical relationship with the heresies which, from those of the Vaudois and the Cathars to those of Wyclif and John Huss, during the period from the thirteenth to the early fifteenth century shook the Roman Church to its foundations and were ruthlessly persecuted by the Dominican order. In this connection the iconography of the sword stabbing Mary appears in the late thirteenth-century *Missel des Jacobins* (Toulouse, Bibl. munic., ms. 103, fol. 133vo), and in the "Vision of the Dominican monk" of the *Speculum Humanae Salvationis* the sword pierces a Dominican monk in a scene opposite the Presentation in the Temple (ed. Lutz-Perdrizet, pl. 89). Although the iconographical examples of the theme afforded by C. R. Morey are overwhelmingly German—even discounting those ivories which are by no means German—some other instances of the theme are French under German influence (i.e. the illumination of Christ crucified on the Tree of Life in the Psalter of Yolande de Soissons, Pierpont Morgan Library, ms. 729). Let us add an illumination executed in Bologna under French influence: the Crucifixion in the *Abbreviatio figuralis historie* by Gérard d'Anvers (Florence, Bibl. Riccardiana, cod. 1184M, fol. 12), and the Entombment-Pietà with the sword fixed in the heart of the Virgin painted in Bologna in 1368, by Giovanni dei Crocifissi.

Among the fourteenth-century ivories with the iconography of the sword transfixing the Virgin, the right leaf of a diptych of the second half of the fourteenth century, also in the Walters Art Gallery (inv. no. 71.250), brings a secondary and no less extraordinary element: the martyrdom of Thomas Becket equated with the Crucifixion of Christ and the "co-Passion" of the Virgin. One in the Berlin Museum is certainly German, but with admixture of some emblems of the *Arma Christi* which are not met with elsewhere (Volbach, *Cat.*, n. 674). Nos. 430, and 613 in the *Corpus* of Koechlin, late in the production of fourteenth-century ivories, do not seem to be French and certainly have nothing to do with the workshops of Paris. No. 616, today in the Landesmuseum, Darmstadt, may have originated in Germany and the triptych of the former Botkin Collection (Botkin Cat., pl. 56) is Italian.

CONDITION: Cracked at the left and right lower corners. Repaired at the right lower corner.

PROVENIENCE: Acquired by Henry Walters in 1923.

BIBLIOGRAPHY: C. R. Morey, "A Group of Gothic Ivories in the Walters Art Gallery," *The Art Bulletin*, XVIII (1936), pp. 199-213, fig. 6. Cf. *idem, Gli oggetti di Avorio e di Osso del Museo Sacro Vaticano*, Vatican, 1936, p. 41.

PLATE XCVII WALTERS ART GALLERY, inv. no. 71.200

120 ITALIAN (Milan?), ca. 1400

Saint Catherine of Alexandria, enthroned between Saint Peter and Saint Paul

Ivory, carved and pierced; 3¾ x 2⅝ in. (.097 x .067 m.)

There are two cavities on the left side of this plaque, which would suggest that it is the right

wing of a diptych—but a diptych in openwork is difficult to conceive. Diptychs featuring just figures of saints do not even exist among French ivory carvings. On a certain number of diptychs or fragments of diptychs of the second half of the fourteenth century, it is the Virgin who stands between two saints. On a single example in the *Corpus* of Koechlin (529 *ter*) two saints are represented, but this one probably is not French and it is not a pierced plaque. The technique of our piece—openwork—seems to have remained very little practiced in the French ivory workshops. The traceried niches with rosaces and gables alternating with crocketed pinnacles are similar to those of a pierced relief showing Christ between St. Peter and St. Paul, in the Victoria and Albert Museum (n. 213-1865), possibly a Milanese ivory of the early fifteenth century—an attribution suggested by the architectural features of the framework and the Germano-Italian style of the carved figures. Plaques in the same technique, with religious or mundane subjects alien to the formulae of the French ivories, exist in the British Museum (Dalton, *Cat.*, n. 311), the Museum of Niort (Koechlin, n. 872) and the Berlin Museum (Volbach, *Cat.* n. 648). The type of St. Catherine—with crown and nimbus, her long hair flowing over her shoulders, dressed in a closely fitting robe with low-cut neck and a mantle wide open and clasped with a morse—derives from two larger ivory reliefs of the saint in the Cluny Museum, Paris, and in the Bargello (Koechlin, nos. 712-3), except for a slight change in the pose of St. Catherine due to the circumstance that in the two groups mentioned she points with her right hand to Emperor Maxentius, whom she tramples underfoot. Because of the smaller size of our plaque, the emperor has been omitted.

PROVENIENCE: Very Rev. Dr. Daniel Rock (1799-1871); Charles Stein, Paris; Sir Thomas Gibson-Carmichael; his sale (London, May 12, 1902, n. 152, ill.). Acquired by Henry Walters in 1903.

EXHIBITION: Loan Exhibition, South Kensington, 1862, n. 199.

PLATE XCIV WALTERS ART GALLERY, inv. no. 71.278

121 ITALIAN, ca. 1400

Mirror-case

Ivory; 3¾ x 3¾ in. (.098 x .095 m.)

A youth is offering a comb to a lady in a garden, between two buildings with little turrets. The two figures are in profile. The man, his hair of shoulder length, wears a long coat (*houppelande*) belted rather low at the waist with a hood left down. The lady is dressed in a long robe (*surcot*) with hanging sleeves (*liripipes*), closely fitting the torso and with low-cut neck. The plaits of her hair encircle her forehead and are looped over the ears.

The scene is enframed in a cusped quatrefoil with trefoils in the spandrels; four projecting leaves at the angles make the exterior outline a square. The back is turned with a cavity for the mirror, now missing.

This is one of the numerous copies, in a coarse style, executed after French models in northern Italy. The fashion of the dress is characteristic of the last quarter of the fourteenth century. The stiff silhouettes, the corrugated draperies ending in a straight line, and the angular slash outlining the lower jaw so sharply that it seems to be severed from the neck, are found also in the ivories produced in the Embriachi workshop of Venice. There is an analogous piece in the British Museum (Dalton, *Cat.*, n. 384; cf. Koechlin, n. 1115).

PROVENIENCE: Sir Thomas Gibson-Carmichael; his sale (London, May 12, 1902, n. 7). Acquired in London by Henry Walters in 1903.

PLATE CII WALTERS ART GALLERY, inv. no. 71.269

122 ITALIAN (Venice), ca. 1410

Mirror-case

Ivory; diameter 3¾₁₆ in. (.082 m.)

The bridegroom presents a flower to his bride and asks her to accept it: PRENES (take) is inscribed on the scroll. The gift of true love is presented in a garden. The companion piece, no. 105 of the Sauvegeot Bequest to the Louvre, is today displayed in the Cluny Museum. There the youth proffers a love-crown (*chapeau de fleurs*) and the words inscribed on the scroll EN GRE (kindly) complete the inscription on the first piece. Both were to be used as mirror-cases hanging from a belt (cf. the two holes on the right of our piece). The mirror-case in the Walters Art Gallery has lost the corner leaves which give the Louvre mirror-case a square outline.

The meaning of the two mirror-cases is made clear by the little dog, symbol of loving faithfulness, which the lady is holding in her arms in the Paris piece, and by an eighteenth-century drawing made by Grevemboch, when the two mirror-cases were still together in the collection of Pietro di Giacomo Gradenigo in Venice. Grevemboch wrote under his drawing: *Antico diptico nuziale Veneto.* Probably the two mirror-cases were exchanged by the wife and the husband in the same manner as marriage rings are exchanged today. The inscription *prenez en gré* occurs on a goblet made for Louis I d'Anjou, and the refrain: *Prenez en gré le don de votre amant,* recurs in in a ballard of Christine de Pisan. In the 1440's a similar allegorical subject was painted by the Sienese Domenico di Bartolo on the lid of an exquisite circular marriage box formerly in the Figdor Collection. Our mirror-case must be thirty years earlier, judging by the fashion of the costumes, featuring the long dagged sleeves and the dagged hem of the man's *houppelande,* and the *chaperon* covering his head, as well as the headgear of the lady, a *coiffure à cornes* with a *coiffe côtelée.* Very probably the work was executed in Venice for the court of Milan. Even the French inscription gives further support to that origin because French was largely spoken (it is still to a certain extent today) in Piedmont and was the court language of Milan. The composition of the mirror-case, however, derives more from the German *Minnekätschen* than from a French model.

CONDITION: The corner leaves have been cut off, leaving a circular outline.

PROVENIENCE: Pietro di Giacomo Gradenigo, Venice, mid 18th century. Acquired by Henry Walters in 1914 (as French, 15th century).

EXHIBITION: Norfolk, Va., Norfolk Museum, "Life in the Gothic Age," 1955.

BIBLIOGRAPHY: P. Molmenti, *Storia di Venezia nella vita privata,* I, Bergamo, 1906, fig. p. 437 (cf. p. 68)—cf. Westwood, *Fictile Ivories,* n. 869—Viollet-le-Duc, *Dictionnaire du Mobilier,* IV, Paris, 1873, p. 136, fig. 3—quoted by Koechlin, *Ivoires,* II, n. 1115—M. C. Ross, "A Gothic Ivory Mirror Case, *JWAG,* II (1939), pp. 109-111, fig. 2.

PLATE CII WALTERS ART GALLERY, inv. no. 71.107

123 NETHERLANDISH, early 15th century

Virgin and Child

Ivory statuette; H. 10¾ in. (.28 m.); base: 6¼ x 5½ in. (.16 x .14 m.)

The bare head of the Virgin, her substantial person and the fact that she is not enthroned but seated on a *faldistorium* (folding chair) gives an aura of bourgeois intimacy to this group. Originally, the Virgin held in her right hand an object (now lost) which probably was a toy or a fruit, enamelled on gold, which Jesus, standing on two piled-up cushions, tries to reach. The chair and the cushions once were decked out with tassels in gold and enamel that are missing now, and a precious morse clasped the opened mantle of the Virgin. She would also have worn a rich crown. Holes are the surviving evidence of all these precious attachments. A socle of goldsmith's work,

imitating an architectural structure, may be also surmised as the original support of the group, as indicated by indentations for flanges in the base of the ivory.

Except for the fact that the hair of the Virgin falls partly on her shoulders and breast rather than being gathered entirely back, the treatment of the group, the handling of the draperies and the facial characteristics present striking similarities with the famous *chef d'oeuvre* of enamelled goldsmithswork: the so-called *Goldenes Rössl,* the "Golden Horse" preserved in the church of Altötting in Bavaria. That work of art is a group representing the Virgin and Child seated in a bower among angels and venerated by the King Charles VI, all in enamelled gold. A knight kneels on the other side of the king and, below the platform supporting the group, a groom holds the royal horse; it is from the delightful representation of the horse that the whole work derived its name. It was given to Charles VI by his wife Queen Ysabeau of Bavaria as a New Year's gift in 1404, and is the masterpiece of the art of the goldsmiths and enamellers of Paris at the beginning of the fourteenth century. Its origin in a workshop of Paris does not certify that it was made by French craftsmen. Many artists from Germany and the Netherlands had been invited to work in Paris. Ysabeau of Bavaria was the niece of Catherine of Bavaria, who married William, Duke of Guelders, and she was the sister-in-law of John the Fearless, Duke of Burgundy, who had married Margaret of Bavaria. It was the family relationship between Ysabeau and Catherine of Bavaria that probably accounted for the coming to the court 'of Burgundy of Jan Malwael and of his nephews Paul, Herman and John of Limbourg, who subsequently became the illuminators of the Duke of Berry. Certainly many craftsmen of the regions bordering the Netherlands and the Lower Rhine followed in the wake of these great artists.

The style of this ivory group of the Virgin and Child—which hitherto has always been dated too late in the fifteenth century—is in absolute conformity with the International Style in full bloom in Paris during the first decade of the fifteenth century. The evidence would be tangible if the precious setting and details enhancing the ivory carving had been preserved. It has to be noted that white is the basic ground-color of the enamelled goldsmithsworks of Paris around 1400 and that the artists who produced these jewelled *joyaux* may have used as models ivory carvings enriched with enamel incrusted on gold, or doubtless they also played a part in production of these. The ornament at the center and on the back of the *faldistorium* reproduces one of the *marguerites* in enamelled gold so often entered in the accounts of Philip the Bold. Charles V is seated on a chair similar to our *faldistorium* in the presentation portrait in his *Bible Historiale,* painted by Jean Bondol in 1371.

Our group was created in the circle of artists and craftsmen with a strong percentage of *paintres alemants*—that is from the Lower Rhine and eastern Holland—who were employed at the courts of Charles VI, King of France, and of his uncles, the Dukes of Burgundy and Berry. A more aristocratic, perhaps, but analogous type of the Virgin is found in the illuminations of the Limbourg brothers; her facial characteristics are ethnically like those of the angel between Daniel and Isaiah on the "Well of Moses" by Claus Sluter in Dijon. The debonair approach to the group and the placid countenance of the Virgin, new among the works of art then produced in Paris, and not French (compare the wistful type of the Virgin in the French ivory statuettes of the period around 1400)', derives from German art. The new relationship between the Madonna and the Child was initiated about half a century before. The "Gnadenbild" in polychromed wood, coming from the Liebfrauenkirche in Mainz—today in the church of the Seminar there—was one of the first sculptures to break with the earlier—dogmatic or aristocratic—medieval tradition and to herald an attitude of plain and human realism.

CONDITION: Thumb of right hand broken at the joint, insignificant chips on the hem of the mantle of the Virgin.

PROVENIENCE: Chanoine Sauvé, Laval, France, until 1892, Acquired by Henry Walters in 1913.

BIBLIOGRAPHY: L. de Farcy, *Revue de l'Art Chrétien* (1898), p. 290, pls. XIV-XV (as first half of the 15th century) —Koechlin, *Ivoires,* II, pp. 360-61, n. 982, II, pl. CLXXII (as second half of the 15th century)—C. Enlart, J. Roussel,

Catalogue général du musée de sculpture comparée, Paris, 1926, p. 124 (E. 187)—*Catalogue des moulages, Musée de sculpture comparée*, Paris, 1932, n. 1752—P. Verdier, *Bull. WAG*, VI, 3 (1953).

PLATE C WALTERS ART GALLERY, inv. no. 71.188

Goldsmithswork

124 AUSTRIAN or SWABIAN, later 14th century

Monstrance

Silver with enamelled elements; H. 16⅛ in. (.410 m.); D. of base 12¼ in. (.120 m.)

This monstrance (*ostensorium*) may be compared with one in the treasure of the monastery church of Klosterneuburg, Austria, which is of Viennese workmanship dating around 1400, especially for the soaring structure of its upper part and the details of its handling. In our monstrance the central receptacle (originally of rock-crystal, but now missing), was held by circlets of delicately cut silver trefoils and flanked by a pair of pinnacled buttresses attached to flying buttresses, likewise pinnacled, by a web of architectural tracery. The architectural inspiration culminates with a slender crocketed spire rising from a quadrangular base pierced by traceried windows under gables, and supported again by gracefully flying buttresses crowned with pinnacles. Atop all is St. Luke, standing upon a foliate finial. At the base is an elegantly flaring hexagonal foot, shaped in the silhouette of a six-petalled lily. This base develops from a hexagonal band of trilobed blind arches divided by buttresses at the bottom of the stem, which rises to support the superstructure by a flaring calix from which emanate crisp, spiral leaf-brackets from a pair of buttresses. Half-way up the stem is a flattened hexagonal knop with six lozenge-shaped bosses, each adorned with a quatrefoil on a ground of dark enamel. The latter details are reminiscent of a monstrance from the Sauvageot collection now in the Louvre. The turreted buttresses flanking the central receptacle and the hexagonal band of blind arcades above the flaring foot are, however, still in the tradition of Peter Parler (cf. two monstrances of around 1380 in the Cathedral of Prague). The elegant verticality of our monstrance suggests a date near 1400.

EXHIBITIONS: South Kensington, Loan Exhibition, 1862, n. 1006; Royal Academy, London, 1905-1906, n. J.4 (6).

PROVENIENCE: Hollingworth Magniac, of Colworth, Bedfordshire, England; his sale (London, July 4, 1892, p. 175, n. 790—as from the neighborhood of Cologne, 1400-1450); Charles Borradaile, Brighton. Acquired by Henry Walters in 1912.

PLATE CXIII WALTERS ART GALLERY, inv. no. 57.691

125 BOHEMIAN (Prague), 1387

Reliquary-Monstrance of the Instruments of the Passion of Christ

Silver gilt group *en repoussé* with elements in enamel; H. 11½ in. (.293 m.); base: 8 x 4½ in. (.203 x .114 m.)

This reliquary-monstrance in gilt silver is very important from the point of view of the liturgical and plastic arts, as well as iconography. It was commissioned in 1387 by John XI Sobieslaw, Bishop of Olmütz (capital of Moravia), who had been until then Bishop of Leitomischl and who, in 1388, became Patriarch of Aquileja. He was the nephew of Emperor Charles IV and Margrave of Moravia. The base of the reliquary-monstrance is inscribed with the record of the commission: HANC MONSTRANCIAM CVM SPINA CHORONE DOMINI DNS IOHANNES OLOMVCZENSIS EPISCOPVS PREPARARI FECIT, and bears at each angle four heater-shaped

shields filled with *bassetaille* (translucent) enamel, displaying the coats-of-arms of the Empire (argent, an eagle displayed, sable), the Kingdom of Bohemia (gules, a lion rampant, double queued, argent, crowned or), Moravia (sable, an eagle displayed, chequy argent and gules, crowned or) and the bishopric of Olmütz (per pale argent and gules, a crescent or).

It was made in Prague in the same workshop which, in 1352, executed on commission of Charles IV a base for the eleventh-century Cross of the Holy Roman Empire (Schatzkammer, Vienna) and the reliquary of St. Sigismund, also commissioned by Emperor Charles IV for the church of St. Maurice, Agaune (Switzerland).

On the oblong base, Christ, showing the stigmata of the Crucifixion, is standing as if in anticipation of the Resurrection, both dead and alive, His eyes open but glassy. He wears the loincloth and the Crown of Thorns, at the center of which is set a red stone. At His feet kneel two angels on oval bases, one near the Cross, the other near the Column of the Flagellation entwined with the cord and surmounted by the cock of the denial of St. Peter. They are proffering the scourge and the switches, the hammer and the three nails (some interchange of the instruments of the Passion occurred when this reliquary-monstrance was repaired in the nineteenth century). Both the Cross and the Column are pierced with openings through which were shown small relics of the Passion of Christ. The most important of all, a thorn from the Crown of Thorns, was originally displayed under a piece of rock-crystal in the tall gable-ended niche elevated by a small angel at the front center, who kneels on a little pierced pedestal. The three dice complete the *Arma Christi*.

It will be noted that in the reliquary-monstrance, conceived as a plastic group, only an anthology of the main instruments or relics of the Passion of Christ is shown. The motivation behind such a surprising example of goldsmithswork and similar images of devotion was probably the bull of Pope Innocent IV (1352-1362) recommending that special veneration be paid to the "instruments of the Passion" and that indulgences be awarded to those who prayed before them. Only one other reliquary comparable to the Walters one survives: the reliquary dated 1375 in the Treasure of the Cathedral of San Marco, Venice.

In Italian painting of the fourteenth century, the Man of Sorrows and the *Arma Christi* are fused in very complex compositions. But side by side with the "surrealist" or complicated type, a different one, much simplified, was evolved, in which only the most significant instruments of the Passion are presented and from which Mary and St. John are usually absent. The considerable importance for the history of art of the Walters Bohemian reliquary-monstrance resides in that it is an outstanding work of Bohemian art, as grandiose as monumental sculpture, and that Christ is represented here not as a half-image, emerging from the tomb, but as a tragic solitary figure attended only by two angels. Almost a century is to elapse before a similar plastic group will be re-created: the terracotta one, by Verrochio, today divided between the museums of Budapest and Toledo, Ohio. The reliquary-monstrance of John XI Sobieslaw raises the question of the artistic relationships between Prague and Italy, because the only comparable work, the reliquary-monstrance in gilt silver in Venice, was commissioned in 1375 for a fragment of the column of the Flagellation by the Procuratori of Venice, Michiele Morosini and Pietro Corner.

PROVENIENCE: Acquired by Henry Walters in Paris in 1903.

EXHIBITIONS: Chapel Hill, North Carolina, University of North Carolina, "Mediaeval Art," April 28-May 20, 1961 Cat. n. 31); Vienna, Kunsthistorisches Museum, "Europäische Kunst um 1400," May-July, 1962 (cat. n. 439).

BIBLIOGRAPHY: R. Berliner, "Arma Christi," *Münchner Jahrbuch der bildenden Kunst*, (1955), p. 63, note 299, fig. 16, p. 65—P. Verdier in *Art News* (Sept. 1962), p. 26, fig. 7.

PLATE CIX WALTERS ART GALLERY, inv. no. 57.700

126 FRANCO-BURGUNDIAN, end of the 14th century

Table Fountain

Parcel-gilt, with translucent enamels on silver; 12¼ x 9½ in. (.312 x .242 m.)

This table fountain is the only complete medieval center-piece of its kind that has survived, although many were listed in medieval inventories. A fragment of a similar fountain is in the Mayer van den Bergh Museum at Antwerp.

It is a masterpiece of fanciful architecture in miniature. It is built as a three-level structure of receding octagonal terraces, their parapets crenellated or gabled, around a hollow central pillar through which the water was forced by air pressure. Thirty-two gargoyles spouted the liquid in successive cascades from the top to a receptacle in which the fountain originally stood, but which is missing today.

The summit of the central column is shaped like a castle tower, and must once have supported a small cup or vase in rock-crystal. It is defended by four recumbent monsters, two lions and two dragons, which have their jaws open to spout the liquid. The terrace on which they lie is supported on an openwork structure of eight cusped Gothic arches under crocketed gables, alternating with buttresses whose pinnacles terminate in large finials. Complicated mouldings and pierced tracery enrich this little octagon. On the terrace outside it four vertical gargoyles are ready to spurt a jet of water at a little paddle wheel garnished with bells, which stands before each of them. The turning of the little water-wheels would set the bells to tinkling. The parapet of this terrace is topped with little pierced gables and faced with plaques of translucent enamel depicting musicians and pairs of fanciful creatures drinking from fountains. More gargoyles project from this parapet to send their jets onto the corrugated floor of the terrace below, where sit four nude little human figures, each of whom is prepared to spout water at a bell-garnished mill-wheel which he holds before him. Turrets, engraved with sham courses of ashlar and topped with pineapple finials accent the battlemented parapet of this level, ornamented with enamelled "gro-esques" and little heater-shaped shields, each charged with an eight-pointed star of gold on a circular field, gules. Eight little spout-heads, each different, project from the foot of the towers. The base of the structure recedes beneath this third and widest terrace, becoming a little grotto or crypt around the delicately diapered and beaded pillar in the center. From the eight hexagonal columns encircling this rises a vault—the outer ribs of which end again in gargoyle heads, to complete the system of waterplay.

Such a table fountain belongs to those automatons which met with so much favor at the Flemish and Burgundian courts and of which so many descriptions are recorded in the inventories of the ducal residences of Hesdin, Bruges, Lille, and so on, Christine de Pisan relates that King Charles V had an imposing collection of table fountains. Thirty-eight are listed in the inventory of the jewelry and enamels belonging to Louis I, Duke of Anjou, among which there is one described as a *tabernacle ouvré de maçonnerie à plusieurs tournelles,* and another one as a *pillier de très belle maçonnerie, fait comme en manière de clochier à plusieurs pilers et pinacles et fenestrages esmailliés.* It is hard for us to believe that the most fantastic of them were actual artifacts. The elaborate example in enamelled gold described in the *Roman de Tristan le Blanc* reads like an item entered in an inventory of the time. To their practical purpose little consideration was paid, and it does not matter too much to determine whether this table fountain, of rather modest dimensions, was really used for washing hands. Its function was to charm and to astonish. Such table fountains were sometimes called in the inventories of the end of the fourteenth century *fountaines de jouvent* (fountains of youth). The Middle Ages at their decline would not have conceived a "gadget" for the sake of mere display alone, or, as we know in other instances, only to serve for practical jokes. Such decorative objects had to be imbued with symbolism, mundane or religious, and sometimes Christian and profane allegories were strangely fused in them. Charles V had a table fountain built as a terrace supported by six pillars and sur-

rounded with figures of prophets. On the platform were statuettes of the Virgin and two angels (*Inventaire de Charles V*, n. 2654). Does not the description evoke an association with the "Well of Moses" at Champmol?

The fact that this table fountain was unearthed sometime after the end of the first World War in the garden of a palace of Constantinople adds the aura of historical prestige to its distinction as a *unicum*. The dream of the Dukes of Burgundy—from the crusade of the Count of Nevers (the future Duke John the Fearless) in Hungary against the Turks in 1396, to the expedition of Waleran de Wavrin in the same Danubian region in 1445—was to save Constantinople. Ambassadors at large, like Ghillebert de Lannoy and Bertrandon de la Broquière, journeyed to Constantinople and the Holy Land in the first third of the fifteenth century to prepare the ground. The little fountain may very well have been a part of their splendid luggage, left as a souvenir, or presented on the part of the Duke of Burgundy as a diplomatic gift.

CONDITION: Some damages to the enamels; the basin at the foot is missing, and probably an element atop the castle tower.

PROVENIENCE: Istanbul. Found buried in a garden.

EXHIBITION: Cleveland Museum of Art, "Twentieth Anniversary Exhibition," 1936.

BIBLIOGRAPHY: William M. Milliken, "A Table Fountain of the Fourteenth Century," *Bull. Clev.*, XII (1925), pp. 36-39, illus. on cover (dated as 1370 by Joseph Destrée)—*ibid*, XIII (1926), p. 75, ill.—*idem*, "Early Enamels in the Cleveland Museum of Art," *Connoisseur*, LXXVI (1926), p. 69, ill. p. 70—E. von Basserman-Jourdan, *The Clock of Philip the Good of Burgundy*, Leipzig, 1927, p. 39, figs. 35, 36—*Catalogue of the Twentieth Anniversary Exhibition of the Cleveland Museum of Art*, Cleveland, 1936, p. 19, n. 15—Henry S. Francis, "A Gothic Table Fountain and an Engraved Design for one . . .," *The Print Collector's Quarterly*, XXVI (1939), pp. 224-237—*idem*, "A Gothic Fountain Design . . .," *Bull. Clev.*, XXVI (1939), p. 120, ill. p. 118—N. M. Penzer, "The Great Wine Coolers—II," *Apollo*, LXVI (1957), fig. II, pp. 40, 41.

PLATE CVII THE CLEVELAND MUSEUM OF ART, no. 24.859
 Gift of J. H. Wade

127 FRENCH (Paris), ca. 1400

Necklace

Gold, incrusted enamel on gold, precious and semi-precious stones, pearls; L. 28½ in. (.724 m.); D. of central medallion: 1¾ in. (.044 m.)

This necklace is said to have been offered to the Virgin of Louvain by Margaret of Brabant, daughter of Duke Jean III and wife of Louis de Male, Count of Flanders (d. 1384). There is nothing, in theory, against the possibility of such a gift. Sixteen ornaments similar in style, material and technique to the twelve medallions of this necklace and also made around 1400 by a Paris goldsmith appointed by the French court, were subsequently mounted as a chain and are kept today in the treasure of the Münster at Essen. They were used as separate jewels before having been assembled as a gift to the church. In the present necklace the double chain interspersed with pearls that connects the twelve medallions is modern. However, the medallions were certainly originally part of a necklace, of the kind described in the account books of Philip the Bold, Duke of Burgundy, or which Charles VI sent to Richard II and the Dukes of Lancaster, York and Gloucester on the occasion of the marriage of Isabella of France with the King of England in 1396. The accounts of the Duke of Burgundy give a few details which are of great importance for estimating the social significance of the necklace. Such necklaces were gifts presented usually at the New Year, but also when a marriage was in prospect or after its celebration. They also played a part in diplomacy, for promoting good relationships or helping the conclusion of a new alliance. They seem to have been worn with only a few variations by men as well as by women.

Their richness in gold, precious stones and enamels was enhanced by numerous pearls (in some instances over 200) called *perles de compte,* because in the accounts they were not appraised as a lot but separately. The formal ornamentation was based on *marguerites* ("daisies") executed in gold incrusted with enamel, the petals enclosing pearls mounted on stalks to look like stamens. The motif of the lady in white seated in the lower medallion classifies the necklace as a gift between a newly engaged or newly married couple. For instance in 1380 when Mary, second daughter of the Duke of Burgundy, Philip the Bold, was married at the age of thirteen to the ten-year-old Count of Savoy, she presented her husband with a morse adorned with the emblem of a "lady in white."

The daughter of Margaret of Brabant, the traditional donor of this necklace to the Virgin of Louvain, was the wife of Philip the Bold. If the necklace was associated with the house of Burgundy, it was executed in Paris, because Paris became during the reign of Charles VI (1380-1422) the center that provided not only the French court but the Church and the nobility throughout Europe with a new kind of jewelry, in which enamel, and especially white and crimson enamel, was incrusted on gold reliefs *en ronde bosse* and associated with leaf patterns in gold, white flowers and clusters of pearls often in groups of three.

The central medallion or lower pendant of the necklace is shaped as a bower wherein a girl, a gold figure in relief, pointed up with dots of crimson and clad in a white enamel dress, holds a golden stalk in her hands. Face and arms are enamelled, but her hair is delineated in the gold ground and adorned with a green fillet. Around her radiate oak leaves executed in thin sheets of chased gold and smaller ones form a wreath in alternation with pearls mounted in clusters of three. The two adjoining pairs of medallions are designed as "daisies" of white enamel incrusted on the gold petals, in the heart of which pearls mounted on short stems radiate from the setting of a gem, while gold leaves curl around the edges. The six other medallions are smaller and are comprised of little enamelled flowers looking like Guelder roses combined with small gold cups in which pendant pearls move to and fro, or they alternate pearls and stones in rosette designs. The medallion that serves as a clasp is built as a large enamelled flower bristling with pearls and precious stones and encompassed by a wreath of crisp leaves and clusters of three pearls.

EXHIBITIONS: Detroit Institute of Arts, "French Gothic Art," 1928, n. 75; Cleveland Museum of Art, "Exhibition of Gold," 1947; Bruges, Groeningemuseum, "Le siècle des primitifs flamands," June 26-Sept. 11, 1960, n. 113; Detroit Institute of Arts, "Masterpieces of Flemish Art: Van Eyck to Bosch," Oct.-Dec., 1960, n. 128; Seattle, "Century 21 Exposition—Masterpieces of Art Exhibition," 1962.

BIBLIOGRAPHY: *La Perle*, Sept. 10, 1928—*Art News* (Dec. 1, 1928), p. 18; W. M. Milliken, *Bull. Clev.,* XXXIV (1947), ill. p. 228—idem, "The Art of the Goldsmith," *Journal of Aesthetics and Art Criticism,* VI (1948), p. 321, fig. 6— T. Müller and E. Steingräber, "Die französische Goldemailplastik um 1400," *Münchner Jahrbuch der bildenden Kunst,* V (1954), p. 76, n. 26, fig. 66—*Bull. Clev.,* XLV (1958), ill. p. 57—Cleveland Museum of Art, *Handbook,* Cleveland, 1958, n. 177—Groeningemuseum, *Le siècle des primitifs flamands,* Bruges, 1960, n. 113, pp. 215-216, ill.— Detroit Institute of Arts, *Flanders in the Fifteenth Century: Art and Civilization. Catalogue of the Exhibition Masterpieces of Flemish Art: Van Eyck to Bosch,* Detroit, 1960, n. 128, pp. 289-290, ill. The references to the account books of Philip the Bold in the archives of Dijon are quoted by: H. David, *Philippe le Hardi . . . Le train somptuaire d'un grand Valois,* Dijon, 1947, p. 43, note 3; p. 45, note 4; p. 56, note 8; p. 63.

PLATE CVI

THE CLEVELAND MUSEUM OF ART, no. 47.507
Purchased from the J. H. Wade Fund

128 GERMAN (Lower Rhine), first quarter of the 15th century

Image of Devotion

Silver parcel gilt and gilt copper on wood core; 15⅛ x 10⅛ x 1⅝ in. (.385 x .259 x .043 m.)

An Image of Devotion (*tabula, tableau*) shaped like the end of a chasse and enframing a Crucifixion between the Virgin and St. John. Possibly relics are enclosed inside. The figures are in silver,

cast and chased and parcel gilt. The Virgin and St. John are both hollow. The body of Christ is hollow, except for the soldered arms, and there is a cavity open in the back of His chest. The symmetrical sprays of dry foliage decorating the moulding of the frame also are cast in silver. The Cross, the brackets on which the Virgin and St. John stand, the background and the covering of the frame itself are of gilt copper. The halo of Christ is integrated with the Cross at the meeting point of the shaft and arms, as often occurs in the Crucifixions executed by goldsmiths. The plaque used as a background for the Crucifixion was incised with a toothed roulette in a diaper design of lozenges enclosing engraved quatrefoils. The haloes are carefully tooled with bursting rays and rims of semi-circular motifs punctuated with dots. Engraved on either side above Christ's head are a flamboyant sun and a waxing moon with the crescent enclosing a female face.

The gabled shape of the frame and the diaper-work recall two reliquaries (*tabulae*) of the fourteenth century in the church of Gräfrath, Solingen, in the Rhineland. The reliquary is in an excellent state of preservation except for one or two small damages. What is more important, it does not seem ever to have been tampered with. If relics are still contained inside, they have never been inspected. The sheets of gilded copper are fastened to the wood core with 102 little rosette-headed nails of the type called *pucettes* (little bugs) in the accounts of Philip the Bold, Duke of Burgundy, still preserved in the Dijon archives. There may be a connection with Burgundy, via the Rhineland or the Lowlands. The sprays of foliage used in the decoration of the frame are of the stringy type that was to characterize the painted enamels executed in the Netherlands for Philip the Good. The face of Christ with the enormous crown, the bushy beard, the eyes sunken by suffering in shady sockets, His somewhat wild expression and the hair matted in heavy strands falling on the chest, remind one of Flemish realism (cf. the Corpus in wood from Champmol, executed by Jacques de Baerze in 1390-91, now in the Art Institute, Chicago). His loin cloth, very narrow and diagonally crossed, is draped exactly as on a Netherlandish enamelled Crucifixion in the Victoria and Albert Museum (ca. 1430). Finally, the brutal, slightly vulgar pathos would suggest an attribution in a region of the Lower Rhine close to the Netherlands, but not Dutch. The type of the Cross: very thin and not tall, but high at the top, with concave ends—as well as the characteristics of the Corpus, which are those observed in the Crucifixions towards the end of the fourteenth century—might date this work quite early in the fifteenth century, but for the retardataire tempo of the decorative arts.

CONDITION: The nose of Christ slightly damaged; the tip of the middle finger of His right hand broken off; a repair at His left wrist; His shins and the insteps of the feet slightly crushed. Five of the rosette-headed nails are replacements, but only one of these is recent.

PROVENIENCE: From a French collection. Acquired in 1962.

PLATE CVIII WALTERS ART GALLERY, inv. no. 57.1918

129 ITALIAN (Sienese?), first half of the 15th century

Reliquary Cross for a Thorn from the Crown of Thorns

Rock crystal and gilt copper with champlevé enamels and bassetaille enamel on silver. H. 10¼ in. (.265 m.); W. of of base: 4½ in. (.115 m.)

A Latin cross of rock-crystal with all four ends of trefoil shape and, in the upper vertical arm, a cavity with a sliding lid of rock-crystal for the relic. The stand is of copper gilt with oblong base edged with beaded moulding, a tapering stem, a flattened square knop with rounded sides having two of the lozenge-shaped bosses set with fleurs-de-lys reserved in champlevé enamel and two with rosettes reserved in orange-red enamel.

Above the knop the shaft flares laterally to receive the crystal cross. The front and back of this part of the shaft are set with two trapezoidal silver plaques each engraved with an angel in adoration. The angels are covered with green translucent enamel, with details in yellow; faces

and hands are left bare. The borders enframing the two silver plaques are chiselled with a line of cinqfoils. The semi-circular foot of the rock-crystal cross is set into a silver socket engraved with palmettes and edged with cut-out lilies and leaves.

CONDITION: Cross chipped; stem broken at points where it joins the base.

EXHIBITION: London, Burlington Fine Arts Club, 1897.

PROVENIENCE: Borghese Collection; Sir Thomas Gibson-Carmichael (first Lord Carmichael); his sale (London, May 12, 1902, n. 88); Charles Borradaile. Acquired by Henry Walters in 1912.

BIBLIOGRAPHY: Burlington Fine Arts Club, *Catalogue of a Collection of European Enamels . . .*, London, 1897, n. 39 (as Florentine, ca. 1480).

PLATE CXIV WALTERS ART GALLERY, inv. no. 44.303

Enamels

130 FRANCO-FLEMISH, ca. 1375

Plaque: The Arrest of Christ

Translucent enamel on silver; D. 2¾ in. (.07 m.)

The round silver plaque is decorated with translucent enamels in the *bassetaille* technique with the scene of the Arrest of Jesus. Judas Kissing Jesus, Christ healing the ear of the childish Malchus fallen at His feet, and St. Peter sheathing his sword, all present the details of the scene according to the patterns current in the ateliers of the ivory-carvers and miniaturists. of the last quarter of the fourteenth century. The model was probably a miniature of the Franco-Flemish school of illuminators active in Paris.

Christ wears a deep blue robe with an emerald green mantle. His hair is brown, His halo emerald. Judas wears a mulberry brown cloak over a blue robe, the soldier shows a green helmet and a brownish sleeve. St. Peter wears a deep blue robe, a pale grayish cloak lined with emerald and his sword has a silvery tone. Malchus is dressed in a golden brown robe. All faces seem to be covered merely with flux, pearly white, somewhat opaque. The flanking trees sprout green leaves in emerald enamel. The background is of the same deep blue as the robes.

CONDITION: Some losses of enamel.

PROVENIENCE: Lambert, Paris.

PLATE CXVI MR. and MRS. GERMAIN SELIGMAN

131 FRENCH, second quarter of the 15th century

Medallion: Coronation of the Virgin

Translucent enamel on silver; D. 2½ in. (.064 m.) with frame (of later date): (.076 m.)

Three almost identical middle-aged, bearded men representing the Trinity are seated on a high-backed bench hung with a green curtain. The golden-haired Virgin, dressed in simple garb, kneels at the center, facing outward. She is represented at about half the scale of the Persons of the Trinity and looks like a girl. Two golden-haired angels hover above the throne, holding a large crown of gold, and two more angels flank the bench. The composition, and especially the figure of the Virgin, are akin to the Tyrolese painting of the Coronation of the Virgin (Cat. no. 36), but here in the enamel the Holy Spirit is no longer represented symbolically as the Dove, and the order of the

Three Persons of the Trinity is different. Christ is on the left of the medallion. He wears a deep blue mantle lined in aubergine with a golden collar, open to show His naked body. The Holy Spirit, on the right of the medallion, wears a robe enamelled in the aubergine and a mantle of the same blue. He reaches across with His left hand to help Christ to support the cruciferous orb. God the Father, in the center, is clad in an aubergine mantle with the same gold collar as the others, over a pale silvery blue robe. All Three bless with the right hand and the left hand of God the Father rests lightly on the orb. The location of the Father at the center and the Holy Spirit on His left may be confirmed, in the absence of attributes, by comparison with later works (the tympanum of Verrières in Champagne, and the Töpferaltar in Baden, near Vienna). The robes of the angels are also of aubergine and their wings shine in emerald green against a deep blue background. The throne is a golden brown with golden finials. There are traces of emerald green, in spite of losses, on the tessellated floor.

The Virgin crowned by the Trinity belongs essentially to German iconography in the fifteenth century, but the theme was probably diffused in France at that period by the English alabasters. The first surviving instance of it is a north French drawing of around 1400 (Louvre, Cabinet des Dessins, inv. no. 9832). The Coronation of the Virgin at the center of a tapestry in the treasure of the Cathedral of Sens is a Burgundian work of the third quarter of the fifteenth century. The Three Persons of the Trinity enthroned on a common bench with the Virgin on Their proper right, in the illumination of the Book of Hours of Etienne Chevalier in Chantilly is a work of the mid-fifteenth century. The enamelled roundel presents the common bench and the German treatment of the figure of the Virgin. It seems to be a link between French and German art. Stylistically it belongs to the *détente* stage of the International Style. On the other hand, the synthesis of French style and German iconography could have occurred in northern Italy.

PROVENIENCE: Luigi Grassi, Florence.

PLATE CXVI MR. and MRS. GERMAIN SELIGMAN

132 FRENCH (?), third quarter of the 14th century

Plaque: Isaiah and the Daughter of Sion

Translucent enamel on silver; 1¾ in. square (.045 m.)

This silver plaque chased in *bassetaille* and covered with translucent enamels is set in a square frame. It was originally attached by four pins to the base of a liturgical object, probably a cross. The pins penetrate spandrels decorated with foliage in opaque red enamel. An elderly man proffering a scroll, the attribute of the Old Testament prophets, kneels before a woman whose head is covered with a veil. Each has a nimbus. The woman holds a book in her left hand and uplifts her right in a gesture of wonder frequently given to the Virgin in the scene of the Annunciation. On the scroll are inscribed the letters NR SA which seem to stand for the abbreviated Latin words *Noster Salvator* and to refer to the coming of the Messiah (Exodus 16:6; Isaiah 62:11). Perhaps the virgin of our medallion is to be identified with the "daughter of Sion" mentioned in the verse of the psalm of Isaiah. The subject of the enamelled representation would be an Annunciation of an unusual kind, connected with the allegories of the popular "Drama of the Prophets" in which the prophets were introduced in succession on the stage to announce through symbolical allusions the nativity of Christ.

The translucent enamels are of a magnificent quality: deep blue fluxed over stars engraved in the trellised background; purple and lilac for the veil and mantle of the daughter of Sion and the cap of Isaiah; greens varying in depth for her dress and his mantle; a mulberry color for the robe of the prophet, pointed up by a sparkling note of turquoise blue where the lining shows

under a tucked up fold; dark golden yellow for the chest that is half visible at the end of a pavement which is rendered by a net of perspective lines engraved and covered with a silvery buff enamel. The engraved trellis with its stars reproduces a pattern which is characteristic of fourteenth-century goldsmithswork (cf. the silver paten dated 1333 and the enamelled cruet of about the same date coming from the church of St. Mary of Elsenör, but imported from France, which are in the Copenhagen Museum; or the enamelled plaques of the Evangelists on the base of the Carrand cross in the Bargello, Florence). But this pattern is equally frequent in Rhenish enamels, also. The sharp and edgy graphical quality that characterizes the chiselling of our piece may also be either French or Rhenish. It is noticeable on an enamelled roundel in the collection of Germain Seligman which probably represents Christ and the Virgin in the guise of Solomon and the Queen of Sheba. Both pieces—the Walters medallion and the Seligman one—are certainly by the same hand, since on both the figure of the veiled woman was drawn after the same model, and the horse-shoe outline of the nimbuses makes them look like caps placed on the heads.

The original placing of our plaque is suggested by the foot of the Carrand cross, where are set four small square medallions representing the Evangelists. That silver cross, embellished with *bassetaille* enamel is not Italian, but a northern piece of the mid-fourteenth century, either French or from Cologne. Translucent enamels were fluxed over the whole area of our medallion, except for the flesh tones and the scroll—a leading technique in Siena, but which did not become usual in France before the second half of the fourteenth century. The iconographical elements observed on the Walters and the Seligman plaques betoken a Rhenish influence.

EXHIBITION: New York, Museum of Contemporary Crafts, "Enamels," 1959, n. 52 (title incorrectly given in the catalogue).

BIBLIOGRAPHY: P. Verdier, "A Unique Representation of the Coming of Christ on a Gothic Enamel," *Bull. WAG*, X, 3 (1957).

PLATE CXVI WALTERS ART GALLERY, inv. no. 44.118

133 FRENCH, Southern (Montpellier?), late 14th century

Plaque: Seated Christ Holding the Globe and Blessing

Silver partly covered with translucent enamel. 1 in. square (.025 m.)

This little plaque is not easy to localize. The translucent enamel has been applied only to the blue background, while the shallow relief of the figure remains in the uncovered silver. Its style dating it in the late fourteenth century contradicts the accepted view that throughout western Europe in the second half of the fourteenth century translucent enamels followed the Italian fashion of covering the shallow silver relief entirely with enamel, leaving *en réserve* only the face and flesh tones.

WALTERS ART GALLERY, inv. no. 44.79

134 GERMAN, Northwest (?), late 14th century

Chalice

Silver gilt, with translucent enamels; H. 7¼ in. (.188 m.); D. of base: 5⅛ in. (.130 m.)

The conical shape of the bowl, the slightly elongated proportions, the flattened knop with ridged grooves and the lozenge-shaped medallions applied upon it without intermediary protruding bosses, the hexagonal stem, spreading into a flat, circular foot, are all characteristic of a German origin and of a date in the late fourteenth century.

The scenes on the foot have figures reserved in the translucent enamels, fused over *guillochés*

grounds which are alternately blue and green. The subjects follow each other counter-clockwise: the Annunciation, the Crucifixion, St. Andrew, the Resurrection, the Mass of St. Martin, the Ascension.

The most interesting scene from the iconographical point of view is the Mass of St. Martin. St. Martin had given his tunic to a beggar just before Mass. The other tunic which his deacon brought to him turned out to be too short. When St. Martin uplifted his arms at the altar, they appeared bare, so angels covered them and a globe of fire appeared above the head of the saint.

The style and technique of the scenes are reminiscent of the enamelled plaques set around the Netherlandish chalice preserved in the Museum "Het Catharina Gasthuis" in Gouda (cf. *Europäische Kunst um 1400*, Kunsthistorisches Museum, Vienna, 1962, n. 461, pp. 393-4, pl. 26).

The little reliefs applied against a ground of deep blue enamel in the lozenges around the knop are: the Annunciation, St. Michael, Anna Selbdritt (St. Anne holding Jesus and the Virgin), St. John the Baptist, St. John the Evangelist, the Apocalyptic vision of the Woman and the Child.

The circular shape of the foot of the chalice is unusual (although not uncommon in the Germanic countries, cf. J. Braun, *Christliche Altergerät*, p. 113) at a time when in Europe, since the beginning of the fourteenth century, the priest was wont, after cleansing it with wine and water, to lay the chalice on its side, with the bowl on the paten to drain. A polygonal foot was then devised to prevent the chalice from rolling (cf. W. W. Watts, *Catalogue of Chalices*, London, 1922, p. 23 and nos. 1, 2).

PLATE CXV WALTERS ART GALLERY, inv. no. 44.116

135 ITALIAN (Tuscan), ca. 1375

Thirteen medallions from an altar cloth

Champlevé enamel on copper; each, D. 2⅞ in. (.072 m.)

The subjects are Christ, the Apostles and the Evangelist Luke. Although the medallions make a total of thirteen, four must be missing, because in the original set the four Evangelists were added to the twelve Apostles, as indicated by the duplication of St. John on two medallions, one being dedicated to the Apostle (with the chalice) and the other to the Evangelist (with the eagle). St. Matthew could also have been represented twice, as an Evangelist (on one of the medallions) and as an Apostle (perhaps present on another of our medallions, but without a recognizable symbol). Consequently in the original complete set, the four Evangelists would have surrounded Christ to form a *Majestas Domini* scheme and six Apostles would have been placed on the right of that central group and six on the left.

Three Apostles have books, St. Peter a key, St. Bartholomew a knife, St. Philip a toothed sword, St. James the Younger a club like a sledge-hammer and St. Thomas a carpenter's square. St. Mark is missing.

The figures stand out strongly in their design reserved in the copper plaque, which was subsequently gilt. The inner drawing and sometimes the delineation of the contours is executed by burred lines scratched in the copper and filled with dark blue enamel. The trefoils at the angles are reserved in kite-shaped compartments scooped out around the leaves and filled with red enamel. The background of the figures in dull blue champlevé enamel contrasts with the gleam of the gilded copper. Technique and effect descend from the Austrian champlevé enamels of the second quarter of the fourteenth century produced in Vienna and in the Austrian regions of the Upper Rhine.

The decoration of rosettes combined with two leaves bent in opposite directions, which occurs as a "filler" in nine of the medallions, is also found on a cross, attributed to the Abruzzi, and on an enamelled medallion in the Vatican Museum (Stohlman, *Cat.*, fig. 6 and pl. XXI, S

68). However, the center of production of the Italian champlevé enamels was not the Abruzzi, but appears to have been Tuscany (rather than northern Italy).

The excellent draughtmanship of the figures in our medallions is not unworthy of Pietro di Leonardo of Florence. The holes punched at the corners indicate that they were to be sewn. A group of comparable Italian enamelled medallions in the Cleveland Museum of Art is still sewn onto an altar cloth. Marks are engraved on the back of our medallions to designate their sequence.

PROVENIENCE: Acquired by Henry Walters in Paris in 1913.

PLATE XCII WALTERS ART GALLERY, inv. nos. 44.449-461

136 NETHERLANDISH (Limbourg), ca. 1420

Medallion

"Grisaille" enamel painted on silver; D. 2 in. (.052 m.)

On the obverse is a bust-figure in three-quarter view to the left of the Emperor Augustus. His garment with parallel folds, simply drawn, his flowing beard and long hair crowned with a diadem of spikes and laurel-leaves, all are reminiscent of the portrait of Heraclius on the obverse of the medal in the collection of the Duke of Berry (cf. Cat. no. 155). Upon him, from a flaming cloud motif—adapted from the silks of Lucca and the silks imported from China—falls a golden rain which announces the vision represented on the reverse. On the reverse is represented the group of the Virgin nursing the Child and standing in a glory of sun-rays (cf. the visionary representation of the Virgin of Humility, no. 16 of this Catalogue). The Vision, painted in grisaille enamel highlighted with gold on a background of hard enamel, glazed with midnight blue, is the apparition of the Virgin to Emperor Augustus, according to a legend which started at the time of the fall of Rome in the fifth century. It was first represented in Italian art on a cosmatesque monument in the church of the Ara Coeli on the Roman Capitol, as well as in a lost fresco by a follower of Cavallini in the choir of the same church. In the medieval version of the story, which received its most poetical expression in *The Golden Legend* written by the archbishop of Genoa, Jacopo de Voragine, the Sibyl of Tibur ". . . at the hour of mid-day . . . beheld the heaven, and saw a circle of gold about the sun, and in the middle of the circle a maid holding a child in her arms. Then she called the Emperor and showed it him . . . When Octavian saw that, he marvelled over much, whereof Sibyl said to him: . . . This child is greater lord than thou art, worship him." This legend is based on the so-called Sibylline books and various other sources, of which two will be mentioned here: a) on the Roman Capitol there was an altar dedicated to the virgin goddess, Tanit, whose cult had been imported from Carthage to Rome (*ara deae virginis caelestis*); b) Suetonius relates in chapter 95 of his *Life of Augustus* that when Augustus entered Rome after the death of Julius Ceasar a miraculous corona of rainbow hues surrounded the sun in a clear blue sky.

The iconography of our medallion reflects compositions found on the Italian medals collected by the Duke of Berry and on gold roundels commissioned by him (cf. nos. 153-155 of this Catalogue). The Vision of the *Ara Coeli* was painted in two manuscripts by the illuminators of the Duke, the Limbourg brothers, in the *Belles Heures* now in the Cloisters, New York (folios 26 and 218), and in the *Très Riches Heures*, now at Chantilly (folio 22). The Limbourg brothers may have been the authors or co-authors of a large gold relief illustrating the same subject that remained until 1412 in the Sainte Chapelle of the duc de Berry at Bourges. There are also two visions of Our Lady in the Sun on works in gold registered in the inventories of Louis, duc d'Orléans, perhaps executed under Italian influence (Louis had married Valentina, daughter of Gian Galeazzo Visconti). The miniature of folio 218 in the *Belles Heures* copies that

of folio 1 of a *Golden Legend* manuscript in the Bibliothèque Nationale, Paris (ms. fr. 414), which was probably painted by Pol de Limbourg before 1405, that is, before he entered the service of the Duke of Berry. It was again copied, except for a few differences, in the *Heures de Rohan* (fol. 29vo). The vision of the *Ara Coeli* was interpreted as a promise of perpetual peace, the true peace brought on earth by Christ, as is implied in the *Epitres* of Christine de Pisan, in which this vision is painted again, and of which copies were presented to the Dukes of Berry and Orléans.

Our enamelled medallion is Netherlandish by its very technique, which is specifically designated as such in the late sixteenth-century inventory drawn up of the collections of Archduke Ferdinand of Tyrol. Similar enamels are described in many entries of the inventories of the Dukes of Burgundy. This is the earlist surviving one and the only one which reflects, in a thinned-out and slenderized manner, the International Style of the Limbourg-Guelders brand, which is a hallmark of the manuscripts illuminated for the Duke of Berry between 1400 and his death in 1416, and also influenced the goldsmithsworks executed for him, as we may surmise from copies of his Italian medals and the medallion of Michelet Saulmon. The enamelled Crucifixion in the Victoria and Albert Museum (n. M54b-1910) is a Netherlandish enamel which appears either slightly later or else more Burgundian than ours, and reflecting the art of Claus Sluter. I have recently proposed the attribution of our enamelled medallion of the Vision of the *Ara Coeli* to Arnold of Limbourg, a younger brother of the illuminators of the Duke of Berry, who inherited their estate after their death in 1416, and was a goldsmith living in Nijmegan.

It is of interest also to point out that the type of the Virgin, with her hair falling in long locks on one shoulder only, her mantle open and partly wrapping the naked Child, recalls the very type created earlier by Claus Sluter for the statue over the gateway of the Carthusian monastery of Champmol.

PROVENIENCE: F. W. B. Massey-Manwaring. Acquired by Henry Walters around 1914.

EXHIBITIONS: Vienna, Kunsthistorisches Museum, "Europäische Kunst um 1400," May 7-July 31, 1962.

BIBLIOGRAPHY: Otto von Falke in André Michel, *Histoire de l'art*, II, 2, Paris, p. 893—W. Burger, *Abendländische Schmelzarbeiten*, Berlin, 1930, p. 163—E. Steingräber, *Alter Schmuck*, Munich, 1956, p. 62, fig. 94, p. 56 (as Netherlandish-Burgundian, ca. 1420)—*idem* in *Reallexikon zur deutschen Kunstgeschichte*, V (1960) s.v. Email, p. 43, fig. 29—P. Verdier, *Bull. WAG*, XIII, 3 (1960)—*idem*, "A Medallion of the 'Ara Coeli' and the Netherlandish Enamels of the Fifteenth Century," *JWAG*, XXIV (1961), pp. 8-37, figs. 1-4—Kunsthistorisches Museum, *Europäische Kunst um 1400*, Vienna, 1962, n. 485.

PLATE CXVIII WALTERS ART GALLERY, inv. no. 44.462

137 RHENISH (?), third quarter of the 14th century

Plaque: Christ in Majesty

Bassetaille enamel on silver; 3¼ in. square (.83 m.)

The square silver plaque, which became warped slightly when the translucent enamel was fixed in the kiln, depicts Christ in Majesty, blessing, holding the cruciferous orb and resting His feet on two lions. Type and drawing are still not far from the Christ in Majesty of the Sigmaringen paten in the Museum für Kunsthandwerk, Frankfurt a.M.—a work of the Lake of Constance school, around 1320. But the throne is more complicated, although it does not flare out at the sides as became the practice in the International Style (Cat. no. 20, and the enamelled medallion of Christ in Majesty on the Catalonian paten that belonged to the antipope Pedro de Luna, now in the Cathedral of Tortosa), and the translucent enamels cover the entire plaque, except the orb. The robe of Christ is sapphire blue. His mantle of deep emerald is lined with mulberry brown. His hair is brown. His face, hands and bare feet are covered by a near-white opaque

flux. The halo is emerald, possibly copied after the color preferred for Christ's halo on the Byzantine enamels imported in Germany under the Ottonian emperors and by the Crusaders after the fall of Constantinople in 1204. Christ is seated on a cushion of sapphire blue ornamented with gold brown tassels. The throne is enamelled in a soft brown color with lines drawn in a darker brown. The lions are tawny gold. The angels with censers in tawny gold have brown hair and wings and they are dressed in emerald robes. The background is sapphire blue.

CONDITION: Some losses in white areas of faces, hands and feet.

PROVENIENCE: Alexis Finoclet, Paris.

PLATE CXVI MR. and MRS. GERMAIN SELIGMAN

138 RHENISH (Lower Rhine), second quarter of the 15th century

Last Judgment

Bassetaille enamel on silver; D. 2¼ in. (.059 m.)

This medallion of the Last Judgment, first used on a paten, was mounted in the early sixteenth century in a pyx for the reserved wafer. The pyx was executed in a workshop of Brabant and is stamped inside with the marks of Brussels, the year letter for 1513 and the name of the goldsmith: N. Croisart, lettered around a Maltese cross. The composition and the gamut of color of the translucent enamel reproduced with a considerable degree of faithfulness those of the *bassetaille* enamel medallion representing the Last Judgment on the paten accompanying the so-called Chalice of Willigis in the treasure of the Cathedral of Mainz. Whereas the Willigis paten shows the characteristic flowing draperies of the "soft style," our medallion exhibits the transformation of the German "soft style" into the Flemish "hard style" of the second quarter of the fifteenth century. In particular, the voluminous overhanging folds of the purple mantle of Christ are spoon-shaped (*plis en becs débordant* or *Schüsselfalten*)—a common occurrence in Gothic art around 1300 which returned to favor with the Burgundian and Flemish sculptors in the second quarter of the fifteenth century.

Christ, showing His five wounds, is enthroned on the Apocalyptic rainbow. Two angels blow trumpets. Issuing from the mouth of Christ are a branch with two lilies and a two-edged sword, symbols of the pity and the wrath of God. On the paten of Willigis two swords are represented issuing from the mouth of Christ to symbolize the vindication of the spiritual and temporal power by the Roman church, in reference to the two swords of Luke, 22:38. As on the paten of Willigis, the Virgin and St. John the Baptist raise their hands in supplication, after the *Deisis* in Byzantine iconography of the Last Judgment. In both medallions the resurrection of the dead is also represented, here as naked half-length figures rising from opened graves. A knight wears a helmet and a bishop a miter. A very similar design of the Last Judgment is found at Book XX of a manuscript of the *Cité de Dieu* illuminated in the workshop of Jean Bondol, ca. 1376-80 (Cat. no. 41).

The enamels constitute a harmony of purple, green and yellow. The flesh areas are reserved in the silver ground. The modelling is chiselled under the enamel in shallow relief or engraved. The inner drawing is "nielloed" in blue enamel. The edge and the haloes are enamelled in red. The background is hatched and enamelled in blue.

CONDITION: Some losses to the enamel, and some cold restorations.

PROVENIENCE: Acquired in Holland.

PLATE CXVI WALTERS ART GALLERY, inv. no. 44.113

139 SPANISH (Catalan), third quarter of the 14th century

Plaque from a Crucifix: Majestas Domini

Bassetaille enamel on silver; 2½ x 2¼ in. (.062 x .059 m.)

Christ in glory is seated on the rainbow represented by two arches enamelled in translucent yellow and purple enamel and against a blue background strewn with stars. His cross-nimbus is enamelled in red. His right hand is raised in benediction, His left hand holds a T-globe with undulating lines indicating the ocean. His robe is purple, His mantle pale green lined with deep yellow. The figure is enclosed within a mandorla supported by four angels with wings of green. The chiselled designs are covered by the translucent enamels or, when the silver is left bare, "nielloed" with dark enamel.

The plaque originally was placed at the center of a crucifix and is a Catalan imitation of the Sienese or Tuscan enamels which the goldsmiths of Catalonia imported in quantity towards the middle of the fourteenth century, inspiring a local production. An analogous but earlier plaque, probably Sienese, adorned the center of the obverse of a Catalan silver-covered crucifix stamped with the hallmark of Barcelona, formerly in the Martin le Roy Collection. A plaque similar in design and colors passed from the Bardac into the Hoentschel Collection.

PROVENIENCE: Joseph Egger, Vienna. Acquired by Henry Walters in 1906.

EXHIBITION: New York, Museum of Contemporary Crafts, "Enamels," 1959, n. 53.

PLATE CXVI WALTERS ART GALLERY, inv. no. 44.87

140 SPANISH (Catalan), second half of the 14th century

Plaque: The Last Supper

Enamel on copper; 4⅛ in. square (.105 m.)

This plaque decorated the center of the back of a processional crucifix (cf. the processional cross stamped with the hallmark of Barcelona in the collection of the Hispanic Society, New York). Christ wearing the cross-nimbus is seated at a table, His right hand raised in benediction, His left hand placed on the head of St. John, reclining against Him. On either side are three Apostles. In front, on the free side of the table kneels Judas Iscariot, apparently begging for pity. The craftsman obviously misunderstood his model, in which Judas was dipping his hand in the dish (Matthew, 26:23). The table is laid with two bowls of fish, mystical symbol of Christ, pitchers in brass or pewter, earthenware and knives. Between the front edge of the table and the pleated folds of the cloth are naively represented the feet of Christ and the disciples—a curious example of "conceptual" design. The background is in dark blue enamel and the design is reserved, with details enlivened with red enamel and the engraved lines nielloed with colored enamels. The faces and the table-cloth are silvered, betraying an attempt to compete with translucent enamels on silver. The rest of the plaque is gilt. The edge is cut in cusps with trefoiled finials.

In the Cathedral of Mallorca there is a casket presenting the Story of Christ and of His Passion engraved in the reserved and nielloed metal against a background of blue enamel. The quality of the draughtsmanship on the Mallorca casket is superior to that of our plaque of the Last Supper. But the identity of technique points toward the same localization (cf. also Cat. no. 133).

PROVENIENCE: Acquired by Henry Walters in 1910.

PLATE XCIII WALTERS ART GALLERY, inv. no. 44.12

141 SPANISH (Catalan or Aragonese), second half of the 14th century

Eight medallions

Bassetaille enamel on silver; each, D. 2¼₆ in. (.053 m.)

These eight quatrefoil plaquettes originally were placed at the ends of a processional cross: the pelican at the top, Adam rising from his grave at the bottom, the Virgin and St. John respectively on the right and left of Christ—all on the front of the cross—The four Evangelists, represented by their symbols, were on the back. A similar disposition of eight silver quatrefoils with the same subjects is encountered on a northeastern Spanish processional cross dated 1510, which reused plaques from an earlier cross (Spitzer Collection, n. 303, now in the Walters Art Gallery, inv. no. 44.423). The quality of the drawing of Adam, St. John and St. Matthew is very high and compares with that in the portrait of Peter I on his gold coin (see Cat. no. 156). The Virgin and St. John are represented crouching right and left of the Cross. This iconography of humility comes from Siena. The Spanish medallions are copied after Sienese models.

The palette is very brilliant: deep blue, peacock blue, golden brown, mulberry brown, emerald. Faces and hands, the beaks of the pelican and eagle, the claws of the latter, the halos and scrolls are reserved in the silver and gilded.

PROVENIENCE: S. Radin, Vienna.

PLATE CXVII

MR. and MRS. GERMAIN SELIGMAN

Metalwork

142 ITALIAN (Sienese), second half of the 14th century

Chalice by Paolo di Giovanni and Giacomo da Siena

Copper gilt and *bassetaille* enamel on silver; H. 8¼₆ in. (.205 m.)

A new departure in the type of the chalice was adopted in the workshop of the Sienese goldsmith Pacino di Valentino in the thirteenth century. The earliest surviving example of the Gothic chalice devised in the workshops of Siena with application of ornaments in translucent enamel is the vessel signed by the Sienese goldsmith Guccio di Manaia, presented to the basilica of San Francesco in Assisi by Pope Nicholas IV shortly after 1288.

The Sienese chalice is a tall vessel consisting of a bowl either conical or ovoid and provided with a rim slightly bent outwards, set in a calyx or collar of six petals shaped like ogee arches, on a hexagonal stem having a bulbous knop with a foliate beaten and chased pattern, adorned with bosses, and a foot shaped as a cusped hexafoil enframing medallions within raised and studded ribbons embossed and punched, which are interlocked in a meandering, flamboyant pattern. The foot has an enriched edge and flange. The bowl is in silver, parcel gilt, the rest of the fabric of the chalice is gilded copper, the decoration in *bassetaille* enamel (translucent enamels fluxed over designs incised in shallow relief on silver plaques). The chalice of the Sienese type was diffused throughout Italy in the fourteenth century.

On the example here exhibited the calyx holding the bowl is decorated with cherubs in red and blue champlevé enamel on copper. On the hexagonal stem, both above and below the knop, are birds in flight arranged by pairs, in *bassetaille* enamel. Around the knop are six enamelled silver quatrefoils: Christ as Man of Sorrows, the Virgin, St. John the Evangelist, St. Peter, an unidentified female saint, St. Paul. On the foot, the six hexafoil medallions, the upper lobe of

each extended in a point, contain representations in translucent enamel on silver of the Crucifixion, the Virgin, St. John the Evangelist, St. Peter, a bishop saint and St. Paul.

Between the stem and the foot is an enamelled inscription in Lombardic characters: PAVOLO DI GIOVANI E IACOMO DE SENI. Perhaps this Giacomo of Siena is the same goldsmith who signed FRATE IACHOMO TONDUSI DE SENA on a chalice of the second half of the fourteenth century in the Victoria and Albert Museum (W. W. Watts, *Catalogue of Chalices*, London, 1922, n. 6, p. 48, pl. 9).

CONDITION: The enamels have suffered to some extent from chipping.

PROVENIENCE: F. Spitzer, Paris; his sale (Paris, 1893, I, n. 285, p. 51).

BIBLIOGRAPHY: On the family of Giacomo Tondusi, alias Tondini or del Tondo, around 1360-1363, see G. Milanesi, *Documenti per la storia dell' arte senese*, I, Siena, 1854, p. 104.

PLATE CXII WALTERS ART GALLERY, inv. no. 44.223

143 ITALIAN (Sienese), second half of the 14th century

Chalice

Copper gilt and *bassetaille* enamels on silver; H. 8¼ in. (.210 m.)

This example resembles no. 142 very closely, although the bowl flares more widely. The calyx is the same. The upper part of the stem is decorated in *bassetaille* enamel with birds arranged in three symmetrical pairs; below the knop it shows ornamental motifs. The round bosses of the knop enframe six *bassetaille* enamelled roundels depicting the Crucifixion and Man of Sorrows, the Virgin, St. John the Evangelist, St. George and an unidentified bishop saint. The six medallions of the foot are shaped exactly like those of Cat. no. 142 and set in the same manner in a strapwork of studded copper ribbons with raised leaves in the intervals. They contain representations in translucent enamel on silver of the Crucifixion, the Virgin, St. John the Evangelist, St. Peter, St. Lucy (?) and St. Nicholas (?) The remaining intervals on the surface of the foot are, at the top, filled with cusped plaques of foliate pattern and, at the extremeties, with little lozenges showing alternately foliate and heraldic motifs, all in translucent enamel. The arrangement on the foot of Cat. no. 142 is identical, but without the heraldic escutcheons.

In addition to the two Sienese chalices here exhibited and the one signed by Giacomo Tondusi in the Victoria and Albert Museum, must be mentioned the chalice signed PICINUS DE SENIS in the Lyons Museum. This unpublished chalice, very similar to the Princeton one and consequently to the Walters chalice, is the work of Bartolommeo di Tommé, called Pizzino, a goldsmith active in Siena between 1381 and 1404.

PROVENIENCE: Otto H. Kahn, New York; Joseph Brummer; his sale (Parke-Bernet Galleries, New York, 1949, Pt. II, p. 187, n. 723, ill.). Presented by Mr. Gordon McCormick.

BIBLIOGRAPHY: Marvin J. Eisenberg, "A Late Fourteenth Century Italian Chalice," *Record of the Art Museum, Princeton University*, IX, 2 (1950), pp. 3-11.

PLATE CXII THE ART MUSEUM OF PRINCETON UNIVERSITY, no. 49.125

144 ITALIAN (Sienese), early 15th century

The Monstrance of Thadea Petrucci

Rock-crystal and gilt copper with translucent enamels on silver; H. 24⅛ in. (.63 m.)

The monstrance was a liturgical vessel that appeared following the institution of the Feast of Corpus Christi by Pope Urban IV in 1264, and was used in the processions on each anniversary

of that feast. It was called in Italy a movable tabernacle, *tabernaculum mobile,* in Germany a monstrance, *monstrantia* ("monstrantia cristallina in qua portatur corpus christi in die corporis christi," as entered in an inventory of Prague Cathedral in 1354), in France *custodia* or a reliquary ("reliquiaire a porter le corps Notre Seigneur," as described in two entries of the Inventory of Charles V, King of France, in 1379).

The form of the Italian monstrance is very close to that of the Italian reliquaries for the relics of saints, as they became more and more frequent in the fifteenth century. The Italian monstrance, characterized by a median vertical cylinder in rock-crystal to hold the consecrated wafer, so that it was visible from all sides, was sometimes made of silver, but often of gilt copper, and such were kept in the treasures of the most richly endowed churches.

The foot, shaft and knop of the monstrance here exhibited resemble closely those of Italian chalices of the fourteenth and fifteenth centuries, except that the dimensions have been increased. The foot is a cusped hexafoil of gilt copper with moulded flange and border. The six hexafoil medallions of the foot are enframed by a ribbon-like moulding which intersects itself in order to determine six ogee arches pointing downward around the slanting base of the shaft. In the spandrels between the medallions are embossed and chased sprays of foliage, separated by silver knobs incrusted with blue enamel. Of the six enamelled silver medallions, originally set in the hexagonal cusped cavities on the foot, only one copy remains, engraved with a quatrefoil design but the enamel is lost. Between the foot and the stem are set, escutcheon-like, six cusped and pointed silver plaquettes, ornamented in translucent enamel with angels represented as three-quarter figures, five in profile, one in full face, playing bagpipes, the double flute, small drums, cymbals, the psaltery and the tambourine. Against an enamelled background of a lapis lazuli blue the enamels are principally green, pink and golden yellow.

The decoration of the stem, both above and below the knop, is composed of six silver plaques, alternately decorated with a girl's head in profile and a crocket of foliage in translucent enamel against a blue enamel ground. The four angles of each of the silver plaquettes applied against the hexagonal shaft have been filled with trefoils of red enamel.

The knop is bulbous and adorned with foliate designs raised above a punched ground. The quatrefoils of translucent enamel set in six conforming bosses represent three-quarter bust figures of St. Nicholas, St. Dominic, St. Peter, a cardinal and two Antonine abbots, one young and one old.

The rock-crystal receptacle for the Host is held by three vertical bands hinged to the lower and the upper rims of gilt copper. These rims are cut into corbel-tables of *archetti pensili* inspired by a motif familiar in Italian Gothic architecture. The *lunula,* or moon-shape container for the Host, is missing within the rock-crystal cylinder. The receptacle is covered with a dome and hinged to a cupola of rock-crystal reinforced externally by six ribs. These ribs are riveted at the base of a hexagonal turret with twin trefoiled and intersecting bays (the *bifore* of Italian churches), buttresses with their dripping mouldings, crocketed gables with finials, a steeple and on the top the statuette of St. Agnes holding the lamb.

Around the base of the hexagonal stem runs, in two lines, an enamelled inscription in Lombardic characters: + HOC OPVS FECIT FIERI DNA THADEA PETRVCI + PRO REMEDIO SVORVM MORTVORVM ("Mistress Thadea Petrucci had this made for the salvation of her dead").

The Petrucci family name does not seem to apply to the Florentine family known by three generations of goldsmiths, but to the Sienese family of craftsmen, of which Andrea was a goldsmith (a chalice and a paten by him are in the Museum of Avila, another chalice by him is in the Fitzwilliam Museum, Cambridge) and Francesco, a smith. It seems to have been customary for the widow of a goldsmith to commission in the workshop of the family a liturgical vessel to be presented as an *ex-voto* (for instance, the silver chalice donated in 1395 by the widow of the Sienese goldsmith, Giacomo di Guerrino).

CONDITION: All of the six-lobed enamels of base missing; rock-crystal cracked.

PROVENIENCE: Camillo Castiglioni, Vienna; his sale (Amsterdam, Nov. 17-20, 1925, n. 232).

PLATE CXIII WALTERS ART GALLERY, inv. no. 53.51

145 ITALIAN (Lombard), ca. 1400

Corpus from a Cross

Gilt copper; 7 x 5¾ in. (.175 x .143 m.)

This north Italian Corpus may be compared with the beautiful one, also in gilt copper, in the National Museum, Florence (Carrand Collection). However, the new arrangement of the loin cloth with its two symmetrical and softly billowing folds, the no longer strongly accented anatomy, the more relaxed and straightened position of the body, the understated expression of dereliction and suffering, all are in keeping with the general evolution of the representation of the Crucifixion towards the end of the fourteenth century.

PROVENIENCE: Prince Trevulzio, Milan.

PLATE CX JANOS SCHOLZ

146 ITALIAN, ca. 1433

Ceremonial Sword of Emperor Siegmund I

Steel, etched and gilt, with ivory grip; L. 36¼ in. (.96 m.)

The twin-eared pommel is shaped like that of an oriental yatagan. The grip, in ivory carved with spiral flutings, is intended to imitate a horn of a narwal and thus to secure to the owner of the sword the magical virtue of protection attributed to narwal horn. The quillon is shaped as a dragon with coiled neck and tail, crouching, in a symbolical relationship of Christian victory over the enemies of God, upon the gilded cross engraved in a rectangular panel with hatched ground at the top of the blade. The blade is grooved on each side with short canals etched with gilt guilloches and scrolls. Larger guilloches are etched on either side of the canals. Two inscriptions, each ending with a cross read: on one side of the blade: REX HVNGARIE, and on the reverse: COLOMANVS EPS. Siegmund I became King of Hungary in 1387, King of the Germans in 1410, King of Bohemia in 1419 and he became Emperor in 1433. The letters EPS after COLOMANVS are a mistake for PCS (*princeps*). The pilgrim and martyr Prince Coloman was one of the patron saints of the Kingdom of Hungary. On each side of the blade are also stamped four marks.

The use at this early date of etched decoration denotes an origin in northern Italy. A drawing similar to that of the dragon of the quillon, by Pisanello, is in the Ambrosiana Library, Milan. The dragon and the cross were the emblems of the Order of the Dragon (*Lindwurm Gesellschaft*) founded by Siegmund as King of Hungary. After Siegmund has been crowned Emperor in Rome in 1433, he designated Italian nobles as new knights of the Order of the Dragon. The sword perhaps was used by the new Emperor for dubbing the knights on that occasion in Mantua and Verona. It may have been executed for the journey of 1433, or before the coronation. On the other hand, it may well be slightly after 1433 because, in the capacity of Master of the Order of the Dragon, the Emperor would have used only the designation of King of Hungary, as inscribed on the blade.

PROVENIENCE: Made for Emperor Siegmund I; House of Luxemburg; Armory of the Hapsburgs at Ambras Castle.

EXHIBITIONS: Budapest, "Millenniums-Landes-Ausstellung," 1896; Vienna, "Europäische Kunst um 1400," May 7-July 31, 1962.

BIBLIOGRAPHY: J. Szendrei in *Catalogue* of the Budapest exhibition, 1896, p. 280, n. 852, fig. p.281—Boeheim, *Album hervorragender Gegenstände aus der Waffensammlung des Allerh. Kaiserhauses*, I, Vienna, 1894, pl. 7/2 (cf. Boeheim, *Handbuch*, fig. 279)—idem, *Katalogue der Wiener Waffensammlung*, Vienna, 1936, 1/52/5—O. Gamber, "Die Mittelalterlichen Blankwaffen der Wiener Waffensammlung," *Jahrbuch der Kunsthistorischen Sammlungen in Wien*, LVII (1961), pp. 24-25, fig. 14, p. 21—Kunsthistorisches Museum, *Europäische Kunst um 1400*, Vienna, 1962, n. 557, pp. 503-504.

PLATE CXX KUNSTHISTORISCHES MUSEUM, VIENNA
 Arms Collection A 49

147 MOSAN (Dinant), end of the 14th century

Four Symbols of the Evangelists: Reading desks of a lectern

Brass, cast and chased, natural patina; average dimensions: 17⅜ x 16 in. (.442 x .408 m.)

The Angel (St. Matthew), the Lion (St. Mark), the Ox (St. Luke), the Eagle (St. John) are rendered with outspread wings to form the rests for the open Gospel-books supported on a ledge pierced with trellis-work. These four reading desks were originally supported by brass arms branching out of a central column, which rose as a crocketed pinnacle above the desks and was topped by a pelican striking his chest—a symbol of Christ. The central column was also linked with the horizontal part of each of the four branching arms by a half arch of ogee curvature adorned with trefoiled cusps on the intrados. This whole structure stood upon a massive octagonal moulded base borne by recumbent lions. The framework described here no longer exists. It was destroyed in the earthquake that wrecked the Cathedral of Messina in 1908. Only the four desks in the form of the Evangelist symbols have survived. Mr. Henry Walters was told that they had been sold to contribute to a fund for the repairs of the Cathedral of Messina.

The lectern was used to read the Epistle and the Gospel, and was located on the left of the main altar. In the important churches there was usually a second lectern, used for the antiphonary song, the lessons and the Gradual, that was placed in front of the altar. Each desk of our lectern could swivel on its base and the complete object be pivoted on its axis, in order that the Evangeliary for the day would be turned toward the congregation according to the Gospel to be read. Its original height— some nine feet—was almost three feet higher than the lectern signed around 1370 by Jean Josès in the church of Our Lady of Tongres, Belgium. A similar lectern, probably the work of Colard Josès of Dinart, was installed about 1387 in the choir of the church of the Carthusian monastery at Champmol (Moléon, *Voyage littéraire*, p. 156). An analogous one is mentioned at the Cathedral of Dunkeld in Scotland and a gigantic late fifteenth-century candlestick with seven branches towering above the symbols of the Evangelists exists at Lund in Sweden. Around 1400 there was an active export trade in brass lecterns cast in Mosan workshops or at Malines to England, Spain and Italy (cf. lecterns in the church of San Stefano and in the Museo Correr, Venice). In Genoa, the Mosan exports of brass artifacts competed with the candelabra from England in the first decades of the fifteenth century. In the Cathedral of San Lorenzo, Genoa, there is still a paschal candelabrum with the symbols of the four Evangelists.

PROVENIENCE: Cathedral of Messina, Sicily; the certain identification of the four reading desks as parts of the Mosan lectern formerly located in this cathedral is made possible by an engraving and reference in M. Digby-Wyatt, *Metalwork and its Artistic Design*, London, 1852, p. 78, pl. 5. Acquired by Henry Walters in Paris.

EXHIBITIONS: Baltimore Museum of Art, "Themes and Variations," 1948, n. 49; Bruges, Groeningemuseum, "Le siècle des primitifs flamands," June 26-Sept. 11, 1960; Detroit Institute of Arts, "Masterpieces of Flemish Art: Van Eyck to Bosch," Oct.-Dec., 1960.

BIBLIOGRAPHY: C. C. Oman, "Niederländische Messingpulte in Italien," *Pantheon*, XX (1937), pp. 274-277, ill. including an early photograph, pl. 5—M. C. Ross, "Vier Evangelistenpulte aus Messina," *Pantheon*, XXII (1938), pp. 290-292—J. Squilbeck, "Le lutrin-pélican de Bornival," *Bull. des Musées Royaux d'Art et d'Histoire* (Nov.-Dec. 1939), p. 132—idem, "Les lutrins dinantais de Venise et de Gènes," *Bull. de l'Institut historique belge de Rome*,

XXI (1940-41), pp. 347, 356—S. Collon-Gevaert, "Histoire des arts du métal en Belgique," *Académie Royale de Belgique, Cl. des Beaux Arts, Mémoires,* VII (1951), p. 253—Groeningemuseum, Bruges, *"Le siècle des primitifs flamands,* 1960, n. 122, ill, p. 223—Detroit Institute of Arts, *Flanders in the Fifteenth Century: Art and Civilization,* 1960, nos. 109-112, pp. 277-279, ill., including early engraving—R. Didier, "Expansion artistique et relations économiques des Pays-Bas méridionaux au Moyen Age," *Bull. de l'Institut Royal du Patrimoine artistique,* IV (1961), p. 73, fig. 3, p. 66.

PLATE CXXI WALTERS ART GALLERY, inv. no. 53.70-73

148 NETHERLANDISH (Limbourg), ca. 1425

Crucifixion

Copper gilt, embossed, chiselled and engraved; 11⅛ x 9¼ in. (.282 x .242 m.)

Christ is crucified between the discs of the sun and moon on a Cross, the beams of which are wide, and the upper end on which is nailed a blank *titulus,* is short. Under each of His hands a flying angel collects the dripping blood in a chalice. On the left side, the blind Longinus is helped by a kneeling Jew to thrust the spear into the chest of Christ and his gesture proclaims that he is miraculously recovering his sight. Behind him Stephaton proffers the sponge on a reed. On the extreme left is another executioner. A halberd and three lances bristle above the group.

The foot of the Cross is clasped by the Magdalene, kneeling on the ground littered with bones and a skull. In the left foreground, the swooning Virgin is supported by St. John and one of the holy women. On the extreme right one of the bystanders spoken of in Matthew's Gospel (27:40) shouts: "If thou be the Son of God, come down from the Cross," as engraved on the scroll: SI FILIVS DEI EST DECENDE (*sic*) DE CRVCE. The Centurion exclaims: "Indeed this man was the Son of God," according to Mark 15:39, as is inscribed on a second scroll: VERE FILIVS DEI ERAT ISTE.

In the group of the swooning Virgin, St. John turns his head abruptly toward heaven, much as in the famous illumination on folio 135 of the *Grandes Heures de Rohan,* John, supporting the fainting Virgin, twists his head in a sudden and pathetic movement toward God the Father. The centurion wears the extravagent oriental-looking fur hat which, in the illumination of the Flight into Egypt in the Rohan Hours, had been derived from that worn by one of the kings in the miniature of the Meeting of the Three Magi in the *Très Riches Heures,* painted by the Limbourg brothers for the Duke of Berry. The bystander is designated as a Jew by the special pointed hat which the Jews were obliged to wear in the Middle Ages and which is mentioned in texts written in Strasbourg and in Germany. This hat is a regular attribute of the Jews in the late fourteenth-century ivory plaques of the Crucifixion, especially those carved in Germany or executed under German influence. It invades the illuminations of the Passion of Christ painted in French or Parisian workshops after the mass arrival of Flemish artists in Paris, for instance in the Crucifixion scene attributed to Jacquemart of Hesdin, ca. 1385, in the *Trés Belles Heures* of the Duke of Berry, in the Royal Library, Brussels, and on fol. 142 of the *Belles Heures,* illuminated around 1410 by the Limbourg brothers, now in The Cloisters, New York. Without any derogatory significance whatsoever, but rather in order to conjure a touch of "couleur locale", it is given to Joseph of Arimathea in the illumination of the Descent from the Cross of the De Buz Hours (cf. Cat. no. 57) and in a similar Descent from the Cross of the Ste. Geneviève Hours, a manuscript also coming from the workshop of the Master of the Rohan Book of Hours.

The details of costume in our Crucifixion plaque are those of the period around 1400, such as the *chaperon* of Longinus with its peak flopping forward like a Phrygian cap, the *chaperon* and the pinked collet of the executioner, the long *houppelandes* of the bystanders, worn baggy, belted low. The heads of the old men with their shaggy beards, delineated in every detail, and the style of the drapery with its parallel, simply furrowed folds, are those of artists connected

with the Limbourg region (cf. the head of Augustus on the obverse of the Netherlandish medallion (Cat. no. 136).

The hatched background, as well as the general type of the composition with the decorative pattern of scrolls (features both of which reappear in the woodcuts of the second half of the fifteenth century), would suggest a connection with the models of the incunabula of copper engraving. No copper engraving, however, similar to our copper relief has survived. But it is not devoid of interest to indicate that in the generation following that to which this Crucifixion is attributed, the Master "der Weibermacht" was active in the region of the Rhine, not far from Limbourg and Guelders.

PROVENIENCE: Acquired by Henry Walters in 1928.

PLATE CXI WALTERS ART GALLERY, in. no. 53.52

Coins and Medals

149 ENGLISH, last quarter of the 14th century

Noble of Richard II, King of England (1377-1399)

Gold; .0345 m.

Obverse: The King standing and facing front, in a ship with three ropes from the stern and one from the prow, crowned and holding a sword and a shield bearing the arms of England (the type is that of the nobles issued by Edward III, slightly modified). Inscription between two beaded borders: RICARD': DEI: GRA': REX: ANGL': DNS': HIB': AQ[t]. Reverse: Within an octofoil, a floriated cross within a treasure of arches with initial R at the center of the cross. Between two beaded borders the inscription: IHC AVTEM TRANSIENS PER MEDIVM IL-LORVM IBAT.

JOHN WORK GARRETT LIBRARY of the JOHNS HOPKINS UNIVERSITY, no. 6583

150 FLEMISH, second half of the 14th century

Noble of Louis II de Male, Count of Flanders (1346-1384)

Gold; .0335 m.

Obverse: Lion heaumé: a lion seated on a podium with four pinnacles and bearing a helmet, the crest of which represents a *tête de lion dans un vol*. In exergue: FLANDRES. Inscription between two beaded borders: LVDOVICVS: DEI: GRA: COM: &: DNS: FLANDRIE. Reverse: Within a wreath of twenty cusps, a cross with foliage and finials, in its quarters the letters F L A N and in its center the letter D' with a dot in the middle. Inscription between two beaded borders: BENEDICTVS: QVI: VENIT: IN: NOMINE: DOMINI.

JOHN WORK GARRETT LIBRARY of the JOHNS HOPKINS UNIVERSITY, no. 5412

151 FLEMISH, 1388-1389

Noble of Philip the Bold, Duke of Burgundy, Count of Flanders (1384-1404)

Gold; .034 m. Copied after the English nobles, cf. Cat. no. 149.

Obverse: The shield bears the arms of Burgundy and the inscription reads: PHS . DEI: GRATIA:

BVRG': COMES: & DNS: FLAND'. Reverse: The arms of the cross are topped by fleurs de lys (Philip the Bold was Regent of France) and in each quarters is repeated the lion of Flanders crowned.

JOHN WORK GARRETT LIBRARY of the JOHNS HOPKINS UNIVERSITY, no. 5414

152 FLEMISH, end of the 14th century

Angel (Noble) of Philip the Bold

Gold; .031 m.

Obverse: A standing angel, facing front, holds on his right the arms of Burgundy, on his left the arms of Flanders. The inscriptions are as in Cat. no. 151, but PHILIPPVS is here inscribed in full, and DNS (*dominus*) is omitted. Reverse: In a quatrefoil, the foils of which alternate with triangles, a floriated cross with a lion in each quarter. The inscription is as on the gold noble of Louis II de Male, but here the letters are separated by small floriated crosses.

JOHN WORK GARRETT LIBRARY of the JOHNS HOPKINS UNIVERSITY, no. 5415

153 FRENCH, early 15th century

Cast (unicum) of the reverse of a medallion in the collection of Jean de Berry

Bronze; 3¾ in. (.096)

In article 234 of the inventory of the Duke of Berry, drawn up after his death in 1416, is mentioned a "round jewel not set with gems, where there is on one side an image of Our Lady holding her child . . . and on the other side a half-length [a bust] portrait of my lord [the duke] . . . which jewel my lord bought from Michelet Saulmon, his painter— (*lequel joyau Monseigneur acheta de Michelet Saulmon son peintre*). This last sentence could be translated, *à la rigueur*: "a jewel for which my lord paid Michelet Saulmon, his painter (illuminator)." The same artist could very well have been both goldsmith and illuminator. For instance, the Limbourg brothers, Pol and Herman, had been apprenticed to the Paris goldsmith Albert de Bolure (alias Alebret de Bonne) before they were introduced to the Duke of Burgundy, and afterwards, around 1410, entered the service of his brother, the Duke of Berry, as illuminators.

The Berlin medallion is a cast of the reverse of the "round jewel." There is no surviving cast or reproduction of the effigy of the Duke of Berry which was chased in gold on the obverse of the medallion. The Duke, who had bought the medals of four Roman and Byzantine Emperors, possessed a gold plaque of Emperor Philip the Arab and also a lead cast of the first coin to be struck in Italy as a commemorative medal with the portrait head of the ruler (the medallion of Francesco Novello Carrara, 1390), wanted also to be portrayed himself on a round jewel in the manner of his numismatic medals. Perhaps this late ambition or fancy had something to do with the heavier political responsibilities shifted to him by the death of his brother, Philip the Bold, Regent of France in 1404, and by the murder of the Duke of Orléans in 1407.

On this unique cast we see the relief of the Virgin of Tenderness in half-figure, turned toward the right, under a canopy held by four angels atop a turreted building, reminiscent of that whereof Christ is the cornerstone (*lapis angularis*) on the Annunciation wing painted by the Master of Heiligenkreuz, now in the Kunsthistorisches Museum, Vienna. The diameter of the Duke of Berry's medallion coincides with that of the best casts of the medals of Constantine and Heraclius. The style of the draperies which is like that of the figures on the reverse of the medal of Constantine, suggests that Michelet Saulmon might have been the goldsmith who executed for the Duke of Berry the gold replicas of the medals of Constantine and Heraclius.

PROVENIENCE: F. Spitzer; his sale (Paris, 1893); presented to the Berlin Museum in 1893.

EXHIBITIONS: Essen, Villa Hügel, "Europäische Bildwerke von der Spätantike bis zum Rokoko, 1957."

BIBLIOGRAPHY: W. Bode in *Amtliche Berichte aus den königlichen Kunstsammlungen*, Berlin, XXXVIII (1917), p. 317, fig. 102—*idem*, "Die Medaille von Johann Duc de Berry und ihr mutmasslicher Künstler Michelet Saulmon," *Archiv für Medaillen und Plakettenkunde*, III (1922), pp. 1 ff.—G. Habich, *Die Medaillen der italienischen Renaissance*, Stuttgart, 1922, p. 26—E. F. Bange in T. Demmler, *Staatliche Museen zu Berlin, Die Bildwerke des deutschen Museums*, II, *Die Bildwerke in Bronze . . .*, Berlin, 1923, p. 75, n. 2181, pl. 3—H. Vollmer in Thieme-Becker, *Künstler-Lexikon*, XXXVII, Leipzig, 1950, p. 72, s.v. Meister der Kaisermedaillen—*Europäische Bildwerke von der Spätantike bis zum Rokoko*, Essen, 1957, p. 32, n. 123.

PLATE CXVIII STIFTUNG PREUSSISCHEN KULTURBESITZ, BERLINER MUSEEN, SKULPTURABTEILUNG

THE ITALIAN MEDALS OF THE DUKE OF BERRY

The medals of Constantine and Heraclius are known only as casts made after two north Italian gold medals purchased by Jean Duke of Berry—or, rather, the copies of these ordered by the Duke. The original medal of Constantine was bought in Bourges in 1402, from a Florentine merchant established in Paris. In 1401, the duc de Berry had bought a medal of Emperor Augustus and a medal of Tiberius, from another Florentine merchant established in Paris. In the collection of the Duke the four medals were mounted in precious settings with rubies, sapphires, emeralds, garnets and pearls, so that they could be worn as pendants. The medals of Constantine and Heraclius (see Cat. nos. 154, 155) were the most important and the most expensive of the four, as we are informed by the inventories of the Duke of Berry, drawn up in 1403 and 1413 (items 199-200) and the Duke also had these two reproduced in gold copies, one of each (items 201-202). Among the few existing casts in silver and bronze, there are variants which indicate that we have to do with independent copies, rather than with recasts after the original models.

The medals of Augustus and Tiberius were simpler and represented the profile head and neck of the two Roman Emperors, in the manner of the numismatic effigies of the emperors struck on the imperial coins. In article 55 of the inventory of 1413, we note also a gold plaquette of the Emperor Philip the Arab, represented kneeling in prayer to God for the salvation of the Roman Empire and the human race. This completed a series of half-pedantic, half-fantastic forgeries *all'antica*, illustrating the relationship between the Roman Empire and Christianity before and after the recognition of the Christian religion as the religion of the Roman State. As Julius von Schlosser proposed, the medals of Augustus and Tiberius cover the interval of time between the birth of Christ and His death. The plaquette of Philip the Arab, who was believed in the Middle Ages to have been the first Christian Emperor (although secretly), is connected with the date 246 A.D., the millennium of the founding of Rome, which marked the incipient transformation of the Roman Empire into the cradle of Christianity. The symbolical meaning of the medals of Constantine and Heraclius is explained under Cat. nos. 154, 155. Whenever and wherever they were made, these medals were pregnant with the urgency of the times, because their inspiration is Paleologian. The diplomacy of the Paleologus Emperor Manuel II (1391-1425) was directed toward trying to stimulate in Italy the spirit for a new crusade for the liberation of Constantinople from the encircling forces of the Turks.

The medals of Constantine and Heraclius have considerable importance in the history of ideas and in the history of art. They stand chronologically midway between the medallion of Peter the Cruel (see Cat. no. 156), which is, however, struck, not cast and chased, and the first medal of Pisanello—that of the next-to-last Byzantine Emperor, John VIII Paleologus (1425-1448), which he made in Ferrara in 1438, during a diplomatic journey of the Emperor in Italy, undertaken to enlist Christian support against the Turks. Apart from having been the models inspiring Pisanello, the medals of Constantine and Heraclius enjoyed such a fame in northern Italy that in the last quarter of the fifteenth century they were still copied in terracotta reliefs on the socle of the façade of the Certosa

at Pavia. They exerted a deep influence on the duc de Berry's illuminators, the Limbourg brothers, who could study them at leisure in the ducal collection. The mounted king at the left in the miniature of the Meeting of the Three Magi on folio 51 of the *Très Riches Heures* at Chantilly, reproduces, as Durrieu first noticed, the obverse of the medal of Constantine (Cat. no. 154). The other two Magi in this miniature are composed according to a numismatic pattern since, like monetary types, they could be inscribed within a circle. The chariot of the triumph of the Cross, in which Heraclius drives to Jerusalem, (Cat. no. 155), was copied on folio 156 of the *Belles Heures* (now in The Cloisters, New York) to illustrate the Hours of the Cross, and it was transformed into the chariot of the Sun in the tympana topping the illuminated pages of the Calendar in the *Très Riches Heures*. Jean Fouquet reused it in the ninth book of the *Antiquités Judaïques* (Chariot of Salmanazar). The delicate feeling for the nude shown in the figure of "Nature" or "Paganism" on the reverse of the medal of Constantine inspired the astrological figure and the scenes in the Garden of Eden of the *Très Riches Heures*.

BIBLIOGRAPHY: Jacopo Strada, *Epitome thesauri antiquitatum*, 1557, p. 227 (believing the medal of Heraclius to be a genuine Byzantine medal)—Justus Lipsius, *De Cruce*, 1594, III, 16 (reproduces the medal of Heraclius)—Joseph Scaliger, *Constantini Imp. Byzantini numismatis argentei expositio*, in Du Cange, *Glossarium mediae et infimae latinitatis*, X, ed. Favre, CCXXXIX-CCXLI (interprets the figures on the reverse of the Constantine medal as emblems of Faith and Hope)—Du Cange, *Glossarium, op. cit.*, pp. 150, 152 (rejects the medal of Heraclius as spurious and the medal of Constantine as a spurious medal—not of Constantine the Great, but of the last Emperor of Constantinople, Constantine XIII Palcologus 1448-1455)—S. Köhler, *Historische Müzbelustigung* XVI, 37 (both medals as Italian, 15th century—the author cites the 16th-century mention of the medals by Cuspinian, Strada and Goltzius) —L. de Laborde, *Glossaire des émaux*, II, Paris, 1853, p. 385 (the first to mention the entries of the medals in the inventories of the Duke of Berry)—J. Guiffrey, "Médailles de Constantin et Heraclius acquises par Jean duc de Berry en 1402," *Revue Numismatique*, (1890), p. 87 ff.—J. Guiffrey, *Inventaires de duc Jean de Berry, 1401-1416*, I, Paris, 1894, Inventories 1402-3, and 1413, nos. 199-202—J. von Schlosser, "Die ältesten Medaillen und die Antike," *Jahrbuch der Kunsthistorischen Sammlungen des Allerhöchsten Kaiserhauses*, XVIII (1897), pp. 64-108 (as Burgundo-Flemish)—J. Simonis in: *Revue Belge de Numismatique* (1901), p. 68 ff. (as Italian)—H. de la Tour in: *Bulletin de la Société Nationale des Antiquaires de France* (1903), p. 297 (as Italian)—P. Durrieu, *Les Très Riches Heures de Jean de France, duc de Berry*, Paris, 1904, pp. 39-40, cf. pl. I-XII, and commentary to pl. XXXVII—G. F. Hill, *Pisanello*, London, 1905, pp. 100-101, pl. 26—E. Babelon, in André Michel, *Histoire de l'art*, III, 2, Paris, 1908, p, 907-913 (as Italian)—P. Durrieu, *Les Antiquités Judaiques et le peintre Jean Fouquet*, Paris, 1908, p. 113—G. F. Hill, "A Note on the Mediaeval Medals of Constantine and Heraclius," *The Numismatic Chronicle*, 4th series, X (1910)—W. V. Bode, "Die Medaille von Johann Duc de Berry und ihr mutmasslicher Künstler Michelet Saulmon", *Archiv for Medaillen-und Plakettenkunde*, III (1921), pp. 1 ff.—G. Habich, *Die Medaillen der italienischen Renaissance*, Stuttgart 1922, pp. 23-26, fig. 2-3—E. Panofsky. *Studies in Iconology*, Oxford, 1939, p. 154, n. 85 cf. n. 86: fig. 110 and cf. fig. 79, 109, 111—*idem, Early Netherlandish Painting*, Cambridge, Mass., 1953, pp. 63-64, n. 2, 5—National Gallery of Art, *Renaissance Bronzes from the Kress Collection*, Washington, D.C., 1951, p. 125—R. Krautheimer, *Lorenzo Ghiberti*, Princeton, 1956, p. 59, n. 28 (for a possible origin of the medals, medieval forgeries *all'antica*, in Venice)—P. Verdier in *JWAG*, XXIV (1961), pp. 10-14, 21. There is an unpublished dissertation by S. K. Scher, deposited at the Institute of Fine Arts, New York University, an excellent study of the iconography (under the supervision of Professor Richard Krautheimer).

154 ITALIAN (North), end of the 14th century

Medal of the Emperor Constantine I the Great (306-337)

a) Silver cast and chased; 3½ in. (.087 m.). b) Bronze galvano cast of a bronze metal in the Münzkabinett, Vienna; 3¾ in. (.095 m.), including the rim.

Two versions of this medal are exhibited: one (a) in silver and one (b) in bronze, both replicas of one of the lost gold medals purchased by the Duke of Berry (see above).

Obverse: The Roman Emperor with long hair and beard, wearing a sort of Byzantine crown and dressed in a long surcoat enriched with orphreys and having elegantly dropping sleeves (*manches coudières*), revealing the long-sleeved tunic beneath, rides to the right on a pacing stallion with rich trappings and saddle, the rein of which Constantine draws with his left hand.

The inscription in Gothic characters reads: + CONSTANTINVS . INXPO . DEO . FIDELIS . IMPERATOR . ET . MODERATOR . ROMANORVM . ET . SEMPER . AVGVSTVS . On version (a), below the raised hind leg of the horse are struck the Arabic numerals 234, as on the silver cast of the same medal in the Cabinet des Médailles, Paris, and on the cast upon which Joseph Scaliger commented (cf. the *Supplément* of Du Cange, *Glossarium mediae et infimae latinitatis*) .

Reverse: On the left and right of a cross stuck into a *pigna* or pine-cone, sit an elderly woman garbed in a flowing robe and a young woman, nude except for drapery around her legs. The *pigna* alludes to the ancient Roman fountain in the form of a monumental bronze pine-cone which had been transferred in the early Middle Ages to the atrium of St. Peter's. Jets of water spurted from between the scales, as indicated on this medal. On version (a) of this medal, the numerals 235 appear in the field left and right of the cross. Inscription: MIHI : ABSIT : GLORIARI : NISI : IN : CRVCE : DOMINI : NOSTRI : IHV : XPI : (Galatians, 6:14) .

The extraordinary iconography is complicated by many strange details: on the base of the *pigna* are coiled two gargoyle-like dragons, from whose mouths water flows into the well, while a mermaid holds their tails. On the base of the well, under a relief of a lion passant, an aperture reveals the foot of the cross transfixing a serpent. The matron reverently touches a scale of the *pigna*. The nude young woman turns her head aside, while her foot rests on a strange pet. Two eagles, heraldically turned toward each other, are represented near the chairs in which these two allegorical figures are seated. In the late Renaissance these figures were interpreted as symbols of Faith and Hope, and in modern times as a typological opposition between Christianity and Paganism. Probably the most provocative interpretation was offered by Erwin Panofsky, who published a twelfth-century miniature in a manuscript in the library at Verdun (ms. 119, in which the Church veiled and the Synagogue half-naked stand on either side of a well from the water of which emerges a cross; and also a miniature in the Homilies of St. Basil (Paris, Bibl. Nat., ms. grec 923, fol. 272) —brought to the attention of Panofsky by Kurt Weitzmann—showing St. Basil standing between the nude figure of "Worldly Happiness" and the draped figure of "Heavenly Life." Heavenly Life is a sort of a wise virgin "who, owing to her innate virtue is endowed with the quality and title of a bride"; Worldy Happiness is the antithetic foolish virgin but daughter of the same father, who is advised to provide her with "decent raiment, lest she be refused by her bridgegroom when she appears before him." Since the cross in the *pigna* stands for the Fountain of Life, and the cross piercing the dragon is the Constantinian symbol of the victory of the Christian Empire over its enemies, it seems that the Greek moral allegory, expressed in the St. Basil miniature as a conflict between Nature and Grace, was integrated by the author of the medal into a program of revival of Early Christian symbols pertaining to the establishment of the Christian Empire by Constantine. For political reasons, the source of such a symbolism must be searched for in Paleologan Constantinople. The inscription on the obverse reflects the Byzantine conception, Christian and autocratic, of the ruler, and XRO is a Latinization of Greek.

PROVENIENCE: version (a): Landgraf Wilhelm IX of Hesse

(a) MUSEUM OF FINE ARTS, BOSTON, no. 57.170

PLATE CXIX

(b) MÜNZKABINETT, KUNSTHISTORISCHES MUSEUM, VIENNA

155 NORTH ITALIAN, ca. 1400

Medal of the Emperor Heraclius (610-641)

Galvano cast of the bronze medal in the Münzkabinett, Kunsthistorisches Museum, Vienna; d. 3⅞₆ in. (.09).

The bronze cast of this medal in the Museum of Vienna differs slightly from the original ver-

sion represented in the silver cast of the Cabinet des Médailles, Paris. In contrast to the medal of Constantine the Latin inscriptions are not in gothic characters—the letters are Roman capitals, but the E is uncial with one exception. The Greek and Latin inscriptions on this version of the medal have been "corrected", and not always for the better. Under the head of the Emperor an enigmatic Greek word (a spurious signature?) is missing. This cast coincides with that of a gold example in the royal collection of France published by Ducange in the seventeenth century.

Obverse: The Emperor, wearing a crown of tiara type, with pseudo-Byzantine acroteria on the cap and western finials on the circlet, is represented as a bust-portrait, facing to the right. His hands, emerging from his mantle, are intertwined with the strands of a flowing beard, minutely delineated. The glory of God shines above his head. On the lunar crescent cutting across the chest of Heraclius is the inscription: SVPER TENEBRAS NOSTRAS MILITABO (sic) IN GENTIBVS. The inscription does not specifically refer to any quotation from the Bible. But the moon crescent evokes the "Golden Horn," Constantinople, where a coalition of Avars and Sasanians besieged Heraclius. The meaning is made explicit by the inscription: ILLVMINA VVL - TVM TVVM DEVS, which, drawn from Psalm 67:1, corresponds to the verse recited on September 14 at the Introit of the Feast of the Exaltation of the Cross—the True Cross which Heraclius rescued from Chosroes. Around the rim runs an inscription in Greek, which reads like a slightly enlarged version of the Latin inscription on the obverse of the medal of Constantine.

Reverse: In a coach, partly medieval, partly derived from the *carpenta* struck on the reverse of certain monetary issues of the Roman Empire, drawn by three horses guided by a postillion, is seated Heraclius, dressed as on the obverse of the medal, a bridle across his chest tying the two sides of his mantle. He brings back to Jerusalem the Cross that had been taken away by the Sasanians. At the top, hanging from a rod, are three blazing lamps (four in the Paris medal). In the ground of the medal is a Greek inscription praising God for having broken asunder the "iron gates"—the frontiers of the Sasanian Kingdom likened to Hell—and having saved the holy Emperor Heraclius. Around the rim is a Latin inscription: SVPER ASPIDEM ET BASILISCVM AMBVLAVIT (sic)—ET CONCVLCAVIT (sic) LEONEM ET DRACONEM (Psalm 90 (91) : 13). This has a Constantinian and Early Christian ring. It refers to Christ as Savior and to the Emperor as the Victor.

PLATE CXIX MÜNZKABINETT, KUNSTHISTORISCHES MUSEUM, VIENNA

156 SPANISH, 1360

Coin of Peter I the Cruel, King of Aragon and Castille (1350-1369)

Gold: 2%₁₆ (.065 m); weight: 45 gr. 020, equal to ten nobles of Castille.

Obverse: Within a circle of sixteen foliated cusps, the bust of the King in profile to the left wearing a bejewelled crown with fleurons and an open mantle with embroidered borders, low at the neck, clasped by a circular morse. His hair flows freely unto one shoulder. Within a double beaded border, the inscription reads: DOMINVS: MICHI: ADIVTOR: ETEGO: DISPICIAM: INIMICOS: MEOS: E. Reverse: Within a circle of sixteen foliated cusps the quartered arms of Castille and Leon. Within a beaded border the inscription reads: PETRVVS: DEI: GRACIA: REX: CASTELLE: ELEGIONIS: E: M: CCC: LXXXX: VIII.

The year given is 1398 of the *era Hispanica*, that is 1360 of the Christian era. Probably the inexplicable letter E at the end of the inscription on the obverse relates to the era of Spain.

The coin was struck in the guise of a medal at the start of the struggle of Peter the Cruel against Aragon, which was marked by the climax of his crimes. It is not, as hitherto stated, a commemorative coin or medal struck in 1398. The inscription on the obverse, couched in terms

reminiscent of a verse of a psalm, rings like a defiance. Possibly we have here the earliest attempt in the Middle Ages to revive a medallion *all 'antica* with the portrait of the ruler.

Other examples of this coin are in the Biblioteca Nacional, Madrid, the Cabinet des Médailles, Paris, one formerly in the Vidal Ramon Collection, Barcelona.

BIBLIOGRAPHYS A. Heiss, *Descripcion general de las monedas hispano-cristianas* . . . Madrid, 1865, I, p. 56, 58, pl. VII, 1—A. Engel and R. Serrure, *Traité de numismatique du Moyen Age*, III, Paris, 1901, pp. 1339-1340.

PLATE CXVIII JOHN WORK GARRETT LIBRARY of the JOHNS HOPKINS UNIVERSITY, no. 5650

Textiles

157 ITALIAN (Lucca), second half of the 14th century

Fragment of the back of a Chasuble, with a contemporary German (Cologne) Orphrey
Diasper weave, silk and metallic thread; L. 42 x 27 in. (1.06 x .685 m); the orphrey, W. 2⅜ in. (.06 m.)

Silk textiles from China were imported in great quantities along the caravan route to the Middle East and Europe, after Kublai Khan established the Tartar peace over Asia in the last quarter of the thirteenth century. These were used both for ecclesiastical purposes and personal adornment. By the middle of the fourteenth century, their patterns and motives were imitated in Lucca, the most important center of the silk industry in Europe. On this chasuble, swooping phoenixes—a Chinese motif harking back to the Han dynasty—seem to bite at pseudo-Kufic inscriptions, which also are copied after the Islamic motives which the Chinese had introduced in textiles intended for their markets in the Near East. Seated on flowery mounds are cheetahs. The satin ground is brocaded with Cyprian gold thread.

On the gold ground of the Cologne orphrey band, applied in the shape of a cross, the name MARIA alternates with a stylized tree, a rosette and a pelican feeding his young (a symbol of Christ). The orphrey bands are bordered by strips of floral embroidery in polychrome silks and gold.

EXHIBITIONS: Cleveland, Detroit, Los Angeles, "2000 Years of Silk Weaving," 1944.

BIBLIOGRAPHY: *Art News* (March 9, 1929), p. 3—G. Underhill, "A Textile of the Fourteenth Century," *Bull. Clev.* XVI (1929), p. 51—Branting and Lindblom, *Medieval Embroideries and Textiles in Sweden*, 1932, I, p. 139; II, pls. 202 b and 206 b—Adèle Weibel, *2000 Years of Silk Weaving*, 1944, n. 97, pl. 26—Florence Elder de Roover, "Lucchese Silks," *Ciba Review* (June, 1950), p. 2927—Adèle Weibel, *Two Thousand Years of Textiles*, New York, 1952, n. 195, p. 134—Cleveland Museum of Art, *Handbook*, 1958, n. 163—Hugh Honour, *Chinoiserie*, London, 1961, p. 246, pl. 2.

PLATE CXXII THE CLEVELAND MUSEUM OF ART, no. 28.653
 Purchase from the J. H. Wade Fund

158 ITALIAN (Florentine), late fourteenth century

a) The Crucifixion; b) the Resurrection
Embroidered in silk on linen; a) 11¼ v 16½ in. (.287 x .42 m.); b) 14¾ x 20 in. (.375 x .509 m.)

These two panels from a reredos originally had the same dimensions, those of the Crucifixion having been reduced, and they are part of a sequence of embroidered scenes of the Life and Passion of Christ, of which four others remain. The six existing panels depict the Adoration of the Magi, the young Jesus teaching in the Temple, the Kiss of Judas, the Flagellation and the present two subjects. The series is dispersed among four collections: those of Mr. Robert Lehman and the Metropolitan Museum in New York, and of the museums of Boston and Cleveland. Their original number is not known. Possibly there were three times as many, and they were

arranged in vertical and horizontal rows, like the embroidered reredos signed by the Florentine Geri Lapi, today in the Cathedral of Manresa, Spain. In the fourteenth century, such embroidered reredoses in *opus florentinum* were exported and sold in France by Florentine merchants established in the south of France at Toulouse and Avignon.

The two panels are embroidered in satin stitch (*point fendu* or *Kettenstich*) with silk yarns of various weights, according to the areas to be filled. The ground is of linen warp and cotton weft. The satin stitch, which follows the contours of the forms, and the silks of primary colors produce a simple, effective and brilliant modelling which vies with tempera painting. The highlights are often rendered in yellow shading into green or blue, with effects akin to those obtained in contemporary Florentine illumination. Special stitches are used, as, for instance, the backstitch for the chain mail of the soldiers and the herringbone stitch for the trees in the Resurrection panel. The background is decorated with scrolls in relief made of cotton yarn that was intended to be covered with gilt silver threads. A similar raised decoration is found on the *columnae* (embroidered orphreys) on two fourteenth-century Florentine chasubles in the Museum of Fine Arts in Boston and on three panels in Judge Irwin Untermyer's collection in New York.

The embroidered reredos of which the Crucifixion and Ressurection panels were part, shows the survival in the second half of the fourteenth century of the formulas of the art of Giotto and his immediate successors, especially Taddeo Gaddi. Florentine embroideries were not copied by the needleworkers after cartoons; they were part and parcel of the art of painting. As we learn in Cennini's *Libro dell'Arte* (chapters 164 and 166 of the Milanesi edition; pp. 100, 102, in the D. V. Thompson edition), the design was first sketched on the fabric in charcoal by a painter, then worked up in ink outlines and washes. Thus, the layout and elaboration of the design were not left to the embroiderers, who did not belong to the corporation of the painters, but to the silk guild. The similarities in composition and treatment of our panels (and of a few other contemporary Florentine embroideries) to the frescoes of Giotto and the aftermath of Giottesque art, indicate that the designs were established in specific painters' ateliers after pattern-books which were the property of the painters. The task of the embroiderers was confined to the execution in colored silks. The style of such Florentine embroideries is strikingly close to works by Taddeo Gaddi and, in the later production, to paintings by Agnolo Gaddi, Jacopo del Casentino and Giovanni da Milano. The first conservatory of the formulas of Giotto in this respect was the workshop of Taddeo Gaddi. After his death in 1366, the education of his two sons, Agnolo and Giovanni, was entrusted, as Vasari tells us (*Vite,* ed: Milanesi 1906, I, pp. 583-4), to Jacopo del Casentino, while Giovanni da Milano took charge of their artistic formation. Marthe Schubert has advanced the belief that from some time after 1366 up to the years around 1400, Agnolo Gaddi and another member of the family, Zanobi Gaddi, were at the head of an active business in Florence, which exercised a copyright on Giottesque models to be used by the embroiderers. Their workshop was not satisfied with stereotyped copies, but experimented with innovations and may have enlisted at some time or another the cooperation of progressive young artists like Starnina.

If we compare the panels of the Crucifixion and Resurrection and the four others of the same series, with those of the reredos signed by Geri Lapi, we note that all of them exhibit a frontality which contrasts with the diagonal schemes—inspired by Taddeo Gaddi—that obtain in the Manresa reredos. The scenes embroidered on the *columnae* of the two Florentine chasubles in Boston, the decoration of which is characterized by the same raised scrolls as in our panels, derive from paintings not only by Taddeo Gaddi, but by Agnolo Gaddi, Giovanni da Milano and the follower of the latter in the Rinuccini chapel, Santa Croce, Florence. *A tertium comparationis* may be introduced: the recently published Florentine chasuble in the Museum of Decorative Arts, Budapest. In that piece, the panel depicting Christ teaching in the Temple is close to the second in the series of six embroideries which we are discussing. Both depart from the purely Giottesque model for this subject (the fresco in the Arena, Padua) and use a space convention of elevating Christ on steps, which is mid-fourteenth century (cf. Cat. no. 2). The Baptism of

149

Christ on the Budapest chasuble was made after a drawing copying the relief with this subject on the silver altarpiece of the Baptistery, Florence, a derivation which dates the orphrey well into the last quarter of the fourteenth century. The figure of Christ resurrecting Lazarus on the chasuble is repeated in the figure of a bystander on the left in the Kiss of Judas, scene 3 in our series of six panels. The drawing of the figure of Christ and of that of the bystander have a noble ponderousness and a drapery style which are no longer Giottesque and could be termed early Masacciesque. Other classical features and anticipations of High Renaissance painting are met in our panels. For instance, the resurrecting Christ standing immobile, with one foot resting on the edge of the sarcophagus, shows an undisturbed frontality and a sculptural impassiveness which contrast with the diagonal and emotional rendering of the Resurrection in the reredos of Manresa and anticipate Piero della Francesca. But it should be noted that the soft curves of the folds of the mantle gathered on His arm are modelled in a pattern characteristic of the International Style.

The panels of the Crucifixion and the Resurrection raise, as does the Florentine chasuble in Budapest, the question of determining what elements of their classicizing aspect are due to a revival of Giotto rather than a mere continuation of his style, and what already indicate the formation of the art of Masaccio. Would the mysterious personality of Starnina afford one of the clues for the solution of the problem? A dating in the last two decades of the fourteenth century would, on the other hand, be substantiated by the technical detail of the raised scrolls, which correspond to a certain extent to the *compas d'enleveure de cordon* twice noted in entries of Florentine embroideries in the 1403-1405 inventory of the collections of the Duke of Berry (Nos. 1311, 1312).

PROVENIENCE: Leopold Iklé Collection, St. Gall, Switzerland.

EXHIBITIONS: Boston, Museum of Fine Arts, 1940; Hartford, Wadsworth Atheneum, 1948; Detroit Institute of Arts, "Decorative Arts of the Italian Renaissance," November 18, 1958—January 4, 1959.

BIBLIOGRAPHY: A. Fäh, *Textile Vorbilder aus der Sammlung Iklé*, Zürich—L. de Farcy, *La Broderie du XIe siècle jusqu'à nos jours . . . II Supplément*, Angers, 1919, p. 151, pl. 187—G. Underhill, "Old Embroideries in the Museum," *Bull. Clev.*, XVI (1930), pp. 151-154, ill.—B. Kurth, "Florentine Trecento-Stickereien," *Pantheon*, VIII (1931), pp. 455-462, figs. 5, 6—Cleveland Museum of Art, *Handbook*, 1958, n. 156—Detroit Institute of Arts, "Decorative Arts of the Italian Renaissance," 1958, n. 179 (as perhaps Geri Lapi)—M. Schubert, "Une chasuble florentine du XVème siècle au Musée des Arts Décoratifs," *Az-Iparmüvészeti-Múzeum Ev Könyvei*, III, IV (1959), pp. 203-232—A. S. Cavallo, "A Newly Discovered Trecento Orphrey from Florence," *The Burlington Magazine*, CII (1960), pp. 505-510—R. Grönwoldt, "Florentiner Stickereien in den Inventaren des Herzogs von Berry und der Herzöge von Burgund," *Mitteilungen des Kunsthistorischen Instituts in Florenz* (1961), pp. 33-58—L. von Wilckens, "Textilien in Westeuropa, Literatur von 1945-1961," *Zeitschrift für Kunstgeschichte*, XXIV 3/4 (1961), pp. 269-270.

PLATE CXXIII

(a) MUSEUM OF FINE ARTS, BOSTON, no. 43.131
(b) THE CLEVELAND MUSEUM OF ART, no. 29.904
Purchased from the J. H. Wade Fund

159 ITALIAN (Florentine), ca. 1415 or earlier

The Coronation of the Virgin

Embroidered in silk and gold on linen; D. 22¾ in. (.579 m.)

The Virgin seated on the same throne as Christ, on His right, crosses her hands on her breast and bows her head to receive the tiara-shaped crown. The brocaded cloth of honor is upheld by two angels. Standing on either side of the throne are St. Verdiana (patron saint of Castelfiorentino, whose relics were venerated in Florence) characterized by her attributes: a snake and a basket; and St. Anthony Abbot. In the foreground, kneeling or seated angels play the timbrel, fiddle, cornet, bombard, lute and harp. The embroidery is executed with colored silks passing over and under gold threads laid in pairs on the linen ground (*or nué* and split stitch technique). Each figure was worked separately and stitched to the area prepared for it in the gold

embroidered background. Miss Dorothy G. Shepherd has called attention to the similarity of the style of the scene to two paintings of the Cornation of the Virgin by Lorenzo Monaco (Uffizi Gallery, Florence and the National Gallery, London). These were painted in 1414 and 1415, respectively, at a time when the International Style had reached its peak in Florence and found its most lyrical and sweet expression in the works 'executed during that period by Lorenzo Monaco. Miss Shepherd also indicated that the embroidery is backed by a reused parchment with Latin writing over which is penned in Italian the inscription: "This palliotto was embroidered in the year 1486 by the venerable Margherita del Caccia nun of this monastery." Could the roundel have been taken from an earlier altar ornament and transferred to a new antependium, since obviously the style of the Coronation of the Virgin cannot be reconciled with a date as late as 1486? It is not marked by the characteristics of the International Style at its most florid stage, although it is certainly later than the Florentine antependium in the Museo degli Argenti, Florence. We know of a complete embroidered altar ornament with the Coronation of the Virgin at the center of the reredos, which the Duke of Burgundy, Philip the Bold, bought in 1394 from Berthel du Cygne, a Florentine merchant. Also Florentine must have been the embroidered altar-cloths inventoried in the chapel of Philip the Bold by Jehan de Hallarville in 1404. Five out of six mentioned had as their central theme the Coronation of the Virgin. The entry of number 5 would be perfectly appropriate as a description of our embroidered roundel: "Item une autre table d'autel *de brodeure d'or* ou quel est l'ystoire de la vie Nostre Dame et ou milieu Dieu et Nostre Dame par manière de couronnement, et tient Nostre Seigneur la couronne en ses mains *par manière de thiaire eslevez.*" In the inventories of the Duke of Berry, drawn up in 1403-05, nine *frontiers* (antependia), *doussiers* (reredoses) or *grants tables,* all of *brodeure de l'ouvrage de Florance,* were dedicated to the life of the Virgin, with scenes or images centered around the motif of the Coronation. Seven of the entries mention "anges entour, jouans de pluseurs instrumens." We can only speculate on the style of such religious textiles of *opus florentinum* ordered for the courts of the dukes of Burgundy and Berry, but, taking into account the suddenness of the invasion of the International Style into reluctant Florence in the first years of the fifteenth century and the obscurity surrounding the circumstances of its introduction, one may surmise that the decorative arts already flourishing in Florence played their part in this. Patronized as they were by the rich art collectors of northen Europe, these arts required new models in accord with the dictations of a new taste.

EXHIBITIONS: Detroit Institute of Arts, "Decorative Arts of the Italian Renaissance—1400-1600", November 18, 1959 —January 4, 1960.

BIBLIOGRAPHY: Shepherd, D. G. "A Fifteenth-Century Florentine Embroidery", *Bull. Clev.* (1954), pp. 211-13, ill.— Cleveland Museum of Art, *Handbook* (1958), n. 223—W. M. Milliken, *The Cleveland Museum of Art,* New York, (1958)—Detroit Institute of Arts, *"Decorative Arts of the Italian Renaissance 1400-1600",* 1958, n. 181, p. 80, ill.

PLATE CXXIV

THE CLEVELAND MUSEUM OF ART, no. 53.129
Purchased from the J. H. Wade Fund

160 FRANCO-BURGUNDIAN (Arras), first quarter of the 15th century

The Offering of the Heart

Wool tapestry; 8 ft. 5½ in. x 6 ft. 7⅛ in. (2.58 x 2.09 m.)

In a fairy landscape with a grassy mound bestrewn with flowers, among which rabbits scamper, a dashing gentleman advances toward a young lady to whom he proffers a little heart held between the thumb and forefinger of his right hand. He is dressed in a dagged cape lined with ermine, flung wide open, and a *chaperon* with its end flopping forward like a Phrygian cap. On his high-necked tunic is seen a knight's necklace. The young lady is seated on the mound, holding a falcon on her gloved hand. With a snap of the fingers of her right hand she is calling her little dog to jump into her lap. Her headdress studded with pearls and her exquisite gown

recall the costumes of the ladies riding in a fashionable company, who were painted by the Limbourg brothers in the calendar picture for May of the *Très Riches Heures* of the Duke of Berry.

The theme of the offering of the heart is frequent on the *Minnekästchen* and is found on the rare French ivories deriving from them. It occurs more frequently on ivory mirror-cases made in northern Italy. The scene represented in this tapestry has a dream-like aspect. The ground has the darkness of night, the tufts of leaves explode into shooting stars, and the gnarled trunks of the trees gleam like tiny lightning flashes. No ground-line disturbs the admirable decorative effect. The composition is based on perpendicular emphasis. The flatness of the pattern renders the bodies of the lovers unsubstantial, so that they seem delicate, fleeting and unreal images. The same treatment of the background as an ornamental *continuum* occurs in the miniatures of the treatise on hunting that was so popular in the fifteenth century—the *Livre de la Chasse* of Gaston Phébus.

Chronologically this tapestry belongs to the early productions of the Arras looms. Its weaving comes after the Story of St. Piat and St. Eleutherius which was finished in 1402. It is close to the three remaining pieces of the *Cinq pièces à sujets courtois* in the Cluny Museum, illustrating an unidentified French novel, which were once in the Castle of Canche in Britanny. In them we find again the same adaptation of the landscapes of woods and castles painted by the Limbourg brothers to the abstract two-dimensional space and decorative flatness proper to tapestry. Paris lost its importance as a center of tapestry production in the last quarter of the fourteenth century and Arras, after 1400, became the leader of the industry under the patronage of the Dukes of Burgundy, rivals of the "Armagnacs" of Paris (the party of the Queen Ysabeau de Bavière and Duke Louis d'Orléans).

Probably a drawing in the Cabinet des Dessins of the Louvre, representing a lady holding a falcon, is a survival of a preliminary sketch made by the artist who executed the cartoon of this tapestry of the Offering of the Heart.

PROVENIENCE: Devillier Collection.

EXHIBITIONS: Chicago, Art Institute, "Masterpieces of French Tapestry," Mar. 17-May 5, 1948; Vienna, "Europäische Kunst um 1400," 1962.

BIBLIOGRAPHY: B. Kurth, "Die Blütezeit der Bildwirkerkunst zu Tournai und der burgundische Hof," *Jahrbuch der Kunsthistorischen Sammlungen des Allerhöchsten Kaiserhauses* (1917), p. 67—H. Schmitz, *Bildteppiche*, Berlin, 1921, p. 177 ff., fig. 92—B. Kurth, *Gotische Bildteppiche aus Frankreich und Flandern*, Munich, 1923, p. ix, fig. 14—H. Göbel, *Wandteppiche*, I: *Die Nederlande*, Leipzig, 1923, pp. 77, 225, 241 ff., fig. 217—G. Migeon, *Les arts du tissu*, Paris, 1929, p. 220, fig. 217—R. Van Marle, *Iconographie de l'art profane* . . . I: *La Vie Quotidienne*, La Haye, 1931, p. 462, fig. 458—Chicago, Art Institute, *Masterpieces of French Tapestry*, n. 8, p. 23—R. A. Weigert, *La tapisserie française*, Paris, 1956, p. 47—D. Heinz, *Europäische Wandteppiche*, I, Brunswick, 1962, p. 63, color pl. IV—Vienna, Kunsthistorisches Museum *Europäische Kunst um 1400*, 1962, n. 516.

PLATE CXXV MUSEE DE CLUNY, Paris, no. L.0A.3131

ADDENDUM

161 BURGUNDIAN, ca. 1433

Pyx of Philip the Good

Rock-crystal; mounts parcel gilt, enamelled; 2 in. (.052 m.); D. 1½ in. (.019 m.)

This little pyx in rock-crystal, mounted in silver and topped by a conical silver lid decorated with leaves in blue, red and green translucent enamel, originally contained, wrapped in crimson silk, the fragments of a miraculous consecrated wafer which Pope Eugenius IV sent to the Duke of Burgundy, Philip the Good, in 1433. The pyx was discovered in 1939 in a casket that had been deposited in the church of St. Michel, Dijon, by a canon of the Sainte Chapelle on the 7th of January 1791, before the dissolution of the Chapter. The miraculous wafer is said to have been stamped with a representation of Christ enthroned, stained by blood at the spots where a sacrilegious hand had desecrated it with a stylet.

The gift of the Pope was made to acknowledge the diplomatic support brought to the cause of Eugenius IV by Philip the Good at the Council of Basel. The reliquary was kept in the Chapelle de la Sainte Hostie opening on the southern side of the choir of the Sainte Chapelle in Dijon. Inside the pyx was found in 1939 a certificate in parchment authenticating the relic and inscribed: *Ibi reconditae sunt particulae sanctissimae hostiae.*

EXHIBITIONS: Paris, "Peintures et objets d'art récemment classés par les Services des Monuments Historiques," 1942, n. 10; Bruges, "Orfèvrerie d'art," 1950, n. 72; Dijon, "Le grand siècle des ducs de Bourgogne," 1951, n. 167; Amsterdam, "Bourgondische Pracht," 1951, n. 241; Brussels, "Le siècle de Bourgogne," 1951, n. 221; Dijon, "Musées de Dijon et de Bourgogne," 1956, n. 49; Dijon, "Le diocèse de Dijon, histoire et art," n. 164.

MUSEE DE DIJON, France

Twenty-five hundred copies of this catalogue were produced for THE TRUSTEES OF THE WALTERS ART GALLERY through the facilities of THE JOHN D. LUCAS PRINTING COMPANY, Baltimore, Maryland.

The type faces used throughout were 8 and 10 pt. Baskerville with display in Times Roman by the MERGANTHALER LINOTYPE COMPANY.

The text pages were lithographed on 70 lb. basis white Gainsborough Text from the HAMILTON PAPER COMPANY. The plates were printed letterpress on 80 lb. basis Black & White Enamel from the MEAD PAPER COMPANY.

The engravings in the plate section were made by the ADVERTISERS ENGRAVING COMPANY, Baltimore, Maryland.

MOORE AND COMPANY, Baltimore, were the binders of this publication.

PLATES

PLATE I

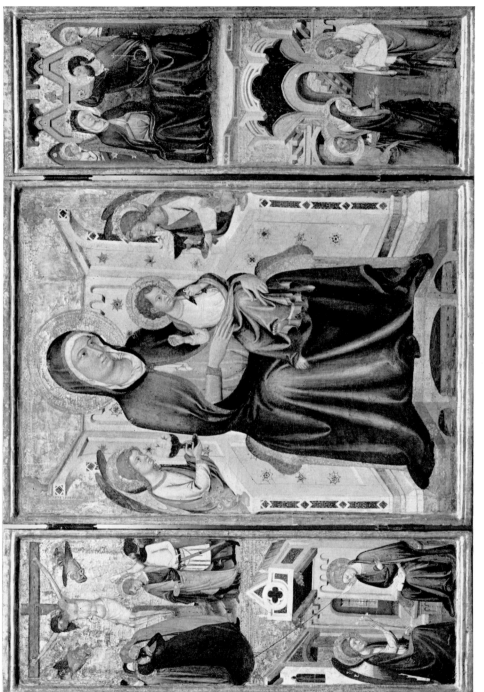

No. 7

PLATE II

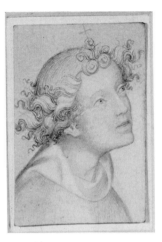

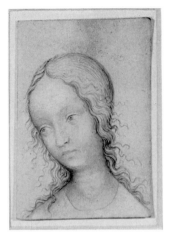

No. 5a No. 5b

No. 4

PLATE III

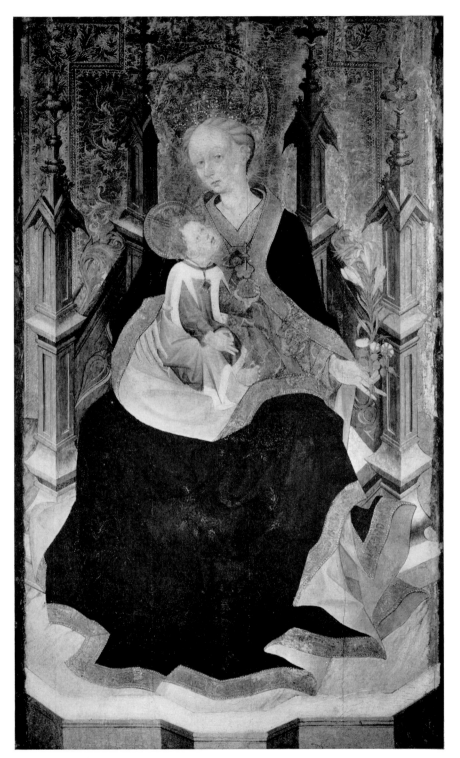

No. 20

PLATE IV

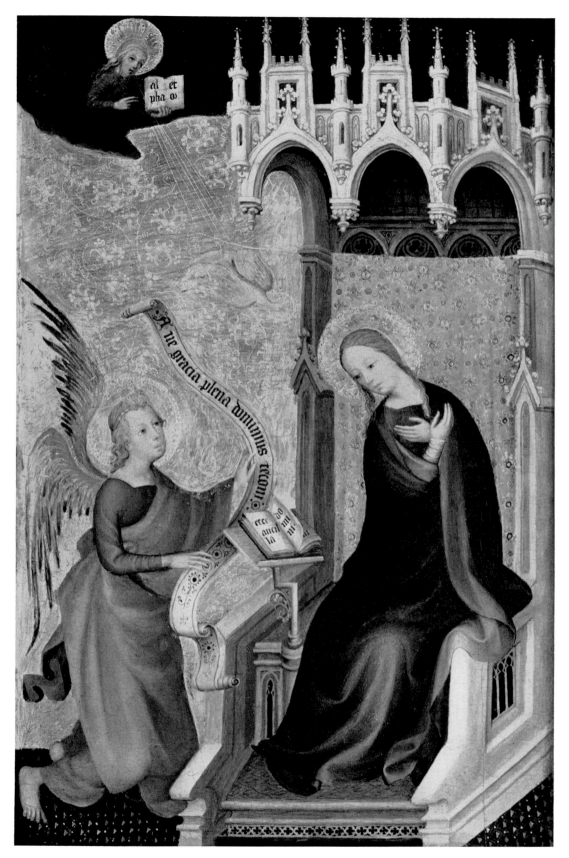

No. 24a

PLATE V

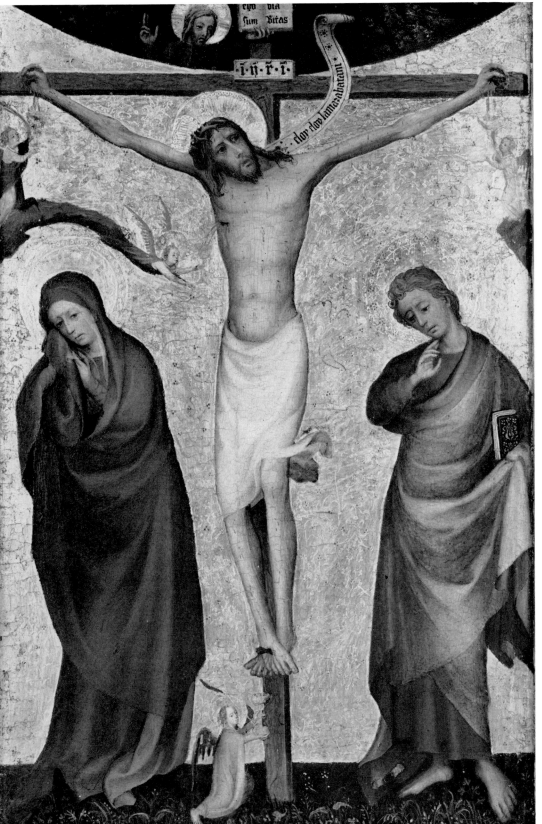

No. 24b

PLATE VI

No. 37

PLATE VII

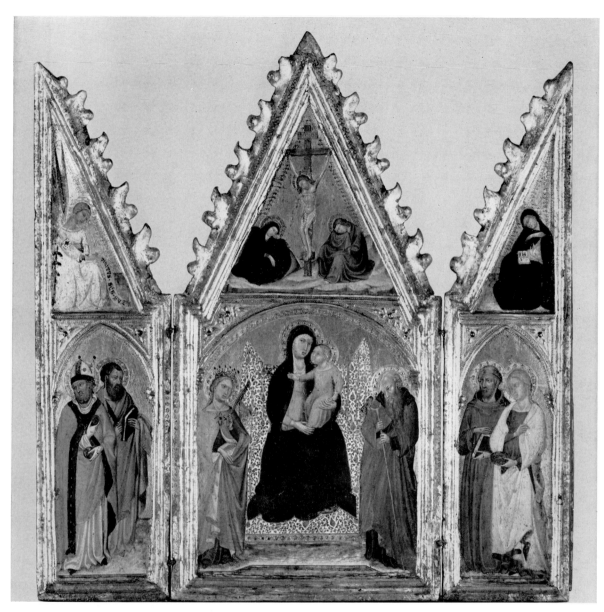

No. 26

PLATE VIII

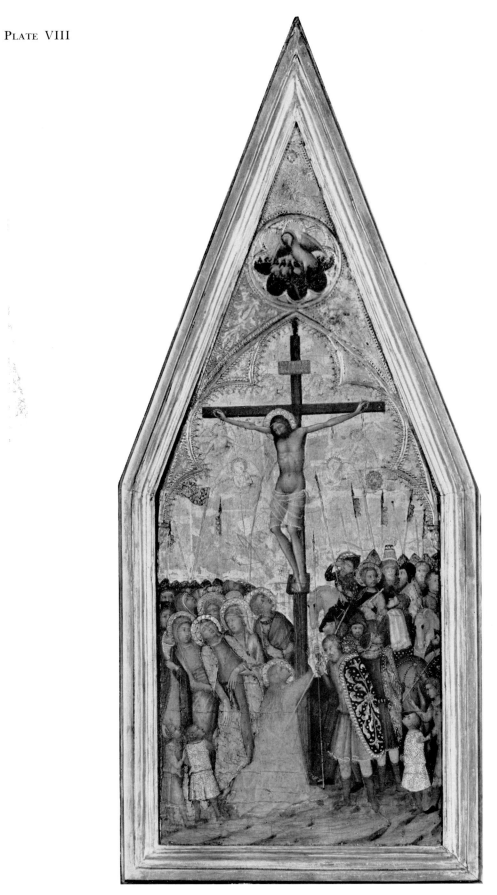

No. 29

PLATE IX

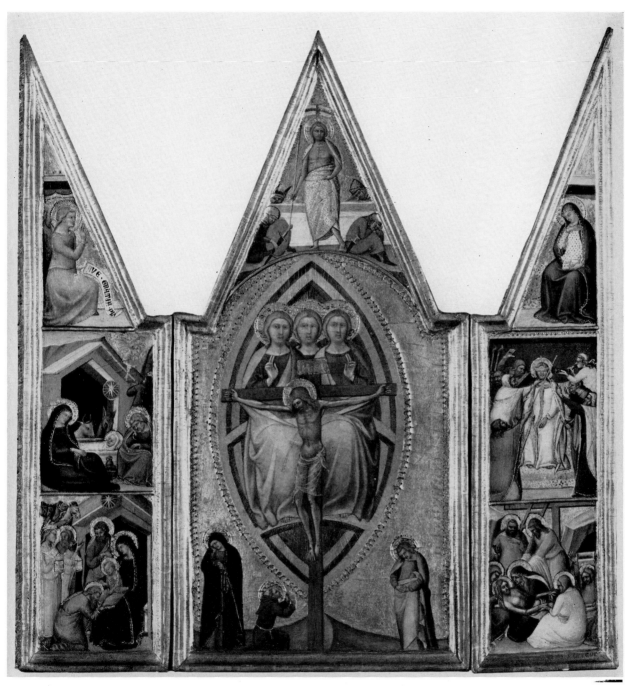

No. 17

PLATE X

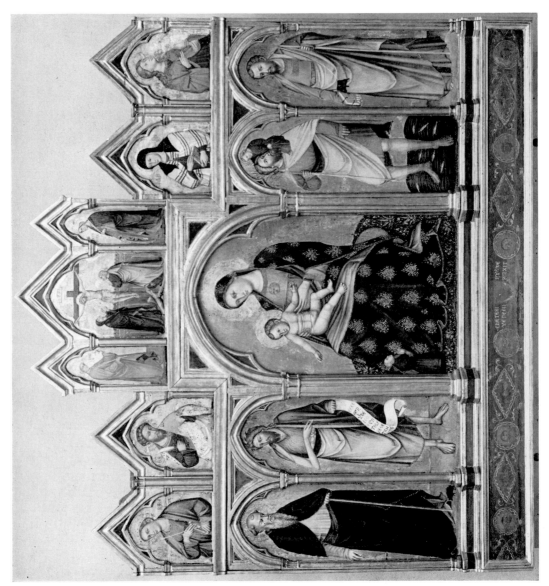

PLATE XI

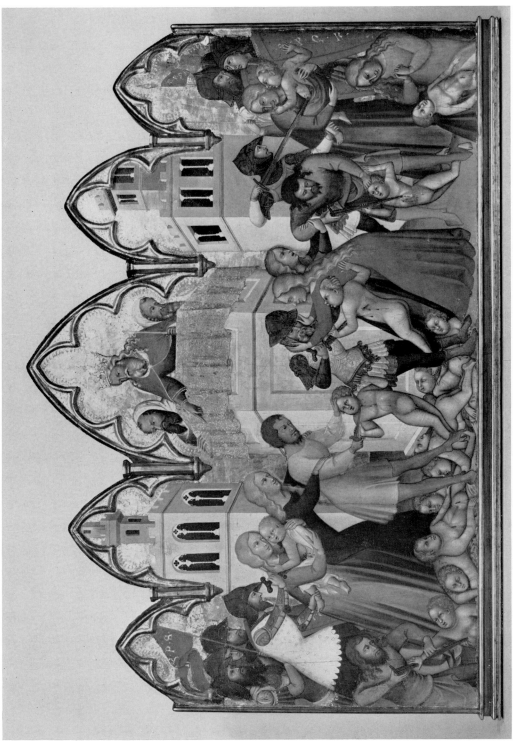

PLATE XII

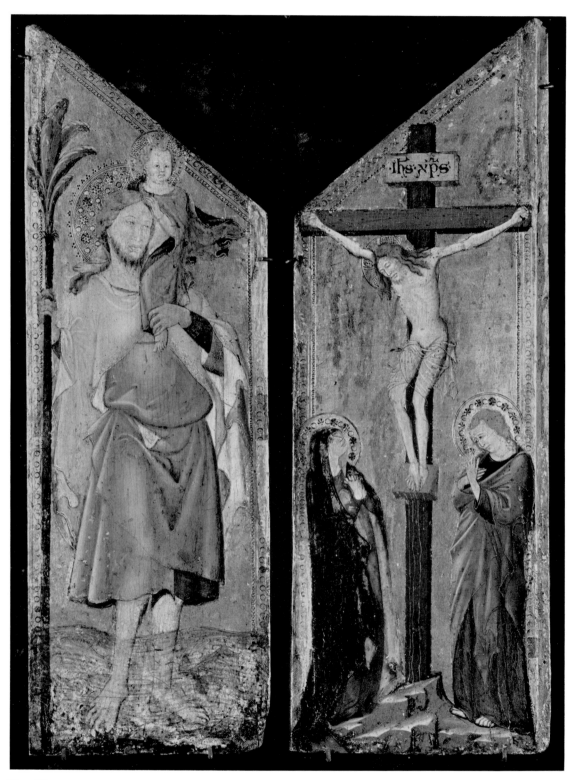

No. 30

Plate XIII

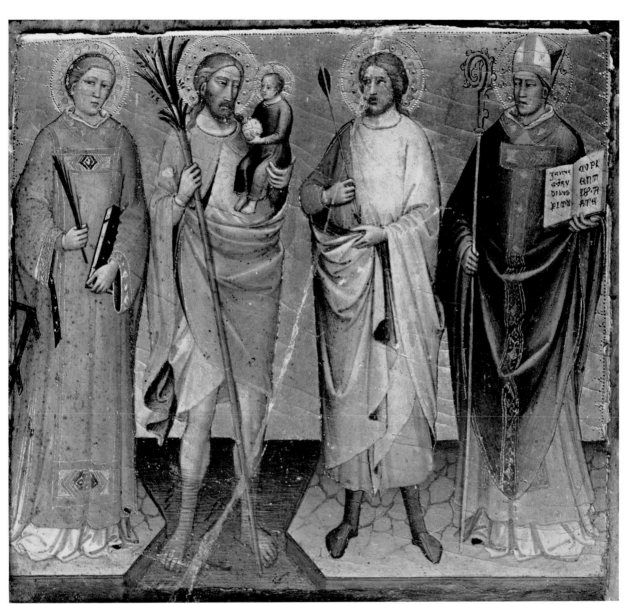

No. 18

PLATE XIV

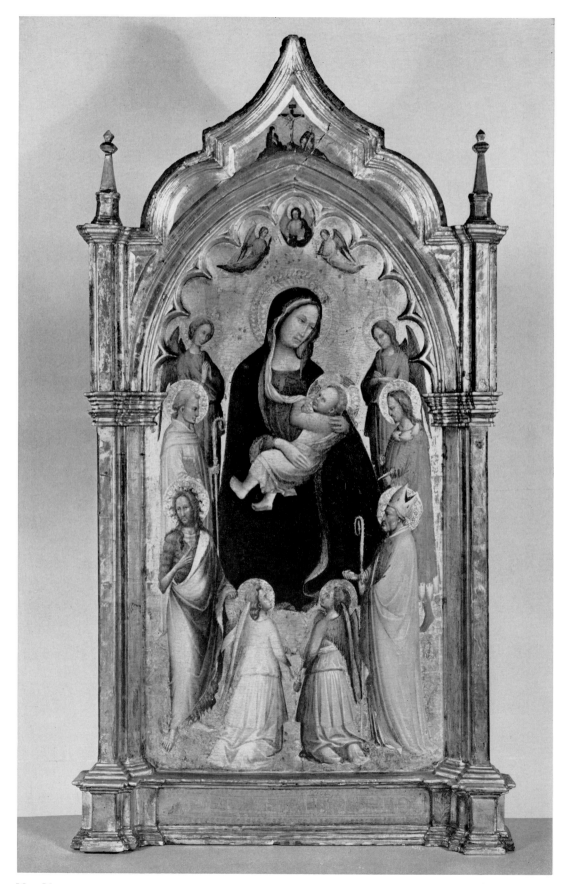

No. 21

PLATE XV

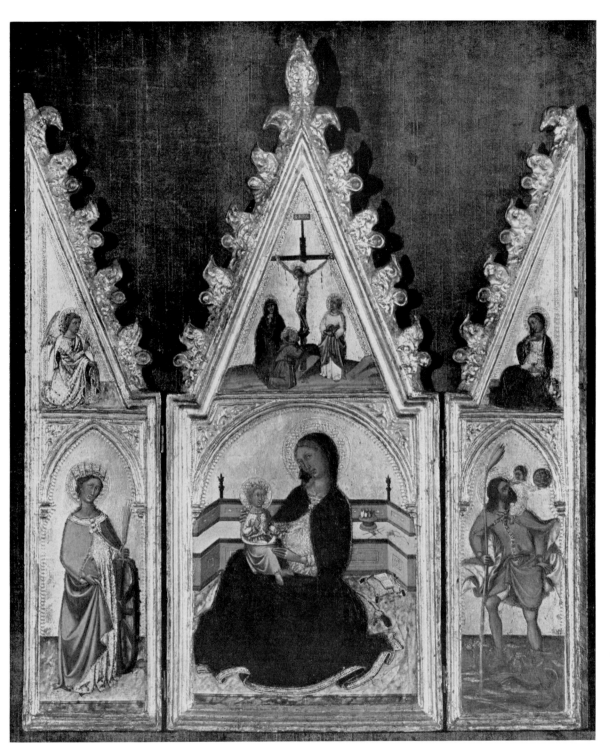

PLATE XVI

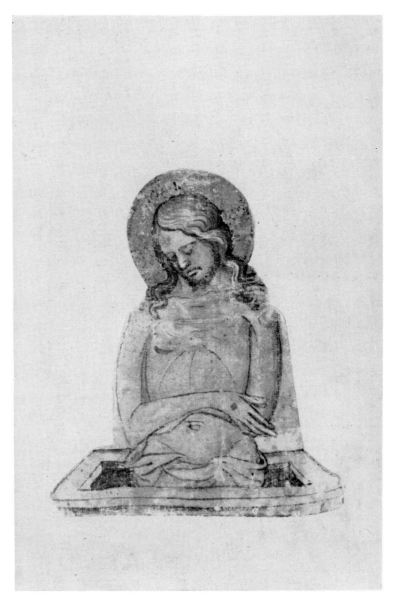

No. 23

PLATE XVII

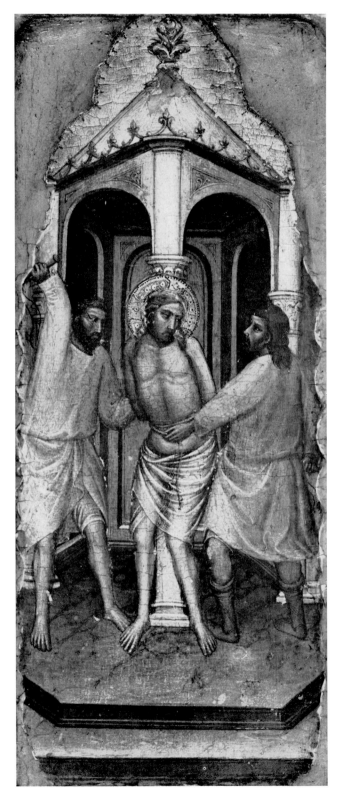

No. 19

PLATE XVIII

PLATE XIX

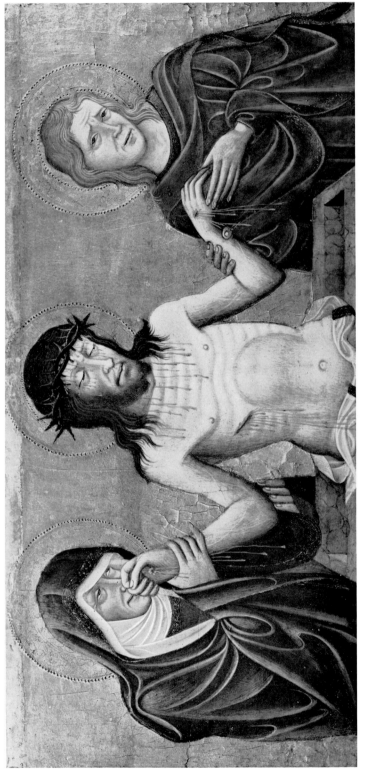

No. 10

PLATE XX

No. 9

Plate XXI

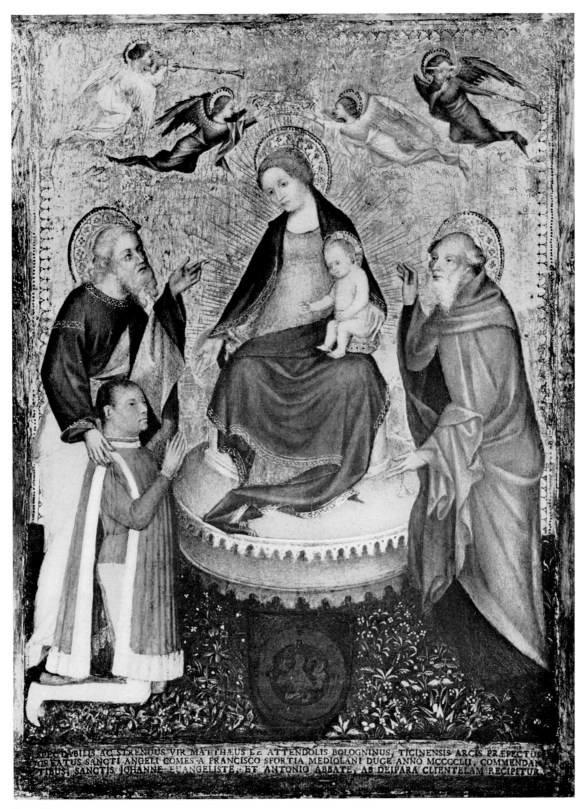

No. 15

PLATE XXII

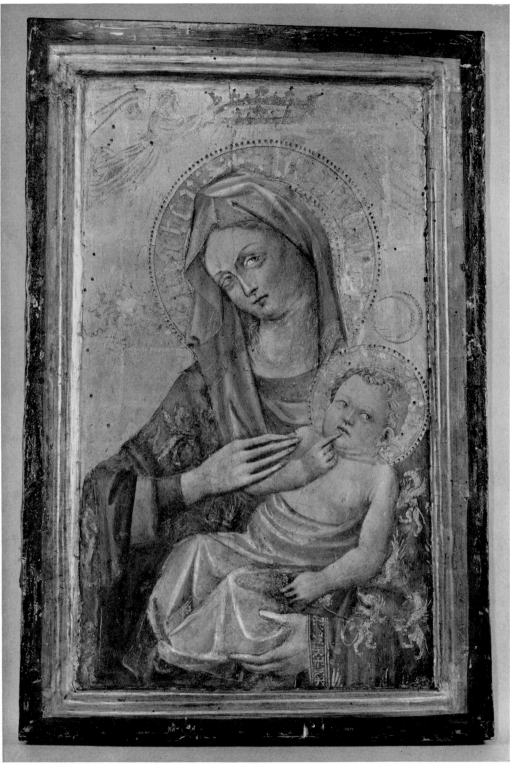

No. 22

PLATE XXIII

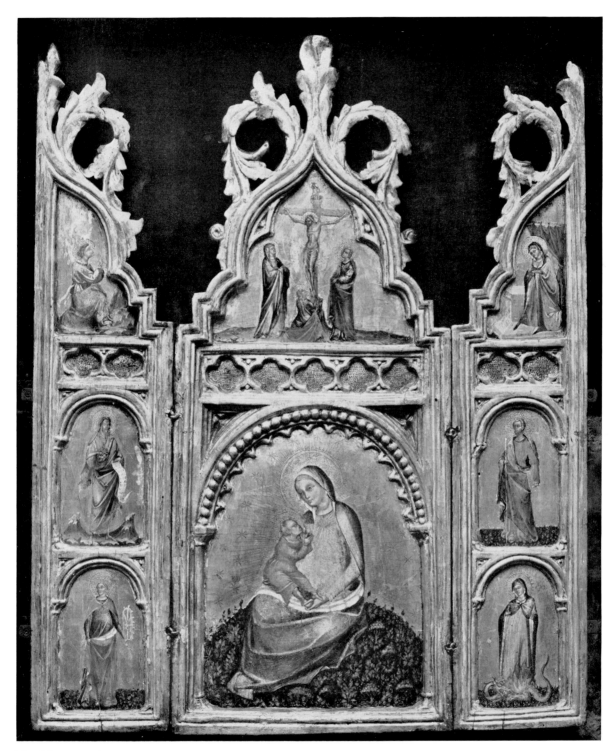

No. 16

PLATE XXIV

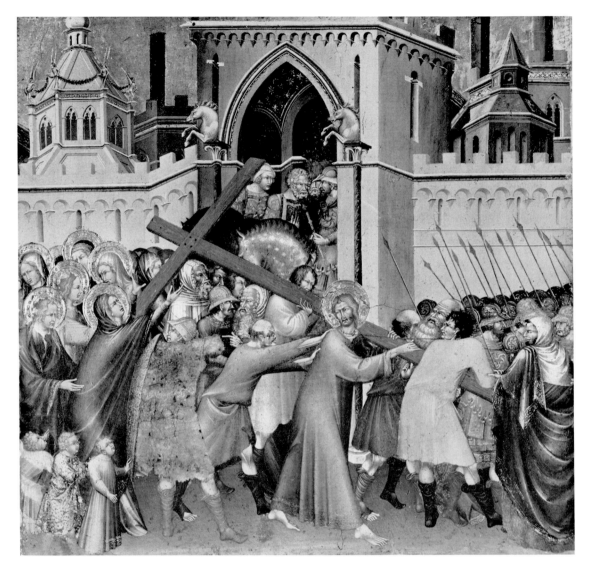

No. 11a

PLATE XXV

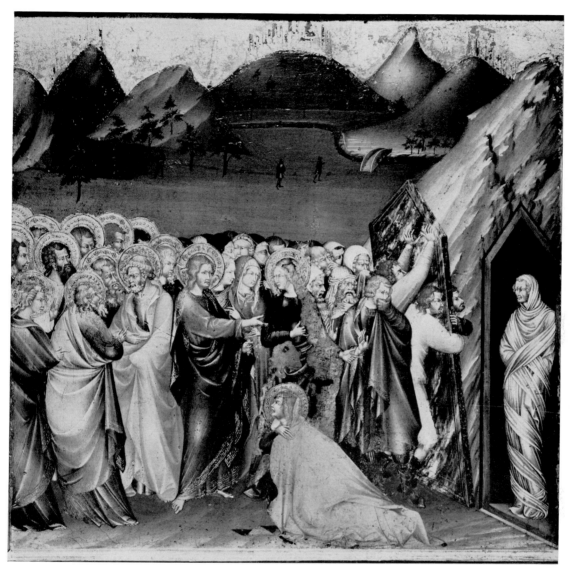

No. 11b

PLATE XXVI

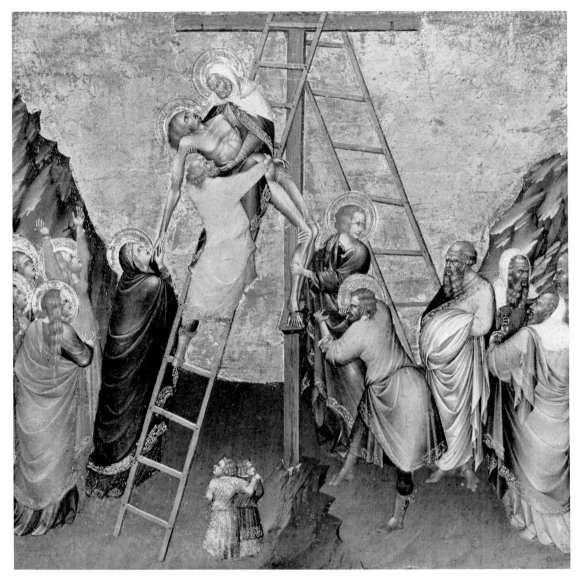

No. 11c

PLATE XXVII

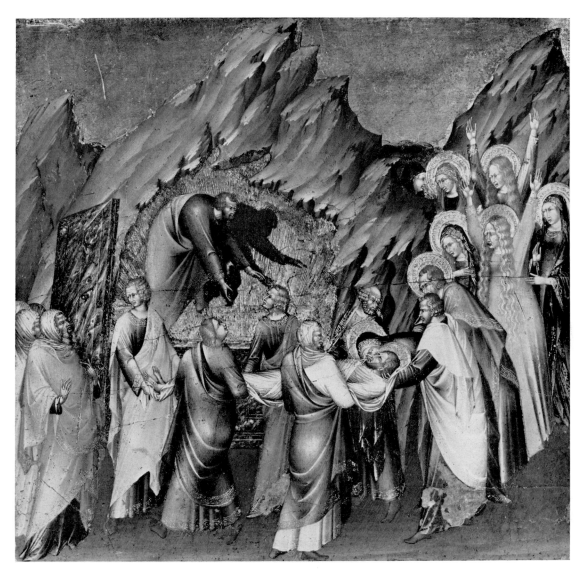

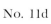
No. 11d

PLATE XXVIII

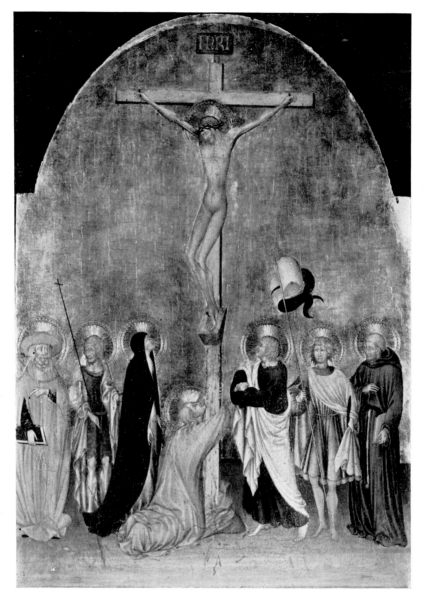

No. 27

PLATE XXIX

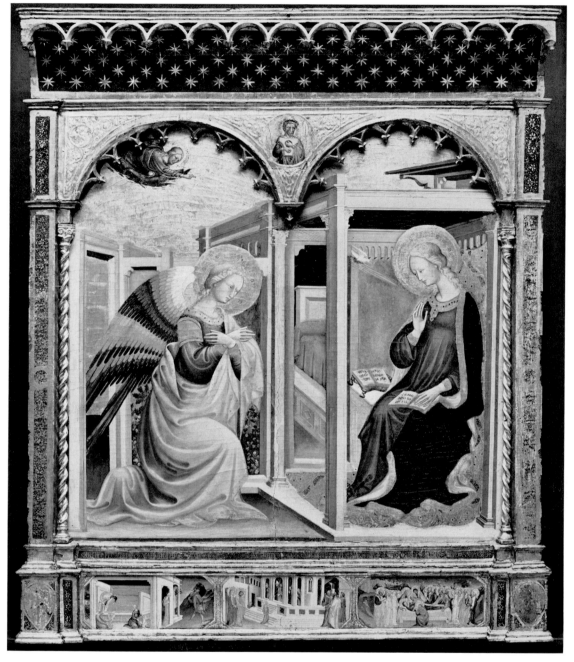

No. 3

Plate XXX

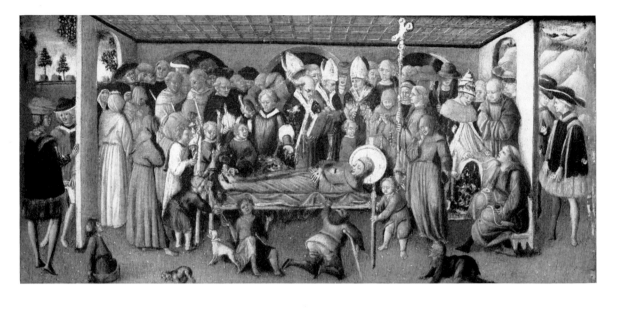

No. 28 and detail

PLATE XXXI

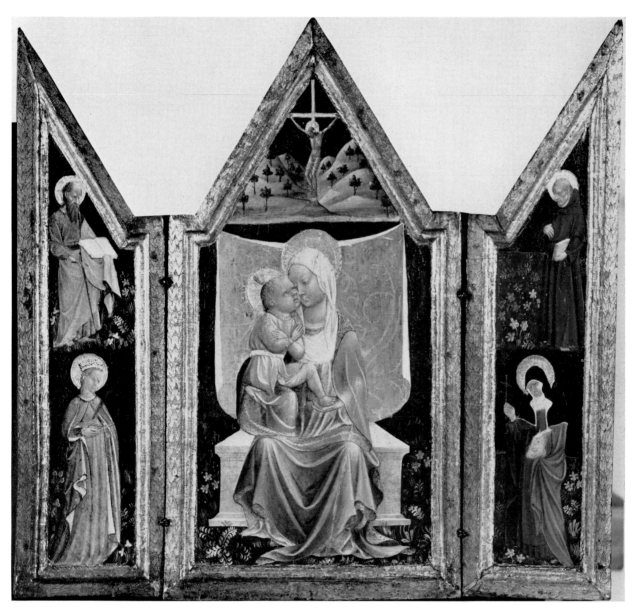

No. 12

PLATE XXXII

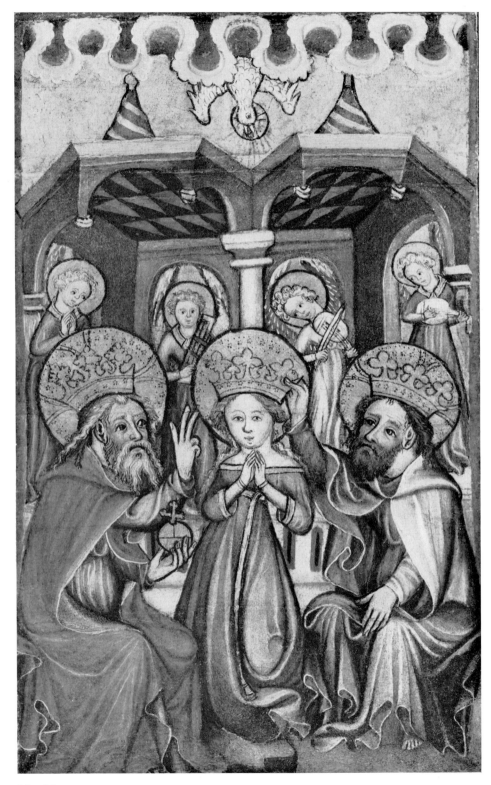

No. 36

PLATE XXXIII

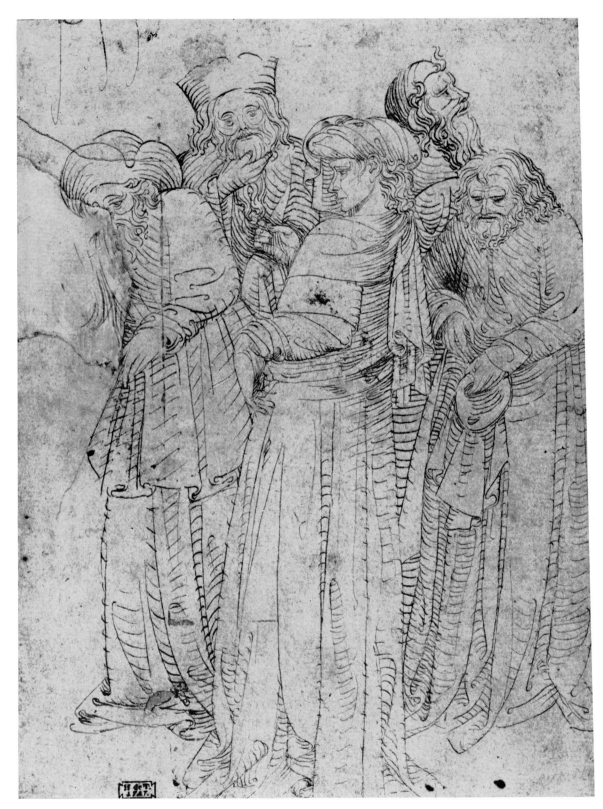

No. 33

PLATE XXXIV

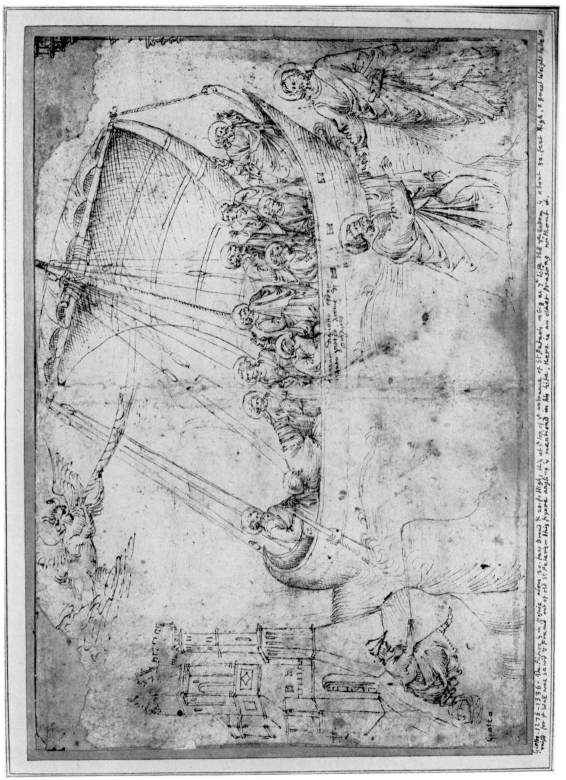

PLATE XXXV

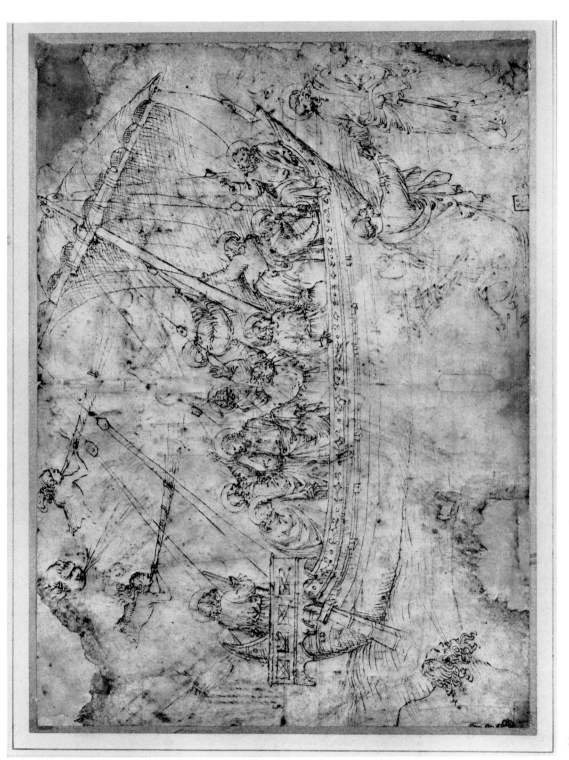

PLATE XXXVI

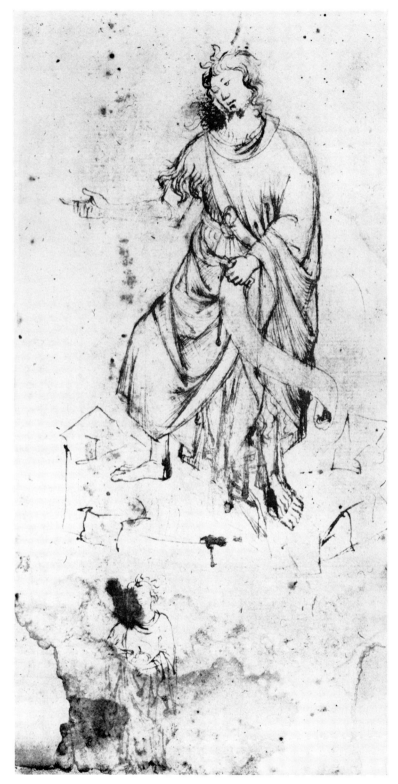

No. 35

PLATE XXXVII

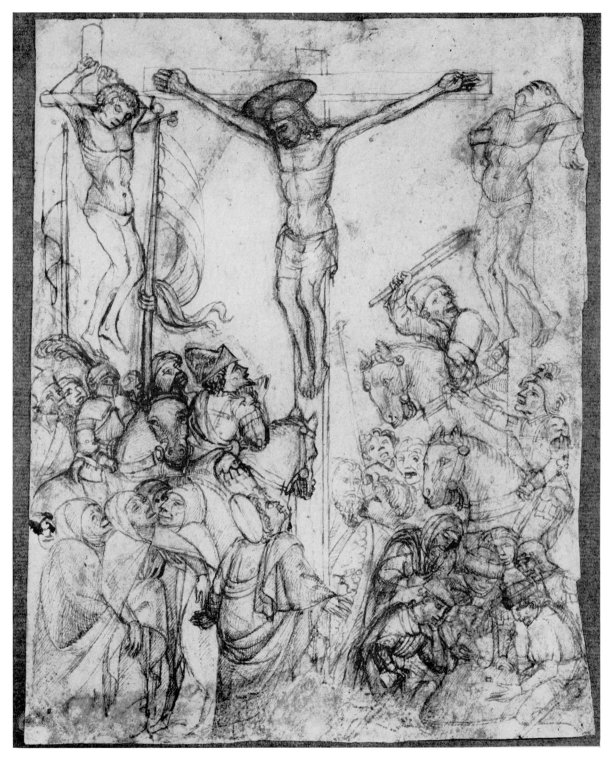

No. 1

Plate XXXVIII

PLATE XXXIX

PLATE XL

No. 14

PLATE XLI

No. 56

PLATE XLII

No. 38

No. 52

No. 39

PLATE XLIII

Uan gode uander godheit en uander trinitept.
Primu capitel.

Je prophete mi
cheas seyt wt den
monde godes. O
mensche ic sal di
op seggghen wat
goet is ende wat
ic uan di eyssche·
vmmer dat du mi
kennes ende we
tes dat ic bin ende
wie ic sy·

Dat god is wt
mit veel dinghen

bewijst· Die kersten gheloue beruechdet· Die
scrifture spreecket· Alle ghelyc bewijstet· Natu
urlike reden bedichtet· Alle creaturen roepent·
Alle die heilighen predikent

Dat daer een god is wele alle menschen acu
teden· wele die natuer ghift te kennen· wele alle
conscienne outsien· wele gheen gheschicket har
te mach haten

Dat die selue god mer alleen en is· dat woecht
hi selue daer tn seyt· Siet ic bin alleen ende daer

Hut mi heer wart ghelone·

No. 67

PLATE XLIV

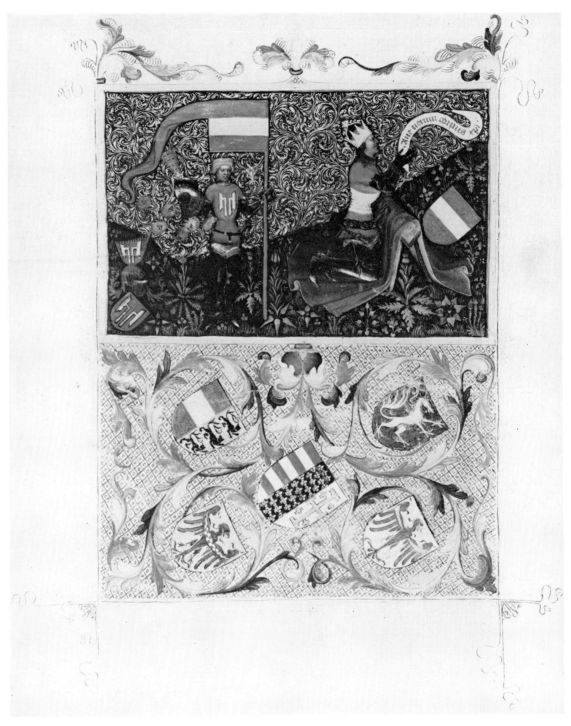

No. 65

PLATE XLV

No. 44

PLATE XLVI

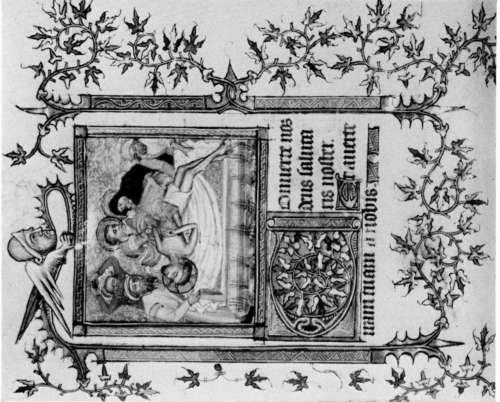

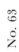

PLATE XLVII

No. 71

No. 68

PLATE XLVIII

No. 54

No. 41

PLATE XLIX

Plate L

No. 46

No. 42

PLATE LI

No. 43

No. 50

PLATE LII

No. 45

PLATE LIII

No. 40

PLATE LIV

No. 51

No. 64

PLATE LV

No. 47

No. 48

Plate LVI

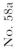

PLATE LVII

No. 70

No. 69

PLATE LVIII

No. 60

PLATE LIX

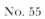

No. 55

PLATE LX

No. 61

PLATE LXI

No. 57

PLATE LXII

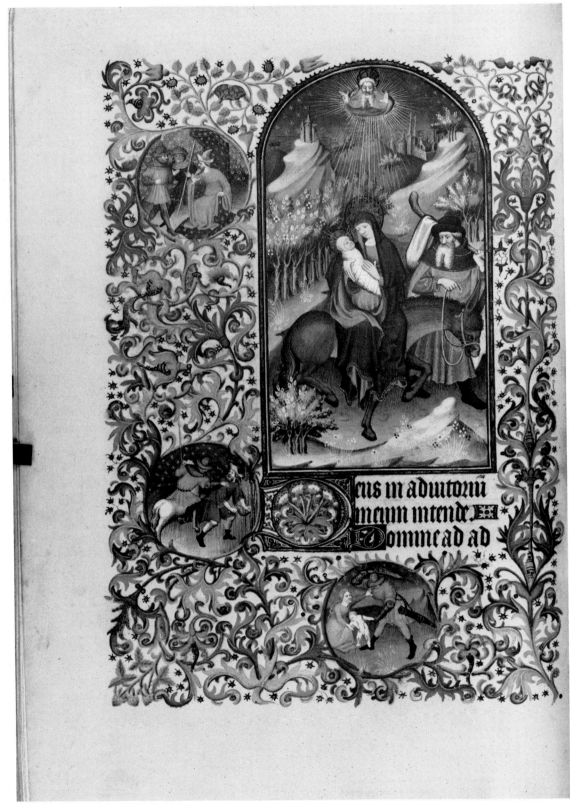

PLATE LXIII

PLATE LXIV

No. 72

Plate LXV

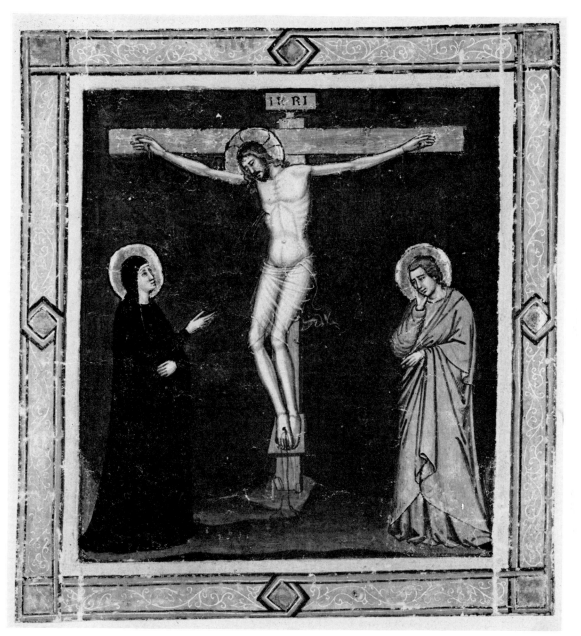

PLATE LXVI

No. 74

PLATE LXVII

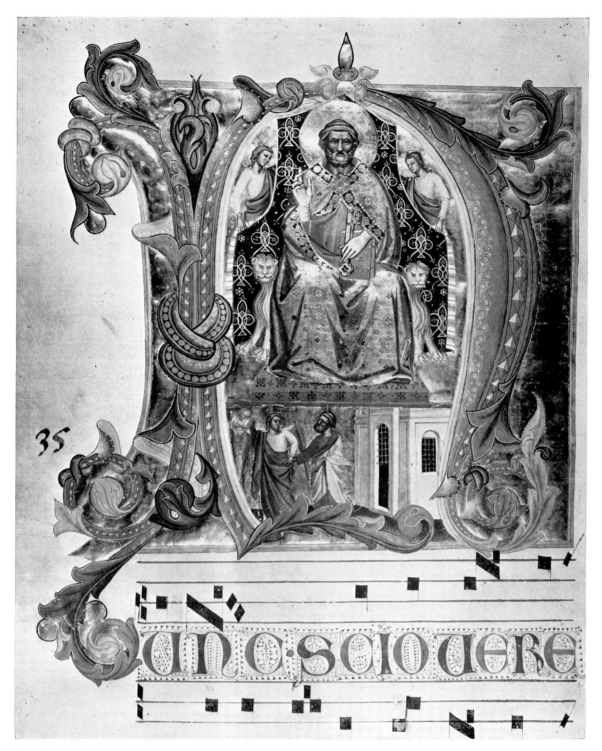

35

No. 73

PLATE LXVIII

No. 66

PLATE LXIX

No. 76

PLATE LXX

No. 97

PLATE LXXI

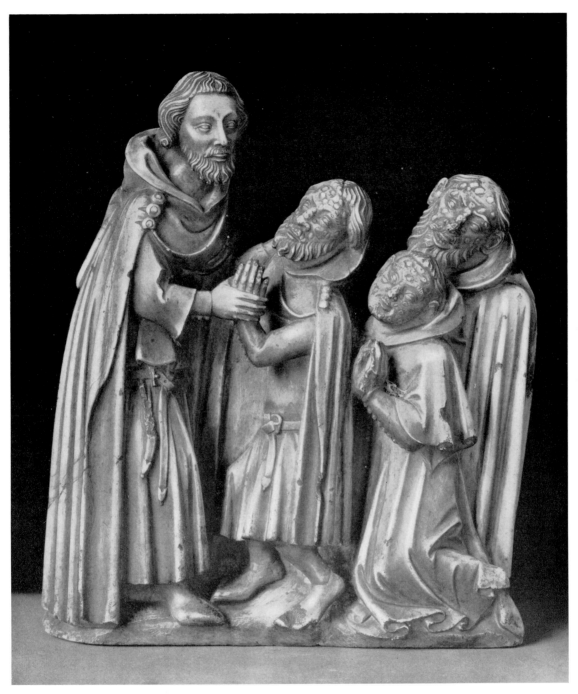

No. 95

PLATE LXXII

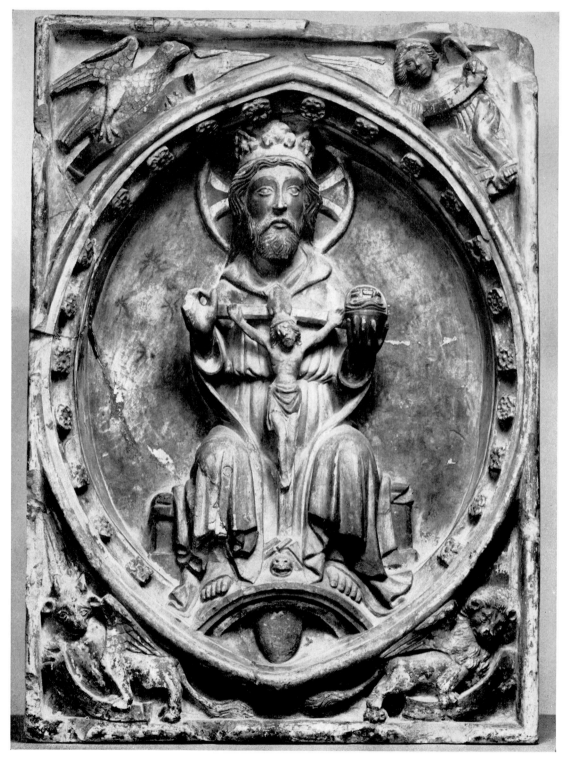

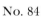
No. 84

PLATE LXXIII

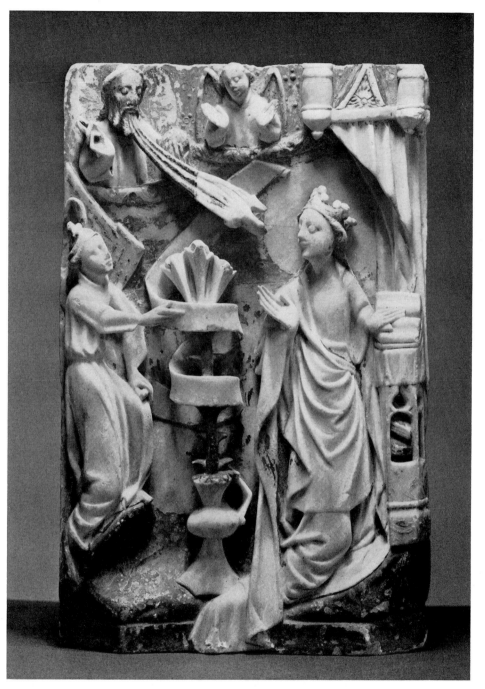

No. 85

Plate LXXIV

No. 86

No. 89

PLATE LXXV

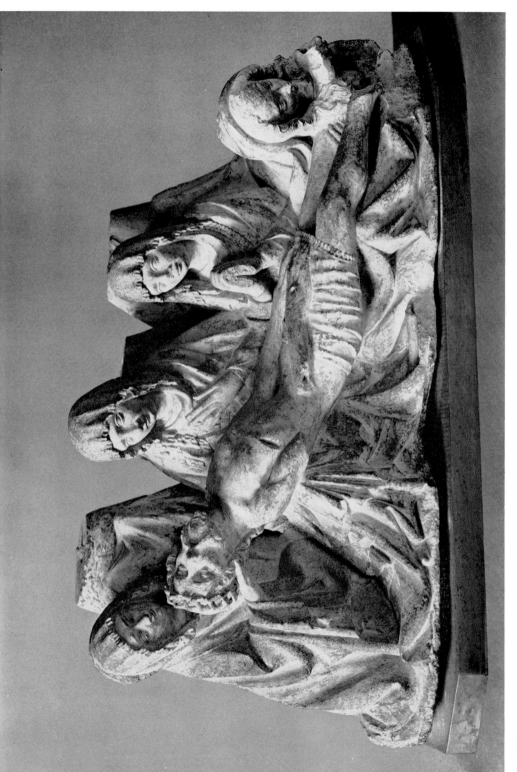

PLATE LXXVI

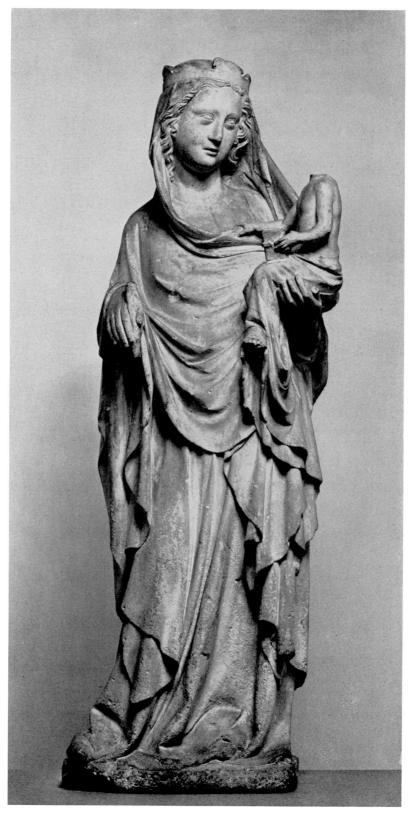

No. 90

PLATE LXXVII

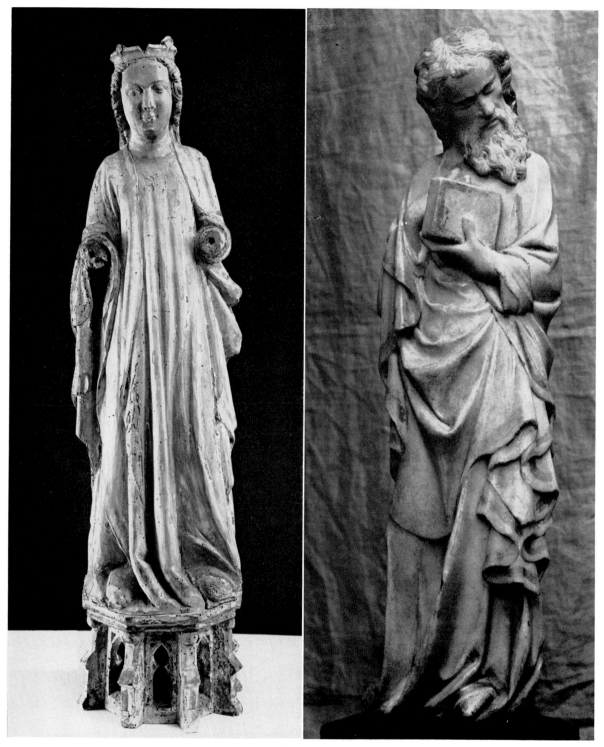

No. 77 No. 94

PLATE LXXVIII

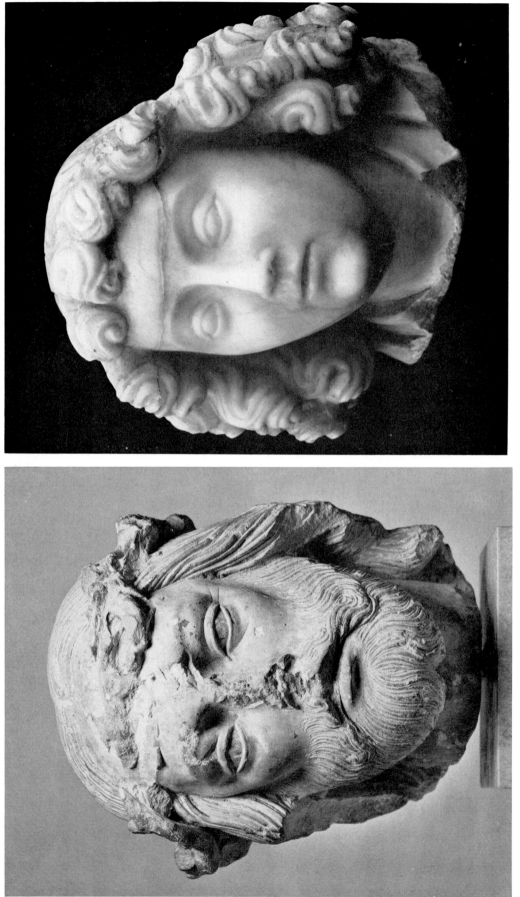

No. 88

No. 91

PLATE LXXIX

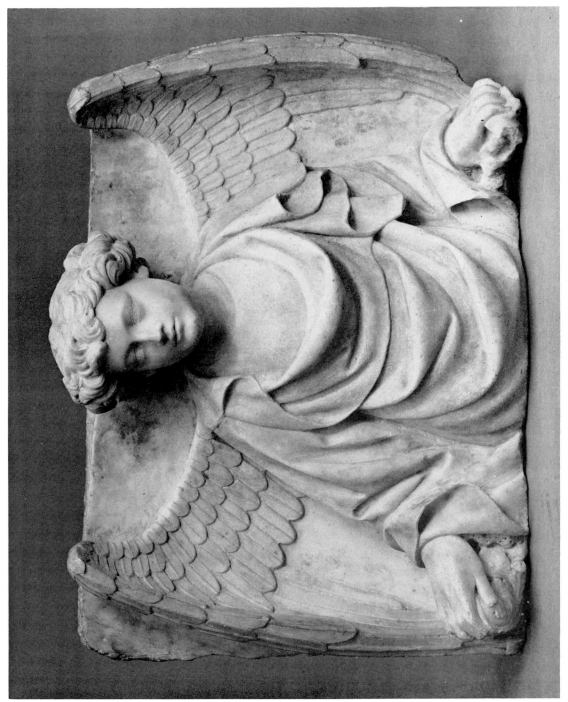

PLATE LXXX

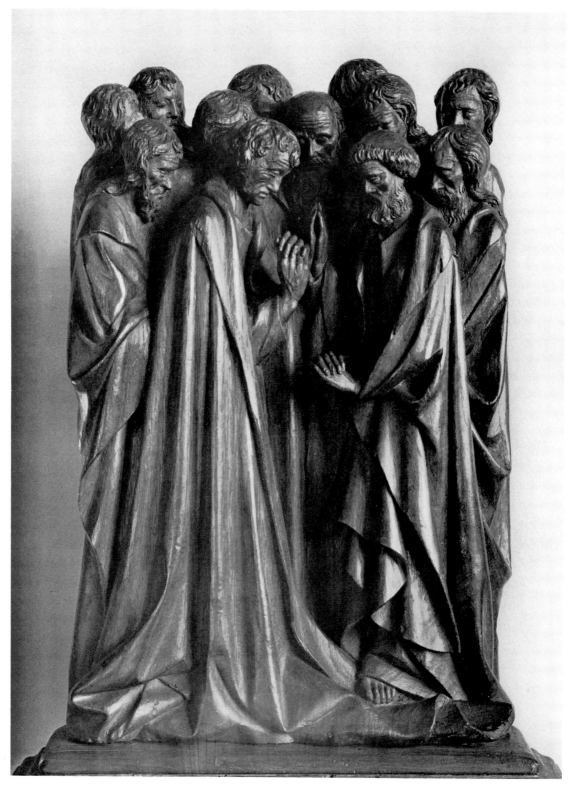

No. 87

PLATE LXXXI

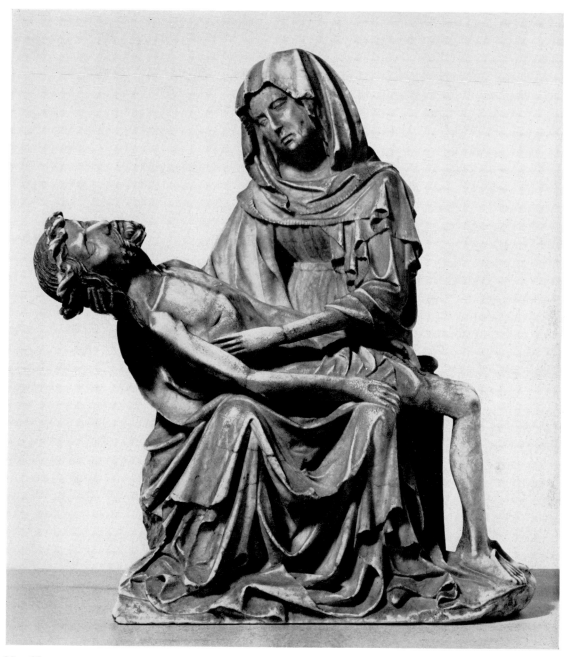

No. 99

PLATE LXXXII

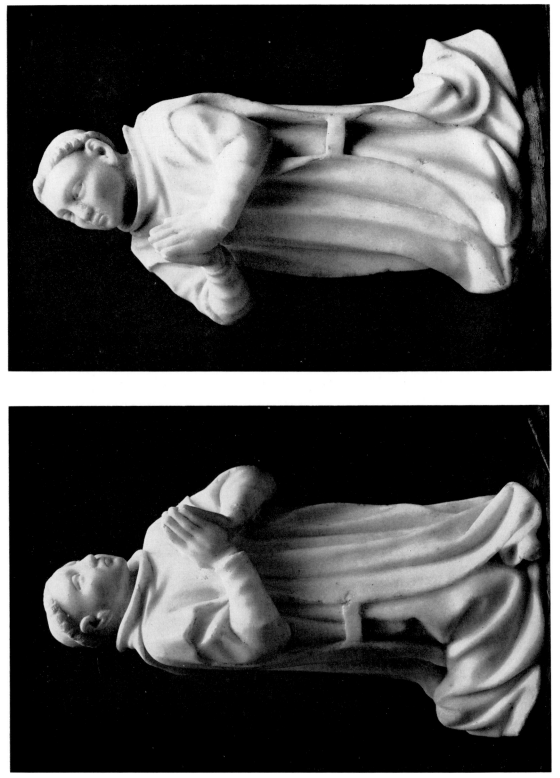

PLATE LXXXIII

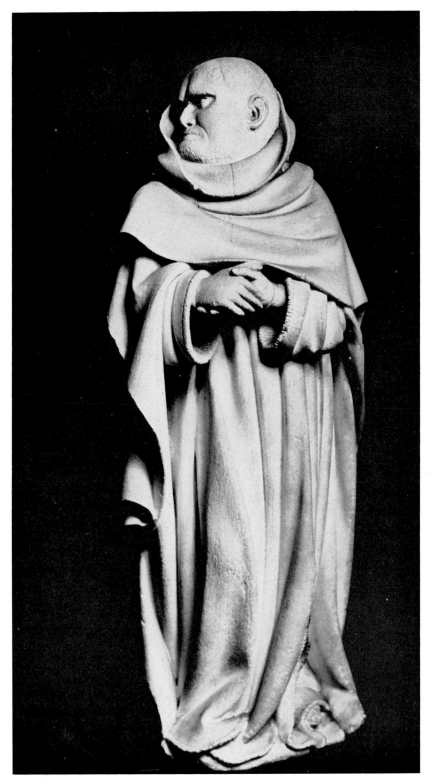

No. 96

PLATE LXXXIV

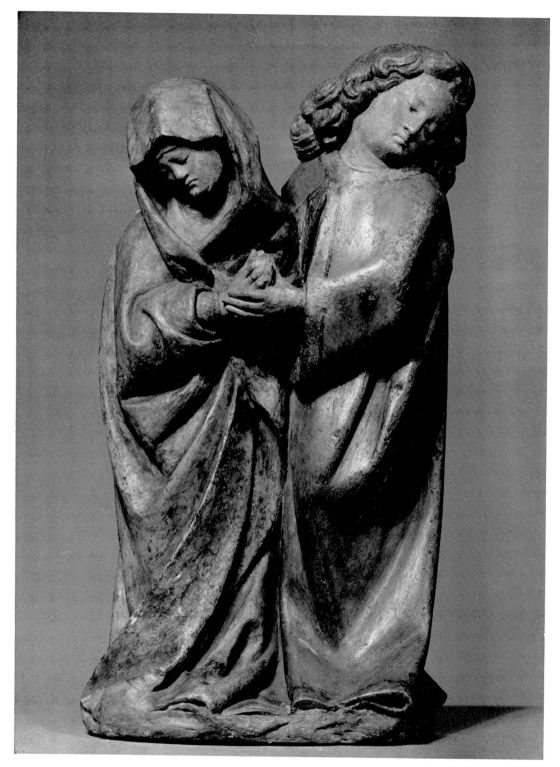

No. 82

PLATE LXXXV

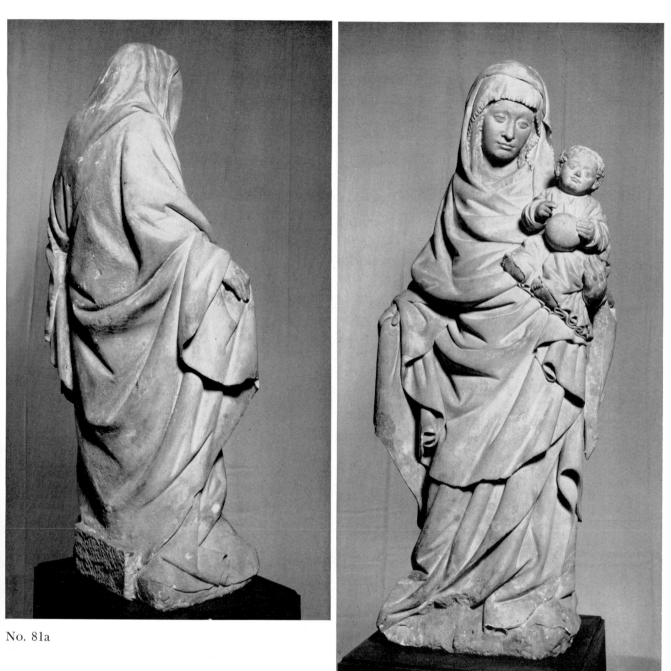

No. 81a

No. 81b

Plate LXXXVI

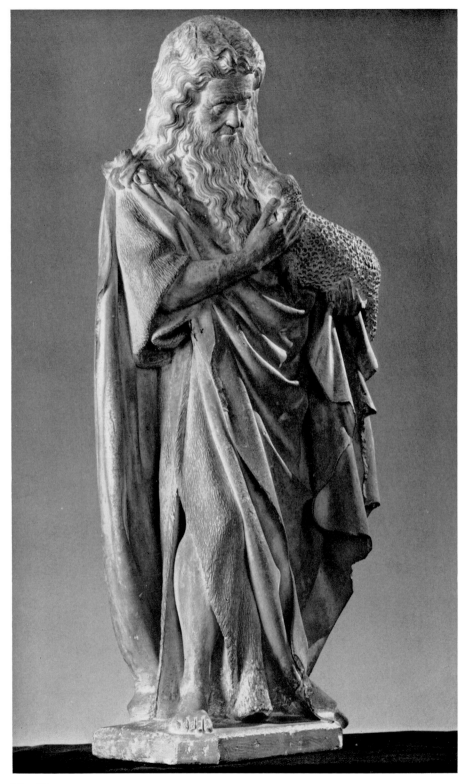

No. 83

PLATE LXXXVII

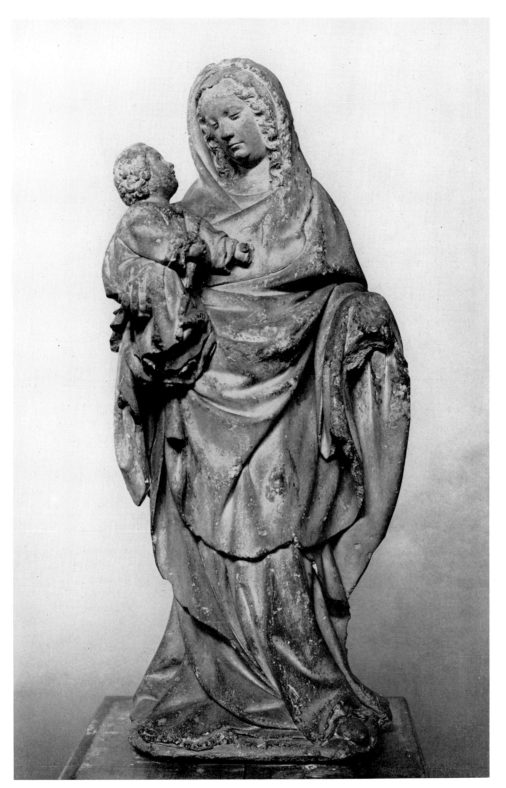

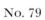

No. 79

PLATE LXXXVIII

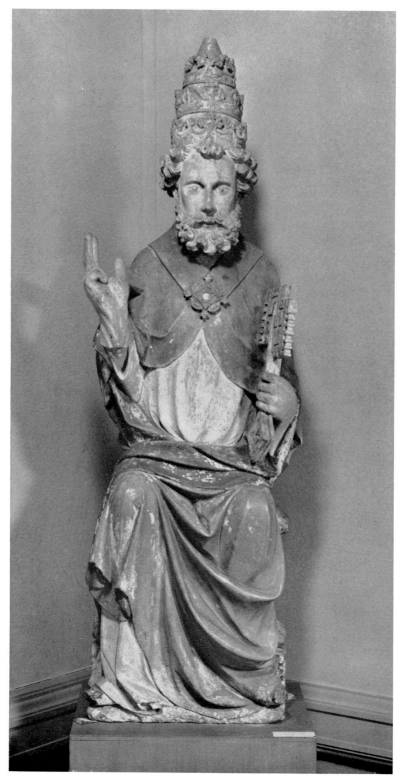

No. 93

PLATE LXXXIX

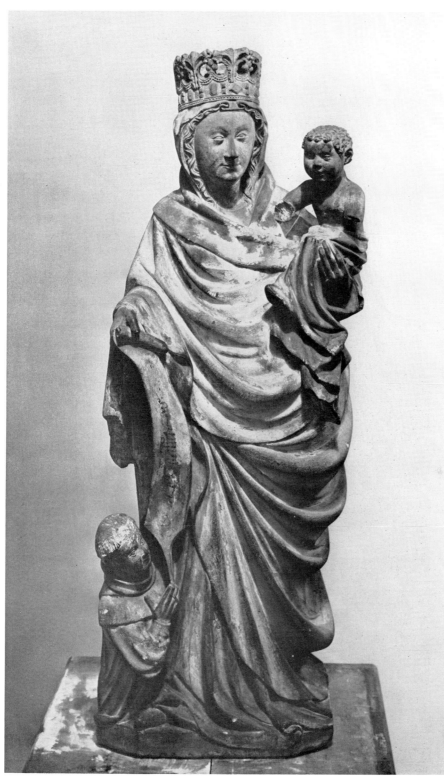

No. 80

PLATE XC

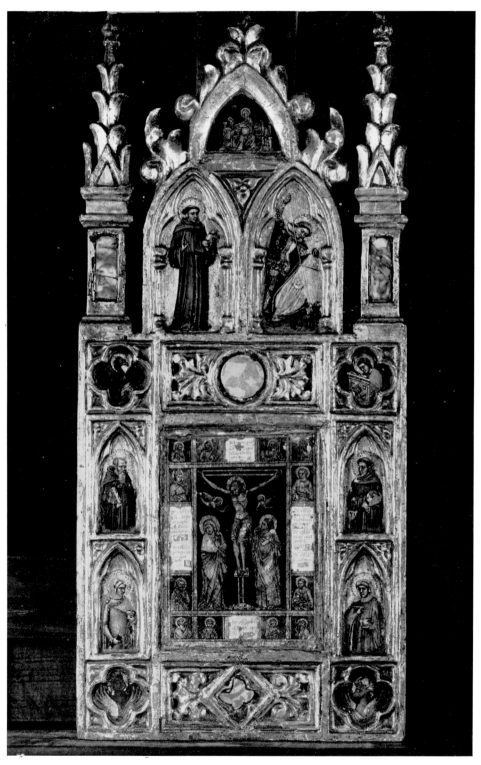

No. 100

PLATE XCI

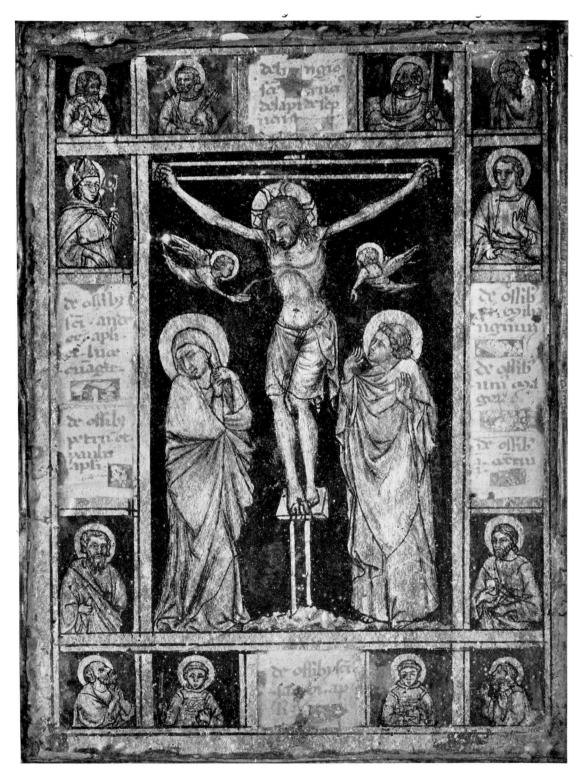

No. 100 (detail)

PLATE XCII

No. 135

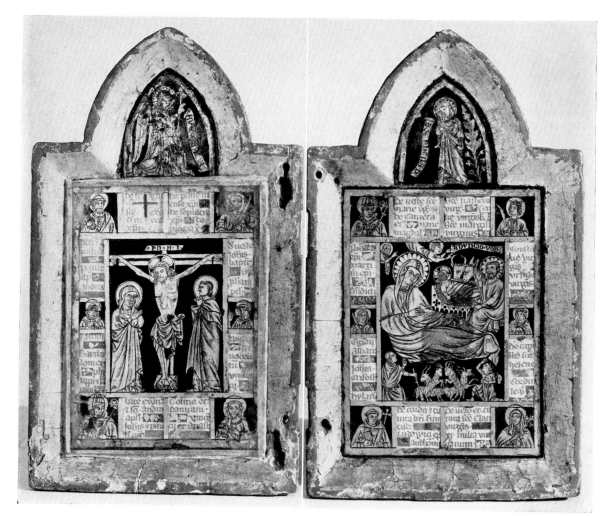

No. 101

PLATE XCIII

No. 140

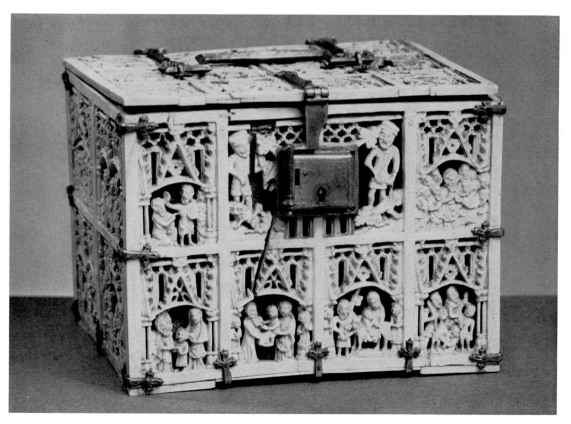

No. 109

Plate XCIV

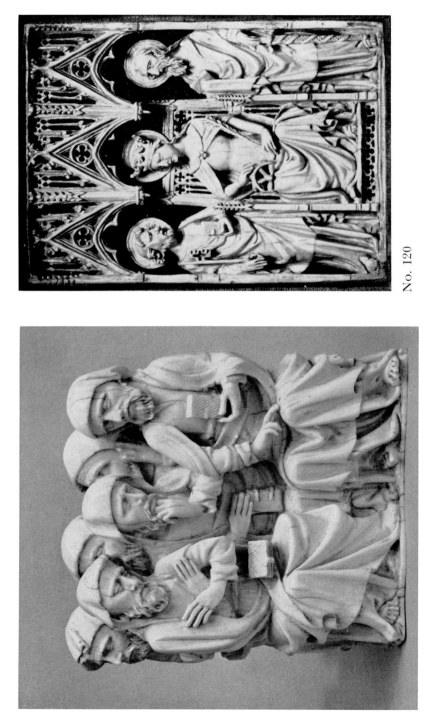

No. 120

No. 117

PLATE XCV

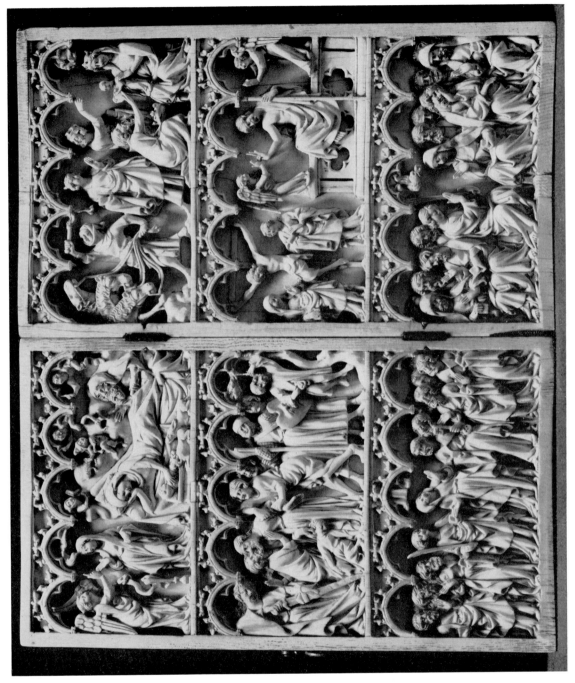

PLATE XCVI

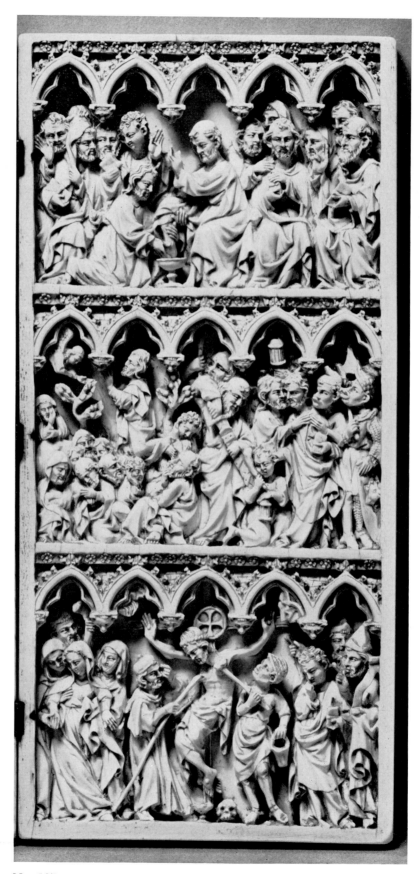

No. 107

PLATE XCVII

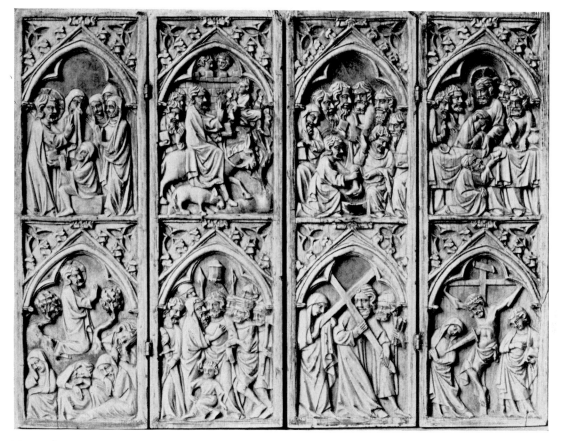

No. 119

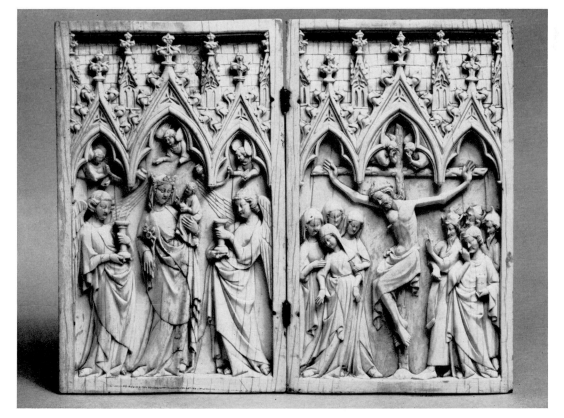

No. 118

PLATE XCVIII

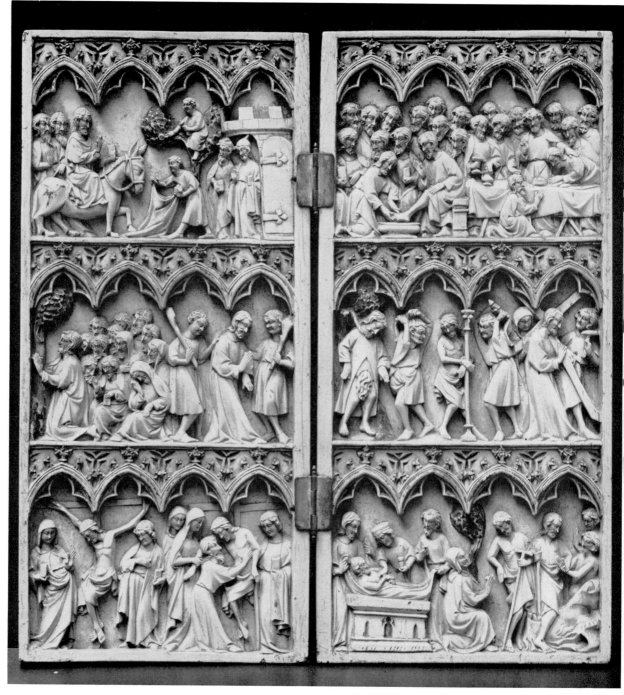

No. 116

PLATE XCIX

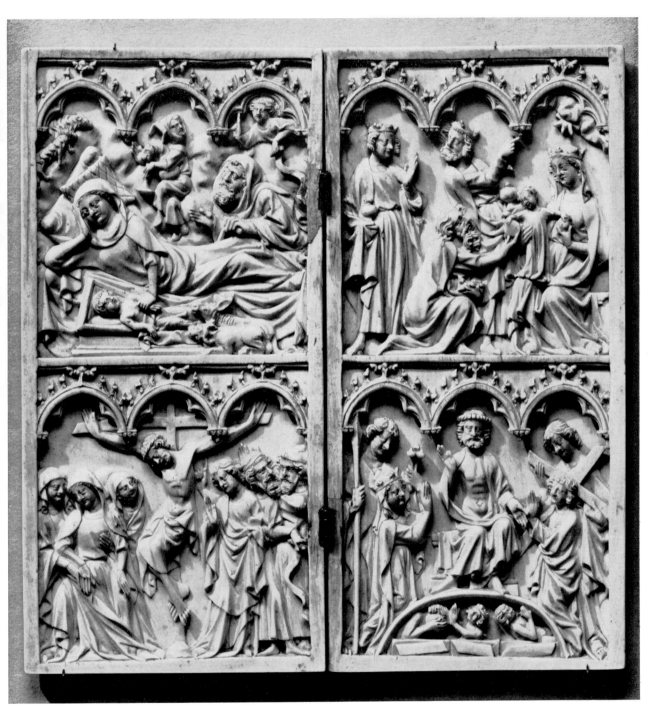

No. 110

PLATE C

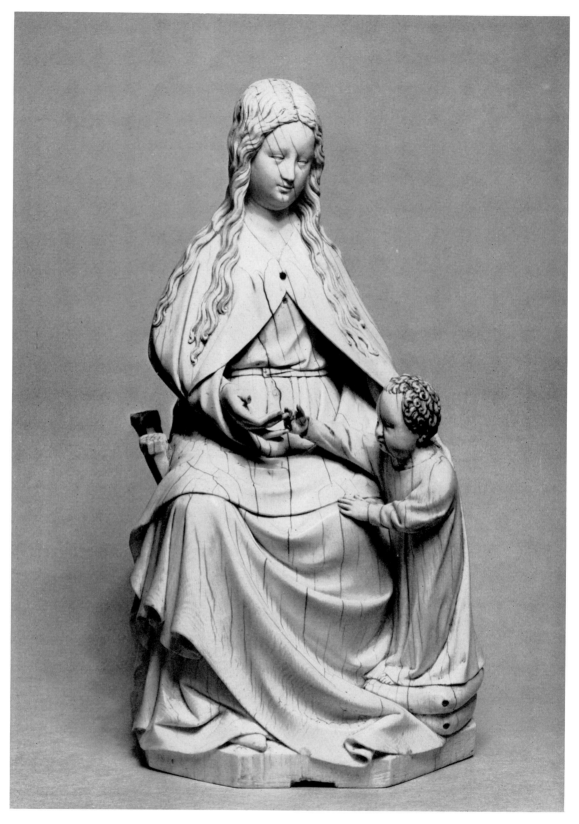

No. 123

PLATE CI

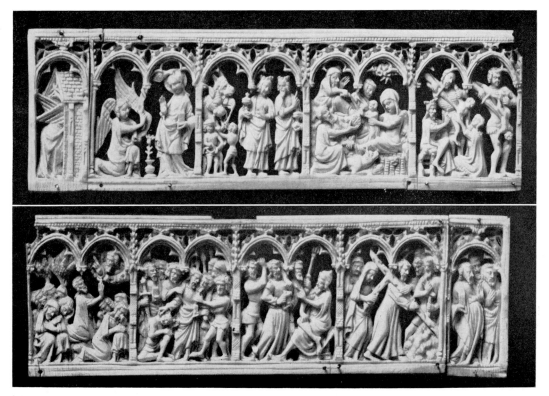

No. 108a

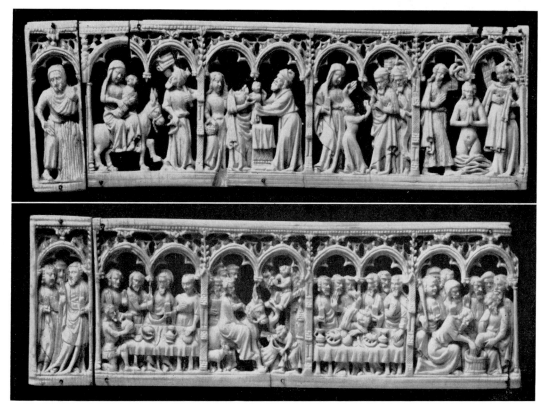

No.108b

PLATE CII

No. 121

No. 122

No. 102

PLATE CIII

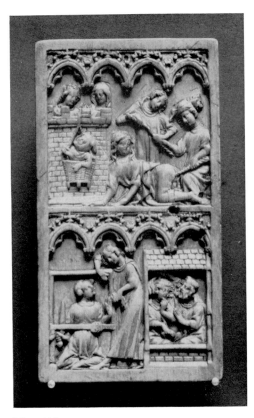

No. 112

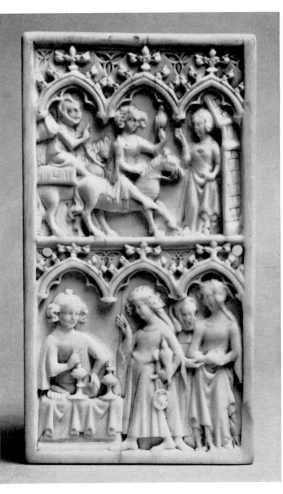

No. 114

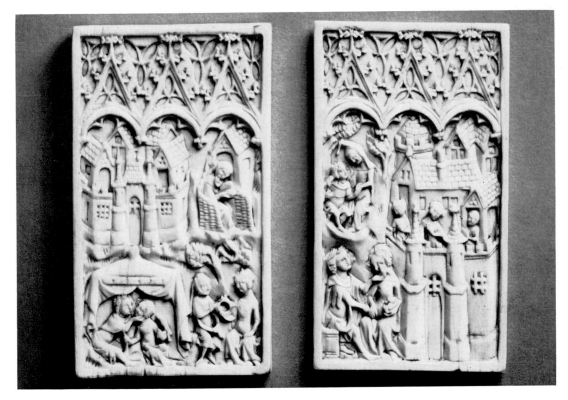

No. 111

PLATE CIV

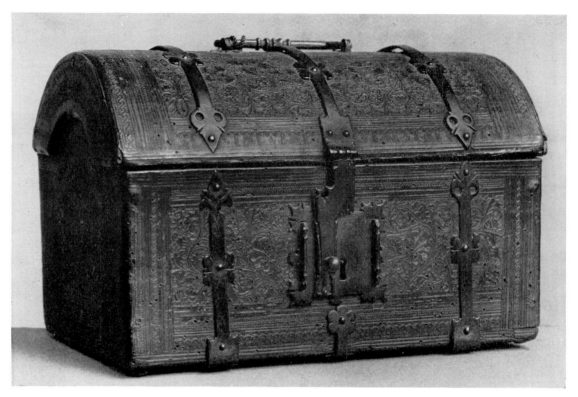

No. 104

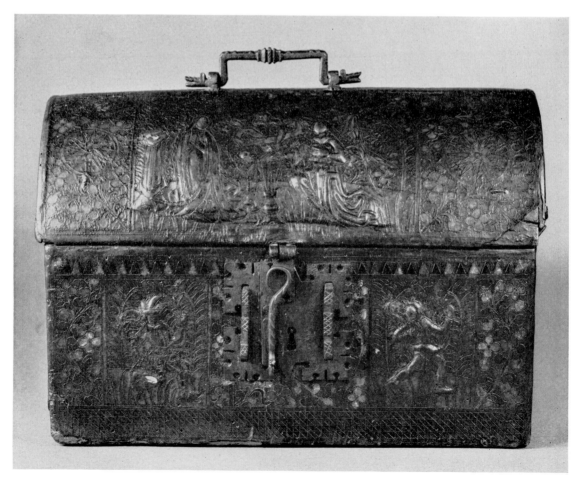

No. 103

PLATE CV

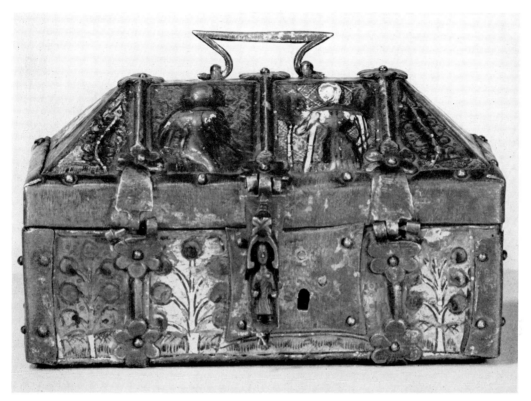

No. 105b

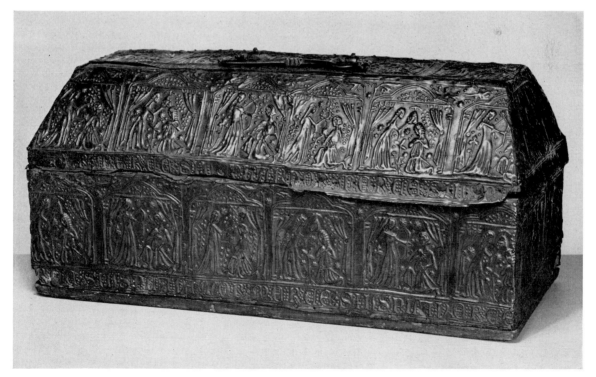

No. 106

PLATE CVI

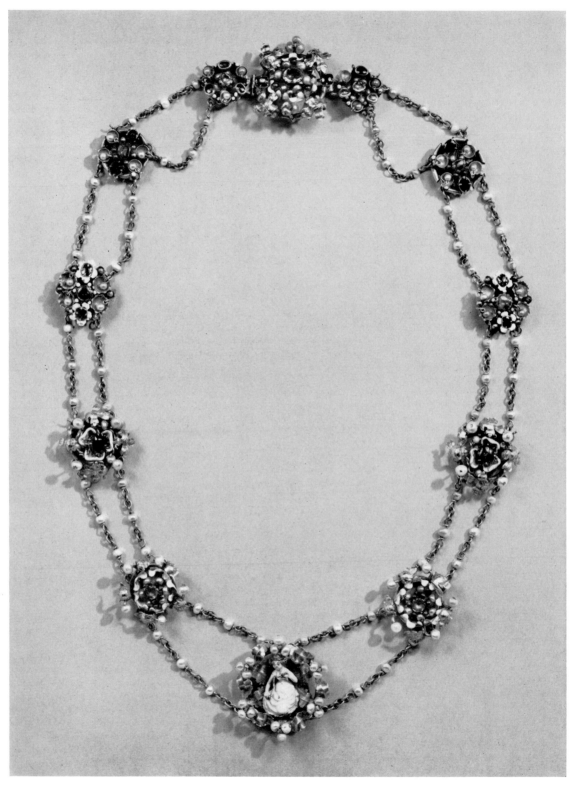

No. 127

PLATE CVII

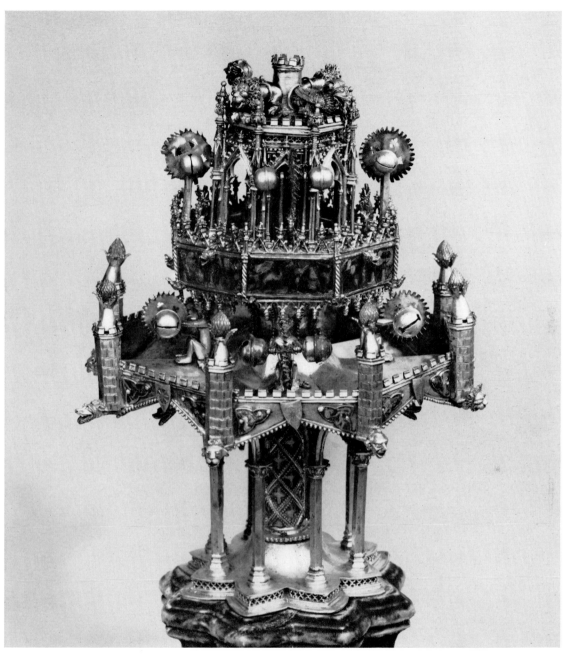

No. 126

PLATE CVIII

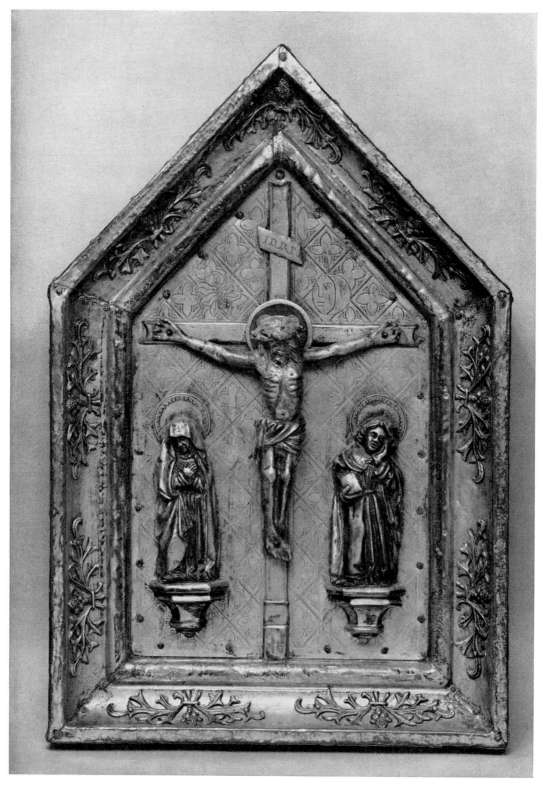

No. 128

PLATE CIX

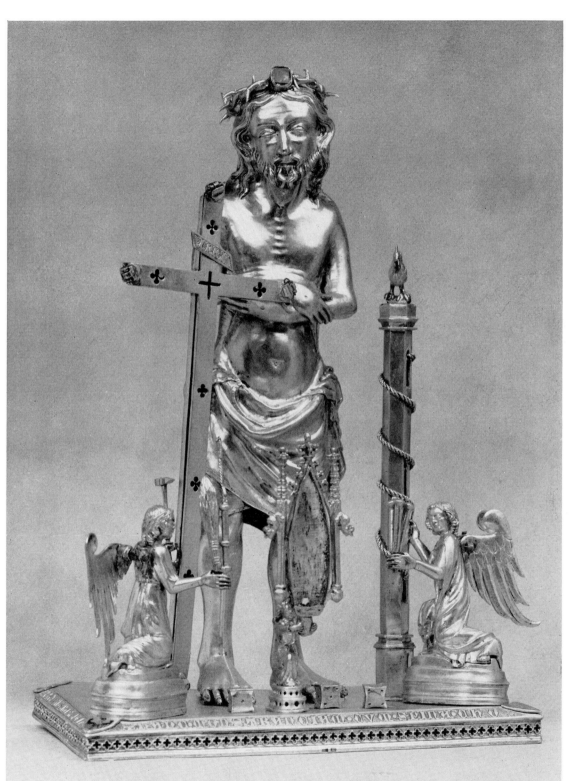

No. 125

Plate CX

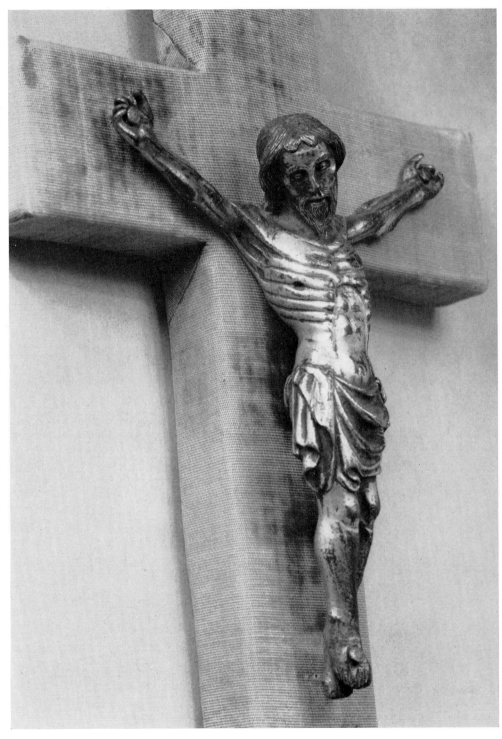

No. 145

PLATE CXI

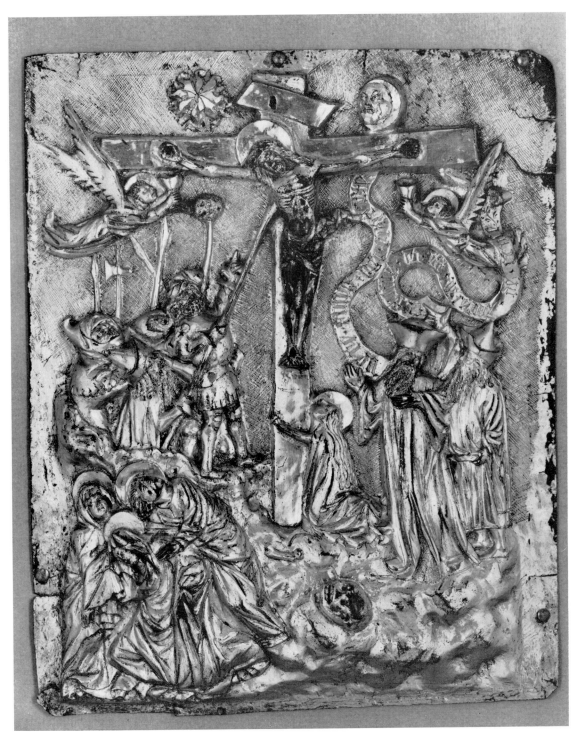

No. 148

PLATE CXII

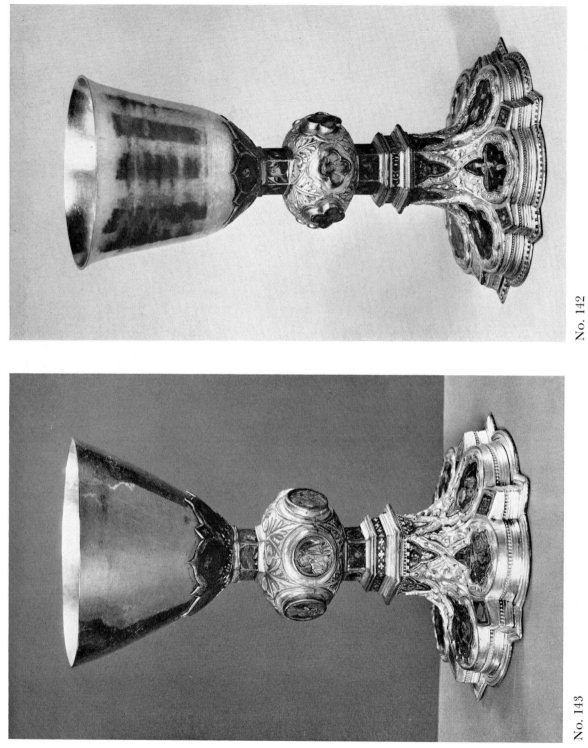

No. 142

No. 143

PLATE CXIII

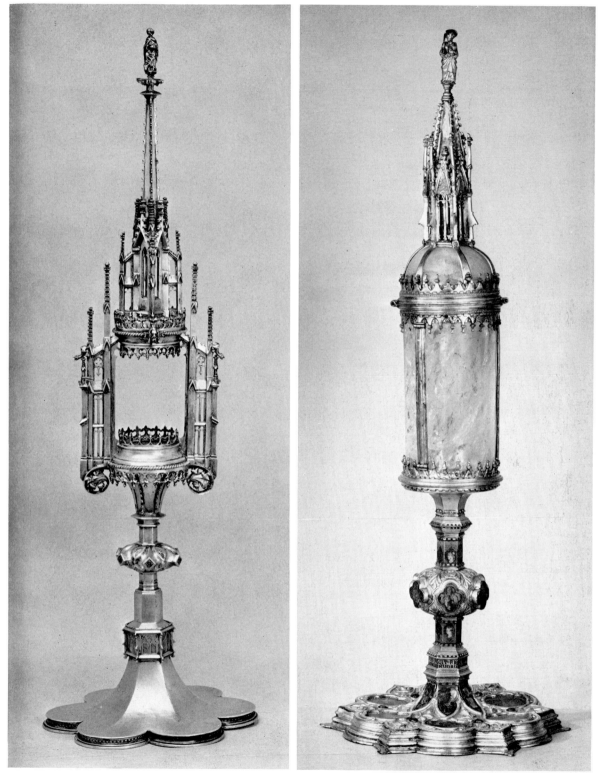

No. 124 No. 144

PLATE CXIV

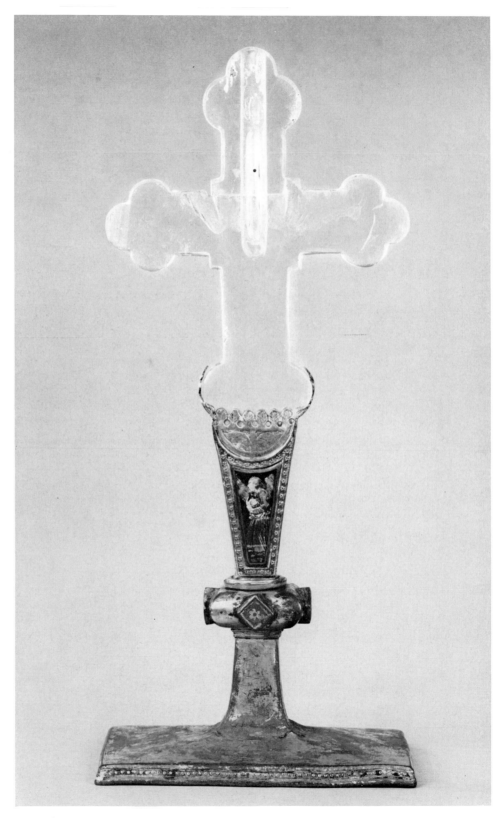

No. 129

PLATE CXV

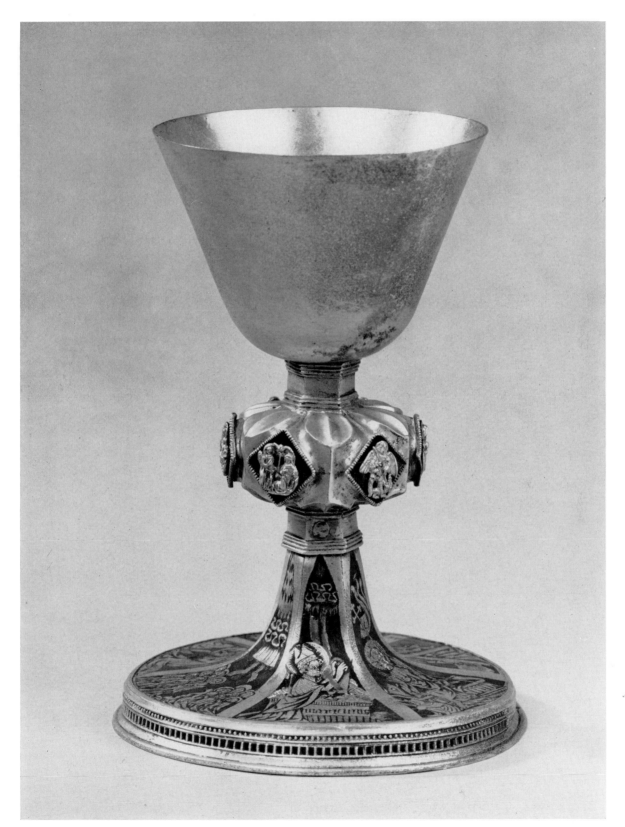

No. 134

PLATE CXVI

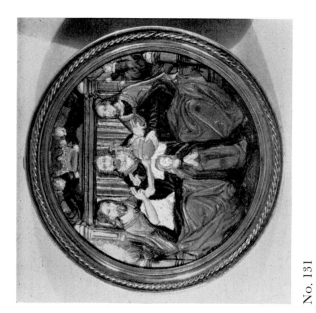

No. 131

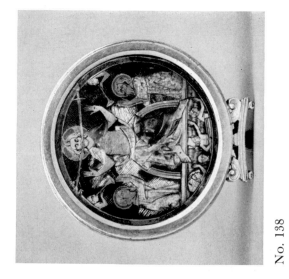

No. 138

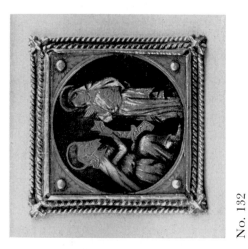

No. 132

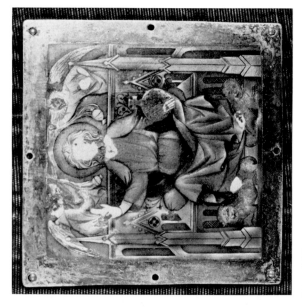

No. 137

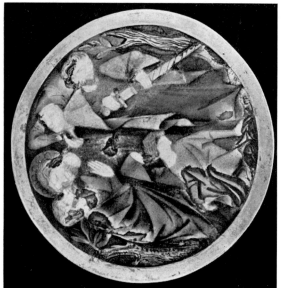

No. 130

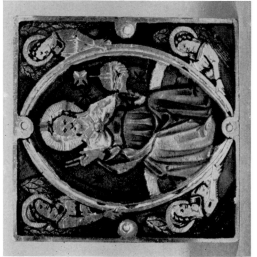

No. 139

PLATE CXVII

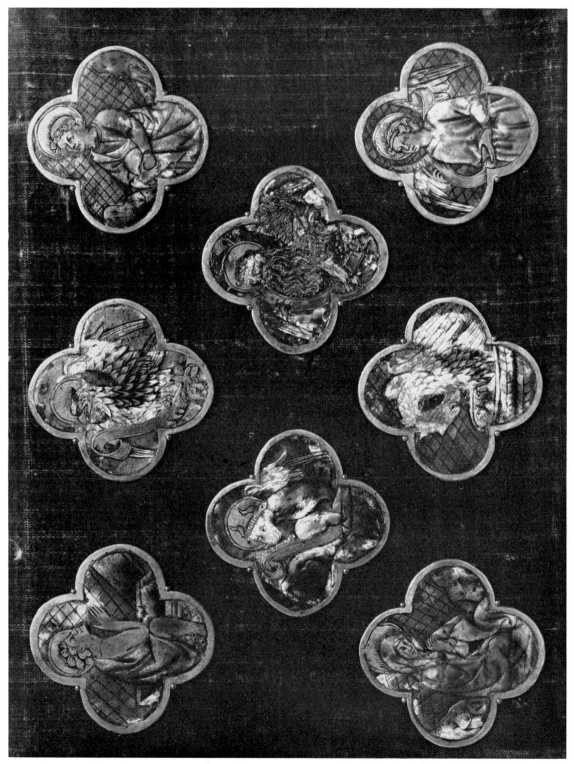

PLATE CXVIII

No. 136a

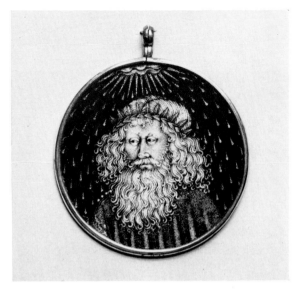

No. 136b

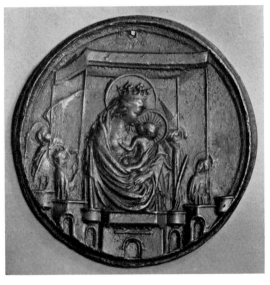

No. 153

No. 156a

No. 156b

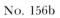

PLATE CXIX

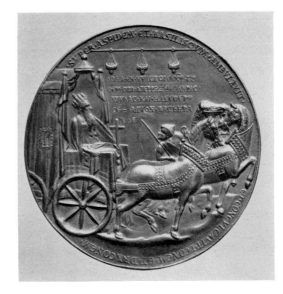

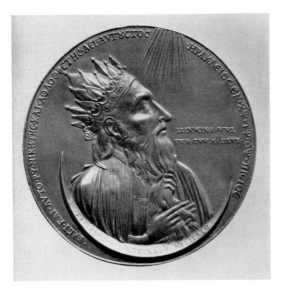

No. 155

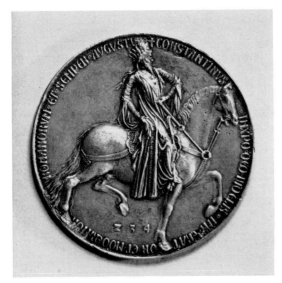

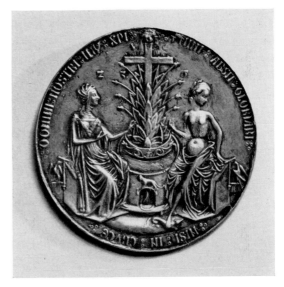

No. 154a

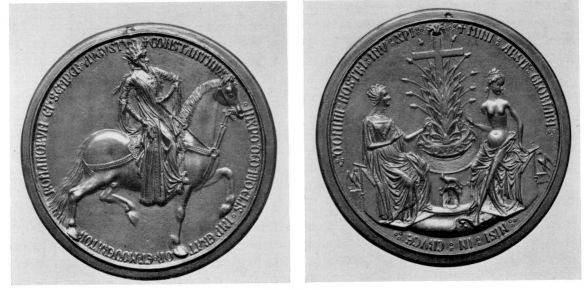

No. 154b

PLATE CXX

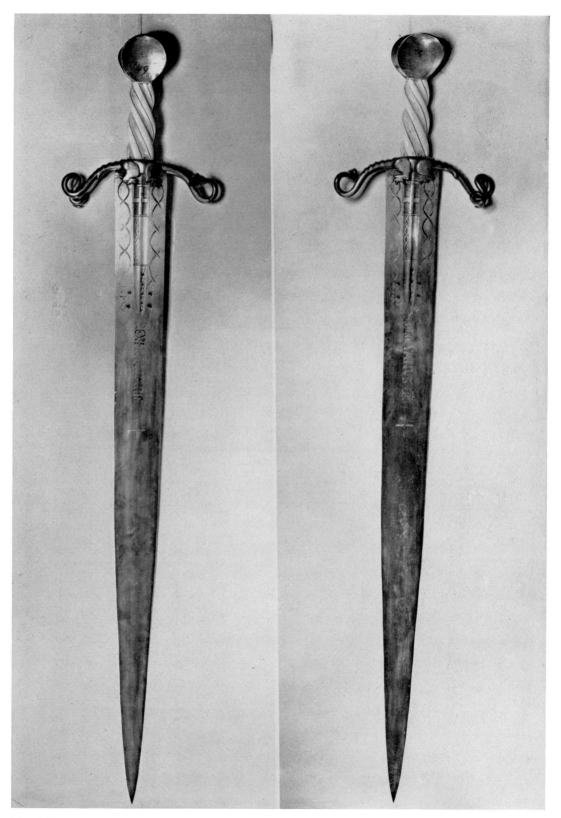

No. 146

PLATE CXXI

No. 147a

No. 147b

No. 147c

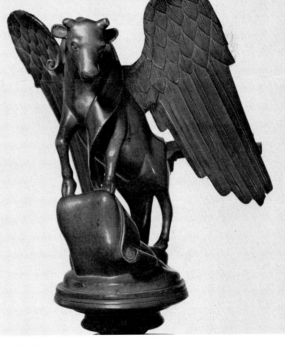

No. 147d

PLATE CXXII

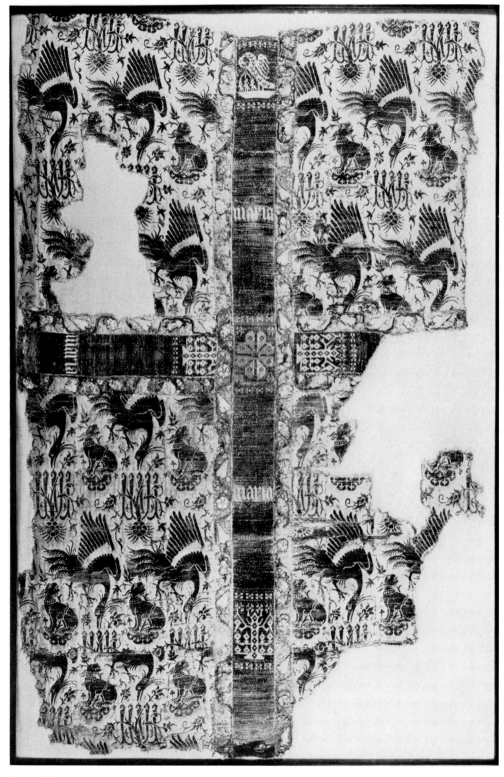

No. 157

PLATE CXXIII

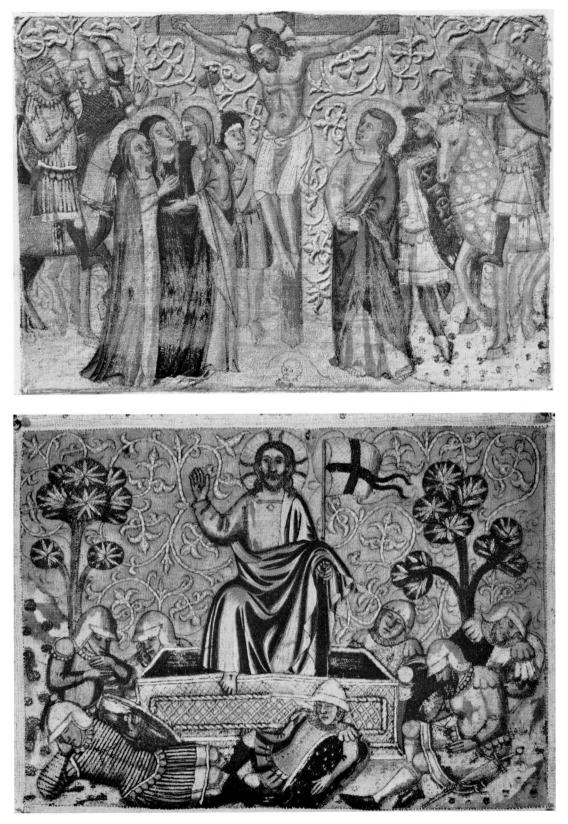

No. 158a *(above)*, 158b *(below)*

PLATE CXXIV

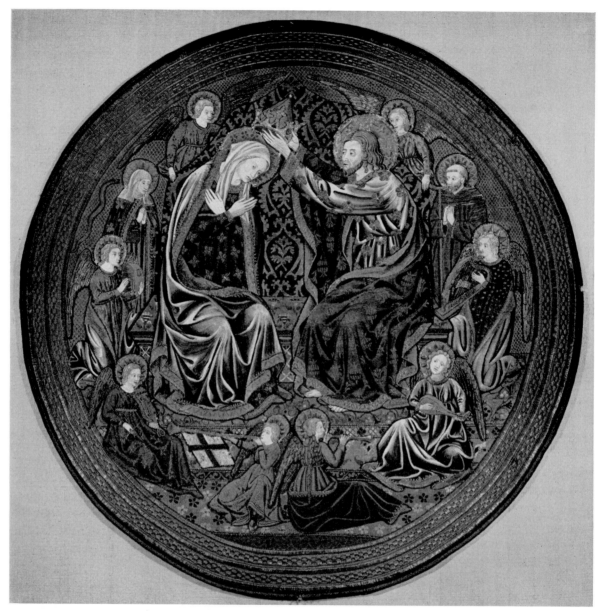

No. 159

PLATE CXXV

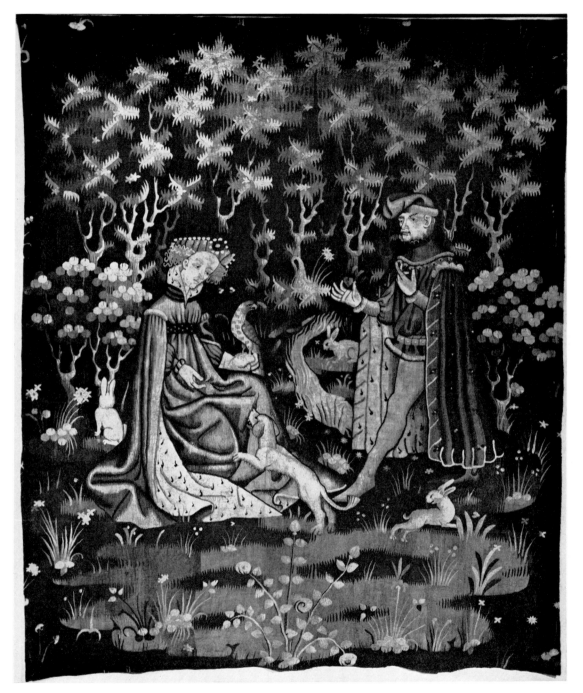

No. 160